Caravaggio and His Followers

Philip [Neri] urged men to humility both for its own sake and because it is the sister of another virtue which he prized just as much, simplicity. Simplicity, as he conceived it, was the direct and inseparable effect of humility. The man is simple who is humble, and therefore does not glory in possessing exceptional graces, who seems to pay no attention to such things, but behaves like everyone else How little [Philip] made of visions and ecstasies

—Ponnelle and Bordet, *St. Philip Neri and the Roman Society of His Times*, 1932, p. 586.

IV

Caravaggio and His Followers

By Richard E. Spear

Revised Edition

ICON EDITIONS
HARPER & ROW, PUBLISHERS
NEW YORK, HAGERSTOWN, SAN FRANCISCO, LONDON

CARAVAGGIO AND HIS FOLLOWERS (Revised Edition). Copyright
© 1971 by The Cleveland Museum of Art. Copyright © 1975 by
Richard E. Spear. All rights reserved. Printed in the United States
of America. No part of this book may be used or reproduced in
any manner whatsoever without written permission except in the
case of brief quotations embodied in critical articles and reviews.
For information address Harper & Row, Publishers, Inc., 10 East
53rd Street, New York, N.Y. 10022. Published simultaneously
in Canada by Fitzhenry & Whiteside Limited, Toronto.

FIRST ICON EDITION

ISBN: 0-06-430034-X

77 78 79 10 9 8 7 6 5 4 3 2

02/24/82 - 6.95

PREFACE

Modern art historians and critics relish the "rediscovery" of great masters, just as connoisseurs delight in the "discovery" of lost or unknown masterpieces. While some of these *trouvailles* are genuine discoveries, too often the sensationalism accompanying pseudo-discoveries is the price we pay for the cult of personality and originality—whether in the rediscovered artist or in the discovering critic. If taken to heart, Coomaraswamy's often repeated remark that one who made a thought truly his own was no mere imitator might help to redress the lack of balance revealed by the almost universal acceptance of such criteria as those of originality, discovery, invention, and progress.

Of the many "discoveries" in the history of art, only that of Vermeer has credentials commanding respect. The proof of deserving respect is that there has been so little, if anything, recovered of this artist's biography or of contemporary opinion about him. He was evidently not widely esteemed in his own time; so we of the nineteenth and twentieth centuries can be said to have "discovered" him. Almost all other claims for discovery of all but the most minor artists can be shown to be works of rehabilitation and restoration, of one generation revising the priorities of the immediately preceding one or refining the judgment of earlier, forgotten generations. Thus El Greco and Piero della Francesca, for example, were warmly embraced by the critics of the early twentieth century; but their credentials were great in their own time, as witness contemporary documents and the important works commissioned from them by their individual and institutional patrons. No artists patronized liberally by Federigo da Montefeltro, Sigismondo Malatesta, Phillip II, and the Archbishop of Toledo can be truly discovered by us—except insofar as we really make them a part of our being, their artistic language a part of our visual vocabulary and syntax.

And so it is with Caravaggio. The lack of attention given him in the nineteenth and early twentieth century has been replaced since World War II with a flood of articles, monographs, and attributions. The present re-evaluation and deification of Caravaggio inevitably leads to excess. All dark genre pictures become either Caravaggio or Caravaggesque. His influence has been extended to include artists who could never have seen his works, except in remote reflections. Exhibitions on the continent, in Milan and Paris, did much in providing occasions to see his work and that of his followers, but also obscured the true meaning and extent of the master's impact on European painting of the seventeenth century.

The purpose of this exhibition is in part to provide the first opportunity for people over here to see the master and his followers together in selected originals. It presents an opportunity to display the considerable wealth of Caravaggesque material in this country and also to show some unknown and unpublished paintings. Finally, there is an effort to define the true nature of his art and influence.

Where Berenson saw in him the "death of art," his contemporaries and we see in him a truly towering figure who dared to change the course of painting by his "common realism" at the same time he restored one of its ancient but temporarily lost virtues—monumentality.

The realism is plain to see; indeed, Berenson, for all his uneasiness before the works of the master, makes a telling comparison. "If at the sword's point I had to find a recent parallel to Caravaggio, it would be no other than Courbet. Neither could reject the comparison."[1] Equally evident is his emphasis on nocturnal and arbitrary lighting, murky but nonetheless integrated with the dramatic piety of his religious works and with the ambience of badly lit "lower class" environments. Poor people—poor light. Not for him the aristocratic sun.

But Caravaggio's restoration of monumental design was equally important. I, for one, failed completely to understand his art until, after several visits to S. Luigi dei Francesi and S. Maria del Popolo in Rome, I could see the forest for the trees. After the complicated textural patterns of the "Mannerists," Caravaggio's large-scale figures, his suppression of extraneous detail, his dramatic focus of attention and design—all seem a revelation, even if founded on the great wall decorations of Renaissance and High Renaissance Italy.

[1] B. Berenson, *Caravaggio: His Incongruity and His Fame*, London, 1953, p. 68.

We have been most privileged to have Professor Richard E. Spear of Oberlin College as organizer of the exhibition. His careful and rigorous selection is paralleled by the thoroughness and insight of his catalogue and text. Ann Tzeutschler Lurie, the Museum's Associate Curator of Paintings, and Delbert Gutridge, the Museum's Registrar, were invaluable in working out the details of organization and in supervising the performance of the innumerable tasks involved in assembling and exhibiting this major loan exhibition.

Our sincere thanks go to those in Italy who have helped us so greatly in our endeavors to assemble this exhibition: the Consiglio Superiore delle Belle Arti in Rome; Professor Italo Faldi, Director of the Galleria Nazionale d'Arte Antica in Rome; Professor Oreste Ferrari of Rome; His Excellency Egidio Ortona, Italian Ambassador to the United States; His Excellency Graham Martin, United States Ambassador to Italy; and Russell L. Harris, United States Cultural Attaché to Italy. Among the French, we are very grateful to Jean Chatelain, Directeur des Musées Nationaux; Hubert Landais, Conservateur-en-chef des Musées Nationaux; and Michel Laclotte, Conservateur-en-chef du Départment des Peintures, Musée du Louvre, for their support to and interest in our project. We owe special thanks to Xavier de Salas, Director, Museo del Prado, for his continued efforts and for his interest in this exhibition.

An important exhibition such as this naturally involves the work and cooperation of the entire staff of a museum, and I give thanks to everyone. However, special mention should be made of Lillian M. Kern, Administrative Assistant to the Director; Hannelore Osborne, Assistant, Department of Paintings; Leigh Washer, Secretary, Department of Paintings; William E. Ward, Museum Designer; and Merald E. Wrolstad, Editor of Museum Publications.

SHERMAN E. LEE
Director, The Cleveland Museum of Art

CONTENTS

FOREWORD

Caravaggio is the only seventeenth-century Italian paint-er whose name may be known to the general American public. His paintings and those of his followers have never prompted a major exhibition in this country,[1] even though everyone familiar with the history of art has an idea, imprecise as it may be, of what constitutes a Caravaggesque picture. This situation is not surprising, for the general literature of art propagates an enormous-ly wide notion of which painters should be included un-der the rubric "Caravaggesque," and even the special-ized writings on the Caravaggisti do not clarify the problem, since naturalism and chiaroscuro so often are wrongly attributed to the master's influence.

Caravaggio and His Followers is conceived as a critical re-examination of the deceptively simple question: Who were Caravaggio's actual followers? Although the pan-Caravaggesque "inclusive" attitude that has domi-nated twentieth-century scholarship is rejected, there is no pretense that a definitive list of names has been achieved. Personal visual persuasions and changing taste

undoubtedly will invite modification, revision, and re-finement. But if disagreement over particulars can be set aside for a fundamental reappraisal of what legitimately can be entitled Caravaggesque art, then a primary schol-arly purpose of this exhibition will have been fulfilled.

Individual paintings were selected with quality as the foremost consideration, but it must be emphasized that pictures in American collections received priority, while foreign loans had to be kept to a minimum. Nevertheless, an effort was made to present a group of little-known paintings,[2] and to provide an indication, as accurately as was possible within the framework of the exhibition and the restrictions on loans, of the breadth and variety of Caravaggesque activity. Inevitably, certain problems proved to be insurmountable. Thus, in some instances artists are not represented by their most Caravaggesque paintings; Caravaggio's still-life style is not to be seen in the exhibition; there is no example of his Roman altar-pieces; and a small number of his followers have been excluded more by necessity than choice (for example, Jean Le Clerc and Orazio Riminaldi). A larger group of the Caravaggisti, discussed in the catalogue but not in-cluded in the exhibition, were intentionally omitted, either because they were mediocre artists, such as Mao Salini, Rodriguez, Minniti, Jan Janssens, and Manzoni, or because they were minor figures historically—I refer to men like David de Haen and Gysbert van der Kuyl.

The reasoning behind the decision to exclude draw-ings should be understood. There is no known drawing from Caravaggio's hand;[3] there are relatively few draw-ings by the Caravaggisti;[4] and those which have been identified reveal no consistent style or method of draughtsmanship. Like frescoes, drawings are inherently incompatible with Caravaggio's artistic principles. As a young artist in Lombardy, Caravaggio unquestionably was trained to draw; and one cannot categorically ex-clude the possibility that later in his career he occasionally worked with pen or chalk. But it is a denial of Caravag-gio's art to contend that he publicly falsified his studio methods when he declared that all he required was the live model from the streets, and to assume that chance alone (or Caravaggio himself!) destroyed all of his draw-ings. Furthermore, technical considerations undercut that supposition. The well-known x-rays of the *Martyr-*

1. There have been at least two small exhibitions: Caravaggio and the Caravaggisti, Durlacher Brothers, New York, 1946; and Caravaggio and the Tenebrosi, Seattle Art Museum, 1954. A summary catalogue accompanied the former exhibition, and only a checklist the latter; neither is illustrated.

2. Comparative material discussed in individual catalogue en-tries supplements the body of unpublished works.

3. See Moir, 1969, for bibliographical references to this prob-lem; the conclusions reached by Moir are contrary to the position presented here.*

4. There is, for example, a small number of drawings by some of the Northern followers such as Honthorst, Terbrugghen, and Baburen; a drawing in Milan possibly is by Manfredi (ill. in Moir, 1967, II, fig. 104); Vouet was an active draughtsman later in his career, but little is known about his Roman years; one can-not ascertain to what extent Borgianni, the Gentileschi, Cavaroz-zi, et al. drew, in particular when they prepared their most Caravaggesque paintings; Caracciolo is the exceptional close follower of Caravaggio who consistently seems to have made drawings. These, and numerous other examples, only serve to prove that there was no consistent attitude toward drawing among the Caravaggisti, who generally seem to have relied on their local traditions when drawings were made.

* All bibliographical abbreviations refer to the full citations on pp. 203 ff.

dom of St. Matthew[5] prove that Caravaggio was very far from his final design when he first touched brush to canvas. If he was prepared to rework his largest and most ambitious public composition *alla prima*, there is little difficulty in believing that smaller, less elaborate paintings were executed directly from the model at hand. A second point confirms this interpretation. A series of Caravaggio's mature paintings carries unusual traces of incomplete contour incisions in the priming of the canvas, which are understandable only as working guidelines, unpremeditated, scratched into the ground during study of the live model [cf. 17].*

Numerous scholars both in America and abroad have contributed to this exhibition. I am indebted, above all, to Benedict Nicolson with whom I discussed countless problems and whose deep understanding of the Caravaggisti was generously shared with me. The extensive lists of Italian paintings in public American collections prepared by Professor Federico Zeri and Burton Fredericksen were unselfishly put at my disposal prior to publication, and Mr. Fredericksen personally facilitated my perusal of them. Dr. Marilyn Lavin patiently coped with many questions concerning Barberini provenances and kindly released important documentary information prior to her publication of the seventeenth-century Barberini inventories; Dr. Frances Vivian willingly provided additional notes on the later inventories of the same paintings. Likewise, I am very grateful to Chandler Kirwin, whose discovery of Cardinal del Monte's inventory enriches this catalogue. Professor Oreste Ferrari's counsel concerning the Italian loans was particularly helpful and is deeply appreciated. For careful reading and criticism of the final manuscript, I am indebted to Professor Ellen Johnson.

Valuable information and suggestions concerning bibliography, location of paintings, arrangements of loans, and a variety of issues raised in the catalogue were furnished by Joële Almagià, Professor Italo Faldi, Myron Laskin, Luciano Maranzi, Patrick Matthiesen, John Maxon, Professor Alfred Moir, Dr. A. E. Pérez-Sánchez, Anne Poulet, Dr. Herwarth Röttgen, Pierre Rosenberg, Dr. Luigi Salerno, Dr. Erich Schleier, Professor Wolfgang Stechow, Julian Stock, Professor Michael Stoughton, Yvonne Tan Bunzl, Professor Harold Wethey, and Christopher Wright. My sincere thanks are extended to each of these persons. With warm gratitude I also recall the hospitality and cooperation I enjoyed from the individual private collectors lending to this exhibition and the extensive assistance given to me by the staffs of many of the lending institutions.

It is a pleasure to acknowledge the sponsorship of The Cleveland Museum of Art, in particular the assistance provided by Dr. Sherman E. Lee, Ann Lurie, Dr. Merald Wrolstad, and Norma Roberts, and to express my appreciation to Oberlin College for the released time from teaching granted to me during the initial phase of my research.

My wife, Athena, participated in nearly every aspect of preparing *Caravaggio and His Followers* and contributed invaluable encouragement and criticism at each stage of my work.

Finally, I must emphasize that if the definition of Caravaggesque painting presented here is more restricted than that put forth by Professors Longhi and Moir—and issue is often taken with specific points in their writings—I nonetheless am deeply indebted to the pioneering, perceptive research of the late Professor Longhi and to the valuable publication of extensive material in Professor Moir's book on Caravaggio's Italian followers.

R.E.S.
Oberlin, Ohio

* Numbers in brackets refer to catalogue entries.

5. See L. Venturi, 1952.

FOREWORD TO THE PAPERBACK EDITION

The demand for *Caravaggio and His Followers,* which was out of print by the time the exhibition at Cleveland closed in January of 1972, warranted a second edition; but production costs necessitated a photographic reprinting as opposed to a fully revised edition. Nonetheless, it seemed desirable to summarize critical reaction to the Cleveland exhibition and to try to take into account new information that has come to light since 1971.

In order to achieve these goals within restrictive production possibilities, we had to leave the original text basically unaltered. Only factual and typographical corrections have been made (the most significant of which are Caravaggio's newly discovered birthdate 1571–72 instead of 1573, and Tournier's deathdate, 1638–39 not "after 1657"). "Unknown Pictures by the Caravaggisti (with Notes on *Caravaggio and His Followers*)," an article I published in *Storia dell'arte,* no. 14, 1972, pp. 149–61, is the basis of the Appendix to this edition. However, the notes of that article have been considerably expanded, and Part II, on the Cleveland exhibition, has been reworked in order to include Borea's opinions and to consider, among other recent literature, the new monographs on Georges de La Tour, the French Caravaggisti exhibition of 1973–74, and the special Caravaggesque issue of *The Burlington Magazine,* October 1974.

A selected bibliography (page 241) updates the Cleveland one (and includes two omissions from the 1971 edition: Askew, 1969, and Matthiesen-Pepper, 1970), but only the most important publications relevant to this book are listed.

The editors of *Storia dell'arte* kindly granted permission for my earlier article to be published in revised form in this context. I also am grateful to Dr. Herwarth Röttgen, whose forthcoming review of the Cleveland exhibition (in *The Art Quarterly*) was put at my disposal some time ago.

Richard E. Spear
Oberlin College
February 1975

CARAVAGGIO AND HIS FOLLOWERS

I

When Michelangelo Merisi da Caravaggio arrived in Rome as a young man, probably late in 1592 or early in 1593,[1] the tradition of Mannerism—the Cinquecento *maniera*—was already under significant attack.[2] A select number of older masters had tempered their imagination (what Federico Zuccaro would call *disegno interno*)[3] and had begun to approach, indeed to prophesy, the clarified, empirically founded style that soon was to become the hallmark of a generation of young reformers. It cannot be emphasized too strongly, however, that if today Annibale Carracci's role in this latter group is well known, it has been exaggerated to a point where he, along with Caravaggio, is often considered to be *the* progenitor of Seicento painting, while earlier origins of the Baroque—and those in centers other than Bologna—have been too summarily dismissed. The significant contribution of Annibale's cousin Ludovico has been eclipsed in the course of this simplification, but, more importantly, many artists have been generally neglected. Friedlaender[4] rightly stressed the pioneering attitudes of Barocci, Santi di Tito, Cigoli, and Cerano, to whom must be added, among others, Antonio Campi, Jacopo da Empoli, Cristoforo Roncalli (Pomarancio), Scarsellino, Francesco Vanni, Bartolomeo Cesi, Domenico Cresti (Passignano), Scipione Pulzone, Girolamo Muziano, and Giuseppe Cesari (the Cavaliere d'Arpino).[5] Admittedly, the degree of "reform" discernible in these masters' work varies widely, as does the quality of each artist

and of individual commissions. Nevertheless, an historical understanding of Caravaggio and the Carracci is possible only when they are seen within, and as inseparable from, this broader tendency, and only when they are studied not as unique phenomena, but as quintessential manifestations of the fresh breeze that was sweeping all major centers of art in Italy.

The change which occurred in Italian painting and quickly took hold in every European country cannot, therefore, be assigned to a specific geographical region, school, artist, or decade. Throughout the 1570's and 1580's (not by coincidence the years immediately following the closing of the Council of Trent, 1545–63),[6] artists in the avant-garde were concerned with effecting a style that was based on observation of nature and was preeminently intelligible to the beholder. Spatial ambiguities of tightly compressed or rapidly receding settings, the decorative and expressive qualities of attenuated figures, contorted poses and *couleurs changeantes*, and, most importantly, the emotional content of paintings steeped in the *maniera*[7]—all were challenged by a radically different, if as yet not clearly defined, set of values. The artistic means whereby this change took place, notably the lucid organization of space, emphasis upon natural proportions and simplified postures, and a preference for unbroken colors, can be clarified by an analysis of style. Investigation of the fundamental issues of motivation and intention leads to an understanding of the immediacy—the human presence—in late Cinquecento art, which ultimately differentiates the new attitude from the old and is the primary characteristic of Baroque painting.

Although no picture can be assigned to Caravaggio's pre-Roman years, a homogeneous group of secular and religious paintings belonging to the period 1592/93–96 reveals both the Venetian-Lombardic heritage and the distinct personality of the young painter. Longhi's and Friedlaender's penetrating analyses[8] of the artistic milieu in which Caravaggio was raised and educated emphasize the role that artists like Antonio Campi and Lorenzo Lotto played in determining the boy's vision, in directing him to appreciate the lyrical naturalism and the dramatic chiaroscuro that already were deeply rooted in the Lom-

1. See Borla, 1962, for Caravaggio's arrival in Rome; a summary biography of the artist is found below, pp. 67-68.
2. In particular, see Friedlaender, 1957, pp. 47 ff.
3. On Zuccaro and Caravaggio, see Friedlaender, 1948. Also, see Mahon's discussion in 1947, pp. 155 ff.
4. Friedlaender, 1957, pp. 50 ff.
5. It is interesting to note that although the learned eighteenth-century Jesuit historian Luigi Lanzi stressed the importance of the Carracci (ed. 1854, III, 64 ff.), he also was very perceptive in recognizing the earlier reforms in other centers, such as Florence (ed. 1852, I, 209–10 and especially 437–38) and Siena (ed. 1852, I, 309–10, 314), and in masters like Barocci (ed. 1852, I, 440 ff.), Cesi (ed. 1854, III, 49 ff.), etc.
6. See Wittkower's remarks in ed. 1965, pp. 1 ff. (with further bibliography).
7. See the provocative study by Shearman, 1967 (with further bibliography).
8. Longhi, 1968-b [1928–29], and Friedlaender, 1955, pp. 34–56. Also, see Pevsner, 1928–29.

Figure 1. *Boy with a Basket of Fruit*. 27-1/2 × 26-3/8 inches. Caravaggio. Galleria Borghese, Rome.

Figure 2. *The Fortune Teller*. 39 × 51-1/2 inches. Caravaggio. Musée du Louvre, Paris.

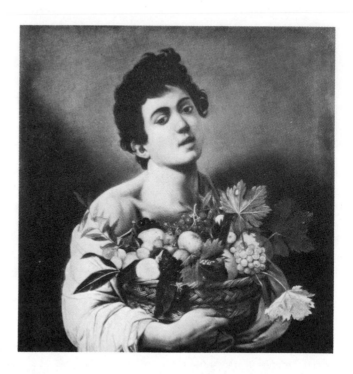

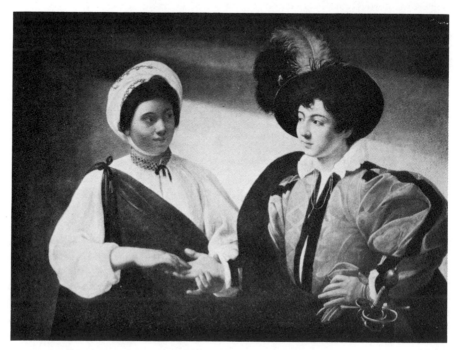

Figure 3. *The Card Sharps*. Approximately 39 × 54 inches.
Caravaggio. Whereabouts unknown.

3

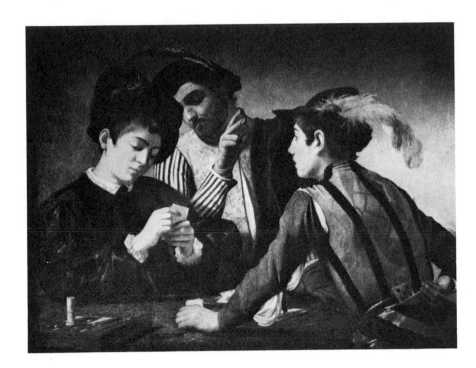

bardic tradition. The art of Moretto and Savoldo, of Titian and the Bassani, not to speak of Caravaggio's own teacher, Simone Peterzano,[9] undoubtedly was important during the master's formative years; but despite these connections, consideration of his first known pictures leads to an acknowledgment of the originality, as well as the dependence, of his visual conceptions.

The *Boy with a Basket of Fruit* (Fig. 1), like the *Bacchino malato* (also Galleria Borghese), reveals many of Caravaggio's early preoccupations: the representation of half-length, androgynous youths performing inconsequential duties but actually more concerned with the observer; the portrayal of calmly arrested, yet clearly momentary, postures; the development of an internal scale and subtle chiaroscuro that stress the sculptural solidity of forms; and the mastery of a *fattura* capable of

recording the subtle nuances of flesh, fabrics, and fruits. As enclosing walls force one's concentration on the life-size figures and accessories in these paintings, so the clarity, saturation, and variety of local colors strengthen their verisimilitude. Reds, greens, and browns dominate the palette, while blue is conspicuously absent. There is no sense of atmosphere, and only a minimal suggestion of depth. Caravaggio's two musical subjects, a *Luteplayer* (Leningrad) and *Una musica* [15], are variations on the style of the Borghese picture, just as the *Fortune Teller* (Fig. 2) and the lost *Card Sharps* (Fig. 3) cover similar ground.

It must be emphasized, however, that if these six pictures form the nucleus of Caravaggio's genre oeuvre, they are not pioneering in the sense of exploring "pure" genre. Whereas the *Bacchino malato* (together with the slightly later *Bacchus* in the Uffizi) represents Caravaggio's rare portrayal of a mythological deity, and the musicians and bohemians are linked to a well-known tradition of moralizing allegories,[10] only the *Boy with a Basket of Fruit* is apparently devoid of secondary mean-

9. For Peterzano, see Calvesi, 1954.
10. E.g., see Friedlaender, 1955, pp. 82 ff., and especially Bauch, 1956-b. Also, see Salerno, in Salerno, Kinkead, and Wilson, 1966, pp. 106–12.

Figure 4. *Judith and Holofernes.* 56-3/4 × 76-3/4 inches. Caravaggio. Galleria nazionale d'arte antica, Rome.

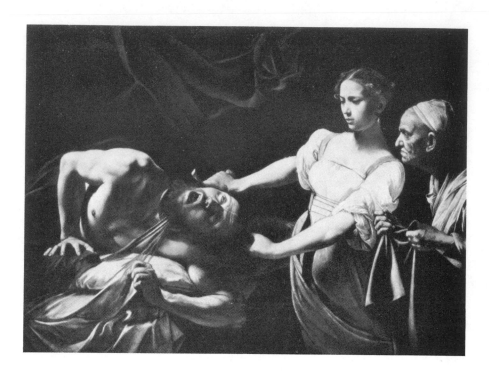

ings.[11] There are few stylistic features in Caravaggio's early secular paintings that cannot be traced to contemporary, or earlier, North Italian art, and the depiction of a bohemian world of rogues, half-length musicians, and still lifes clearly was not an innovation in the 1590's. Caravaggio's originality in these paintings is based on a personal and inimitable synthesis of many elements, stylistic and iconographic alike, that were already prevalent in later sixteenth-century art. In particular, one recognizes his unrelenting naturalism, contained within the matrix of an Italian sense of composition (which distinguishes his work from that of Northern genre painters); his consistent preference for life-size forms; his successful combinations of casualness and formality (figures in Caravaggio's early works always pose for the observer), of movement and rest (tilted heads and turned shoulders relieve static postures, parted lips break the silence); and especially his remarkable poetic strain, which imbues the most roguish scenes with a lyrical beauty (the *Fortune Teller*, paradoxically, is comparable with the *Rest on the Flight into Egypt* [Galleria Doria]). The rarefied air, the

absence of either a defined setting or modern dress,[12] the stopping of words and song on the actors' lips, and the chiaroscuro, demanding of attention but unyielding of

11. The *Boy Bitten by a Lizard* (Longhi Coll., Florence) almost certainly was pendant to a lost painting by Caravaggio, known today via a copy in Atlanta (see Voss, 1951, Bordeaux, 1955, no. 1, and Della Pergola, 1964, pp. 253 and 256, n. 1). Longhi's painting (which is superior to the version in the Korda Coll.) logically would represent "Touch" of the senses and/or "Fire" of the elements (Slatkes, in press, has argued that the subject is the choleric temperament); however, on the basis of only one other known composition—the Atlanta painting—it is difficult at this time to determine the original allegorical theme of the series. Longhi's picture measures 26 × 21-1/4 inches, and the Atlanta painting 26-1/2 × 20-3/8 inches; an unrecorded copy of the former was in the possession of Katz, Dieren (27-1/2 × 22-7/8 inches), and a version of the latter was sold at Sotheby's, June 7, 1950, lot 120 (26 × 20 inches). Numerous provocative questions raised by these two compositions, their interrelationships and correspondences with the Seicento sources, fall beyond the scope of consideration here (see Spear, in press).

12. Pearce, 1953, argues that Caravaggio's costumes were in use in Italy in the 1590's, but her comparisons with illustrations in Vecellio are not convincing.

its source, remove Caravaggio's pictures from the world of experience and place them instead in an imaginary realm. A fundamental quality of the master's art is here encountered, one which distinguishes him and his followers from the real pioneers of Italian genre, the Bamboccianti, whose pictorial vision is founded on daily life and whose narrative themes are depicted as independent of the spectator.

It would be misleading, however, to assume that Caravaggio's art from the very outset was not grounded in empirical observation. His training in Peterzano's shop prepared him for his early Roman years of poverty when he painted "flowers and fruits, which he imitated so well that from here on they began to attain the high degree of beauty so fully appreciated today."[13] Bellori also remarks Caravaggio's skill in rendering effects of transparency and reflection and "the freshest dew drops" —phenomena consistently dependent on light. Unfortunately, there is no pure still life[14] preserved from the early Roman years when Caravaggio worked for d'Arpino, although the fruits and accessories in paintings such as the *Boy with a Basket of Fruit* and Caravaggio's later *Still Life* in the Ambrosiana offer a clear idea of the pictures he was making to earn a living. Again one must recognize that still-life painting, especially in the circle of the Campi, had a firm foothold in Lombardy. But it is important, too, that Caravaggio's naturalism (his withered and diseased leaves and worm-infested, over-ripe fruits come to mind) surpassed that of his predecessors, and that he carried this style to Rome, the center of European art of his time.

In addition to Caravaggio's profound interest in the effects of light, the capturing of extreme and momentary expressions recurrently raised a challenge. In this regard the *Boy Bitten by a Lizard* in the Longhi Collection is an exceptional endeavor among the early secular works, for rarely was Caravaggio stirred to depict such dramatic action. His *Judith and Holofernes* (Fig. 4) and *Medusa* (Uffizi) build upon this youthful study of physiognomy, which undoubtedly was inspired by the achievements of his "small pictures... drawn from his own reflections in a mirror."[15]

Thus, like Bernini, in his formative years Caravaggio mastered a technical ability that could boast brilliant effects of light, expression, and arrested movement, without sacrificing clarity of design. And like Bernini's, Caravaggio's religious art slowly matured, was nourished by the secular works, and soon reached a perfected form that bears witness to the genius and profound originality of a great artist.

The *Rest on the Flight into Egypt* (Galleria Doria), one of Caravaggio's earliest religious paintings, is exceptional for many qualities: it harks back to the artist's Venetian-Lombardic heritage more openly than any painting in his entire career;[16] it contains the only full landscape that the master ever painted; and its blonde tonality, linear elegance, and calm, sylvan setting create a lyrical mood that complements, but surpasses, all of Caravaggio's early pictures. The candid, domestic tranquility of the Virgin slumbering, while Joseph, like an overgrown schoolboy, holds a partbook and rubs together his large bare feet, is as peaceful as the tender, sympathetic mood evoked in the earlier *Ecstasy of St. Francis* [14]. The dark shadows that soon became synonymous with Caravaggio's name appear for the first time in the Hartford *St. Francis*, unquestionably under the influence of the nocturnal setting. Of particular importance is Caravaggio's concentration on the principal figures and his indication, but subordination, of secondary details such as the shepherds and Brother Leo. A brilliant light that cuts the deep night on Mt. Alverna reveals in clear, forceful terms Francis' willing acceptance of the stigmata. A quiet, mystical ecstasy replaces the turbulence, astonishment, and gesticulation that so often accompanied the miracle. For Caravaggio, it was through profound love and faith that Francis achieved spiritual union with

13. Bellori, 1672, as transl. in Friedlaender, 1955, p. 246.
14. Bellori specifically mentioned a (lost) painting of a "carafe of flowers," which Friedlaender (1955, p. 80) thought actually referred to a detail *within* a figural composition (the *Luteplayer* in Leningrad); however, the recently discovered inventories of Cardinal del Monte's collection (see below, cat. nos. 14–16) prove that Caravaggio did paint "pure" still lifes.
15. Baglione, 1642, as transl. in Friedlaender, 1955, p. 234.
16. In particular, see Longhi, 1968–b [1928–29], pp. 114, 117, 131; and Friedlaender, 1955, pp. 45–47, 150–52. Röttgen, 1964, p. 222, draws attention to a similar composition by d'Arpino.

Christ and became one, if only momentarily, with Him. Indeed, no tenet of Counter Reformational thought in general, and Ignatian principles in particular, is stronger than the direct relationship between spiritual perfection and an imitation of Christ. For, as Loyola writes, through rigorous application of the senses, the faithful could "smell and taste in [their] imagination the infinite fragrance and sweetness of the Divinity, and of the soul, and of its virtues, and of all else, according to the character of the person [one] is contemplating."[17] The thought of St. Francis de Sales, as Pamela Askew has recently shown,[18] is remarkably harmonious with the spiritual tenor of Caravaggio's Hartford picture. And still earlier, the Spanish Franciscan Juan de los Angeles had also emphasized the importance of love and humility and the inward meaning of Francis' stigmata, as distinct from its external manifestations.[19]

In the *Ecstasy of St. Francis* Caravaggio rejected the spiritual norm of *maniera* painting and discovered the artistic means and an emotional level that he was destined to pursue in his religious art. A variety of mature Mannerist painters (Cigoli and Muziano especially must be cited) had moved in this same direction, achieving a simplified style and intensified message, paving the way for the young reformers of the 1590's and ultimately for the generation of Cortona and Bernini. But if Cigoli and Muziano never achieved the perfected clarity and spiritual depth of Caravaggio's statement, it is equally true that Caravaggio's *St. Francis* proved to be premature within his own development.

Approximately three years after Caravaggio completed the *Ecstasy of St. Francis*, Cardinal del Monte commissioned from him a *St. Catherine of Alexandria* [16] which, as Bellori perceptively noted, signaled a change in the artist's style. Iconographically, it epitomizes an unprecedented interpretation of saints that quickly passed through Caravaggio's repertoire, while stylistically it presages the painter's most mature works.

Bellori's criticism that only the presence of traditional attributes transforms Caravaggio's beautiful, seated young lady into a *Mary Magdalene* (Galleria Doria)[20] is equally applicable to *St. Catherine*. Yet on these grounds one must not accept the mistaken notion that Caravaggio's religious paintings of this period are primarily sec-

ular in conception, or disguised "artistic exercises," *tours-de-force* made saleable through facile iconographic transformations. The character of the *Ecstasy of St. Francis* and of all Caravaggio's mature religious paintings indicates that a consistent attitude prevailed, even though varying degrees of success are discernible in its visual manifestations. For Caravaggio, St. Catherine (like St. Francis and Sts. Peter, Paul, and Jerome) was above all else a human being, capable of fear and pain, love and pride; and for him this essential quality invariably took precedence over all iconographic considerations. The presence of the Divine might be indicated by miraculous light, or more rarely, as in *St. Catherine*, by a halo. But never in Caravaggio's work is a saint idealized beyond the reality of earthly existence. Nor do the ideas and works of Carlo Borromeo and Filippo Neri[21] seem irrelevant when one confronts Caravaggio's holy figures, for their human qualities are as undisguised as the benevolence and humility of the two popular reformers. It is true that in *St. Catherine* Caravaggio failed to convey the spiritual conviction of his Cerasi paintings, his *Death of the Virgin* (Louvre) and *Madonna di Loreto* (Fig. 5); but his intentions are nevertheless clear, and their relationship to the popular reform movement in the Church is too strong to be disregarded.

As the half-length, androgynous youths and scenes of musicians and rogues all predate Cardinal del Monte's *St. Catherine*, so the lyrical blonde tonalities and shallow, enclosed settings disappear by about 1597. Stronger, darker shadows replace the chiaroscuro that softly modeled the early figures, and an undefined blackness prevails where formerly there were light-yellow and greenish walls. The illumination is sharper, forcefully directed on the single Saint, isolating her amidst a pool of darkness. As a result, Catherine more convincingly occupies and displaces space than any form the artist had previous-

17. *The Spiritual Exercises of St. Ignatius*, Second Week, First Day, Fifth Contemplation.
18. Askew, 1969.
19. See Peers, ed. 1951, I, 310–11, 318–19, *et passim*.
20. Bellori, 1672, p. 203; Toesca (1961), however, identifies the figure as St. Thaïs.
21. See Friedlaender, 1955, pp. 117 ff.; and especially Ponnelle and Bordet, 1932.

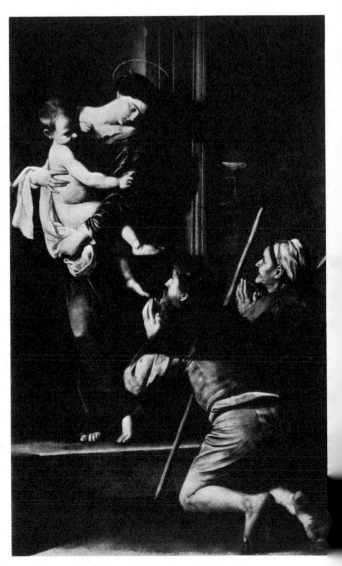

ly painted. She is Caravaggio's first truly monumental figure.

The seventeenth-century biographers refer to approximately twelve portraits painted by Caravaggio, ranging from very early pictures of modest importance to late commissions of considerable significance.[22] Unfortunately, there is only meagre evidence from which one can attempt to assess the master as a portraitist, for neither a preserved, undisputed original nor an unquestioned copy based on his design is known today. Nevertheless, the destroyed *Portrait of a Woman* (formerly Berlin) and *Alof de Wignacourt* (Louvre) should be accepted as authentic and characteristic examples of Caravaggio's portraiture, even though one must conclude on the basis of the two pictures that the master's originality in this category of painting was minimal. Titian, and especially the tradition of Pulzone, were the primary influences on his portraits, and the problematic nature of every attribution in itself seemingly reflects the lack of a truly distinctive contribution.

Expectedly, the social positions of Caravaggio's sitters rose as his own fame increased: from an early portrayal of an innkeeper to Maffeo Barberini and Giambattista Marino, to Paul V Borghese and the Grand Master of the Knights of Malta. If there is no indication that compositionally or psychologically Caravaggio was a pioneer in the evolution of Baroque portraiture, his directness, his naturalistic rendition of skin and fabrics, and his strong chiaroscuro lend to the extant paintings a strength of modeling and a physical presence that probably were characteristic of all of his portraits in the 1590's as well as the first decade of the new century.

The years around 1600 must have provided any perceptive Roman patron of the arts with extraordinary stimulation. With Agostino's assistance, Annibale Carracci was completing the ceiling decoration of the Galleria Farnese, offering the world one of its finest fresco cycles and setting the tone for a long series of anti-Mannerist

22. See Friedlaender, 1955, pp. 217–21 and Kitson, 1969, nos. 17, 18, 22, 23, 62, and 83, for a summary of the evidence and the problems involved.

projects.[23] At the very same time, Caravaggio was deeply involved with his first major public commission, the Contarelli Chapel;[24] he had undertaken, and quickly completed, two paintings for Tiberio Cerasi;[25] and he executed his first *Supper at Emmaus* (London), a masterpiece that summarizes a decade of rapid artistic growth. If a half-century later critics such as Bellori differentiated between Annibale and Caravaggio in the sharpest terms, it nevertheless is apparent with the hindsight of three centuries that the two masters had much more in common within the context of European art around 1600 than is often recognized today. One must always bear in mind that while Annibale methodically prepared his compositions through a long series of detailed drawings, Caravaggio shunned such laborious study, preferring—as far as we can judge today—to work directly on the canvas;[26] that Annibale excelled in fresco painting, the most admired and demanding traditional technique, but Caravaggio, like Poussin, found it totally unsuitable for his style;[27] and that the Carracci shop was formed on the basis of a long Renaissance tradition of teacher-student collaboration, while Caravaggio, unlike Annibale, never trained a single painter. It is obvious that in theory and practical organization Annibale was eminently traditional, whereas Caravaggio, a self-styled iconoclast, openly spurned such conventions.

Yet, when the final results of Annibale's and Caravaggio's work are considered apart from theory and method, the similarities between the two painters clearly emerge, especially if one sets aside specific aspects of style that must be classified as artistic *means*. There is no doubt, of course, that Annibale's and Caravaggio's paintings are as readily distinguishable from one another as Guido Reni's are from Guercino's, or Velázquez' from Zurbarán's. A primary concern of the historian, however, must be with artistic motivation and intention, and the disparities between Caravaggio and Annibale diminish in the face of these considerations. Our most reliable evidence, other than the paintings themselves, is Caravaggio's own testimony of 1603, the importance of which must not be minimized despite its brevity Asked to name the good painters of Rome, he singled out from a list of acquaintances the Cavaliere d'Arpino, his former teacher-employer and one of the most important artists

in the city; Federico Zuccaro, Pomarancio, and Antonio Tempesta, three "Mannerists" whose paintings obviously were not distasteful to Caravaggio; and Annibale Carracci. Pressed to define a "good artist" (what he had called a *valentuomo*), he said it is he "who knows how to practice his art well... how to paint well and to imitate natural things [sappi depinger bene et imitar bene le cose naturali]."[28]

One can argue that Caravaggio's list of *valentuomini* was highly prejudiced, based on a selection of artists whose styles were very unlike his own and intended to downgrade any competition. And indeed this factor might have played some role in his thinking, consciously or not. But his own definition of a "good painter" shows no hints of perjury. According to one of his arch-supporters, the wealthy Genoese collector Vincenzo Giustiniani,[29] Caravaggio once remarked that it is as difficult to do a flower piece as it is to do a figural painting, an attitude which seems to be at odds with Annibale's life-long devotion to religious and mythological subjects, that is, to the esteemed category of "history painting." One too easily forgets, however, that in addition to his well-known early genre pictures, such as the *Bean Eater* (Galleria Colonna), Annibale revealed throughout his

23. This term is used in the sense that Friedlaender (1957) developed in his essay.
24. For the complex question of the chronology of the Contarelli Chapel, and new documentation, see Röttgen, 1965; also, see Röttgen, 1969. Longhi, 1968–a, pp. 19–20, still maintained that the first *St. Matthew* was painted in the very early 1590's, and the lateral paintings ca. 1595 (pp. 24 ff.).
25. See Friedlaender, 1955, pp. ix–x, 183–86.
26. As is well known, he worked out the composition of the Contarelli *Martyrdom of St. Matthew* on the canvas (see L. Venturi, 1952); it was the most ambitious compositional project of his entire career. Also, see pp. above, and cat. no. 17.
27. The ceiling painting cited by Bellori as "held to be Caravaggio's" (1672, p. 214) still exists, and recently was published by Zandri (1969). Despite Zandri's arguments in favor of the attribution, it is disturbing that no source earlier than Bellori refers to the painting; that Bellori himself was doubtful; that Caravaggio is reported to have refused to do ceiling painting; and that until the painting is cleaned, the attribution cannot be sustained on a stylistic basis. In any event, the medium—oil on plaster—does not mitigate the statement that Caravaggio never worked in fresco.
28. Samek Ludovici, 1956, p. 151.
29. See Bottari and Ticozzi, 1822, VI, 123.

life a profound interest in "le cose naturali." His *Arti di Bologna* drawings alone deny a strict "idealist" label, and his portraits, caricatures, and landscapes add further evidence that his hand followed his eye as well as his mind.

Vincenzo Giustiniani, who "with the perception that usually comes only from hindsight... realized the full implications of the artistic revolution that had occurred at the end of the sixteenth century,"[30] understood, as few people have, the similarities between Annibale's and Caravaggio's contributions to the history of painting.[31] In a famous undated letter,[32] he divided painting into twelve modes, defining the tenth, "di maniera," as that in which the artist with "long practice of drawing and coloring [di disegno e di colorire], through his imagination [fantasia] without any models, forms in painting that which he has in his imagination." Giustiniani cites Barocci, Passignano, and the Cavaliere d'Arpino as practitioners of this mode. The eleventh, he writes, is "to paint by having natural objects in front of oneself." However, he warns that a simple record is not enough. "It is necessary... that the work be executed with good drawing and correct proportions, beautiful and accurate color... [that the lighting] be not crude, but handled with delicacy and unity; distinct, however, in the dark and illuminated parts...." Rubens, Ribera, Honthorst, and Terbrugghen,[33] not by coincidence all foreigners, are assigned to this category. It is important to bear in mind that Giustiniani deeply respects the quality of art produced in each of these categories, even if the twelfth "is the most perfect... because it is the most difficult, the

uniting of the tenth and eleventh modes... as Caravaggio, the Carracci and Guido Reni and others" have done. "Some prefer more the natural mode than the maniera, and others more the maniera than the natural, without, however, separating the one from the other."

Giustiniani's distinction between the final modes (and especially his placement of Caravaggio in the twelfth) is as instructive as it is perceptive. It reveals at once why Caravaggio's art, even from the early 1590's, is not, as we have noted, simply "di natura," and why so many of Caravaggio's followers fall so far short of the master. The essential quality that separates these artists and Giustiniani's final modes is true artistic invention, an original imagination that alters and orders the "cose naturali." For Annibale, drawings were a necessary step in making concrete this gift; for Caravaggio they were not. Nevertheless, each painter achieved through his own means a world of material reality in which figures (regardless of their physical or emotional state) are designed with the primary purpose of appealing to the beholder in unequivocal terms. In short, each created an art that exists to stir the faithful through empathetic response and sensory stimulation—that is, the art of the Baroque.

Caravaggio's attention at the turn of the century was focused on achieving intensified sculptural forms. Preserving many characteristics of his earlier paintings (close-up views, unidealized types, airless space, strong local colors), he explored this new territory with remarkable success. The Contarelli and Cerasi paintings, as well as the *Supper at Emmaus* (London) and the slightly later *Entombment of Christ* (Vatican), reveal in explicit terms his most important discovery: that in the proper context, direct, forceful gestures are enormously expressive and not necessarily disruptive. One realizes that where the youthful pictures were consistently calm,[34] motion now plays a dominant role; and it is equally apparent that full-length figures replace the truncated forms of earlier years. Still more important, however, is the recognition of a simple but insufficiently stressed principle of Caravaggio's art: that two distinctive compositional modes were utilized. The religious paintings from the earlier 1590's invariably had contained full-length figures, whereas not a single example of the more

30. Haskell, 1963, p. 30.
31. This is not to deny, of course, that important stylistic distinctions exist between the painters; but the matter of emphasis is crucial. See Mahon, 1947, pp. 32 ff. for a discussion of early critical differentiation between Caravaggio and the Carracci.
32. To Dirk Ameyden, published in Bottari and Ticozzi, 1822, VI, 121–29. Friedlaender, 1955, pp. 76–78, discusses Giustiniani's letter and compares Caravaggio with Annibale; Haskell, 1963, p. 94, n. 3, discusses the date of the letter.
33. Giustiniani's reference is to "Gherardo" and "Enrico," which almost certainly means Honthorst and Terbrugghen (see Nicolson, 1958-a, pp. 26–27).
34. In the single exception, the *Boy Bitten by a Lizard*, movement is iconographically motivated; even Caravaggio's *Judith and Holofernes* is remarkably static.

numerous secular pictures included a complete human form. Thus, the marked decline of half-length figures in Caravaggio's oeuvre is dependent upon a fundamental change in iconography, namely, the fact that after 1600 Caravaggio never painted secular subjects.[35] As his reputation increased and he was given larger, more lucrative public commissions, he had less time and undoubtedly less need to paint genre themes. Nevertheless, such a basic and complete shift in his orientation must also be related to a change in his inner being, as is amply documented in the character of the paintings themselves.[36]

In one sense, the first *St. Matthew* (formerly Berlin) and *Supper at Emmaus* can be considered the last of Caravaggio's youthful pictures (one cannot escape the feeling that as in the *St. Catherine* the real meaning of the event is still partially subordinate to visual effects); however, in the *Entombment* and the Cerasi paintings (the *Crucifixion of St. Peter* and *Conversion of St. Paul*) he rose to new spiritual heights. Above all, gestures and movement assume essential roles, for in addition to important narrative and expressive functions, they decisively define space. As deeper shadows and simplified garments increase the solidity of forms, so the actions of figures penetrate a void which Caravaggio begins to use as a positive factor. The misgivings that Peter expresses in touchingly human terms are made more poignant by the irrevocable movement into an ominous enveloping darkness; Paul's arms, widely open to embrace the light of conversion, hew from cramped quarters a block of essential space; and at the left of the *Entombment*, a hand held above Christ's limp body stops all movement at His drooping head, drawing attention from the noisier despair of the Mary with opened arms. Caravaggio's use of a darkened void was to be refined further in his post-Roman years, but like Rembrandt, he first had to discover the potentialities and limitations of movement before the qualities of physical withdrawal were to be understood completely.

The sickness and poverty that Caravaggio experienced upon arrival in Rome were long past when the new century opened, for by 1600 he had risen from anonymity to a position of city-wide fame—renown among a small group of cognoscenti, a good (if fragile) reputation with a broader circle of ecclesiastical patrons, and increasing notoriety with the Roman police. The irony of Caravaggio's mature years in Rome is that as his personal life became scandalous and unlawful, and his arrogance and volatile temperament led to physical quarrels of quickening frequency, his art became profoundly religious, although in an unconventional way. Precisely because his artistic means were unconventional, a concomitant paradox arose: the paintings of deepest spiritual significance—most notably the *Madonna di Loreto* (Fig. 5) and the *Death of the Virgin* (Louvre)—were subject to severe criticism and occasionally to outright rejection by the commissioning body.

Whereas the *Calling of St. Matthew* must be counted among Caravaggio's most influential compositions (its "cellar" lighting, seated, moody *bravi*, and Masaccesque intruders at the right echoed for decades in the minds of Caravaggio's followers), his *Madonna di Loreto*, despite its extraordinarily beautiful and original color, bore few offspring. It should not be surprising that this is so, however, for if the "populace made a great clamour over the disparaging treatment of certain elements which should have been handled with more respect,"[37] and Scannelli felt that "the painting lacks proper decorum, grace and devotion,"[38] Caravaggio's followers were equally uninterested in the tender, steadfast faith that the painting expresses, or in the acute social sensibility that led Caravaggio to shatter the barriers between simple, ignorant belief and formal ritual. His experience with the Cerasi paintings yielded a mature grasp of solid, volumetric forms, which govern the space of the later Roman paintings with new slow rhythms. Nevertheless, in the *Madonna di Loreto* a linear elegance of the Virgin's shoulder and lowered head unmistakably evokes the delicacy of the youthful *Rest on the Flight into Egypt*, just as the striking nearness of the pilgrim's soiled feet has antecedents in the master's earlier works. But the silence of the

35. In fact the *Medusa* (Uffizi), which may have been painted as late as 1601, but under special circumstances (see Heikamp, 1966), and the *Sleeping Cupid* (Palazzo Pitti), of 1608, are the only non-Christian subjects, other than the *Portrait of Wignacourt* (Louvre).
36. See the excellent discussion in Friedlaender, 1955, pp. 118-20.
37. Baglione, 1642, as transl. in Friedlaender, 1955, p. 189.
38. Scannelli, 1657, as transl. in Friedlaender, 1955, p. 189.

couple's modest prayer and their humble love and ingenuous confidence in the physical presence of the Virgin are symptomatic of Caravaggio's late Roman years. The compatibility of Loyola's methodical system of spiritual exercises with the achievement of divine revelation seems to be vindicated by two poor pilgrims, "a man with muddy feet, a woman with a messy and dirty bonnet,"[39] who are brought into Her presence and receive Christ's blessing. It is remarkable that three years later Henry IV, as if stirred by the meaning of Caravaggio's recent work, urged Francis de Sales to write a guide to spiritual perfection "in which religion should be shown in all its native beauty, stripped of all superstition and scruple, practical for all classes…"[40] (in 1609 De Sales did publish his *Introduction to the Devout Life*).

The *Death of the Virgin* (Louvre), like the *Madonna di Loreto*, attests to the originality of design and sincerity of expression that are dominant in Caravaggio's art of his final seven years. Painted in 1605–6 for Santa Maria della Scala (a church of the Barefoot Carmelites),[41] the altarpiece was refused by the fathers of the Church because, they insisted, it lacked decorum.[42] "One can see how much wrong the moderns do: if they decide to depict the Virgin, our Lady, they portray her like some filthy whore from the slums";[43] the author is Mancini, writing ca. 1620. As is well known, the large canvas was bought at Rubens' recommendation by the Duke of Mantua, and eventually was replaced by a more traditional representation of the same theme by Saraceni.[44]

For the controlled harmony of reds and warm browns, the slow, sad descent along the bowed, bared heads, and for the profound grief contained in the majestic figures of the Apostles, Caravaggio's *Death of the Virgin* takes its place among the masterworks of religious art. As in Hugo van der Goes's great painting (Bruges) of the same subject, Caravaggio concentrates on the reactions of the mourners and makes the living convey the meaning of death. But unlike Hugo, Caravaggio withholds the comfort of any reference to Her impending Assumption. The magnitude of the loss is stressed through the frank admission that She is irrevocably dead. Her ankles and stomach swell; Her dress is extraordinarily common, and only a thin halo reveals Her divinity. Neither movement nor sound breaks the spell of the tragic vigil, no detailed accessories nor sharp foreshortening detract from the central drama. Together with the subdued contrasts of color, these essential reductions in Caravaggio's style signify that a détente has settled in, one which would govern the remaining years of the painter's life. If the motionless world of the early 1590's reasserts itself, it is in the context of an entirely new spirit.

Prior to Caravaggio only Geertgen tot Sint Jans, the Haarlem painter of remarkable originality and profound sensitivity, represented St. John the Baptist (Berlin) in a state of psychological dejection. But whereas a poetic landscape serves to relieve the melancholy of Geertgen's forlorn Saint, black shadows and dense foliage close in on St. John in Caravaggio's Kansas City painting [17]. Caravaggio's *Baptist*, like his *St. Jerome* (Galleria Borghese) and lost *Magdalene* (painted shortly after his flight from Rome),[45] answer Bellori's charge that Caravaggio's saints are holy figures only because of their attributes. The quiet, internalized emotions that are dominant in the *Madonna di Loreto* and *Death of the Virgin* are equally prevalent in these paintings, where Caravaggio again rejects traditional means of expressing divinity. For even though a halo may be depicted, all other conventional references to holy inspiration and apparitions are absent. There is no hint whatsoever of John's manly prowess in the wilderness, nor any indication of his gifted leadership. Likewise, Jerome is represented as completely engrossed in his scholarly activities, rather than in confrontation with an angel, and thus, like John, is foremost a mortal being. The saints' spiritual conviction, and by extension Caravaggio's, is conveyed through an unwavering concentration and seriousness. A sober, modest maturity guides their lives and replaces the youthful worldliness that characterized Caravaggio's earlier saints.

39. Baglione, 1642, as transl. in Friedlaender, 1955, p. 189.
40. As quoted in Hon. Mrs. Maxwell-Scott, *St. Francis de Sales and His Friends* (London, 1913), p. 196.
41. See Friedlaender, 1955, pp. 195 ff., no. 28.
42. A penetrating analysis of the reasons the painting was rejected is given by Hinks, 1952 [1953].
43. Mancini, ca. 1620, as transl. in Friedlaender, 1955, p. 195.
44. Ill. in Ottani Cavina, 1968, fig. 120.
45. See Friedlaender, 1955, p. 205, no. 32, and Bodart, 1966.

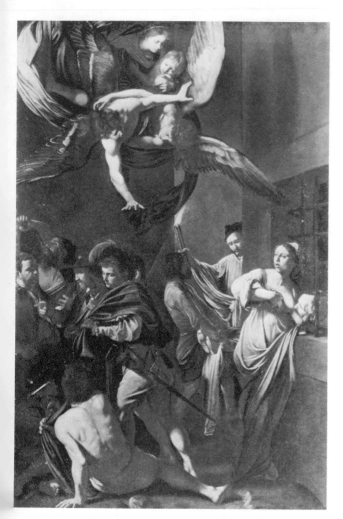

Figure 6. *Seven Acts of Mercy*. 153-1/2 × 102-3/8 inches. Caravaggio. Pio Monte della Misericordia, Naples.

A significant stylistic change occurred in Caravaggio's art during the post-Roman years, a change initiated in the paintings of ca. 1603–5 and fully apparent in the *Supper at Emmaus* (Brera), probably of 1606.[46] As a complement to the basic alteration in mood from a literal to an interpretative attitude, the precision of Caravaggio's early naturalism yields to an expressive, evocative *fattura*. His brushwork becomes markedly broader, frequently composed of strong, relatively flat, dry strokes. Browns assume a primary role by uniting somber (*tenebroso*) tonalities with a blotchy modeling of surfaces. A transformation in Caravaggio's light is especially evident, for the firm, sharply delineated forms of the 1590's now surrender to a murky, erosive atmosphere. The tactility of the early objects is therefore diminished, while momentary actions, saturated colors, and bold spatial recessions are tempered. As a result Caravaggio's late figures, placed on a shallow middle-ground stage, act out their tragic roles in constrained pantomime, engulfed by the darkness of night.

The literalness of Caravaggio's naturalism in the first *Supper at Emmaus* never occurs in the post-Roman paintings. Like the *Supper at Emmaus* in Milan, the *Seven Acts of Mercy* (Fig. 6) and especially the *Beheading of the Baptist* (Fig. 7) typify Caravaggio's late sense of drama. If the *Seven Acts of Mercy* recalls the *Martyrdom of St. Matthew* because of its general mood of turmoil and unresolved composition (and the presence of a sprawling semi-nude male in the foreground), the *Beheading of the Baptist* has the quiet dignity and evocative space of the *Calling of St. Matthew*. In each instance, the later painting is much more broadly handled and the palette is noticeably darker. The bizarre (and unique) signature of Caravaggio, written with the Baptist's blood, does not detract from the classicism that controls the organization of the *Beheading*. The figures assume postures which reinforce the picture plane, and an emphasis on vertical and horizontal accents governs the overall composition. The silent darkness and massive architecture feed the humility of the four witnesses symmetrically arranged above the slain John. They, in turn, are dominated by the heavy archway which echoes the semi-circular organization of their

46. See Friedlaender, 1955, pp. 167–68

Figure 7. *Beheading of the Baptist.* 142-1/8 × 204-3/4 inches. Caravaggio. Cathedral of St. John, Valletta, Malta.

13

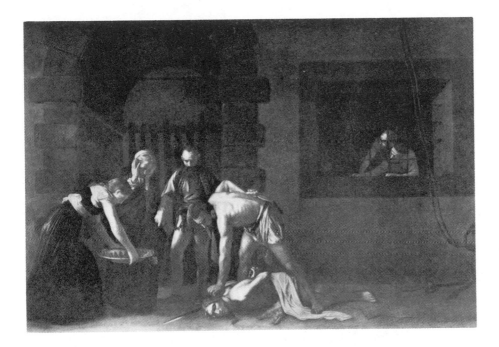

bodies. The massing of all principal forms on one side of the composition is extraordinarily original, and highly effective in relieving the potential artificiality of the design.

The clarity of geometrical organization of the *Beheading of the Baptist*, although unprecedented in Caravaggio's oeuvre, is sustained in the next paintings, as the *Burial of St. Lucy* in Syracuse (1608) and the *Raising of Lazarus* in Messina (1609) indicate. More than ever before, Caravaggio insists upon a frieze-like arrangement of figures, earthen colors, and a laden atmosphere that weighs heavily upon the grieving witnesses. The shallowness of the figural groupings intensifies the apparent height of the somber settings, and the silent dark void above expands with an openness that is basically antithetical to the artist's earlier work. In fact, this radically

transformed use of space is the most significant innovation in Caravaggio's late style, for if the descriptive naturalism of the Roman period is basically absent, so is the enclosed setting; and in its place is an open space which imparts to these works the naturalism of actual vision.

"In the church of the Capuchins at Messina Caravaggio made a painting of the *Nativity* picturing the Virgin with the Child before a decayed barn, with its boards and rafters bared; St. Joseph leans on his staff, and there are several shepherds."[47] The directness of Bellori's description, albeit tinged with disapproval, is eminently befitting Caravaggio's *Nativity* (or *Adoration*) of 1609, still in Messina. As Friedlaender recognized and succinctly wrote, "it is unsurpassed in its expression of Filippine simplicity, poverty and humility.... It is difficult to imagine a more desolate place than this poor and half-ruined stable where the pathetic figure of the Virgin is seen on the ground, reclining against a wooden manger and pressing the Infant tightly against her body as though she were protecting Him from the nocturnal cold...."[48] A simple geometrical design once again unites the com-

47. Bellori, 1672, as transl. in Friedlaender, 1955, p. 216.
48. Friedlaender, 1955, p. 127; there is no "large opening through which one sees a burning strip of sunset shining in the dense tenebrosity" in the *Nativity*, as Friedlaender states (p. 216, no. 41).

14

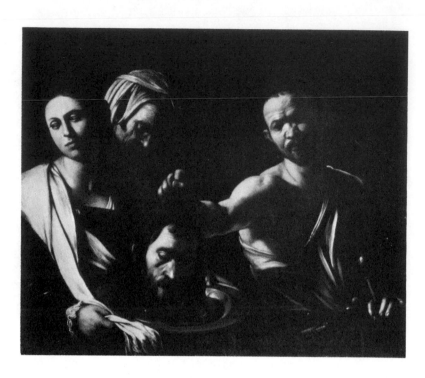

position. And just as the grave-diggers in the *Burial of St. Lucy* define the space in which the Saint lies at rest with the symmetrical clarity of giant parentheses, and the *Raising of Lazarus* depends upon a long diagonal descent to a radial center of which Lazarus himself is the hub, so in the *Nativity* forms are painstakingly interrelated to focus attention on the Mother and Child. The classical, geometrical organization of these late paintings should not be minimized, for it imbues them with a monumentality and timelessness that Caravaggio had not achieved earlier in his career.

In October of 1609, when Caravaggio returned to Naples (probably anticipating a return to Rome), he was brutally attacked and wounded. A period of inactive convalescence undoubtedly followed, but his presence in the city until July of 1610, a stay of approximately nine months, led Longhi to search for paintings that stem from the final phase of the artist's life.[49] The most convincing candidate for this period is the *Salome with the Head of the Baptist* (Fig. 8), a variant of the composition in the Escorial which often has been identified as the "half-figure of Herodiade with the head of St. John in a basin" that Bellori specifies was painted during Caravaggio's second journey to Naples.[50] Returning once more to the theme of beheading, Caravaggio interprets the Biblical story with the silent compassion and melancholy that underlie all of his late works. Neither Salome nor Herodias finds any satisfaction in the murder that they have brought about, nor is the executioner proud that he followed orders against his own judgment. The breadth of handling of paint that is so apparent in the definition of the head of the Baptist and in the executioner, and the posture of the executioner as well as the style of his garment, immediately bring to mind Caravaggio's *David* in the Galleria Borghese. There is general agreement that these paintings belong to a common phase of Caravaggio's career, but whether it is ca. 1606

49. In particular, see Longhi, 1959-b; also, see Longhi, 1968-a, pp. 46 ff.
50. See Friedlaender, 1955, p. 217, no. 43; but also Longhi, 1959-b, and n. 51 below.

or 1610 still remains unsettled.[51] On stylistic grounds, it appears to be more likely that the two pictures are developments out of the *Sleeping Cupid* of 1608 (Palazzo Pitti) and the Sicilian paintings of 1609, rather than their antecedents. The characteristics of Caravaggio's late style as discussed above are brought to their extreme refinement in *Salome* and *David*. Psychologically, these canvases also share with Caravaggio's altarpieces of 1609 the humility and understatement that are foreign to his earlier years. As if writing the epilogue to his own life, Caravaggio presents the tragic consequences of rashness and violence. He had portrayed, when a youth, the external horror and physical pain of decapitation in *Judith and Holofernes*, placing particular stress on the instant the head is severed. The overt drama of execution and its inherent bloodiness were consciously emphasized, and maintained at an equally jarring pitch in the famous *Medusa*. By the time of the *Beheading of the Baptist* in Malta, however, a complete *volte-face* had taken place. The artist's searching of inner emotions quickened, and in his last representation of decapitation the beholder is made to realize that the worst pain of capital crime is the suffering in the heart of the guilty. Whether or not Caravaggio's personal involvement in murder and flight from justice led to a more profound understanding of penance is impossible to establish. Yet the visual evidence remains, and like an echo from the past it haunts the imagination.

The death of Caravaggio in 1610 passed with relatively little notice. His absence from Rome had been prolonged, and the work of his followers and the young Bolognese painters was sufficiently promising that no vacuum of consequence was created when the master died. His reputation, however, was firmly established, and even a cursory review[52] of early critical reaction to Caravaggio dispels the notion that he was derided in his lifetime or during the following generation. The list of his private patrons in itself is impressive, signifying that an appreciation of Caravaggio's art was strongest when style was the primary criterion and not religious indoctrination. Above all, Cardinal del Monte and Vincenzo Giustiniani, two leading figures in the Roman art world, must be singled out as his most consequential benefactors, for not only did they personally acquire many of his paintings, but they actively promoted his reputation throughout the city. If a small number of clerics were blinded to Caravaggio's art by propagandistic prejudices, there is no evidence that Caravaggio met real hostility in serious art circles.[53] The earliest written assessments are consistently favorable. The poets Marino, Murtola, Francucci, and Gigli all penned words in praise of Caravaggio, and Van Mander, the artist's first (and only contemporary) biographer, was laudatory. (It is important to bear in mind, when one cites his predilection for Caravaggio's naturalism, that Van Mander was a Northerner.) Mancini, writing in the subsequent decade, was basically appreciative of Caravaggio's painting and was one of the first in a long line of critics to emphasize his qualities as a colorist. But Mancini was equally prophetic in lamenting the artist's personal "extravagance in... habits" (that "diminished somewhat the glory which he had won through his profession")[54] and in judging Caravaggio and his followers to be deficient in multi-figured compositions.

It cannot be stressed too often that between the Cinquecento flourish of Mannerist treatises on painting and mid-Seicento writings there were no publications in Italy on art theory.[55] Agucchi's classical bias was of little consequence early in the century, and only Baglione, Caravaggio's arch enemy, put in print in 1642 a strong attack on his art, particularly on its influence: "Some people consider him to have been the very ruination of painting, because many young artists, following his example, simply copy heads from life without studying the fundamentals of drawing and the profundity of art and are satisfied with color values alone. Thus they are

51. A review of the late chronology taking into account Sussino's life of Caravaggio is found in Borla, 1967; her argument concerning the identification of the Escorial *Salome* with Bellori's reference to an *Erodiade* is inconclusive (pp. 13–14, n. 15).
52. The following remarks are based on Cutter, 1941, Mahon, 1947, Longhi, 1951-a, Keown, 1965, and Kitson, 1969, which should be consulted for fuller discussion. Also, see Longhi, 1968-a, pp. 53–58.
53. See Cozzi, 1961, for a discussion of Caravaggio's "fame" in clerical circles as revealed in a letter of 1603.
54. Mancini, ca. 1620, as transl. in Friedlaender, 1955, p. 258.
55. See Mahon, 1947, pp. 155 ff., and Friedlaender, 1948.

incapable of putting two figures together or of composing a story because they do not understand the high value of the noble art of painting."[56]

Baglione's denouncement contains most of the seeds of later criticism: Caravaggio's inadequate command of drawing, his inability to compose on a grand scale, his undesirable personality, and, as a result, his anti-tradition attitude (which Baglione equates with anti-art). The most influential Seicento critic-biographer, Giovanni Pietro Bellori, echoed many of Baglione's barbs, but at the same time recognized many of Caravaggio's virtues: "There is no question that Caravaggio advanced the art of painting because he came upon the scene when realism was not much in fashion and when figures were made according to convention and manner and satisfied more the taste for gracefulness than for truth. Thus by avoiding all prettiness and vanity in his color, Caravaggio strenghtened his tones and gave them blood and flesh."[57] Bellori's adverse comments, however, outweigh the favorable: "Like herbs which produce salutary medicaments as well as the most pernicious poisons, Caravaggio, though he did some good, nevertheless caused a great amount of damage and played havoc with every embellishment and good usage of painting. Indeed, painters who strayed too far from nature needed someone to set them in the right path again, but how easy it is to fall into one extreme while fleeing from another. By withdrawing from mannerism and following nature too closely they separated themselves from art altogether and remained in error and darkness until finally Annibale Carracci came to enlighten their minds and to restore beauty to the representation of nature."[58]

Unfortunately, very few Baroque artists have left us written records of their attitude towards Caravaggio, even though the extent of his influence *per se* is clearly of paramount importance and an indirect testimony to his critical success. Various painters of antithetical persuasions expectedly reacted differently to his art, as is evidenced by Cortona's objective acceptance of his style as a viable, praiseworthy alternative; and Albani's damnation, as recorded by Malvasia in the *Felsina pittrice*: "This manner is the precipice and total ruin of the most noble and accomplished art of painting, because, although the mere imitation of nature is partly commend-able, it was destined nonetheless to engender all those evils that have ensued in the past forty years. One sees, indeed, imitations of the real, but not of the probable, nor does one achieve representations of characters or liveliness of movements.... [Caravaggio's followers] present to our view a half-length figure and pass it off as a complete picture, thereby freeing themselves from the obligation of painting the thighs, the legs, and the floor on which it stands—for it is only from the waist up—and dispensing with perspective, with thoughts, with expressions, and—what I should have mentioned before—with inventions."[59]

Thus, while usually recognizing Caravaggio's talent in coloring and his command of naturalism, the later Seicento critics were opposed to his style and its influence because, they maintained, it denied the "art" of art by substituting nature for it. No assessment of Caravaggio's work is more colorful and representative of mid-century criticism than that of the Florentine-born Spaniard, Vincencio Carducho: "In our times, Michelangelo da Caravaggio arose in Rome with a new dish, prepared with such a rich, succulent sauce that it has made gluttons of some painters, who I fear will suffer apoplexy in the true doctrine. They don't even stop stuffing themselves long enough to see that the fire of his talent is so powerful... that they may not be able to digest the impetuous, unheard-of, and outrageous technique of painting without any preparation. Has anyone else managed to paint as successfully as this evil genius, who worked naturally, almost without precepts, without doctrine, without study, but only with the strength of his talent, with nothing but nature before him, which he simply copied in his amazing way?... This anti-Michelangelo, with his showy and superficial imitation, his stunning manner, and liveliness, has been able to persuade such a great number and variety of people that his is good painting, and his method and doctrine the true ones, that they

56. Baglione, 1642, as transl. in Friedlaender, 1955, pp. 235–36.
57. Bellori, 1672, as transl. in Friedlaender, 1955, p. 252.
58. Bellori, 1672, as transl. in Friedlaender, 1955, p. 253.
59. Malvasia, 1678, as transl. in R. Goldwater and M. Treves, *Artists on Art*, New York, 1947, p. 127.

have turned their backs on the true way of achieving eternity...."[60]

By the close of the seventeenth century Caravaggio's reputation had generally declined to a low level, which it was destined to hold for more than two hundred years. To cite but one telling example, Sir Joshua Reynolds never mentioned Caravaggio in any of his fifteen *Discourses*. Luigi Lanzi, writing in 1792, granted Caravaggio credit for "bringing painting back from mannerism to truth," but he nevertheless criticized the excessive "common and vulgar" figures and basic lack of decorum. Lanzi's Bellorian analysis (in which the Carracci were seen as the true saviors of art) was often repeated throughout the nineteenth century as well, when Victorian morality led John Ruskin to lash out at Caravaggio for "seeking... and feeding upon horror and ugliness, and filthiness of sin." Yet, it must be stated that basically Caravaggio's art was no longer an issue, for if his *Entombment* (Vatican) was consistently regarded as his most successful work, his paintings were usually neglected, often banished to museum reserves, and his name was attached to scores of pictures with a carelessness that is as astonishing as is the indifference it reveals.

It is surprising that neither Romanticism nor Neo-Classicism fostered a reassessment of Caravaggio's art, and that during the development of later nineteenth-century naturalism there was not a greater appreciation of the master's work. His colorful personality and independence inevitably touched the heart of occasional authors, as was manifest at the turn of the century with

Roger Fry: "[Caravaggio] was, indeed, in many senses the first modern artist; the first artist to proceed not by evolution but by revolution; the first to rely entirely on his own temperamental attitude and to defy tradition and authority."[61]

The resurrection of Caravaggio in the twentieth century presaged the general revival of Italian Baroque painting. A long list of scholarly studies and three important exhibitions devoted to Caravaggio and his followers[62] attest to the strength of the resurgent interest in his work, and the present exhibition is one further link in that movement. More than any other scholar, Roberto Longhi is responsible for promulgating Caravaggio's fame and for bringing to light numerous paintings from his circle. In the wake of this revival and renewed appreciation of the master, however, countless painters from Rembrandt to Carlo Dolci have been placed in Caravaggio's shadow and assigned positions in the ranks of the Caravaggisti.[63] If the obscurity and disdain which shrouded the careers of Caravaggio's closest followers have been gradually diminished, a pan-Caravaggesque attitude has swung critical acumen to an opposite extreme, and tended to embrace every naturalistic or tenebristic painting as a mirror of Caravaggio's style.

II

"There is also a certain Michel Angelo of Caravaggio, who is doing remarkable things in Rome.... As regards his way of painting, it is such that it is very pleasing in an exceedingly handsome manner, an example for our young artists to follow."[64] These observations were made by Van Mander as early as 1603, when various painters were soon to alter their styles under the influence of the young Lombard and to form, in no organized sense, a group of painters commonly known today as the Caravaggisti. To attain a consistent and historically tenable definition of Caravaggio's followers certain minimal criteria must be established, at least two of which are essential: that to be considered a follower of Caravaggio, an artist, if foreign, must have visited Italy and been in direct contact with Caravaggio's art —if not with the master himself, at least with his prin-

60. Carducho, *Diálogos de la pintura* (Madrid, 1633), as transl. in R. Enggass and J. Brown, *Italy and Spain, 1600–1750: Sources and Documents* (Englewood Cliffs, 1970), pp. 173–74.
61. Fry, in *Discourses Delivered to the Students of the Royal Academy by Sir Joshua Reynolds, Kt.* (London, 1905), p. 170.
62. Milan, 1951, Utrecht, 1952, and Naples, 1963; see the bibliographies in the catalogues of these exhibitions, and in Moir, 1967 (with addenda in II, 135–36), and Bodart, 1970. The exhibitions in Rome, 1955, and Florence, 1970 (ed. Borea), although limited in scope, also merit attention.
63. The extreme position is represented by Borea, 1966 and 1970, and Moir, 1967 (see the discussion of the latter in Kitson, 1967; Paolucci, 1967; Nicolson, 1968; Kultzen, 1969; and Dempsey, 1970).
64. Van Mander, 1604, as transl. in Friedlaender, 1955, p. 260.

cipal disciples—and, that the artist must have made a determined *and* sustained effort to emulate what he believed Caravaggio or his closest followers had accomplished.

It should be readily apparent that neither a brief flirtation with Caravaggio's style nor a superficial imitation of it, especially when imposed on a fundamentally different attitude, can be considered sufficient evidence for classifying a painter as a follower of Caravaggio. Nor should arguments be required to show that pictures with an analogous use of light or naturalism, when independently discovered or derived from another source, must not be confused with works that actually stem from Caravaggio's vision. Consideration of these basic distinctions is prerequisite to any assessment of Caravaggio's historical importance and to an understanding of the origins and development of Baroque painting in Italy and beyond the peninsula. It is desirable, therefore, to give a summary indication at the outset of which artists frequently associated with the master's name should be excluded from the ranks of the Caravaggisti, and thereby to clarify our conception and definition of Caravaggio's followers.

A small category of important artists fell under the influence of Caravaggio for a brief period. Guido Reni's Caravaggesque interlude perfectly exemplifies this phenomenon, for despite his telltale interests in *affetti* and elegance of design (Reni's *grazia* was never disguised), he did make a serious effort to understand Caravaggio's innovations. But the consequences of the short encounter are more revealing than the initial attraction, for despite whatever debts to Caravaggio remained, Reni's style was fundamentally based on a vision antithetical to Caravaggio's. Thus, to deny that Reni was a true follower of Caravaggio in any sense is not to dismiss the significance of the abortive experiment. But to place him in the circle of the master would be as erroneous from an historical and aesthetic point of view as it would be to call Brancusi a disciple of Rodin on the basis of his early investigation, and rejection, of Rodinesque modeling.[65]

A more serious and far more consequential challenge is raised by those artists whose styles do resemble Caravaggio's, but whose origins in fact are fundamentally independent of his influence. It is important in this context to recall that prior to the 1590's the "reform" of Mannerist painting was well under way, and that in numerous artistic centers a return to naturalism had been initiated. For instance, neither the firm modeling, nor sharp, cutting light of Ludovico Carracci's *Conversion of St. Paul* (Bologna), painted in 1587, can be associated in any manner with Caravaggio's art. Elsheimer's influential experiments with poetic nocturnes were parallel to, but basically autonomous of, Caravaggio's chiaroscuro, just as the raking light and earthen colors of Ribalta's paintings were divorced from developments in Rome. There is a twofold significance in recognizing that a profound interest in naturalism, frequently strengthened through dramatic chiaroscuro, existed simultaneously and independently in major centers of European painting during the last decades of the sixteenth century. First, one becomes acutely aware of the historical fallacy involved in naming one artist or center as the progenitor of naturalism, and that it is no more fruitful to search for priorities or to demand cross-influences in this context than it is to debate the question of the first abstract painting. As Cubism and Fauvism were equally influential upon the rise of non-objective art, and Kandinsky, Picabia, and Dove almost simultaneously reached abstraction on their own, so Baroque naturalism grew from disparate sources and appeared in various guises. Secondly: as Constructivism, Orphism, Synchromism, Futurism, Rayonism, Suprematism, etc., reveal the multi-faceted, yet often interrelated forms that the European vanguard assumed in the early teens, so numerous painters in the early Seicento worked along parallel but occasionally merging lines that developed the potential of the "late-Mannerist" reform.

One of the largest and most frequently misrepresented groups of what might be called the pseudo-Caravaggisti is comprised of Bolognese-oriented artists. Guercino, Lanfranco, Badalocchio, and Schedoni, to cite the primary examples, investigated the paths opened by Ludovico Carracci and not Caravaggio. Despite the generic

65. On Reni and Caravaggio, see Pepper in *The Art Quarterly*, XXXIV, 1971, no. 3 (in press).

similarities that one may find between their paintings and the Lombard's, the visual evidence overwhelmingly reveals that their colors, figure types, and especially their fractured use of light—usually scattered over surfaces to disrupt rather than to unify form—are fundamentally different from Caravaggio's. Their use of dramatic gestures, too, is markedly distinct, and the basic sentiment is keyed to elaborate ritual and visions of the divine. Artists like Bassetti, Ottino, and Turchi absorbed elements of Ludovico's and only occasionally of Caravaggio's style, and their paintings unquestionably belong with the attitude fostered by the Carracci. Fiasella's two large canvases in Sarasota,[66] often cited as the artist's most Caravaggesque works, actually are telling evidence of his profound admiration for Ludovico, the dean of the Carracci and one of the most progressive artists active in Italy in the 1580's.

Because it would beg the issue to dismiss Velázquez as a Caravaggesque artist simply on the grounds that he had not visited Italy when he completed his Sevillian period, the important question of Caravaggio's influence in southern Spain[67] must at least be raised, although an exhaustive treatment of the problem falls beyond the scope of this essay. It is remarkable, in fact, that Velázquez' bodegones and earliest religious paintings are repeatedly explained in terms of Caravaggio's art, despite the visual contradictions that this thesis raises. For when one is confronted with the Spaniard's youthful works of ca. 1617–20 (photographs are very misleading), the conclusions reached by López-Rey are eminently valid, even though what may be entitled the Caravaggio mystique still persists. López-Rey writes: "Unlike Caravaggio, young Velázquez uses an environing light, weighted with a greenish tinge, which brings out the sensorial differences of the natural forms within an at-

mospheric space. Much as he may have had Caravaggio at the back of his mind, Velázquez attained from the beginning a sensorial rendition of the accidents of shape, colour and texture, an atmospheric depiction of spatial depth, and a pictorial expression of the polarity of the divine and the human—all of which were alien to Caravaggio's naturalism."[68] If the actual sources of Velázquez' early style are expectedly complex, embracing both Spanish and Northern elements, it nevertheless is correct to state that Venice rather than Caravaggio must be seen as the principal Italian influence on the artist's color and atmospheric effects. The Bassano, in particular, could have provided him with rich visual stimulation, as a comparison of his Adoration of the Magi (1619, Prado) with paintings by the Bassano so tellingly reveals.

But there is no necessity to look to either Italy or the North for an explanation of Velázquez' interest in naturalism. No tradition was as firmly dedicated to naturalism as was Spanish literature of the sixteenth century, from the Celestina (1499) to the Quixote (1605–15) and the writings of Alemán, Quevedo, et al. Is it reasonable to seek foreign inspiration behind Velázquez' bodegones when a principal episode of Guzmán de Alfarache turns on an old woman cooking eggs for a naïve youth? When Lazarillo de Tormes uncompromisingly foreshadows the most vigorous realism of Baroque painting? Or when Cervantes declares in the author's introduction to the first part of the Quixote (1605), "[this work] has only to avail itself of truth to nature in its composition, and the more perfect the imitation the better the work will be"? Despite the possibility that Caravaggio's art was known in Seville at an early date,[69] and the facts that Maino had returned to Toledo by 1611 and three of Saraceni's paintings were in that city by 1614,[70] there simply is no indication that Velázquez' iconography, brushwork, color, or figure types were affected by Caravaggio. To the contrary, his first trip to Italy confirms a predilection for Venetian art, as is substantiated by his copies after the Venetians, a lost Self-portrait said to have been done "in the manner of the great Titian," and the total absence of any studies after Caravaggio or his followers.

In short, an objective appraisal of Velázquez' early style must yield a judgment in favor of non-Roman

66. Ill. in Moir, 1967, II, figs. 248–49.
67. The essential bibliography on this question is Longhi, 1927 and 1950-c; Ainaud, 1947; and especially Soehner, 1955 and 1957.
68. López-Rey, 1963, p. 26.
69. For the problematic reading of Siviglia or Sicilia in Mancini's life of Caravaggio, see Longhi, 1954; and Salerno, 1955, and Salerno in Mancini, ed. 1956–57, pp. 112–13, n. 886.
70. See Madrid, 1970, pp. 506–11.

sources. *Colore*, as in the art of Borgianni [cf. 6, 7, 8], was dominant from the outset. Influence from Caravaggio cannot be sustained. At the most, one can admit that Caravaggio's art could have strengthened and encouraged the development of a reformed vision in Seville—but it did not determine the artistic means.

The thesis that naturalism was fundamentally indigenous to Spain, where it surfaced during the decades around 1600, as it did in Bologna and Rome, finds corroboration in Sánchez Cotán's remarkable still-life paintings executed prior to 1603—the year he left Toledo to become a Carthusian lay-brother. His exacting verisimilitude, impressive weightiness, and perfected order produce a silent, mysterious world that exists on two levels of reality, where simultaneously objects seem to be substance and spirit. Strongly prophetic of Zurbarán's art, and ultimately Dali's, Sánchez Cotán's paintings spring from the spirit of Teresa and Ignatius, from that uniquely Spanish combination of the pragmatic and the mystical. As in the writings of Luis de Granada, only the eye's vivid love of nature rivals the heart's communion with divine order. And it is this latter quality which makes Sánchez Cotán's ascetic pictorial world so profoundly different from Caravaggio's.

As Velázquez' Sevillian paintings are misunderstood when explained as a direct product of Caravaggesque influences, so a number of artists active in Naples by the second quarter of the century are misrepresented if classified under the rubric Caravaggisti.[71] The activity of Caracciolo and Ribera in Naples was of major importance for the development of a Neapolitan style, and their tenebrism popularized what Caravaggio's few paintings in the city had initiated. But to group painters like Stanzione and Vaccaro with Caravaggio's followers is to misjudge the basic orientation of Neapolitan art after the mid-1620's. There is no doubt, of course, that Caracciolo's intensely black palette was derived from Caravaggio, and that it, in turn, inspired some paintings from the early careers of Stanzione and Vaccaro. But whereas Caracciolo's painting is fundamentally emulative of Caravaggio's in both means and effect, the art of the younger Neapolitans is predominantly based on principles developed in Bologna. The presence

of Reni, Domenichino, and Lanfranco in Naples was of lasting significance, for a survey of composition, color, and expression in the art of the second-generation painters discloses artistic means that are unmistakably classicistic. The dramatic contrast of value that had become endemic to Neapolitan painting by the 1630's was no longer Caravaggesque in its own right. Caravaggio's influence can be recognizable in the early paintings and to a lesser degree in the mature works of Stanzione and Vaccaro, but in both degree and kind it is inadequate justification for calling these painters Caravaggisti. To insist upon this label would be no less erroneous than to call Fragonard a "follower" of Watteau. The profoundly original insight of both Caravaggio and Watteau altered the history of art, and although each of their visions was quickly absorbed into the mainstream of painting, subsequent generations explored related, but new, problems. Major differences in brushwork, color, space, and content separate Watteau's and Fragonard's paintings, but even these basic discrepancies cannot deny those similarities which immediately identify the masters as Rococo artists. In a parallel manner, the works of Caravaggio and the Neapolitans together express fundamental preoccupations of Baroque painting through essentially distinct modes of vision.

One actually could contend that Stanzione and Vaccaro more properly should be called followers of the Carracci than of Caravaggio, because their lasting debt was to the tradition of Bologna. To see them as followers of *both* schools cuts to the quick of the pan-Caravaggesque attitude, for at once it lays open the compatibility of Caravaggio and the Carracci and unmasks the simplicity and distortion that accompanies a pan-Caravaggesque interpretation of Seicento painting.

Numerous other important influences were operative in Naples from the 1630's onwards, most notably the later paintings of Artemisia Gentileschi and Ribera. However, even the presence of some of Caravaggio's closest followers in Naples during the second decade[72]

71. They are so classified in Causa, 1966. Ferrari, 1970, pp. 1223 ff., convincingly outlines the rise of classicism in Naples during the second quarter of the century.
72. See a summary in Moir, 1967, I, 155–56.

did not prevent the development of a trend away from the art of the master. Our observations regarding Stanzione and Vaccaro are applicable, *mutatis mutandis*, to Cavallino, and to Finoglio, Pacecco de Rosa, Guarino, Codazzi, Micco Spadaro, and other painters whose peculiar blend of decorativeness, mannered elegance, and Riberesque naturalism is as unmistakably Neapolitan as it is alien to Caravaggio's sensibility.

A second group of important Neapolitan artists often described as having been dependent upon Caravaggio is made up of still-life painters. Luca Forte, Giacomo Recco, Paolo Porpora, Giuseppe Recco, and even Giovan Battista Ruoppolo have been analyzed as Caravaggisti, and their works explained as the logical fulfillment of Caravaggio's youthful representations of fruits and flowers. Any consideration of this group, however, must recognize three essential factors: that the careers of the early Neapolitan still-life specialists remain highly problematic;[73] that Caravaggio's still-life style was primarily formed by North Italian painting and its sources; and that the most convincing parallels which can be found for early Neapolitan still lifes point toward Northern and Mannerist origins and only secondarily to Caravaggio, whose compositions and choice of objects are distinctly different from those of the Neapolitans.

In the face of these circumstances it is highly tenuous to assert that Caravaggio's oeuvre, which was not primarily devoted to this artistic genre, was the foundation of Neapolitan still-life painting. Furthermore, his early pictures with fruits and flowers are not known to have reached Naples. It is eminently more reasonable, therefore, to believe (as Causa has argued)[74] that Giacomo Recco (and still-life painters of his generation) stems from the naturalistic tradition of Flanders as represented by Jan I (Velvet) Brueghel, who was in Naples in 1590 and in Rome ca. 1592–94 and was a very close friend of the Milanese Federico Borromeo. The Lombardic still-life heritage, so forcefully expressed in Fede Galizia's pictures,[75] was also indebted to the North, but in turn it fed numerous southern centers, including Spain. Painters such as Pietro Paolo Bonzi ("il Gobbo"), Mario Nuzzi (Mario dei Fiori), and Evaristo Baschenis testify to the diversity of Italian still-life painting as well as to its multiple origins. The recent reassigning of a group of initialed pictures once called Tommaso Salini (ca. 1575–1625) to the Lucchese artist Simone del Tintore (ca. 1630–1708)[76] is but one strong indication of the work that remains to be done in this complex area of study. Nevertheless, as general outlines slowly emerge, it becomes increasingly clear that Caravaggio's still-life paintings indeed were a brilliant manifestation of the growing interests in Italy in *natura morta*. But it is equally convincing that our limited documentation and misdirected hero worship have thrust Caravaggio to the forefront of a movement which actually had begun, and certainly would have developed, without his outstanding contribution.[77]

The question of the Bamboccianti[78]—those artists from the North who were affiliated through the Bentvueghels in Rome, dedicated to a rustic *petite manière*, and joined by a few Italians (most conspicuously Cerquozzi)—has been judiciously assessed by Moir. Reconsidering the popular interpretation that hails Van Laer, Miel, Both, et al. as the "true heirs of Caravaggio" (despite the fact that the movement began only in the 1620's), Moir concludes: "The style of the *bamboccianti* was miniaturistic, small-scale, and intimate, an art of illustration rather than one of psychological situation, and more concerned with man's environment than with his emotions and personality. Non-religious in subject matter, it presented the world of the common man, but as picturesque, with a clearly implied attitude of condescension toward its simple subjects. Thus it seems to be Caravaggesque only by default of any school of painting

73. See Naples, 1964, and especially pp. 150–56 for an extensive bibliography on Italian still-life painting (of special importance for developments in Naples are the studies by Bottari, and Causa, 1961; Causa, 1962; and Bottari, 1963-b).
74. Causa, 1961. Also, see Longhi, 1950-b; and Naples, 1964, for further bibliography.
75. See Bottari, 1963-a; and Naples, 1964, for further bibliography.
76. See Naples, 1964, pp. 86 ff.
77. Sterling, ed. 1959, pp. 58 ff., presents a good survey of Italian still-life painting in the early seventeenth century, but adheres to the thesis that Caravaggio was the primary force in its growth.
78. For the Bamboccianti, see especially Briganti, 1950, and Rotterdam, 1958. Artists of this group were included in the exhibitions in Milan, 1951, Naples, 1963, and Florence, 1970.

in Rome closer to Caravaggio and his successors...."[79] North European antecedents in fact were once again more consequential for the style of the Bambocciant than was Caravaggio's art, even if one assumes that the master's paintings had significantly accelerated the acceptance of popular subjects in Rome and encouraged a taste for genre themes. But to admit the Bambocciant to the ranks of Caravaggio's followers on the basis of this observation is comparable to citing Christus as a "follower" of Campin, Piero of Masaccio, or Claude of Domenichino simply because in each instance the earlier master had opened new vistas that the younger painters explored. Not only does one overlook the unifying, contemporaneous aspects of artistic expression by linking painter to painter on a "vertical" temporal scale, but one tends to underplay the contributions and originality of later artists by designating them as followers of a great personality.

Because Florentine painting was modified to a small degree by Caravaggio's style—in particular as interpreted by the Tuscans Artemisia and Orazio Gentileschi— it should not pass unmentioned, although the complexities of a regional school necessarily preclude a detailed discussion here.[80] Like many of the Neapolitans, artists such as Vignali, Dandini, Bilivert, Coccapani, Lippi, Fidani, and Martinelli recognized naturalism and chiaroscuro as essential parts of a Baroque vocabulary. But as in Genoese and Venetian painting, their Tuscan tradition far outweighed external influences. Bright, local colors, elaborate multicolored garments, and a gentleness derived from Baroccio imbue Florentine art with a staged decorativeness that is antithetical to Caravaggesque painting. If the rare works of Anastagio Fontebuoni that depend upon sharp chiaroscuro and firmly modeled forms are exceptions, it is revealing that he worked in Rome rather than Florence during the second decade.

The lists of the Caravaggisti have expanded so far beyond just measure during the past century that it must suffice to discuss representative examples of the deceiving terminology and interpretations that are in common use, and to assume that analogous arguments could be put forth for many parallel situations. Three interrelated categories of pseudo-Caravaggisti remain to be mentioned. First, there are those painters whose artistic heritage and personal style are so fundamentally different from Caravaggio's that, despite whatever imitative efforts were made, the results do not merit the description "Caravaggesque." Reni, the Neapolitans, and the Florentines could be listed a second time in this context, as could Angelo Caroselli[81] and Theodoor van Loon,[82] especially because they were in close touch with Roman painting early in the century. Caroselli chose to follow Caravaggio only on selected occasions, usually when he believed the subject was appropriate, and even then in a superficial manner; Van Loon's vision, in many ways related to Borgianni's, only skirts the fringes of Caravaggesque art, for his love of paint, nervous vibrations of contours, and rich pulsation of surfaces place him beyond the reasonable limits of the Caravaggisti. But the primary examples are artists like Tanzio da Varallo, Bernardo Strozzi, and Peter Paul Rubens. The second group, composed of foreigners who were attracted to Italy but absorbed Caravaggio's art to a very limited degree, is epitomized by Abraham Bloemaert and Pieter Lastman. Finally, a large number of later Baroque painters —Giordano, Traversi, Francesco del Cairo, and Piazzetta first come to mind—are chronologically so far removed from Caravaggio and inevitably from the means and intention of his art that it is purposeless to see them as his followers.

Tanzio visited Rome at an early date and was strongly attracted to Caravaggio.[83] A painting such as his *Circumcision* (Fara San Martino)[84] undeniably is Caravaggesque in intention and effect. Somber, humble figures find substance through a strong, raking light, which

79. Moir, 1967, I, 152.
80. See the excellent essay by Gregori, 1962, and Moir, 1967, I, 213–15. Borea, 1970, represents the pan-Caravaggesque attitude in interpreting Florentine Seicento painting (see the critical reaction in Nicolson, 1970–a, Spear, 1971, and Schleier, 1971).
81. The fundamental study is Ottani, 1965-b; also, see Moir, 1967, I, 52–56.
82. See Boschetto, 1970.
83. For a summary of Tanzio's life and development and further bibliography, see Moir, 1967, I, 260–65.
84. Ill. in Moir, 1967, II, fig. 351.

painstakingly searches out the sculptural qualities of garments. The space, however, and the distribution of forms within it are painfully unimaginative, and the archaic design of the *Madonna of the Fire* (Pescocostanza)[85] underscores Tanzio's dependence upon his Mannerist heritage. Were the majority of Tanzio's paintings of this character, he properly could assume the Caravaggesque role that is so often assigned to him. But this is not the case, and it is ironical in fact that the most successful aspects of his art are precisely those features which are antithetical to Caravaggio's style. Tanzio's rich impasto, brilliant and highly personal color schemes, eccentric gestures and expressions, and shimmering landscapes are original, distinguished contributions and clearly traceable to Morazzone and Cerano—who in the long run meant much more to Tanzio than did Borgianni and Orazio Gentileschi. A close analysis of the paintings yields the clear verdict that despite whatever intentions he may have had, Tanzio did not, and undoubtedly could not, alter his deeply ingrained, late-Mannerist, Lombardic heritage.

Although there is not a single painting by Strozzi which is as Caravaggesque as Tanzio's *Circumcision* (a not surprising fact since Strozzi never visited Rome), his iconography includes many subjects that were favorites of Caravaggio's followers, and a few of his compositions, in particular the *Calling of St. Matthew* (Worcester),[86] pay direct homage to the master. Nevertheless, Strozzi's colors are manifestly Genoese. His rich use of impasto reflects the strong Flemish influence that was present in Genoa, and the nervous figures, acting and reacting with urgency, can be traced to North Italian sources. A raking light which cuts the background wall of the Worcester picture is derived from the Contarelli *Calling of St. Matthew*. But how telling is the reversal of the light source; for, by entering the room from the side opposite Christ, it is deprived of all of its spiritual strength and becomes commonplace illumination. A *bravo* is dressed in the costume dear to the Caravaggisti, but he and his companions relinquish the psychological

unity of Caravaggio's design to a fractured rhythm that is heavily dependent upon an expressive play of hands. In this respect Strozzi's painting is comparable to Terbrugghen's interpretation of the same theme in Utrecht.[87] But unlike Terbrugghen, Strozzi never understood the spiritual meaning of Caravaggio's paintings. If the means—the color, brushwork, and composition—are not properly speaking Caravaggesque, and since the prevailing mood of Strozzi's art is that of noisy animation, little remains that could qualify him as a follower of Caravaggio. Strozzi's early paintings undeniably are dependent upon a strong sense of naturalism, as is verified by the boldly foreshortened instruments of his musicians, the realistic portrayal of facial expressions, and a predilection for rustic costumes. Like Fetti, Langetti, and Pietro della Vecchia, but to a greater degree, Strozzi owed a part of his vision to Caravaggio and his disciples. His deep love of color and paint, however, proved to be contradictory to a true Caravaggesque style, and quickly he shed the thin shell that had inadequately disguised his youthful works.

Rubens' eclectic education in Italy, based on a careful study of ancient, Renaissance, and contemporary art, was deeply affected by an examination of Caravaggio's mature religious works, for there is no doubt that it accelerated the young Fleming's discovery of a means to transform the heroic qualities common to Hellenistic sculpture and that of Michelangelo into two dimensions. Rubens' copy of Caravaggio's *Entombment* (Ottawa) is firm evidence of his admiration for the Italian, and the Antwerp altarpieces provide additional testimony to his early assimilation of Caravaggio's figure scale and use of chiaroscuro. But even Rubens' most Caravaggesque paintings are the product of many sources; and if the Venetian elements are readily discernible and of paramount importance, the separation of Caravaggio's influence from Annibale's is never a simple matter. Rubens' oeuvre, like Strozzi's, contains no example of a painting that can unequivocally be called Caravaggesque. In Strozzi's art Caravaggio's influence, whenever present, reveals itself at once as an experimental veneer, while in Rubens' work it is infinitely more subtle. Rubens' style, more than Jordaens', was determined by so many factors that it is deceiving to stress Caravaggio's

85. Ill. in Moir, 1967, II, fig. 350.
86. Ill. in Moir, 1967, II, fig. 255.
87. Ill. in Nicolson, 1958-a, pl. 27.

influence at the expense of others which were often more significant. Paradoxically, Rubens understood Caravaggio's art more profoundly than did many of Caravaggio's actual followers. But he refused, as all truly great artists must, to become the follower of any single master.

Bloemaert and Lastman merit attention because they played pivotal roles in the development of Dutch Baroque painting, and because they are frequently included among Caravaggio's followers. If the Utrecht Caravaggisti had not studied under Bloemaert, and Rembrandt had not been influenced by Lastman, the importance of Caravaggio for the two Dutchmen probably would be exaggerated less often. Terbrugghen, Honthorst, and Baburen, however, developed their interpretations of Caravaggio's style in Italy without the aid of Bloemaert; and Rembrandt himself certainly cannot be considered a follower of Caravaggio. Thus, Bloemaert's and Lastman's indebtedness to the Lombard must be judged on the basis of their own works, which upon analysis provide little justification for a Caravaggesque label. Bloemaert's artistic personality was molded by his Dutch heritage; by the schools of Fontainebleau, Vienna, and Prague; by Bolognese painting; and only at a late date by Caravaggio. As it has been aptly stated, "Bloemaert learned as easily as he taught."[88] Responding to the success of his Utrecht pupils, in his maturity he assimilated elements of Caravaggio's style; but Caravaggio's influence on Bloemaert was no more dominant than was Michelangelo's influence on Raphael, who fortunately has not had to bear the label Michelangelesque.

As regards Pieter Lastman, it would be more legitimate to write him into the family tree of Elsheimer than of Caravaggio. The Roman milieu of the Frankfurt master, which included Jan and Jacob Pynas, Jan Tengnagel, and slightly later Leonaert Bramer—Saraceni must also be mentioned—was indisputably important for early Rembrandt, via Lastman. Caravaggio's art attracted Lastman when he visited the South, and it should be noted that as early as 1617 he could have seen Caravaggio's *Madonna of the Rosary* in Amsterdam. Nevertheless, it was the circle of the Northerners in Rome whose impact was far more consequential for him and for his pupils.

Whereas Bloemaert and Lastman were directly, if only slightly, affected by the art of Caravaggio and his followers, painters later in the century rarely returned to the early sources. Giordano's chiaroscuro and naturalism, for instance, are fundamentally a product of the Neapolitan school, which demonstrably was not Caravaggesque at mid-century. Likewise, Traversi's, Del Cairo's, and Piazzetta's modes of vision are totally different from Caravaggio's, and only if one were to ascribe all naturalism and chiaroscuro to the Lombard's influence, regardless of the date or style of a painting, could these artists be understood as Caravaggisti in any sense.

It undoubtedly has become apparent that any pan-Caravaggesque interpretation of Seicento painting rests on two distinct fallacies: that all naturalism and chiaroscuro stem from Caravaggio, and that artistic influence, no matter how remote or slight, signifies discipleship. The latter issue is not simply one of semantics. Fragonard, Géricault, and Cézanne were influenced by Caravaggio, whose art also stimulated Jacques Louis David. Because the latter artists are acknowledged masters in their own right and representatives of a different stylistic period, it is relatively easy to separate influence and admiration from emulation. But there is no justification whatsoever for blurring this distinction within the seventeenth century. To the contrary, the need becomes even greater to maintain critical judgment as one approaches Caravaggio chronologically, for the similarities between Ludovico Carracci, Velázquez, or Vaccaro and Caravaggio are obviously greater than between Géricault and Caravaggio. The factors common to the former artists feed and enrich our understanding of the Baroque, while the differences allow us to tell Bolognese, Spanish, or Neapolitan painting apart from Roman. If history inevitably must be written from our own vantage point, an effort nevertheless should be made to avoid the simplified explanations that are prompted by respect for a great master, on the one hand, and less familiarity with his fellow artists, on the other. As every wrong attribution of a painting reveals a misunderstand-

88. Rosenberg, Slive, and Ter Kuile, 1966, p. 17.

ing of two artists, so our appreciation of Caravaggio's style and the development of Seicento painting, as well as the artists in question, are tainted by every wrong use of the terms Caravaggisti and Caravaggesque. With the way at least partially cleared of some of the most misleading signs,[89] it may be possible to gain a better perspective on Caravaggio's actual followers.

III

An overview of Caravaggesque painting in Rome reveals four phases of activity which generally correspond with four groups of artists, although some of Caravaggio's followers expectedly were active during more than one of those periods. Our knowledge of the first, or earliest phase—the years prior to Caravaggio's flight from Rome—is regrettably slight. But an introductory summary of chronological developments and artistic exchanges is nevertheless important, for it suggests that Caravaggio's absence from Rome actually may have stimulated Caravaggesque painting after 1605 and that early in the second decade, and again after 1620, there were important resurgences of the master's influence.

Very little is known about Caravaggio's impact during the 1590's. His earliest companions were Prospero Orsi ("Prosperino delle Grottesche"),[90] Mario Minniti,[91] and Antiveduto Grammatica. Minniti and Caravaggio arrived in Rome about the same time, probably in 1592 or 1593, and immediately became close friends. Caravaggio collaborated with, or worked for, Grammatica, as he also assisted d'Arpino, but nothing can be established about Minniti's, and only a little about Grammatica's art in the 1590's. Judging from Grammatica's early altarpiece in S. Stanislao dei Polacchi, his conversion to a Caravaggesque idiom was a slow process. Orsi, who was considerably older than the other painters, did not alter his style because of Caravaggio's activity. Filippo Trisegni, who belonged to Caravaggio's circle of friends at least by 1603, is a completely mysterious figure, for absolutely nothing is known about him artistically, nor is there any evidence of when he became Caravaggio's companion.[92] Orazio Gentileschi had been in Rome for about fifteen years when Caravaggio arrived, but only gradually (and partially) was he transformed into a Caravaggesque painter. Spadarino was in Rome in 1597, and the first of the Northerners, Abraham Janssens, arrived the following year; but we know nothing about the early art of Spadarino, and Janssens' initial phase is distinctly un-Caravaggesque. In the same year, 1598, Saraceni settled in Rome, yet it was some time before his interests were fixed on Caravaggio. Mao Salini,[93] like Orazio, Grammatica, and Orsi, had been in the city for many years when Caravaggio arrived, and although he is said to have specialized in still-life painting very early in the century (possibly as early as the 1590's), not a single picture of this genre can be assigned to him with certainty. Finally, nothing by Borgianni that predates his return to Rome from Spain in 1605 can be classified as a Caravaggesque picture.

From this brief outline one must conclude that factually nothing is known about Caravaggesque painting prior to 1600, which should not be surprising. Recent deductions from Susinno's *Vite* have confirmed Caravaggio's late arrival in Rome, and because the Contarelli paintings were not executed until the end of the decade and the first years of the Seicento, there were no public works by Caravaggio visible in Rome until the seventeenth century.

As ironical as it may seem, Baglione, a bitter enemy and caustic critic of Caravaggio, is the first artist known to have emulated the Lombard's style. His *Ecstasy of St.*

89. The following artists among those frequently cited in publications on the Caravaggisti but unmentioned in this essay should nonetheless be deleted from lists of Caravaggio's followers: Guido Cagnacci, Jacopo da Empoli, Genovesino, Jan Lys, and Pietro Novelli among the Italians; the Dutchmen Paulus Bor, Jan van Bronchorst, Adam de Coster, Wouter Crabeth, Jacob Ochtervelt, Jacob van Oost, and Michael Sweerts; Jean and Richard Tassel, and Claude Vignon in France; the Spaniards Luis Tristán and Francisco de Zurbarán; and the German Simon Peter Tilmann.

90. For a summary of Orsi's contact with Caravaggio, see Moir, 1967, I, 23–24, n. 5. See Salerno, 1966, p. 107, for the possibility that Caravaggio's *Basket of Fruit* in Milan is painted over a picture by Orsi.

91. On Minniti, see Agnello, 1964, and Moir, 1967, I, 185–88.

92. All that is known about Trisegni is that he was one of the defendants during Baglione's action for libel in 1603; he was the son of Domenico, and identified as a Roman painter.

93. For Salini, see cat. no. 27, nn. 2, 3, and 5.

Francis and *Victorious Earthly Love* [3, 4] are painted with the explicit intention of rivaling Caravaggio. It is possible that Caravaggio himself considered these pictures to be the first conscious imitations of his art and that his hostility towards Baglione was immediately kindled. From the opening years of the seventeenth century there are no other Caravaggesque paintings known. Orazio Gentileschi, Borgianni, and Saraceni, so far as we can determine, still had not significantly changed their styles. Manfredi's activities ca. 1600–1605 are problematic, but it is likely that he and Cecco had not yet begun to work in their typical Caravaggesque manners. Finson joined the Roman milieu early in the century, and Terbrugghen arrived in the city about 1604, probably a year or two before Rodriguez,[94] who was there by 1606—but there is no trace of Caravaggesque paintings from their hands during these formative years.

Thus, with the exception of Baglione, it is conceivable that no one seriously copied Caravaggio's style while the master was working in Rome. The coincidence of the absence of any other imitative works, Caravaggio's open hostility towards Baglione, and the rise of Caravaggesque painting after 1605-6 raises the question of whether, in fact, Caravaggio himself did not successfully discourage followers. As is well known, he took on no pupils; he ridiculed traditional methods of preparation and undoubtedly of teaching too; and he could remain close friends with no painter for any length of time. However, if in these circumstances it may seem reasonable to hypothesize that Caravaggio actually intimidated aspiring rivals, one must remember that we are ignorant of Trisegni's art, of Manfredi's and Minniti's earliest paintings, and of Cecco's chronology; moreover, an early Caravaggesque picture by Orazio or Borgianni could still be discovered. But until then, the evidence suggests that artists in Rome did not seriously begin to emulate Caravaggio's style until around 1605-6.

For nearly ten years, from ca. 1605 until the middle of the second decade, Orazio Gentileschi, Borgianni, and Saraceni were unquestionably the leading forces of Caravaggesque painting. Finson and Rodriguez, artists of much lower quality, could offer little competition; furthermore, they both had left Rome by about 1610. Although Terbrugghen's paintings from these years

have not been identified, it is hardly likely that a major body of Caravaggesque work from his hand awaits discovery. Jan Janssens[95] arrived in the papal city sometime around 1610 and remained there for approximately a decade, but judging from his semi-primitive mature paintings, his youthful work must have been nothing capable of revolutionizing Roman art. Baglione basically deserted his Caravaggesque manner, willingly or not, and Riminaldi, who left Pisa for Rome ca. 1610, reportedly was a very slow, if talented, worker.

Only the Mantuan, Manfredi, was beginning to break decisive new ground prior to the middle of the second decade, when an influx of foreigners in Rome initiated a third, stronger period of Caravaggesque activity. Even though Manfredi remains an enigmatic personality, it is certain from seventeenth-century sources and from what can be determined about his style that his role after ca. 1615 was of paramount importance. Many of the young French and Netherlandish painters arriving in Rome were converted to his vision, to what Sandrart called the "Manfredi manner."

Valentin, Baburen, and Seghers all reached Rome about 1612, and were followed by Vouet in 1613. Renieri was in the city in 1615, and Rombouts and Le Clerc by 1616. Honthorst, and probably Cecco, spent the entire decade in Rome, and the Master of the Judgment of Solomon seems to have settled there around 1615, approximately when De Haen[96] joined Baburen. Douffet and the "Pensionante del Saraceni" were active in Rome during these years too. Meanwhile, Maino probably visited Rome ca. 1610, and Ribera's stay there in 1614–15 added further strength to the non-Italian contingency. In fact, only Serodine and Caracciolo (and possibly Rustici and Manetti) can be added to the Italian Caravaggisti in the papal city at this time—but Serodine, having arrived ca. 1613, was still very young, and Caracciolo's visit ca. 1614–15 was brief.[97]

94. Rodriguez has been studied by Moir, 1962; for a resumé, see Moir, 1967, I, 188–91.
95. On Jan Janssens, see Roggen, Pauwels, and De Schrijver, 1949–50, pp. 260 ff., and Roggen and Pauwels, 1953, pp. 201 ff.
96. See Slatkes, 1966.
97. Moir, 1967, I, 161, n. 25, summarizes the problem of dating Caracciolo's trip to Rome.

Whereas the forces of the Northern Caravaggisti were large in number and impressive in quality, Italian leadership waned: Borgianni died in 1616, Orazio often was away from Rome after 1615, and he left Italy for good in 1620. Only Saraceni and Grammatica of the older Italian group remained active in Rome between 1615 and 1620, and Saraceni was destined to leave for Venice in 1619.

It is clear, therefore, that the character of the Caravaggisti had fundamentally changed during the years around the middle of the second decade, and indeed a concomitant shift occurred in the nature of their art. Earlier, with extraordinarily few exceptions, Caravaggio's followers were Italian painters of religious subjects. Later, as if reversing the master's own iconographic growth, a dominant interest in secular themes developed, especially after Manfredi had converted his large following of Northerners.

The final phase of Caravaggesque painting generally corresponds with the 1620's, when Artemisia, Serodine, Vouet (until 1627), Cavarozzi and Rombouts (both until 1625), Valentin, Spadarino, and Grammatica were active in Rome. However, Manfredi died in 1620 or 1621, and Honthorst and Baburen left for Utrecht to join Terbrugghen, who had deserted Italy as early as 1614. Jan Janssens also returned to the North by 1621, the year preceding De Haen's death in Rome, while Douffet is recorded back in Liège by 1624.

This exodus of Northerners, which seemingly would have affected the character of Caravaggesque painting, occurred as a number of new artists entered the scene: Tournier, who was in Rome from 1619 to 1626; Bylert, from 1621 to 1624; and Campino, who arrived in Rome by 1623 and became an important organizing force among foreigners. "Theofilo Bigotti" is documented in Rome in 1620–23 and 1625, and Stomer was probably there in the 1620's, before one of the last of the Caravaggisti, Preti, visited the city around 1630. By contrast, Paolini was the only Italian follower of Caravaggio to reach Rome around 1620. Regarding La Tour, there simply is no real evidence to confirm the hypothesis that he was in Rome either prior to 1616, or ca. 1640.

Caravaggesque genre painting continued to enjoy popularity throughout the third decade of the century when the Bamboccianti were reinforcing a broader taste for mundane themes. Caravaggesque religious painting, of course, had never died, and by the 1620's, under the influence of the "Manfredi manner,' it was frequently more secular in character. But throughout all phases of Caravaggesque activity, mythological subjects were extremely rare, a fact that is properly explained by Caravaggio's own neglect of mythology. Furthermore, history scenes were virtually never represented, which provides support to the conclusion that Caravaggio's style was understood by most of his followers as being adaptable only to certain categories of subject matter. It is more difficult to assess his influence on portraiture, since so little is known about his own portrait style, but it can be observed that at least some of the Caravaggisti (Artemisia, Borgianni, Finson, Grammatica, Paolini, and Vouet) were definitely interested in painting portraits during their Caravaggesque years.

To summarize the fragmentary evidence that has come down to us over three and a half centuries: 1. Caravaggio did not stimulate, or perhaps he successfully discouraged, serious imitations of his style before 1600; during the next five years, Baglione was the only imitator of the Lombard. 2. From ca. 1605 to ca. 1615, a group of Italian Caravaggisti led by Orazio Gentileschi, Borgianni, and Saraceni opened many paths to Caravaggesque art, but limited most of their works to religious subjects. 3. Manfredi, sometime before 1615, discovered the potential of Caravaggio's style for secular themes and thereby popularized a mode of painting which attracted numerous Northern followers; from ca. 1615 on, these followers dominated Caravaggesque painting in Italy, although many Italians continued to discover Caravaggio's style. 4. The latest painters who properly can be called Caravaggisti formed their styles during the decade of the 1620's, after which time few young artists found Caravaggio or his immediate followers to be viable sources.

Although a sojourn in Rome was indispensable for an artist to become a true follower of Caravaggio (La Tour is the only possible exception), the master's paintings, and especially copies of his paintings,[98] were dispersed at an early date. They were few in number and insufficient to foster disciples, but they undoubtedly stimulated pilgrimages to Rome, where Caravaggio's oeuvre could be studied first-hand. Already before 1620, Mancini intimated that one could differentiate between those artists consistently committed to some aspect of Caravaggio's work, those who followed the master for a fraction of their careers, and those who tempered their styles under Caravaggio's influence—sometimes for their entire lives—but nevertheless retained significant un-Caravaggesque tendencies.[99] (It is important to note that all of those artists actually cited by Mancini worked in Rome.) His distinction between three categories of Caravaggisti has withstood well the challenge of historical distance, for the followers of Caravaggio in fact can be understood in terms of their devotion to the master.

Roughly speaking, there were two-score painters whose work was sufficiently guided by Caravaggio's art that they can properly be called Caravaggisti, and they are nearly equally divisible into Mancini's three categories. To the first—painters basically devoted to Caravaggio throughout their entire careers—can be assigned Manfredi, Caracciolo, Grammatica, Spadarino, Salini, Riminaldi, and Rodriguez among the Italians; Valentin, Cecco, Bigot, the "Pensionante del Saraceni," and La Tour among the French; and only Finson and De Haen from the Low Countries. (No classification is possible for the Master of the Judgment of Solomon until his late paintings are identified; and we do not know enough about Rustici to judge his oeuvre.) To the second category—artists who were followers of Caravaggio for some years and then changed their styles, or were erratic in their attachment to Caravaggio—belong Baglione, the Gentileschi (father and daughter), Paolini, Manetti, and Preti; Tournier and Vouet; Baburen, Renieri, Rombouts, and Seghers; and the Spaniard Ribera. The third group consists of Borgianni, Saraceni, Cavarozzi, Serodine, and Spada; Le Clerc; Terbrugghen, Honthorst, Bylert, Stomer, and Jan and Abraham Janssens; and

Maino—all of whom were deeply influenced by Caravaggio, but at the same time maintained a certain stylistic distance from him.

If distinct national patterns emerge from these groupings (clannishness among artists in Rome was common), one must stress that the classifications are by no means rigid, for it is obvious that according to one's visual persuasion some shuffling could occur. Furthermore, it is apparent that our understanding of a number of these artists today is far from complete. The general lines nevertheless seem to be reasonably drawn, and from them it would appear that the Flemings and Dutch were rarely steadfast in their attraction to Caravaggio's art since Finson and De Haen alone are in the first category —and they both died early in the century, before a real opportunity for change arose. The French, on the other hand (always we speak of individuals and never of organized groups), embraced Caravaggism more fully, for Valentin was one of Caravaggio's and Manfredi's closest followers; all of Bigot's known paintings are Caravaggesque (which is true of Cecco and the "Pensionante" as well); and if Tournier and Vouet did alter their styles when back in France, they were deeply moved by Caravaggio during their stay in Rome. There is a corresponding national alignment in the third category, for Le Clerc alone is French, while numerous Netherlandish painters are present. Yet, as revealing as these patterns appear to be, there is a crucial factor which supersedes national origin: the question of whether or not a painter remained in Italy. It suffices to note that excepting Bigot and La Tour (because of the unresolved problems surrounding them) and Finson (who died as early as 1617), all artists in our first category worked in Italy (and usually in Rome) throughout their mature lives. The corollary is that every Northerner in the second category returned to the Low Lands (and the majority of the Italians left Rome). The conclusion to be drawn from these observations is clear: Caravaggio's style was not suited for

98. On the problem and importance of copies, see Longhi, 1960; Moir has referred to a number of copies in 1967, I, 19–20, and will soon publish fuller lists.
99. These categories are discussed by Moir, 1967, I, 18 ff., but with a broader, pan-Caravaggesque interpretation.

export, at least not in its original form. Even when taken a little beyond its natural limits, Rome, it usually was diluted, overpowered by the mainstreams of local traditions.

It remains, therefore, to determine how the Caravaggisti adopted Caravaggio's art, and to isolate those aspects of his style which were imitated and subsequently transformed. As it is evident that regional, financial, and personal factors produced circumstances that never duplicated Caravaggio's own situation, so it is clear that there is no fixed attitude towards art or life which binds together the master and the forty-odd Caravaggisti. Many of the followers employed assistants, taught students, prepared drawings, and even painted frescoes—if predictably in an un-Caravaggesque style. To the question, do the Caravaggisti make up a school or movement, a firm negative response must be given. The absence of any student-teacher relationships with Caravaggio, and the fundamental disparities of style and subject matter within the ranks of the Caravaggisti preclude these binding terms. Caravaggism can best be understood as the collective product of an artistic alternative, one among many present in Italy from ca. 1600 to ca. 1630. Whether youthful or mature, any artist could choose to imitate Caravaggio's paintings, whenever, and however, he preferred. Caracciolo and Manfredi, to cite the two principal followers, found in Caravaggio's art persuasive modes of expression, but each elected a different path, and by having done so epitomizes an important division within the Caravaggisti themselves: those who saw Caravaggio's work primarily as fertile ground for the development of religious art, and those who found their way via his genre scenes. Manfredi and Caracciolo, apart from all other Caravaggisti, depended directly upon Caravaggio, remained close to the master in their interpretation of his style, and were steadfast in their dedication to him. Nevertheless, they were not pioneers in the sense of temporal priority. Instead, they were settlers, making somewhat more secure the shaky foundations of the first explorers.

The earliest adaption of Caravaggio's style to religious painting was made by Baglione [3, 4]. He imitated the deep contrasts of chiaroscuro which Caravaggio had developed after ca. 1597 and approximated his broadly designed, thick fabrics of a single, strong color. Caravaggio's angels were influential upon Baglione's figure types; their long black hair, heavy eyebrows, and sensuous lips—all of which fed their revolutionary, mundane appearance—lived on for years in Baglione's art. Baglione succumbed only in part to Caravaggio's color (bold reds and greens amidst somber earthen hues), for usually his paintings are more decorative, often relying upon richer contrasts. His work reveals only a moderate understanding of the Mannerist reform of the 1580's and 1590's, whether proportions or composition are in question. And if his objects occasionally are rendered with a strong sense of verisimilitude [cf. 4], they never would yield as sharp a ring as Caravaggio's own accessories. Like many of Caravaggio's followers, Baglione quickly learned words of the new Caravaggesque language and mastered a good pronunciation. But even to the semi-trained ear his syntax lacks meaning. The sentiment of his art is frequently trite, reflective of little personal conviction.

Whereas Caravaggio's influence in Baglione's art is skin-deep, it was more fully absorbed by the systems of Borgianni and Orazio Gentileschi. Borgianni's *Christ Disputing with the Doctors in the Temple* [6], its rich surface notwithstanding, builds upon the figural grouping of Caravaggio's *Doubting Thomas* (Potsdam); and the rustic, humble Joseph in the *Holy Family* [7] is derived from Caravaggio's apostles and saints. If in neither painting blue is assiduously avoided as in Caravaggio's work and the red of the Virgin's blouse is Venetian in origin, a strong sense of corporeality is achieved, primarily through the means of chiaroscuro. Deep contrasts of light isolate figures against a shallow darkness, and thus, as in so many of Caravaggio's works, time is suspended because there is no reference to location. Yet, one rarely questions the reality of Borgianni's world; for despite the dancing, phosphorescent qualities of his light and a use of affected gestures that calls to mind Bolognese art, Borgianni's figures invariably act and interact with energy and determination that are eminently human.

The genre paintings of Caravaggio and the arrested expressions and movement of *Judith* (Fig. 4), *Medusa*, and *Boy Bitten by a Lizard* meant very little to Baglione and Borgianni, and even less to Orazio Gentileschi. Ora-

zio's *David* in Dublin,[100] quite exceptional for its violence, is atypical of the discreet behavior that governs the majority of his works. His figures have no kinships at all with Caravaggio's peasant stock, for they are exemplary products of finishing school in manners and dress alike. Paintings such as the *Crowning with Thorns*[101] and *Judith with the Head of Holofernes* [30] exploit the dramatic and ominous overtones of impenetrable blackness, but the greater part of Orazio's vision evokes the light, clear tonalities of spring, and thus is related to the youthful poetry of Caravaggio as exemplified in the latter's *Magdalene* in the Galleria Doria. At an early date Orazio recognized in Caravaggio's art an important alternative to Mannerism,[102] for like Borgianni, he discovered in it strength and beauty revealed in naturalistic form, and space and human expression subtly conveyed by light. Borgianni and Orazio were drawn to some of the principal formal qualities of Caravaggio's paintings, and not only to details of foreshortening, still life, costume, or figure types. At the same time, each artist's individuality foreshadowed major developments among the later Caravaggisti. Borgianni's liquid brushwork and nervous contours point directly toward Serodine and Terbrugghen; Orazio's luminous, lightened colors presaged the palette preferred by the Utrecht followers, and his figure types lived on in the art of Cavarozzi, Artemisia, Maino, and Ducamps.

Saraceni had developed a distinctly personal style prior to succumbing to Caravaggio's art, and like Borgianni and Orazio, he discovered in it the means of strengthening his own religious paintings. From decidedly un-Caravaggesque beginnings linked to an Elsheimerian vision, he slowly explored the effectiveness of individualized life-size figures engaged in intense dialogue or action, of sharp illumination and dark background walls, and of judiciously applied verisimilitude. If figures in Saraceni's world belong to the common classes, they rarely could be found in the streets of Rome, for a streak of exoticism manifest in costumes and physiognomy runs throughout his work (Caravaggio's old women in *Judith and Holofernes* and the *Madonna di Loreto* are the clearest sources for Saraceni's ubiquitous turbaned women). Whether youthful or adult, Saraceni's figures assume their roles with childlike naïveté, which,

like the small, complex folds of his fabrics, tends to preclude a sense of monumentality. Saraceni's paintings, nevertheless, bear the sharp imprint of Caravaggio's secularization of religious art, for the domestic air that prevails in his world is unthinkable without the master's *Rest on the Flight into Egypt*, the *Madonna di Loreto*, and above all the *Death of the Virgin*. Orazio's lyrical vision also had an important effect on Saraceni, who, following Gentileschi's lead, developed at an early date a highly poetic variation on Caravaggio's style.

A significant number of the classic hallmarks of Caravaggesque painting are absent in the works of the principal early followers, who sought to depict religious scenes of convincing earthly reality by imitating many of Caravaggio's means. Caravaggio's youthful paintings were important for their light tonalities, but the early ruffian themes and half-length compositions exerted surprisingly little influence. Only occasionally his emphasis upon the instant of maximum dramatic action was imitated, for as a rule, Baglione's, Borgianni's, Orazio's, and Saraceni's scenes are calm. Very deep contrasts of chiaroscuro were used, but no more often than a strong, single-source light within the setting of middle values. Through Caravaggio's example, light which was form-giving and natural in character became the principal means of unifying objects within a composition.

Nevertheless, a fundamental difference separates Caravaggio's mature works from his disciples', for in every instance the severity of his style was significantly tempered. Whether the intensity of his chiaroscuro, the reduction of anatomical detail, the simplification of colors and garments, or the realism of his figure types is considered, it is apparent that none of the earliest followers attempted to rival Caravaggio on his own terms. A general relaxation of the master's style had the inevitable effect of lessening its impact. The spiritual conviction of his profoundly humble figures and the monumentality of his original designs were usually sacrificed by the Caravaggisti to more pleasing, decorative effects and

100. Ill. in Moir, 1967, II, fig. 69.
101. Ill. in Moir, 1967, II, fig. 70.
102. For Orazio's earliest style, see Bissell, 1964.

to more conventional representations of sacred, often transcendental, subjects.[103]

Sometime around the middle of the second decade Caracciolo visited Rome, and even though his stay was brief, he found in Caravaggio's Roman paintings confirmation of his earlier attachment to the master's Neapolitan works. It was decisive for his artistic formation that for a number of years he had been familiar only with Caravaggio's post-Roman style, with the tenebristic, late religious pictures. Many of Caracciolo's paintings retain Caravaggio's sharp raking light and somber color scheme, rely upon his distinctive figure types, and convey the sense of weightiness characteristic of the master's Neapolitan works. If occasionally, as in the well-known *Christ Washing the Feet of the Disciples* (San Martino),[104] Caracciolo achieved a sense of Caravaggio's subtle space and design, more frequently his scenes are charged with figures tightly compressed within confining limits. But Caracciolo's art, unlike Borgianni's, Orazio's, and Saraceni's, seldom yields to any decorative effects. It preserves the austerity and solemnity of Caravaggio's late style. In form and often in content, Caracciolo was closest to the master among all of the followers devoted to religious art, despite the fact that he was a mature artist when Caravaggio first visited Naples in 1606.

Because Manfredi was the closest follower of Caravaggio to deal extensively with secular themes, he might be considered to be a counterpart to Caracciolo. But while Caracciolo's influence on the Roman world was slight, Manfredi's was enormous, truly unparalleled among the Caravaggisti. It was he who made popular so many of the features today associated with a Caravaggesque style: half-length figures, scenes of gaming and concerts, gypsies and soldiers in *bravo* costumes, enclosed dark settings cut by a strong raking light. Manfredi recognized in Caravaggio's *Una musica* [15], *Fortune Teller* (Fig. 2), and *Card Sharps* (Fig. 3) ground rich for exploration, but by preferring the dark shadows and

cellar lighting of Caravaggio's later style, he made mysterious what in the master's own secular paintings had been lyrical. Caravaggio revolutionized religious art by transforming traditionally idealized figures into common men and women of the street—an innovation in which Manfredi saw further potential for wide variation. Manfredi often cast his religious characters in unconventional worldly roles and blurred all distinctions between church and tavern settings; ambiguity became an important part of his iconography. He was deeply influenced by the unorthodox secular appearance of Caravaggio's *Calling of St. Matthew* and discovered the value of the extreme understatement of Christ and of the tavern-like setting. More than any single painting, the *Calling of St. Matthew* opened the way to the "Manfredi manner," especially to the merging of secular and religious imagery.

Caracciolo and Manfredi share the distinction of having intensified important aspects of Caravaggio's art, unlike the majority of the Caravaggisti who diluted its strength. Caracciolo and Manfredi also were consistent in preferring a *tenebroso* palette, a partiality that had far-reaching consequences for the younger generation. But unlike Caracciolo, Manfredi worked exclusively for private patrons and not the Church, and thus his canvases were small and easily lost. His influence in the early seventeenth century was nonetheless pervasive. Caravaggism received a vital transfusion through the coincidence of his activity and the appearance in Rome of Valentin, Vouet, Tournier, Renieri, Seghers, and the Utrecht Caravaggisti, for his disguising of religious subjects as genre themes quickly stirred the Northern imagination.

It should be understood that Manfredi and his disciples were not the only painters (in addition to Baglione, Borgianni, Gentileschi, Saraceni, and Carracciolo) to have followed Caravaggio's lead during the first and second decades. Mao Salini was dependent upon Caravaggio and Baglione at an early date. Le Clerc had attached himself to Saraceni, whose style stimulated the "Pensionante" as well, although this mysterious painter also turned directly to Caravaggio for sustenance. Maino was attracted to Orazio Gentileschi's clear tonalities and beautiful figure types, but he, too, paid homage to the

103. See the discussion of Caravaggesque religious art in Moir, 1967, I, 110 ff.
104. Ill. in Moir, 1967, II, fig. 185.

Contarelli Chapel in his San Pedro Mártir paintings [42]. Spadarino, as far as one can judge, developed his style on the basis of Caravaggio's, Orazio's, and Saraceni's examples, and like Mao, Le Clerc, the "Pensionante," and Maino, he had little in common with Manfredi. Cavarozzi, too, should be allied with those artists whose styles basically stem from the earliest followers of Caravaggio. Orazio Gentileschi was the dominant influence on his development; yet his *Visitation*[105] in Viterbo can be understood only when Manfredi's art, as exemplified in the *Tribute Money*, is also taken into account.

Two other painters, Finson and Cecco, developed their styles outside the orbit of the "Manfredi manner." Approaching Caravaggio's art with a Northern background, each painter seized upon the master's naturalism. Finson, never truly freed from a Mannerist heritage, applied it to stiff, crowded compositions, often seeking effects of verisimilitude in extreme foreshortening and shimmering garments. Cecco was comparatively a much better artist, a master at depicting the textures and form of still-life objects. But like Finson, he concentrated on details at the expense of unity, and his world seems to be void of meaningful sentiment. Neither Finson nor Cecco played an important role in the development of Caravaggesque art, but they merit consideration for having been among the earliest converts to the Lombard's style.

It is fair to postulate that had Caravaggesque activity followed the course set by Caravaggio, Borgianni, Orazio Gentileschi, and Saraceni, even the most severe critics of Caravaggism never would have penned their attacks. The usual complaints—that Caravaggio's followers displayed an inadequate command of drawing and inability to compose on a grand scale—perhaps could have been leveled at Finson and Cecco, who were minor representatives of the new style. When one realizes that Baglione, Bellori, Carducho, et al. also disapproved of "obscuring" darkness, half-length figures, and ignoble types, it is apparent that Manfredi's style and its progeny, and not the art of the other Caravaggisti, was the real subject of Seicento criticism.

Antiveduto Grammatica is a typical example of the early Caravaggisti who were receptive to Caravaggio's art but later were attracted to stylistic transformations of the followers. His earliest work[106] is allied with Sienese Mannerism, and shows little understanding of Caravaggio's innovations. Later, Borgianni's and Saraceni's work especially impressed him, as did Vouet's and Artemisia Gentileschi's—a clear indication that during the second decade of the century varied currents of influence were strong, but basically compatible. Grammatica's mature style is a compromise between the lyricism of the Gentileschi and the realism of Manfredi, between decorative idealization on the one hand and strong chiaroscuro and naturalistic detail on the other.

Manfredi's style left its strongest mark on two Frenchmen, Valentin and Tournier. Valentin arrived in Rome ca. 1612 and devoted his career to emulating Manfredi's art, yet not without referring back to the fountainhead, Caravaggio. Like Manfredi, he specialized in portraying groups of figures, often half-length, contained within a horizontal format and engaged in seemingly commonplace affairs, whether the actual subject was fortune-telling [71], a concert, Christ expelling the money changers from the temple, or the Four Ages of Man. Because Valentin's oeuvre is so much better defined than Manfredi's, he is a primary representative of the style that was in the forefront of Caravaggesque activity after ca. 1615. A large number of religious paintings from his hand document the complete secularization of Christian iconography that occurred in the wake of Caravaggio's and Manfredi's leadership. Valentin and Tournier were never interested in the light palette of Caravaggio's early style, in his effeminate youths or still lifes, and only rarely in the reformed spirituality of his mature works. The piety of Caravaggio's pilgrims adoring the Madonna di Loreto, like the humility that governs his David, found little response in these French followers, even though the brooding introspection of his late figures was frequently revived by them.

105. Ill. in Moir, 1967, II, fig. 155. See Faldi, 1970, pp. 55–58, for a summary of Cavarozzi's life.
106. An altarpiece in S. Stanislao dei Polacchi, Rome, documented by Baglione (1642, p. 293) and published by Marino, 1968, pp. 48 ff., ill. p. 50, fig. 2.

A third Frenchman, Simon Vouet, joined Manfredi's circle upon arrival in Rome; but unlike Valentin's, Vouet's interests were widely varied. In addition to responding to the "Manfredi manner," he absorbed important lessons from Borgianni, Lanfranco, and the Gentileschi prior to abandoning his devotion to Caravaggism at the end of his Roman sojourn. But even on the basis of his early style, Vouet must be differentiated from Manfredi and Valentin, not only for the multiple sources of his art, but because his attitude was so much more flexible. In addition to a brilliant group of Caravaggesque portraits, he must be credited with a series of traditional church commissions, paintings of the first rank that revive the monumentality of Caravaggio's mature religious works. Moving gracefully from half-length *bravo* pictures to multi-figured allegories, Vouet, like the Utrecht painters, drew upon a rich fund of styles, and thus he is easily misunderstood if classified simply on the basis of his Caravaggesque paintings.[107]

Very few of the Northern Caravaggisti remained unaffected by Manfredi's style. Finson and Abraham Janssens can be cited as obvious exceptions, yet it is probable that Janssens, and possibly Finson, never saw Manfredi's work, having traveled in Italy at such an early date. Cecco and the Ghent artist Jan Janssens[108] more legitimately can be named as Netherlandish painters independent of Manfredi, but all of the others were influenced by him to some extent, whether they came from Utrecht or Flanders.

According to Sandrart, both Seghers and Renieri emulated Manfredi's art when they settled in Rome, and their early works confirm his statement. Each artist was trained in Antwerp but was active in Rome by ca. 1615, exchanging ideas within the circle that included Valentin, the Master of the Judgment of Solomon (Valentin's close follower), Tournier, and of course Manfredi. Seghers' style stands midway between Manfredi's and Honthorst's, for like Manfredi's it stresses the worldly aspects of religious subjects [61], and like Honthorst's, it celebrates the qualities of warm chiaroscuro generated by an internal light source. Seghers' Roman style is difficult to assess with certainty, but it is quite possible that his rich impasto developed at a later date, after he returned North. Rubens—more than Borgianni, Terbrugghen, or Serodine—probably awakened his interests in the qualities of oil paint, but like Stomer, Seghers often exploited it for naturalistic effects. His style is very unlike Renieri's, which is eminently more Italian in character and much more clearly allied with Manfredi's. Renieri's *David* [53], for instance, is a classic product of the Manfredi-Valentin-Vouet circle ca. 1615–20, as the intensely black setting and frontal, superficially melancholic, three-quarter figure declare.

It should be emphasized that the Roman artistic milieu of the second decade was extremely complex, compounded by the arrival of many foreign painters and non-Roman Italians. Within the circles of the Caravaggisti alone there were countless artistic crosscurrents which today one seeks to understand, regardless of the disquieting fact that chronologies and even the identity of artists remain unknown.[109] If it is reasonable to separate the earlier followers of Caravaggio from those who practiced the "Manfredi manner" because a number of important iconographic and stylistic features are divisible, even this simple separation requires qualification, for the painters from Utrecht gracefully bridged the two groups by seeking ideas and offering inspiration within each category.

Terbrugghen's role in the evolution of Caravaggesque activity from ca. 1605 to 1615 unfortunately remains a complete mystery.[110] On the basis of the later paintings, it is apparent that Caravaggio's figure types and compositions influenced him directly, even though Terbrugghen's highly personal and effective sense of color and light are more closely allied with Orazio's sensitivity. Occasionally, as in *St. Sebastian Tended by St. Irene* [68], his religious paintings rival Caravaggio's for their formal sophistication and spiritual strength; yet more frequently Manfredi's provide the best analogies, whether Terbrugghen's half-length drinkers and musicians

107. See Dargent and Thuillier, 1965, for Vouet in Italy.
108. See above, n. 95.
109. A classic example of the unresolved problems is the pair of canvases close to Borgianni painted in 1609 for San Silvestro in Capite, Rome; they are early, of high quality, eminently Caravaggesque—but their author remains unknown (see Toesca, 1960-a).
110. See cat. no. 66, n. 3.

or multi-figured compositions are considered. Neither Manfredi nor his French and Itaian followers can explain Terbrugghen's masterful light, which at once is strong and gentle, realistically consistent and form-defining, capable of producing transparent shadows that vie with Vermeer's. Terbrugghen's brushwork must be compared with Borgianni's [6], but the sequential development of their art and Terbrugghen's relationship with Serodine [62] remain unanswered questions.

Like Terbrugghen, Baburen drew upon the Manfredi-Valentin circle for compositional and thematic ideas, just as he significantly modified the darkness of Manfredi's palette. Baburen's figures are heavier, more manifestly coarse than Caravaggio's, Manfredi's, or Terbrugghen's, and accurately foretell the preferences of Rombouts, Bylert, and Stomer. Terbrugghen and Baburen, along with Honthorst and De Haen, developed a secularized Caravaggesque style that drew upon Italian and French sources, but in its means remained Northern.[111] The Utrecht painters experimented with candle illumination, represented textures with rich impastos, and favored a peasant type that is physically heavier, noisier, and generally less inhibited than its Italian or French equivalent. Their palette is more varied than Caravaggio's or Manfredi's, but individual colors are rarely as saturated. Caravaggio's classic combination of deep red, browns, and black—imitated occasionally by Baglione, regularly by Caracciolo, and popularized by Manfredi—was not to their liking.

The Utrecht Caravaggisti created a distinct tendency within the Manfredi milieu. They substantiated the growing inclination toward secularization of religious themes, supported the spread of genre subjects, and made a major contribution to Caravaggesque art by enriching the possibilities of dramatic illumination. Even though the candle and lantern as internal light sources were investigated at least three times[112] by Caravaggio himself, they cannot be considered Caravaggesque devices in their own right. It was Honthorst, significantly called "Gherardo delle Notti," who more than any other artist popularized the idea; he stimulated Saraceni, Seghers, and La Tour, and presumably Bigot, Artemisia, and the Sienese painters Manetti and Rustici. Honthorst's sources, in fact, were not primarily Caravaggesque, as

a familiarity with Northern, Venetian, and even Bolognese antecedents reveals.[113] But by uniting the preferences of the Manfredi circle with a form of illumination that had been exceedingly rare in Caravaggesque painting, Honthorst significantly extended the limits which the Italian Caravaggisti alone would have set for themselves.

The current of Caravaggesque naturalism that had sprung from the art of Caravaggio and slowly run its course for more than ten years surged with new force in the middle of the second decade. Fed by Manfredi and his Italian, French, Belgian, and Dutch followers, it became a full-fledged stream; like any river it appeared uniform on the surface but actually was comprised of numerous tides, some silent and deep, others swift and shallow. From these waters Artemisia Gentileschi drank deeply. She understood Caravaggio's investigation of expression and profited greatly from it; she learned and imitated Orazio's art of elaborate costume design; she favored the tenebristic lighting of the Manfredi coterie, but also benefited from Honthorst's candle-lit nocturnes; and she gained maturity from a reciprocal relationship with Vouet, who more than any other painter drank of the same waters. One of very few artists indebted to both Orazio and the Manfredi circle, Artemisia Gentileschi carried to Florence and Naples[114] a diversified Caravaggesque style, one that could inspire Cristofano Allori and Massimo Stanzione alike.

At the end of the second decade the younger Italian Caravaggisti, namely Artemisia, Serodine, and Paolini, were less firmly committed to a strict Caravaggesque style than were Tournier and Bylert, two Northerners who arrived in Rome ca. 1620. Like Artemisia, Serodine felt the impact of Caravaggio's own paintings, and concurrently succumbed to Borgianni's and apparently Ter-

111. On Terbrugghen's non-Italian qualities, see the perceptive discussion in Nicolson, 1958-a, pp. 4–10.
112. In his *Seven Acts of Mercy* (Fig. 6), lost *Way to Calvary* (known in copies), and *Denial of St. Peter* (described by Bellori and recently rediscovered).
113. See the discussion in Judson, 1959, pp. 1–33.
114. See Bissell, 1968, pp. 164–65, for Artemisia's possible influence in Genoa.

brugghen's style, but without overlooking the qualities of Bolognese art as well [62]. He specialized in painting religious subjects, with a concentration that had become quite rare since the diffusion of the "Manfredi manner." At its best, his art revives the monumentality and dignity of Caravaggio's mature work, Borgianni's nervous surface movement, and Manfredi's aggressive secular naturalism, all with strong overtones of Guercino's early style. By way of contrast, Tournier and Bylert followed a straighter path from Manfredi, Vouet, and the Utrecht painters, and divided their time between secular and religious subjects. In some instances, Paolini's work resembles theirs [48], but his varied style, like Artemisia's, supports the contention that after ca. 1620 the Italian painters, more than the foreigners, seldom relied on Caravaggio and his followers to the point of rejecting other major trends. Caravaggio had been dead for more than a decade, and he must have been viewed by his compatriots as a great old master, one from whom much could be learned, but whose style needed updating. Two of the last Caravaggisti support this distinction. Stomer, a Northerner, so far as we know worked consistently in a Caravaggesque idiom inspired by Honthorst, while Preti, undeniably attracted to Caravaggio, Manfredi, and Caracciolo, paid great attention to Guercino and other non-Caravaggesque sources, especially when confronted with commissions for religious works.

Tournier and Bylert returned to the North and shortly later dropped their Caravaggesque styles, but Stomer, who presumably remained in southern Italy throughout his entire life, never departed from his painterly interpretation of Honthorst's work. While it is true that this reflects the usual pattern, depending upon whether foreigners left or remained in Italy, by the 1620's the strength of Caravaggio's attraction had diminished on a wide front. Manfredi's death in 1620 or 1621 was a decisive factor, all the more so because it coincided with Orazio's, Honthorst's, Baburen's, and Seghers' departure from Italy and followed Borgianni's (1616) and Saraceni's (1620) deaths. Thus, precisely while the patronage of a Bolognese Pope, Gregory XV (1621–23), favored a flowering of Bolognese art in Rome, many of the principal representatives of Caravaggesque painting disappeared from the city. But even their departure did not signal the final demise of Caravaggesque activity. A core of older painters, Cavarozzi, Spadarino, Grammatica, Cecco, Vouet, and Valentin, preserved the continuity from the earlier decade, while Bylert, Campino, Rombouts, Stomer, and Tournier—all foreigners—offered new support. It nevertheless was the final flourish. By ca. 1630 nearly all of these painters had died or left the papal city, while Cortona and Poussin were breaking decisive new ground. Primarily through the activity of the Bamboccianti, genre painting remained an important strain in Roman art of the 1630's, and thus, as in the later teens and 1620's, a Northern contingency was responsible for producing secular pictures.

It is more remarkable that Caravaggio's influence persisted until ca. 1630 than that it finally subsided. Because taste expectedly changed in a generation, it is a major indication of the originality of Caravaggio's work that its expression and form were meaningful to young painters for three decades. Borromeo and Neri, like Caravaggio, were great early reformers, but their emphasis upon humility, simplicity, and the dignity of the common man must have seemed as anachronistic thirty years later as Caravaggio's paintings. Large-scale decoration, rich in color and movement, adorned palace and church alike, and altarpieces began to reflect the pictorial exuberance that typifies much decoration of the 1630's. At the same time, a major strain of classicism—equivalent not to the epic, but to the ancient tragedy, emerged with significant force. Despite the evolution of means that inevitably accompanied the development of these attitudes, the essential purpose of Baroque painting remained constant. Cortona, Poussin, and Sacchi, no less than Caravaggio, created art with the primary intention of moving the beholder in unequivocal terms, whether communication was based on the senses or the intellect. The sculptural solidity of Annibale's and Caravaggio's paintings—their unifying, consistent light, strong, simple colors, and emphasis upon naturalistic detail—was minimized by artists attuned to excited rhythms of group movement and brilliant colors, and by artists dedicated to cerebrally precise compositions of psychological drama that demand slow examination.

Caravaggio's means were no longer adaptable to these

tendencies. Light, for instance, in all of his pictures is consistent, natural, and self-governing, whereas in paintings characteristic of the 1630's it is subordinated to modeling and hence is not perceived as independent of form. This seemingly minor distinction is of great significance. It isolates one essential difference between early and mid-century painting and at the same time indicates that a fundamental principle of Caravaggio's art was rejected in the later phase. For nearly three decades artists had culled from Caravaggio's work gestures, costume, color, composition, and chiaroscuro. But because his innovations were emulated neither consistently nor in an organized manner, they had not survived as a single, recognizable style. Nevertheless, so long as Baroque painting was grounded in a reform attitude that made naturalism the initial prerequisite of art—which was true for Caravaggio and the Carracci alike—Caravaggio's oeuvre remained a vital source of inspiration. And so long as this inclination prevailed, artists could combine at will elements from Caravaggio's and the Carracci's art without any inherent contradiction.

A major consequence of the stylistic transformation that occurred in Rome during the late 1620's and 1630's was a de-emphasis upon naturalism in large-scale painting. Representative works by Cortona and his circle, as well as progressive examples of classicism by Domenichino, Poussin, and Sacchi, are based on an inner vision that is rational, yet intellectual and artificial, manifestly divorced from common experience. Because Domenichino, Guido, Guercino, and Lanfranco had forged the tools for the decade of the 1630's—for what is commonly called the High Baroque—the tradition of the Carracci survived in Rome, whereas Caravaggism died. By dwelling on the descriptive and secular qualities of Caravaggio's style, the Caravaggisti rarely broke ground for other major artists in the city, particularly when they remained faithful to the master. Thus, Borgianni and Orazio rather than Baglione; Vouet, more than Valentin or Manfredi; and Serodine and Artemisia instead of Bylert or Tournier have important qualities in common with High Baroque painting, because in addition to Caravaggio's style, they absorbed basic elements of Venetian and Bolognese art and thereby managed to keep pace, consciously or not, with the thinking of the young-

er generation in Rome. Baglione, Valentin, Manfredi, Bylert, and Tournier represent the stricter, narrower, aspect of Caravaggesque painting, an attitude which died in Rome but survived in altered form in provincial and foreign centers.

Caravaggio's style was not stifled by public criticism, nor was it willfully modified to achieve more "decorous" results,[115] since, as it has been shown, the wide spectrum of Caravaggio's followers contained all shades of emulation for thirty years. Technical considerations were not of primary importance for its decline either. From the very start, those Caravaggisti desirous of fresco commissions had to develop an un-Caravaggesque manner, just as they were obliged to adopt the techniques of other masters when preparing drawings. Caravaggism declined because the master's style and the many permutations developed by his followers were no longer vital artistic alternatives for young painters. The departure of most of the Caravaggisti from the papal city by the later 1620's coincided with the awakened didactic interest in glorification of the Church as an institution. A sense of security because of successful Counter-Reformational measures, the growth of religious orders, farspread missionary activities, and the increasing political involvement of the Holy See partially explain the propagandistic emphasis upon the size and the status of the Church.[116] Exaltation of the institution was antithetical to Caravaggio's emphasis on the piety and worth of the individual man. The propagation of symbolic art precluded the descriptive approach of the Caravaggisti and made their naturalism and secularism inappropriate modes of expression.

Caravaggesque painting survived only slightly longer outside of Rome. In Naples, Caracciolo remained faithful to his early naturalism and deep chiaroscuro until his death in 1637. But, in the meantime, Ribera's palette lightened and the sentiment of his art became more traditional, while Artemisia also tempered her Caravag-

115. A contrary interpretation is given by Moir, 1967, I, 301–2.
116. See Robert Enggass, *The Paintings of Baciccio* (University Park, Pa., 1964), pp. 54 ff., for an excellent summary of this tendency, especially mid-century.

gesque manner. Stomer in Sicily, Preti in Malta, Paolini in Lucca, and Jan Janssens in Ghent represent those Caravaggisti who settled in provincial centers and by working outside of the artistic mainstream prolonged the Caravaggesque tradition. But even so, unequivocal Caravaggesque elements surfaced in Preti's and Paolini's mature work only sporadically, and it is significant that Janssens was a mediocre painter who repeated himself in style and composition alike, resisting change with exceptional, stifling tenacity. In the papal city itself Gysbert van der Kuyl[117] became a Caravaggesque painter during the 1630's, but he was a foreigner of minor stature. His late attraction to Caravaggesque art was exceptional, all the more so because it occurred in Rome. Representative of the lingering force the "Manfredi manner" exerted on occasional Northerners,[118] Van der Kuyl followed a well-trodden path with little recognizable initiative. The provincial primitiveness of Biagio Manzoni,[119] who was active at least well into the 1630's in Faenza, is still further evidence that when Caravaggism was prolonged in Italy or the North, it usually survived in the hands of unsophisticated painters. Manzoni's art, like Jan Janssens', is awkward, derivative, and lacking in natural human expression.

Georges de La Tour was the only distinguished artist who consistently explored the potentialities of Caravaggesque means after 1630. The origins of his style unfortunately are obscure, and will remain conjectural so long as an early Italian sojourn is in doubt. His famous "daylight" *Tricheur*,[120] like his later nocturnes, reveals strong ties with the Utrecht Caravaggisti, but the role that Bigot and especially Caravaggio's own paintings played is unknown. For documentary reasons any youthful visit to Italy almost certainly predated 1616,[121] which is logical on stylistic grounds as well. Terbrugghen and Honthorst, the Caravaggisti with whom he has strongest affinities, were both active in Rome prior to mid-decade. Because Terbrugghen was absent by 1614, and Honthorst had arrived in the city only a few years earlier, it is tempting to speculate that La Tour's education in Rome would have been amidst these foreigners ca. 1612–14, when Baburen and Seghers were also present. In addition, he could have studied with care the art of Manfredi and that of his compatriots Valentin and Vouet, whose concentration on tenebristic effects undoubtedly would have appealed to him. The possibility also remains that it was La Tour himself who pioneered the new attitude toward candles, lanterns, and nighttime settings. But if so, it is still more puzzling that none of the Seicento sources refers to his presence in Rome.[122] Whether he absorbed Caravaggio's art in Italy, or understood its profound meaning by way of the Nancy *Annunciation*[123] and travel to Utrecht, La Tour must be credited with originating the last great variation on Caravaggio's mature style. Nevertheless, it is imperative to bear in mind that he was active in Lunéville, a minor artistic center, and hence, like Stomer, could afford to work in a manner that had long since become passé in progressive circles.

Stomer, Jan Janssens, Gysbert van der Kuyl, Manzoni, and La Tour are exceptions to the rule. The dominant trend among the Caravaggisti after 1630 is apparent in the work of Honthorst and Bylert in Utrecht, Rombouts and Seghers in Antwerp, Tournier in Toulouse, Vouet in Paris, Renieri in Venice, Maino in Madrid, and the Gentileschi in Naples and London. Almost simultaneously, all of these artists deserted Caravaggesque

117. See Waddingham, 1960.
118. One recalls that "Trofamone pittore," i.e., Bigot, was still active in Rome in the earlier 1630's. Adam de Coster is another example of a Northern painter converted to Caravaggesque nocturnes à la Honthorst and Seghers at a relatively late date; he may have been active in Antwerp through the 1630's (see Nicolson, 1961).
119. See Longhi, 1957, and a summary of other contributions on Manzoni in Moir, 1967, I, 253–54.
120. Ill. in Pariset, 1948, pl. 42[1].
121. See Wright, 1970.
122. The single exception is an early reference to La Tour as "a pupil of Guido" (see Pariset, 1948, p. 111), which, if correct, would necessitate an Italian sojourn.
123. See Pariset, 1948, pp. 108–10 and pl. 2[3], and Longhi, 1959, p. 29, where an attribution to Caravaggio himself is proposed. The *Annunciation* has recently been cleaned at the Istituto Centrale del Restauro, Rome, and major losses were revealed (particularly in the figure of the Virgin). The design of the painting is excellent, highly original, and indicative of an understanding of Caravaggio's mature art. Nevertheless, the Virgin—from what remains to be studied—seems to be eminently French in type, and the angel is equally difficult to accept as autograph late Caravaggio.

painting and thereby declared throughout Europe that the tradition which Caravaggio initiated a generation earlier and which they had formerly embraced was at an end. The concurrent emergence of great foreign talents was decisive. Rubens, Rembrandt, Poussin, and Velázquez nourished centers beyond Italy, and thus, by the second quarter of the century, Antwerp, Amsterdam, Paris, and Madrid had begun to develop distinctive Baroque styles that were extremely progressive and widely influential. Because they were dedicated to principles that are paralleled in Roman painting of the 1630's, they were, by their very nature, un-Caravaggesque. For the first time, young foreign painters found persuasive alternatives at home. And as a consequence, the High Baroque flood tide gained momentum and swept away the remaining vestiges of Caravaggesque activity.

CATALOGUE

Artists are arranged in alphabetical order, with anony-
mous masters appearing last. The brief biographies in-
clude resumés of principal facts and salient points rele-
vant to the subject of this exhibition. Paintings by each
artist are listed chronologically and are followed by any
doubtful attributions exhibited. The date which ac-
companies the title of each entry reflects the opinion of
this author. Dimensions are cited in inches, height pre-
ceding width; the medium invariably is oil on canvas.
When a painting is signed and/or dated, that informa-
tion follows the dimensions. The history of each work
begins with the earliest known owner. In general, only
problematic and less-known subjects are discussed icon-
ographically and related to their literary source. The
notes for individual entries are intended to clarify specific
issues and to refer the reader to the essential modern
bibliography on each artist. However, it was decided
that it is preferable to emphasize substantial contribu-
tions rather than to risk losing them amidst scores of less
important references. Hence, numerous publications
and exhibitions (without scholarly catalogues), es-
pecially regarding the better-known pictures, have been
intentionally omitted. The abbreviations in the notes re-
fer to the full citations on pages 231 ff. Although the
bibliography includes only works cited in this catalogue,
it may serve as a basic guide to the literature on Cara-
vaggio and his followers. It should be noted that page
references to the articles by Longhi published prior to
1935 are cited according to the readily available new
edition of his complete writings; the original dates of
publication are provided in brackets, and full biblio-
graphical references to the original publications are
given under the appropriate years in the bibliography.

DIRCK VAN BABUREN

Ca. 1594/95–1624

Born in or near Utrecht in the mid-1590's, Baburen studied painting under Paulus Moreelse before traveling to Rome ca. 1612, that is, approximately eight years after Terbrugghen and perhaps a year or two after Honthorst. He was patronized by the Giustiniani and Borghese; his most important commission was the decoration of a chapel in San Pietro in Montorio, which he shared with the little-known painter David de Haen. In Italy Baburen possibly knew Manfredi, Valentin, and the Liège artist Douffet, in addition to his Utrecht compatriots. He returned to Utrecht in 1620, a year before Bylert arrived in Rome, and ca. 1622–23 shared a studio with Terbrugghen. Baburen died at an early age in 1624.

I *The Procuress,* 1622

Museum of Fine Arts, Boston (Maria T. B. Hopkins Fund).
39-³/₄ × 42-¹/₄ inches.
Signed in full and dated 1622 at the bottom of the lute.
Collections: Lt. Col. R. Sloane-Stanley, Cowes, Isle of Wight; Christie's, February 25, 1949, lot 52; Colnaghi, London; Roderic Thesiger, Buckinghamshire.

A comparison between the Boston picture and Caravaggio's lost *Card Sharps* (Fig. 3) is very instructive. Baburen borrowed Caravaggio's three-figured composition, basically retained the axes established by the figures' gazes, enclosed the space with a simple wall, and added a raking shadow—one of Caravaggio's own devices. At the same time, however, Baburen's light is less unifying than Caravaggio's; specific textures are more descriptively handled; the brushwork is comparatively very broad; and a generally raucous note, befitting the more vulgar types, signals the transformation of an Italian conception into a foreign language. Furthermore, the old Northern iconographic tradition of mercenary love[1] is superimposed on Caravaggio's subject.

Twice Vermeer represented this painting by Baburen in the background of his interior scenes.[2] Like La Tour, the Delft master undoubtedly was interested in the Utrecht school, and the *Procuress* is specific proof of his knowledge of Baburen's art.

Three other versions of the Boston painting are known: a weak (old) copy in the Rijksmuseum, Amsterdam; a forgery by H. van Meegeren;[3] and a replica recently auctioned, but bought in, at Christie's (November 29, 1968, lot 10).[4]

Notes: (1) See the discussion in Slatkes, 1965, pp. 76 ff. and 116–18, no. A 12. (2) In the *Lady at the Virginals*, National Gallery, London, and the *Concert* in the Isabella Stewart Gardner Museum, Boston; see Gowing, 1951. (3) Slatkes, 1965, p. 117. (4) 38 × 42 inches; described as signed and dated 1621; on the basis of a photograph, this version does not appear to be an autographic replica.

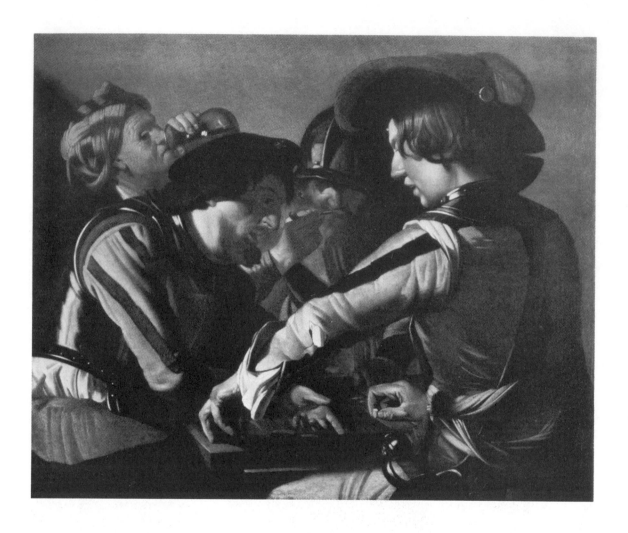

2 *Backgammon Players*, ca. 1622–23

The Akron Art Institute, Akron, Ohio.
50-$\frac{1}{2}$ × 41-$\frac{1}{2}$ inches.
Collections: Knoedler Gallery, New York.

In a lost *Cheating Cardplayers*,[1] Baburen revealed his direct debt to Caravaggio's *Card Sharps* (Fig. 3). The *Backgammon Players* is twice removed from the Italian prototype, but still owes to Caravaggio the romanticized costumes, the raking shadow on the background wall, and numerous compositional principles. However, here the rhythms are characteristically more staccato; the players are transformed into fleshier, decidedly less handsome types; and the theme of card cheating is replaced by apparently honest backgammon playing, which nevertheless carries a moralizing message.[2] If, on the one hand, Caravaggio stands behind Baburen's picture, on the other, both Honthorst and Terbrugghen [67] are indebted to the latter's transformation of the theme.[3]

Two other versions of the Akron picture are known and catalogued as autographic replicas.[4] Inasmuch as none of the three is completely satisfactory in quality, a lost, superior prototype may once have existed. It is likely that this composition was invented while Baburen and Terbrugghen shared common studio facilities.[5]

Notes: (1) Slatkes, 1965, pp. 137–38, no. B 3, fig. 25. (2) See Slatkes, 1965, pp. 72 ff., for a discussion of the meaning of this theme, and especially an engraving after the Akron painting with moralizing inscriptions (ill. in Nicolson, 1962, p. 542, fig. 35). (3) Slatkes, 1965, pp. 127–29, no. A 23, and in Dayton, 1965, pp. 18–19, has shown that Baburen introduced this theme into Utrecht, predating Honthorst's and Terbrugghen's analogous compositions. (4) Slatkes, 1965, pp. 127–28 (Bamberg and The Hague). (5) Slatkes, 1965, pp. 94 ff. *et passim*.

GIOVANNI BAGLIONE

Ca. 1573–1644

Born of Florentine parents in Rome, Baglione was trained by a minor Tuscan artist, Francesco Morelli. Late in the 1580's he contributed to the decoration of the Vatican Library, revealing in his youthful frescoes a Mannerist outlook closely related to the Cavaliere d'Arpino's. Having spent two years in Naples in the 1590's, Baglione radically altered his style ca. 1600 under the influence of Caravaggio's art, despite the fact that Caravaggio publicly ridiculed his efforts in general ("I know nothing about there being any painter who will praise Giovanni Baglione as a good painter...") and his Resurrection of 1603 in particular. (Only his pupil Mao Salini reportedly defended that painting.) His Caravaggesque phase ended ca. 1604, shortly after the famous trial of 1603 when Baglione accused Caravaggio, Orazio Gentileschi, Onorio Longhi, and Filippo Trisegni of slander. Nevertheless, if the influence of Caravaggio ironically reappears in a number of Baglione's later works, it is equally apparent that his paintings of 1600–1605 are not consistently Caravaggesque. His most famous composition in the style of Caravaggio represents Divine Love *(versions in Berlin and Rome), and was commissioned by the Marchese Giustiniani to complement Caravaggio's* Profane Love. *Baglione's later career was active and successful; he received commissions for St. Peter's, the Cappella Paolina (Santa Maria Maggiore), and in the early 1620's he worked in Mantua for the Ducal Court. The first of his writings,* Le nove chiese di Roma, *appeared in 1639, three years prior to his important* Vite de' pittori, scultori et architetti, *one of the fundamental source books for the study of early Seicento painters. Baglione died in Rome in 1644.*

3 *The Ecstasy of St. Francis, 1601*

Private collection, Chicago.
61-1/4 × 46 inches.
Dated 1601 in the margin of the opened codex.
Collections:[1] Borghese, Rome; Cardinal Fesch, Paris and Rome; Breval; Earl of Drogheda, Dublin; Agnew and Sons, London.

Baglione rarely achieved the high quality of the *St. Francis in Ecstasy*, which was painted at the very beginning of his brief Caravaggesque phase.[2] In comparison with Caravaggio's own representation of a similar subject [14],[3] Baglione's is decidedly Manneristic. The essential clarity of Caravaggio's composition gives way to ambiguity, for spatially the three large figures encumber one another and charge the format with great tension. Nevertheless, Baglione's picture is certainly not a typical *fin-de-siècle* Mannerist conception. The bold raking light and strong chiaroscuro; the deep, unbroken colors; and the broad garments as well as the figure types themselves—especially the angels—reveal Baglione's undisguised admiration for Caravaggio's art. The compositional emphasis on nearly parallel diagonal forms is very similar to Baglione's *Divine and Sacred Love* in Berlin, probably of 1602,[4] which also shares with the *St. Francis* the artist's distinctive facial type: fleshy, with long, narrow eyes, thick lips, and very heavy eyebrows.

Described as by Baglione in 1700,[5] the painting later was engraved as by Caravaggio himself[6] and was published as Caravaggio by Benedetti[7] even though Longhi had earlier recognized Baglione's hand.[8] The supposed signature MC (Michelangelo da Caravaggio)[9] is an improper reading of the large initials in the text of Francis' slightly opened book. A late copy, lacking the date in the codex, is in a private Roman collection.

Notes: (1) See Milan, 1951, no. 51; in Chicago since 1959, the painting incorrectly appears in all recent literature as "private collection, Rome." (2) The essential studies are Guglielmi, 1954; Martinelli, 1959-a, and Longhi, 1963. (3) Askew, 1969, pp. 295-96, demonstrates that Baglione's painting does not represent an episode connected with the stigmatization; she suggests that Ludovico Carracci's *Ecstasy of St. Francis* was Baglione's compositional source. (4) See Milan, 1951, no. 69. The "lost" version, formerly in the Italian Embassy in Berlin, was recovered and recently returned (1969) to the Galleria Nazionale d'arte Antica (Palazzo Corsini), Rome (see Rome, 1970, no. 37). (5) By Montelatici when the picture was in the Villa Borghese (see Milan, 1951, no. 51, for the description). (6) By Basan; ill. in Benedetti, 1949, p. 6, fig. 4. (7) Benedetti, 1949. (8) Longhi, 1968 [1930], p. 146. (9) Benedetti, 1949, p. 5.

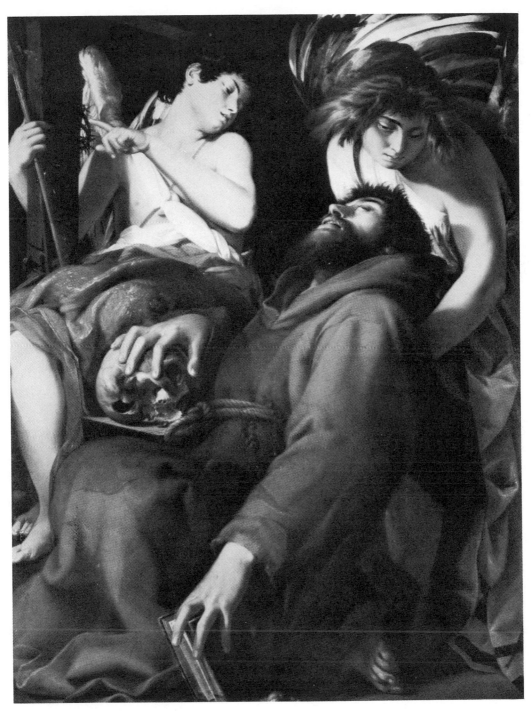

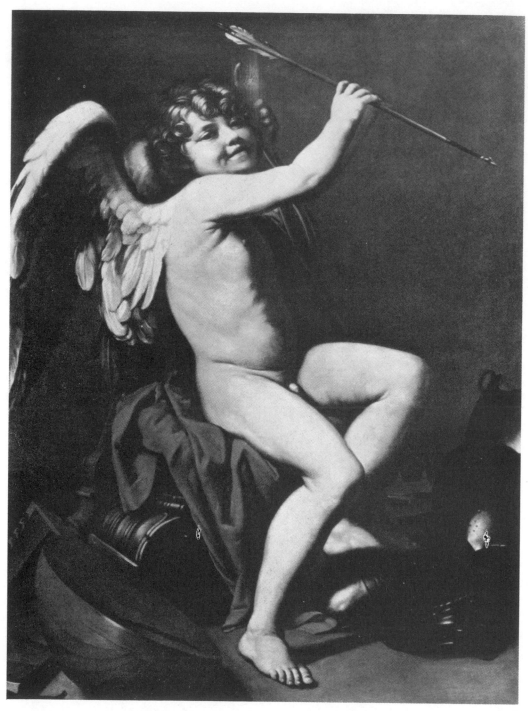

Figure 9. *Victorious Love.* 60-5/8 × 43-1/4 inches. Caravaggio. Staatliche Museen Preussischer Kulturbesitz, Gemäldegalerie Berlin (West).

Figure 10. *St. John the Baptist.* 53-1/8 × 37-3/8 inches. Baglione. Pinacotheque Nationale et Musée Alexandre Soutzos, Athens.

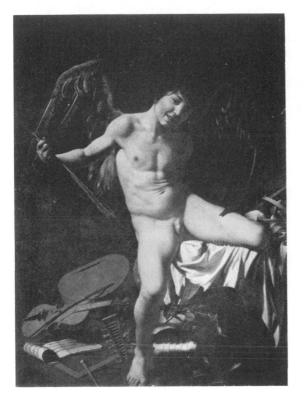

4 *Victorious Earthly Love,* 1602–3?

Private collection, Rome.

51-3/8 × 38-3/8 inches.

Collections: the London trade (1955).

As in Caravaggio's well-known painting in Berlin (Fig. 9),[1] a winged, seated Cupid is conceived as triumphant over many aspects of human endeavor, symbolized by the objects strewn at his feet: musical instruments (music or the arts), armor (military glory), a crown and scepter (government), a laurel wreath (immortal fame), and just visible behind the Cupid, a globe (astronomy or geography). Mischievously raising an arrow (his arm once was slightly lower, as a major *pentimento* reveals), he

proudly proclaims the Virgilian dictum, *omnia vincit Amor.*

In the little-known second edition of his monograph, *Il Caravaggio,* Lionello Venturi published this painting[2] as an autograph work by Caravaggio; he argued that the reference in Gentileschi's testimony of 1603 to an *amor terreno* by Caravaggio and Baglione's citation of Caravaggio's *Cupido a sedere* are not related to the famous *Victorious Love* in Berlin (Fig. 9), as has been generally assumed, but to this picture instead. Venturi agreed that Bellori's and Sandrart's descriptions of an *Amore vincitore* do correspond to the Berlin painting.

Venturi's hypothesis cannot be substantiated on doc-

47

umentary grounds. Orazio testified[3] that Baglione made "a *Divine Love*, which he had painted in order to rival an *Earthly Love* by Michelangelo da Caravaggio. This *Divine Love* he had dedicated to Cardinal Giustiniani, and although this picture was not liked so well as Michelangelo's, nonetheless, from what was reported, the Cardinal presented him with a [golden] chain. This picture had many imperfections, as I told him, for he had painted an armed full-grown man, whereas it should have been a nude child. *So later he painted another, which was entirely nude* [italics added]." Baglione, in his life of Caravaggio, writes:[4] "Caravaggio made a seated *Cupid* done from life for the Marchese Giustiniani in which the color was so very good that thereafter Giustiniani had an unlimited enthusiasm for his works." Elsewhere, in his autobiography, Baglione states[5] that he (Baglione) painted "for Cardinal Giustiniani two paintings of *Divine Love*, who has under his feet Profane Love, the World, the Devil and the Flesh, and these one sees face-to-face in the *sala* of his palace...." Bellori, Scannelli, and Sandrart all confirm[6] that Caravaggio painted for the Marchese Giustiniani a *Victorious Love*, or *Amoretto* or *Cupid* as it was variously called; Bellori's and Scannelli's descriptions are so precise that they unequivocally correspond with Caravaggio's Berlin painting.

There is no reason to doubt that the sources refer to *one* painting by Caravaggio, made for the Marchese Giustiniani. The Berlin *Victorious Love* was acquired from the Giustiniani descendants in 1815. There were, however, three pictures by Baglione: the first, made in competition with Caravaggio's painting and dedicated to Cardinal Giustiniani, the Marchese's brother; a second, which according to Baglione's own description was virtually identical and for some reason was also owned by the Cardinal; and a third, of a nude child, done in response to Gentileschi's criticism.

Both of the pictures owned by the Cardinal can now be identified. One is in the Berlin Museum and comes from the Giustiniani Collection.[7] The other, lost during the war and recently recovered by the Italian State,[8] indeed is a very close variant of the first. It represents a "full-grown man," not a nude child, and hence cannot be identified as the picture referred to by Orazio in 1603.

As for the third painting, Martinelli[9] published a *Vic-*torious Love* portraying a nude *putto*, but his attribution of the picture to Baglione and his identification of it with Orazio's reference have not been accepted.[10]

Thus, Venturi's attribution of this picture cannot be sustained on the basis of Seicento documents, and it is even less acceptable on stylistic grounds. It lacks the perfect ease and vital movement of Caravaggio's painting (Fig. 9), and the accessories are comparatively lifeless. The physical type is not Caravaggio's, nor are the fleshy modeling of the torso and the broadly highlighted curls of hair. Contours are less crisply defined than in Caravaggio's Roman work, and altogether the modeling is more flaccid.

If Venturi's attribution to Caravaggio cannot be accepted,[11] an alternative attribution to Baglione is convincing. Longhi, in fact, recognized Baglione's hand in this picture[12]—as have Carla Guglielmi, Italo Faldi, and Luciano Maranzi—on the basis of a photograph. Those very features which differentiate this picture from Caravaggio's Berlin *Victorious Love* are typical of Baglione, and specific details, such as the heavy-lidded eyes, the fleshy mouth, and the dark contours around the toes, reveal his hand. The composition is analogous to an unpublished *St. John the Baptist* in the National Painting Gallery of Athens (Fig. 10),[13] which, like the *Victorious Love*, is based on the pose of Caravaggio's *St. John the Baptist* and should also be assigned to Baglione.

The obvious question which must be posed is: Can Baglione's *Victorious Love* be identified with the picture cited by Orazio Gentileschi as early as 1603? It does represent a nude *putto*; properly speaking, however, it does not depict "another '*Divine*' Love," although Orazio may simply have confused the iconography. On the basis of style the problem is equally perplexing. The picture is eminently Caravaggesque, certainly done with Caravaggio's painting in mind, and therefore logically part of Baglione's brief Caravaggesque phase of 1601–ca. 1604. Yet, when compared with the *Ecstasy of St. Francis* of 1601 [3], there are great differences, hard to account for by the brief period between 1601 and 1603. Baglione's two paintings of *Divine Love* in Berlin and Rome offer no clear solution either, although the stylistic difference between them—the Roman version is much looser (and undoubtedly later)—provides a hint. It sug-

gests that the *Victorious Love* could have been Baglione's reply to Orazio's criticism and an attempt to challenge Caravaggio with an ostensibly reformed, more painterly, "un-Caravaggesque" style.

Notes: (1) For the iconography of the Berlin picture, see Friedlaender, 1955, pp. 92–94, and Enggass, 1967. (2) L. Venturi, ed. 1963, pp. 56–57, fig. 20. (3) See Friedlaender, 1955, pp. 278–79, doc. no. 12. (4) Baglione, 1642, as transl. in Friedlaender, 1955, p. 235. (5) Baglione, 1642, p. 403. (6) See Friedlaender, 1955, p. 182. (7) See Milan, 1951, no. 69, ill. pl. 62, and Salerno, 1960-b, p. 103, no. 185. (8) See Rome, 1970, no. 37, ill. (9) Martinelli, 1959-a, pp. 83 ff., ill. fig. 49b. (10) See Rome, 1970, no. 37. (11) Salerno, 1960-b, p. 135, no. 9, refers to this painting as probably by Caravaggio. An expertise by Ettore Sestieri, dated 1965, also supports Caravaggio's authorship. Both L. Venturi and Sestieri attempt to discredit the identification of the Berlin painting as the "seated *Cupid*" cited by Baglione because the Berlin figure, technically speaking, is not seated. Niceties of this sort, however, are usually meaningless when one deals with Seicento descriptions. Likewise, Venturi's and Sestieri's reliance on the various titles in the sources has little value. (12) In a letter to the present owner dated March 3, 1970. (13) No. 2163, as "School of Caravaggio"; 53-1/8 × 37-3/8 inches. A second version of the Athens picture was with June Fell, London, in 1967 (see *Apollo*, LXXXV, 1967, no. 63, p. lxxxii); Dr. Herwarth Röttgen recognized Baglione's authorship of the London version and kindly called the painting to the attention of this author.

THÉOPHILE (TROPHIME) BIGOT

Called Trufamond
1579?– after 1649

Benedict Nicolson is primarily responsible for bringing together a large group of quiet, simply composed, tenebristic paintings and assigning them to one artist, whom first he called the "Candlelight Master" because of his predilection for the candle motif. Through Jacques Bousquet's archival discoveries and additional circumstantial evidence, Nicolson and Jean Boyer later identified the Master as Bigot, an artist formerly known via an engraving of a lost Holy Family *in the Carpenter's Shop. Nicolson has postulated an activity in Rome in the 1620's and 1630's, which is substantiated by stylistic features as well as documents that name a "Theofilo Bigotti" in Rome in 1620–23 and 1625. Furthermore, these citations identify Bigot as the "Trufemondi" whom Sandrart mentions as specializing in dark half-lengths and who we know lived with Claude in 1630–31 and 1634. Nicolson placed Bigot's origins in Aix, but Boyer has published additional documents that on the one hand support the Bigot-Trufemondi connection, but on the other raise challenging chronological problems: a Bigot was baptized in Arles in June of 1579, and in 1605 signed his name as "trufamont bigoti," which—because of the Italianized form "bigoti"—signified to Boyer the completion of an Italian sojourn. Other documents and signed and dated paintings place a Bigot in Arles in 1634, 1635, 1636, 1642, 1644, and 1649, and in Aix in 1638, 1639, and 1640.*

Three essential problems must be clarified, however, before Bigot's historical importance can be properly assessed: Is the Bigot of 1579 and 1605 necessarily the same person as the painter? Must the form "bigoti" be explained by an actual trip to Italy? And, most significant, what is the sequential relationship between our painter Bigot and Finson, Honthorst, Stomer, and La Tour, with whom Bigot shares many stylistic affinities?

Figure 11. *St. Jerome.* 51 × 38-1/8 inches. Bigot. Private collection.

5 *St. Jerome*, ca. 1630?

The National Gallery of Canada, Ottawa.
37-3/4 × 47-1/8 inches (reduced on the left side).
Collections: Percy Summerfield, Birmingham,
England; Schaeffer Gallery, New York.

The limited color scheme of reds and warm browns and blacks is typical of Bigot, as is the tear-shaped black area around the candle flame and the blue within it. Jerome's heavy, stiff hands and raised, wrinkled brow are equally characteristic of the master. Bigot undoubtedly was familiar with Caravaggio's mature Roman paintings of single figures of saints, in particular with his *Jerome* in the Galleria Borghese, whose breadth of handling foretells the painterly treatment of the face in the Ottawa picture. Caravaggio's rigorous composition, however, was decidedly relaxed by Bigot, and the sobriety of concentration that is an essential feature of the Italian picture here is less intense. Nevertheless, Bigot's *Jerome* (one of his favorite themes) indicates that despite whatever contacts he had with the art of Honthorst, Stomer, and possibly La Tour,[1] Caravaggio himself was a direct, and important, influence.

The Ottawa painting, formerly attributed to La Tour,[2] is known in two other versions: one, slightly superior in quality, in the Palazzo Corsini, Rome,[3] and a second (Fig. 11), recently discovered, in a private collection.[4] Another *St. Jerome* in a church near Aix is compositionally related to these paintings, but represents the Saint in prayer.[5]

Notes: (1) Nicolson, 1960-c, pp. 156 ff., discusses the influence of La Tour on the Candlelight Master, citing the Corsini *Jerome* as an example and placing it late in the Master's career, ca. 1645. Later (1964, p. 134), Nicolson postulated "after 1635." La Tour's influence on Bigot, however, is difficult to reconcile with the new documents that place Bigot in Italy in the early 1620's and in Provence in the 1630's, since some of the "Italian" Bigots must predate La Tour's comparable pictures (even an early Roman sojourn of La Tour would not explain these stylistic elements). See Boyer, 1963, and in particular 1964, for documents which suggest that Bigot was born as early as 1579, and had been to Italy already in 1605. (2) See Montreal, 1961, no. 38; restored to the Candlelight Master by Nicolson, 1960-c, p. 126, and to Bigot by Nicolson, 1964, p. 128, no. 17; earlier, Judson, 1959, p. 188, had tentatively given the Corsini version to Volmarijn. (3) Nicolson, 1964, p. 128, no. 16 (exhibited as Honthorst in 1955; see Carpegna, 1955, no. 17). The Corsini version has more of the hat and all of Jerome's left hand included within the composition. It is larger (41-3/8 × 54-3/8 inches), although a strip of canvas has been added at the top. (4) Formerly Christie's, Rome, October 15, 1970, lot 72. This version also is larger than the Ottawa canvas (38-1/8 × 51 inches) and, like the Corsini version, includes more of the hat and all of the Saint's left hand. (5) Described by Nicolson, 1960-c, p. 141 (as a copy); accepted by Boyer, 1963, pp. 45–46; Nicolson, 1964, p. 128, no. 20 (as a copy).

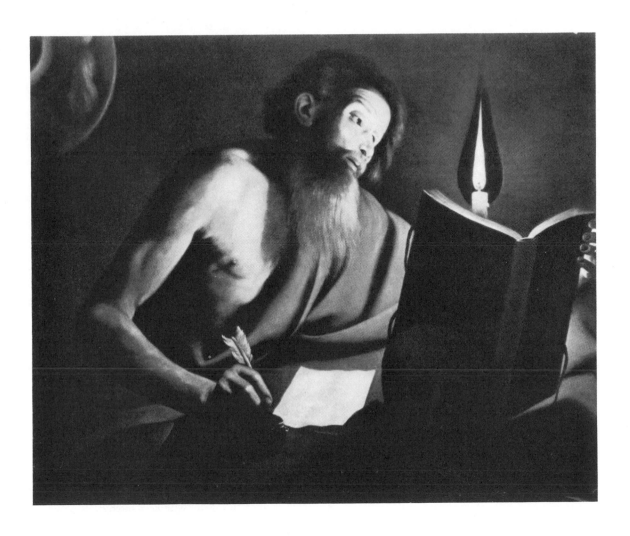

ORAZIO BORGIANNI

Ca. 1578–1616

According to Baglione, Borgianni, one of the rare Roman-born Caravaggisti, died at the age of thirty-eight. His death is documented in 1616, which means that he was born ca. 1578, fifteen years before his signed and dated picture in Catania. Borgianni's half-brother, Giulio Lasso (his correct name is found in Borgianni's recently discovered testament), perhaps was his teacher. Borgianni visited Spain during 1604–1605/7 and probably once earlier, around the turn of the century. He was definitely in Rome in 1603–4 and in 1607 when he settled there permanently. The majority of his paintings belong to this final decade of activity, with the exception of a large group in Valladolid from 1604–5. Borgianni's earlier paintings have strong Venetian and Manneristic overtones, but after ca. 1605–7 he developed a bold style that brings to Caravaggio's naturalism and chiaroscuro an unprecedented painterliness. If his picture in Sezze Romano is extraordinarily Baroque for the first decade of the Seicento (1608) and foretells mature Lanfranco, other paintings by Borgianni reveal a spirit that Serodine, Terbrugghen, and the young Vouet must have admired and seriously studied.

6 *Christ Disputing with the Doctors in the Temple,* ca. 1608–10

Joële P. Almagià, Rome.
$42\text{-}^1/_2 \times 30\text{-}^3/_4$ inches.
Collections: possibly Smith Barry, Marbury Hall;[1] Rome, Italy (in the trade); Julius Weitzner, New York.

Borgianni preferred to stress the drama inherent in dispute and protest rather than to follow strictly Luke 2:47, "and all who heard him were amazed at his understanding and his answers." Zeri[2] first attributed this painting to Borgianni and related it compositionally to the tradition of Cinquecento Venice. The painterly qualities of Borgianni, so evident here, undoubtedly are indebted to Venetian art[3] and in particular to late Titian, whom Borgianni more readily could have studied in Spain than in Rome. All authors[4] agree that this picture should be dated between 1605 and 1610, Zeri favoring the earlier date and Moir the later. Borgianni's *Way to Calvary,*[5] also of this period, shares many features with the Almagià painting.

One notes the very successful coloristic contrast between the red and blue of Jesus' garments and the heavier browns of the doctors' robes; furthermore, their richly painted head bands and turban subtly echo the colors of His clothing. The composition of the six doctors encircling Jesus, the important play of expressive hands, and the roughly painted head bands and turban clearly indicate that Terbrugghen[6] and Serodine [cf. 62] must have studied Borgianni with keen interest.

Notes: (1) Wethey, 1964, p. 154, n. 42, cites an entry in Waagen (1857, p. 410) as the Almagià painting, but the identification is very uncertain. (2) Zeri, 1956. (3) Longhi, 1961 [1914], pp. 111 ff., stressed Borgianni's relationship with Venice and especially with Tintoretto. (4) Zeri, 1956, p. 53; Cannizzaro, 1962, p. 103, as 1605–8 (Cannizzaro's study has been overlooked in the recent Borgianni literature); Wethey, 1964, p. 154, as 1605–10; Moir, 1967, I, 48. (5) Naples, 1963, no. 10. (6) For example, see Terbrugghen's *Calling of St. Matthew* and *Crowning with Thorns* (ill. in Nicolson, 1958-a, pls. 4, 7), both early works by Terbrugghen. Nicolson (1958-a, pp. 6–7) has compared Terbrugghen's paintings with Dürer's *Christ Among the Doctors*, which is equally relevant for Borgianni.

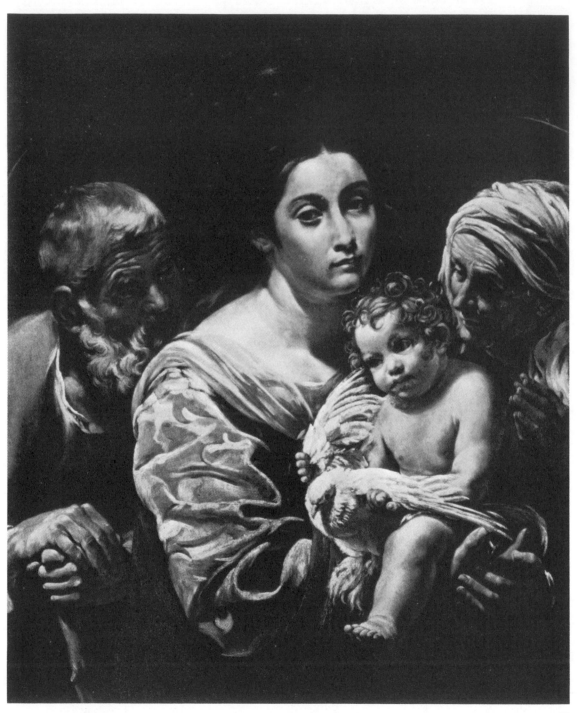

7 *The Holy Family*, 1610–15

Isabelle Renaud-Klinkosch, Switzerland.
37-¹/₂ × 30-³/₄ inches.[1]
Collections: Dorotheum, Vienna, June 4–6, 1930,
lot 205.

Benesch[2] initially attributed this *Holy Family* (which in the recent literature has been accepted as lost)[3] to Borgianni and recognized its affinities with the artist's most Caravaggesque paintings, an opinion all subsequent authors have accepted.[4] Borgianni's large *Holy Family* in the Corsini Gallery, Rome,[5] as Benesch noted, must have been painted at the same time as this picture. Stylistically they are strictly analogous, and figure types seem to be derived from the same models. The compact grouping and especially the firmly modeled face of the Virgin are allied with Caravaggio, even though the colors—especially the fluid, light red sleeve of the Virgin —are not. The combination of Venice and an earthy naturalism produces a style which, primarily in the figure of Joseph, brings to mind the early art of Velázquez.

A second, initialed, version of this painting (Fig. 12) is in the Longhi Collection, Florence.[6]

Notes: (1) *The Holy Family* has been cleaned on the occasion of this exhibition, and the strips of canvas once added to the sides and bottom have been removed, restoring the picture to its original size. (2) Benesch, 1930. (3) Cannizzaro, 1962, p. 111; Wethey, 1964, p. 158; Moir, 1967, II, 49. Julian Stock kindly indicated to this author the present location of the painting, and Yvonne Tan Bunzl generously assisted in securing photographs and arranging the loan. (4) Isarlo, 1941, p. 84; Cannizzaro, 1962, pp. 81, 111; Wethey, 1964, p. 158; Moir, 1967, I, 77, n. 30. (5) See Milan, 1951, no. 73. (6) Cited by Longhi, 1943, p. 42, n. 29 (37-³/₈ × 31-¹/₈ inches), and by Wethey, 1964, p. 158, n. 57.

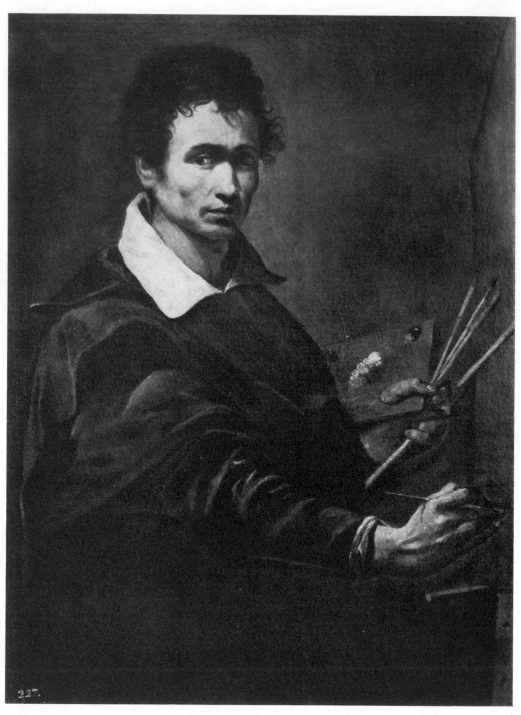

227.

Attributed to Orazio Borgianni

8 *Self-portrait*, ca. 1605

Museo del Prado, Madrid.

37-3/8 × 28 inches.

Collections: Spanish royal collection (at least since 1794).[1]

No one has doubted that this striking painting is an artist's self-portrait. The attribution, however, has been disputed. Mazo's and Esteban March's names (two old attributions) were rejected by Longhi, who first suggested Borgianni,[2] primarily on the basis of the portrait inscribed with his name in the Accademia di San Luca, Rome. More recently, however, Wethey[3] denied Borgianni's authorship, which later Moir also questioned,[4] whereas an alternative attribution to Luis Tristán was proposed by Sabine Jacob.[5]

On the basis of physiognomy alone, the question of Borgianni or Tristán cannot be settled. Comparisons with Tristán's supposed self-portrait in Yepes[6] and Borgianni's two known likenesses—the picture in the Accademia di San Luca[7] and Ottavio Leoni's portrait drawing[8]—reveal that each artist had a thin face with prominent cheek bones, small almond-shaped eyes, and receding dark hair. The straight profile of Tristán's nose is unlike the profile in the Prado picture which, to the contrary, does correspond with Leoni's drawing. However, in Leoni's portrait and that in the Accademia di San Luca, Borgianni's ear is misshapen, a detail not recorded in the Prado painting.

The sense of an unquiet, withdrawn personality, so prevalent in the Prado *Self-portrait*, can be more readily discerned in the portraits of Borgianni than in the Yepes altarpiece.[9] More important, however, is the stylistic evidence which favors Borgianni's authorship, although the attribution must be accepted with caution. The richly modeled hands and face find parallels in Borgianni's paintings of San Carlo Borromeo,[10] and the garment, simple in form, relatively flat but complex in brushwork, is typically his. Tristán's style late in the second decade (to which this picture must belong if it were by him) is heavily dependent upon El Greco, whose influence cannot be sensed in the Prado *Self-portrait*; moreover, Tristán's drapery style is much more sculptural than

Borgianni's. The *Self-portrait* probably was painted shortly preceding, or immediately after, Borgianni's return from Spain in 1605, when the artist was in his late twenties.[11] The forthright conception speaks for an interest in Caravaggio's work at this early date, even though the Venetian qualities remain strong. By combining two tendencies which Tristán and Velázquez also favored, Borgianni created a style which undeniably is analogous to the work of those Spanish artists.

Notes: (1) See Pérez-Sánchez, 1964, p. 45, no. 1. (2) Longhi, 1967 [1927], I, 122; and again in 1943, p. 42, n. 29. A summary of the problems involved in dealing with Borgianni's supposed self-portraits is in Wethey, 1970, p. 747. (3) Wethey, 1964, p. 149, and in press. (4) Moir, 1967, II, 50. (5) Jacob, 1967 a, and 1967-b, p. 124, n. 18. (6) Ill. in Jacob, 1967-a, p. 183, fig. 2. (7) Ill. in Moir, 1967, II, fig. 84. 8) Ill. in Longhi, 1951-c, pl. 16a (dated 1614). (9) Voss, 1962, pp. 9 ff., has attributed to Borgianni another *Self-portrait* and assigned it to ca. 1603; on the basis of Voss's illustration, the identification is not convincing. (10) Ill. in Moir, 1967, II, figs. 88–89. (11) Cannizzaro, 1962, p. 98, suggests ca. 1601–2.

JAN VAN BYLERT

1603–71

Jan van Bylert was born in Utrecht in 1603 and was trained by his father (a glass painter) and Abraham Bloemaert. He spent the years 1621–24 in Italy, when his compatriots Terbrugghen, Honthorst, and Baburen already had left Rome. Bylert returned to Utrecht in either 1624 or 1625. Although his paintings of the 1620's reveal the strong influence of Caravaggio, in the 1630's he began to move toward a prettier, lighter palette; to represent gayer, pastoral themes; and to devote more time to portraiture. Bylert led an active, productive life in Utrecht, where he died in 1671.

9 *St. John the Evangelist*, ca. 1630

Centraal Museum der gemeente Utrecht.
$37\text{-}^{1}/_{4} \times 30\text{-}^{1}/_{2}$ inches.
Signed in full, upper right.
Collections: T. Ward, London;[1] Christie's, November 19, 1926, lot 109; A. Rosner, Tel Aviv, Israel.

The youngest of the Evangelists handsomely conveys a remarkably fresh conviction, tinted, perhaps, with a trace of naïveté. The saturated red robe, unvariegated, set amidst an otherwise achromatic scheme, calls to mind Caravaggio's figures of single saints, as do the clarity of Bylert's modeling, the use of chiaroscuro, and the contrast between the broad folds of the heavier robe and the shallow pleats of the white undergarment. Nevertheless, John's spiritual dependence upon extra-wordly inspiration, rather than introspection, defines a sentiment foreign to Caravaggio.

The Utrecht picture belongs to a series of the four Evangelists, two of which are untraced today.[2] Comparison of the *St. John* with Bylert's works of 1624 and 1626[3] suggests a slightly later date, close to the *Rachel and Laban* in Rotterdam,[4] but not very long after he settled in Utrecht and began to favor a more decorative style that quickly parted from Caravaggio's.

Notes: (1) Isarlo, 1941, p. 90. (2) All four were sold at Christie's, November 19, 1926, lot 109, anonymous property. *Mark* reappeared at a sale in Stockholm, Bukowski, October 22–24, 1952, no. 111, and is since untraced (ill. in Hoogewerff, 1965, fig. 6). *Luke* belonged to the Schwagermann Collection, Schiedam, before the war, but has not reappeared. *Matthew* was on the London art market in 1969 (London, 1969-b, no. 4), and has now been acquired by the Ulster Museum, Belfast. The series is catalogued by Hoogewerff, 1965, nos. 17–20. (3) Hoogewerff, 1965, nos. 21 and 78, figs. 2 and 3. (4) Hoogewerff, 1965, no. 3, fig. 7; and Schneider, ed. 1967, pp. 46–47.

9

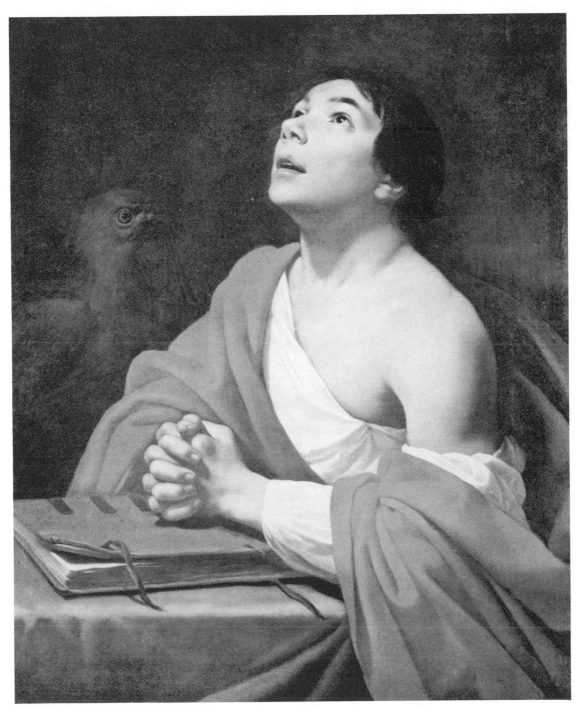

59

GIOVANNI BATTISTA CARACCIOLO, *called Battistello*

Ca. 1575–1635

Caracciolo's birth date in Naples is unknown, as is his early style, which one can postulate reflected the work of his supposed teacher, Francesco Imparato, and of turn-of-the-century Neapolitan art in general. His earliest identified paintings, however, are among the most Caravaggesque pictures ever produced. Caracciolo undoubtedly assimilated Caravaggio's style on the basis of the master's works in Naples (he reportedly copied them), but his trip to Rome—cited by Dominici, although its dates are unknown—must have reinforced his admiration for Caravaggio. Caracciolo possibly traveled in northern Italy (he was called to Florence in 1617), but the few paintings there today are insubstantial evidence to confirm the hypothesis. Unlike most Caravaggisti, Caracciolo was an active frescoist throughout his life. He died in Naples in 1635, having understood Caravaggio's art more profoundly than any other follower. His devotion to Caravaggio's style was very consequential for the development of Neapolitan painting in general, and Neapolitan tenebrism in particular, during the first half of the century.

IO *St. John the Baptist in the Wilderness*, ca. 1615

University Art Museum, University of
California, Berkeley.
$37\text{-}^3/_4 \times 50\text{-}^1/_8$ inches.
Collections: private collection, Switzerland;
Frederick Mont, Inc., New York.

Although compositionally Caracciolo's *St. John* is not related to Caravaggio's paintings of the Baptist [17], stylistically there are clear affinities. The broadly designed, deep red cloth is derived directly from Caravaggio, as is the severely limited color scheme in general, based on red and earthen hues. The sharp, bright light is typical of Caracciolo, and again is traceable to Caravaggio, as, one might surmise, is the slightly effeminate character of the youthful Saint.

The Berkeley picture has been dated by Moir[1] in the 1620's, and compared with Caracciolo's *Sant'Onofrio* in the Palazzo Corsini, Rome, and the *Baptist* in San Martino, Naples.[2] These latter paintings, however, like the

St. Sebastian in the Fogg Museum [13], share a strongly mannered character that is not present in this composition. Instead, stylistic parallels can be discovered in Caracciolo's *Immaculate Conception*,[3] which undoubtedly belongs to the second decade of the century. Another *St. John the Baptist* by Caracciolo, in a private collection in Naples,[4] logically represents a phase between the Berkeley painting and the *Baptist* in San Martino. It retains the clear, unmottled light of the former, but foretells the twisted posture and confining space of the latter. Whether or not the Berkeley picture actually reflects Caracciolo's familiarity with Caravaggio's androgynous youths [15], which would suggest a period after Caracciolo's return from Rome,[5] a date in the second decade is preferable to one in the 1620's. A recently discovered picture in Vienna adds further support to this hypothesis, for stylistically it is very similar to the Berkeley painting, and independently has been dated in the middle of the second decade.[6]

Notes: (1) See Berkeley, 1968, pp. 50–52. (2) Ill. in Moir, 1967, II, figs. 192 and 193. Longhi, 1961 [1915], I, 197, assigned these paintings to the 1620's, which has been accepted by subsequent scholars. (3) Ill. in Moir, 1967, II, fig. 181. (4) See Longhi, 1959-c (as between 1616 and 1622). Whereas this picture and the painting in San Martino are vertical in format, an etching of the *Baptist* by Caracciolo (see Voss, 1927, p. 133, fig. 3) is horizontally designed. (5) See Moir, 1967, I, 161, n. 25, for a summary of the known evidence concerning the whereabouts of Caracciolo in the second and third decades. Caravaggio's effeminate youths were not represented in Neapolitan collections. Michael Stoughton kindly provided this author with the date 1635 for Caracciolo's death (traditionally it is said to have been 1637). (6) See Heinz, 1962, p. 172.

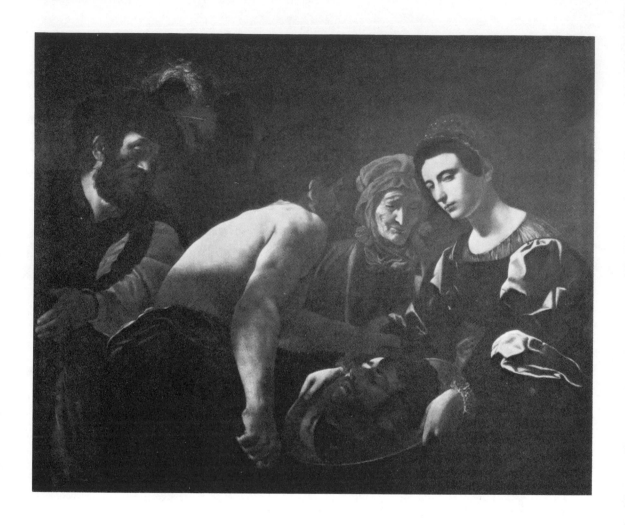

11 *Salome Receiving the Head of the Baptist,* ca. 1615–16?

Galleria degli Uffizi, Florence.
52 × 61-³/₈ inches.
Collections: unknown provenance.

Hermann Voss first attributed *Salome Receiving the Head of the Baptist* to Caracciolo,[1] whose painting of the same subject formerly in the Peltzer Collection, Cologne,[2] is equally dependent upon Caravaggio. In a general sense, both pictures are indebted to the master's asymmetrical compositions and to the melancholic mood of remorse and suspicion which Caravaggio established in his interpretation of the theme (Fig. 8). The old woman in Caracciolo's Florentine picture especially must be compared with the servant in Caravaggio's two depictions of *Salome*, while the executioner in the ex-Peltzer version is directly derived from the corresponding figure in Caravaggio's Madrid canvas.

Borea's suggestion that Caracciolo's Florentine picture is later than the ex-Peltzer *Salome* is convincing;[3] she proposes that it possibly was painted ca. 1618, when the artist was in Florence. Moir[4] assigned both versions to the 1620's, which is understandable only on the grounds of the mannered elements that are present and which recur in Caracciolo's single-figure paintings of the 1620's [cf. 13]. However, closer analogies are to be found in Caracciolo's *Miracle of St. Anthony of Padua* and *Madonna and Child with Sts. Francis and Clair and a Soul in Purgatory*[5]—altarpieces which belong to an early phase of the painter's career—and in his first dated work, the *Liberation of St. Peter* of 1615.[6]

It is logical that Caracciolo would have known Caravaggio's representation(s) of the Salome story prior to traveling to Rome, since Caravaggio's paintings were done in the south of Italy—and probably in Naples itself. Thus, the ex-Peltzer picture reasonably could belong to the early teens, and the Uffizi version to a slightly later date, but before the *Rest on the Flight into Egypt* (which apparently was painted in 1618).[7]

Notes: (1) Voss, 1927, pp. 137–38; Longhi concurred (Longhi, 1943, p. 44, n. 30). (2) See Voss, 1927, pp. 137–38 (ill. p. 137, fig. 7). (3) Borea, 1970, no. 4. (4) Moir, 1967, I, 164. (5) Ill. in Moir, 1967, II, figs. 179 and 182. (6) Ill. in Moir, 1967, II, fig. 183. (7) See Borea, 1970, no. 5.

I2 *Virgin and Child*, ca. 1615–20

Los Angeles County Museum of Art (gift of Jacob M. Heimann).

42-1/2 × 32 inches.

Signed with a monogram[1] at the left margin near the Virgin's right hand.

Collections: Agnew and Sons, London; Hermann Voss, Berlin; Jacob Heimann, New York.

The tender, melancholic intimacy established by Caracciolo is derived from Caravaggio's *Seven Acts of Mercy* in Naples (Fig. 6). The figure types, too, which are highly characteristic of Caracciolo, are based on the same painting, where the Child's puffy cheeks and narrow eyes and the Virgin's tilted, long somber face are already present. Caracciolo's brushwork, however, is tighter than Caravaggio's (although the size of the paintings must be kept in mind), and the tonality of skin in the Los Angeles painting, moving from yellowish, jaundiced passages into pearly greys, is eminently typical of Caracciolo.

Voss, who first published the painting,[2] assigned it to Caracciolo's youth, and Gilbert, likewise, stated "about 1610–15";[3] more recently Moir has proposed to date it much later, in the 1630's.[4] The telling comparison is with Caracciolo's *Virgin and Child with Sts. Francis and Claire and a Soul in Purgatory* (Fig. 13), which Moir himself placed early in Caracciolo's career, and Causa dated between 1615 and 1622.[5] The fleshy Child and especially the Virgin in the Los Angeles painting are so similar in type and modeling to the figures in the Nola altarpiece that they must stem from the same phase in the artist's career, prior to his great *Washing of the Feet* in San Martino (1622).

Perhaps through a print or drawing Caracciolo was familiar with Michelangelo's *Madonna and Child* in Bruges, where the pose of the Child is very similar to the one in the Los Angeles picture.

According to Moir, there was a replica of this painting in the Hausmann Collection in Cologne prior to World War II.[6]

Notes: (1) Caracciolo's well-known monogram is unsatisfactorily explained and rarely discussed. Once identified as the signature of Annibale Carracci (Nagler, *Monogrammisten*, I, no. 308) and Giovanni Battista Galestruzzi (Bartsch, XXI, p. 32, no. 1) on the basis of monogrammed etchings, Voss (1927, pp. 131 ff.) restored it to Caracciolo. Longhi (1959-c, p. 58) interpreted it as "G. Ba.," i.e., Giovanni Battista (or Battistello). It is preferable, however, to see the letters as an interlocked C, A, and (smaller) B, although the back of the B perhaps is intended to transform the C into a G. In either event, the device must refer to Giovanni Battista Caracciolo, even though the large A is difficult to explain. (2) Voss, 1927, pp. 132–33. (3) Gilbert, 1961, no. 4. (4) Moir, 1967, I, 165. (5) See Moir, 1967, I, 160, n. 23. (6) Moir, 1967, I, 165, n. 39.

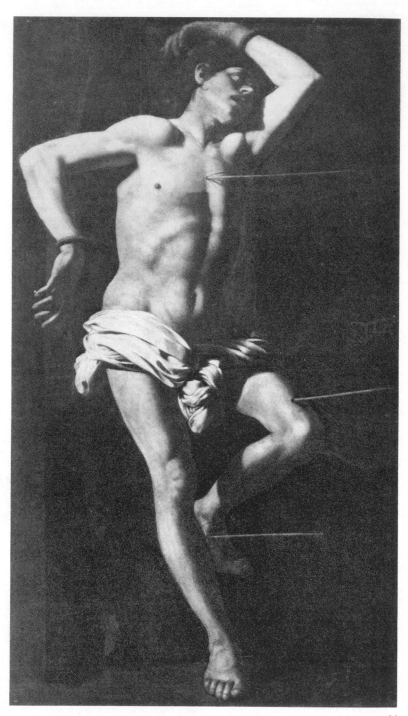

13 *St. Sebastian*, ca. 1625

Fogg Art Museum, Harvard University, Cambridge, Massachusetts (gift of Herbert Pope Arthur Pope, Edward W. Forbes, and Paul J Sachs).

80 × 45 inches.

Collections: Cesare Valenti, Venice; International Art Center, Nicholas Roerich Museum, New York.

During the 1620's, Caracciolo painted a number of nearly nude male saints in tall, narrow formats.[1] Placed before a black background, they are illuminated by a brilliant light and are strongly movemented through bodily gestures and facial expressions. The Fogg *Sebastian* clearly belongs to this group of pictures.[2]

Whereas Moir suggested that Michelangelo's *Dying Slave* in the Louvre was Caracciolo's model,[3] Titian's St. Sebastian in the famous *Resurrection* of 1522 in Brescia is a more convincing source. In the Brescia altarpiece the Venetian established a classic statement of the Saint's martyrdom that was destined to influence innumerable later artists. Caracciolo's painting is particularly indebted to Titian, for in addition to close correspondences in the figures, the confining ·spatial settings are especially analogous. Nevertheless, the Fogg *Sebastian* is a striking example of the complete stylistic transformation which a Venetian prototype underwent in the mind of a Caravaggesque painter, as is witnessed by the sharp contours, the clarity of the atmosphere, and the reduction to a scheme of dramatic chiaroscuro.

Notes: (1) E.g., *Sant'Onofrio*, Palazzo Corsini, Rome, and *St. John the Baptist*, San Martino, Naples (ill. in Moir, 1967, II, figs. 192 and 193). (2) Longhi, 1967 [1927], I, 124–25, and 1943, p. 44, n. 30 (incorrectly as Museum of Fine Arts, Boston), initially published the painting; Moir, 1967, I, 163, n. 30, related it to the abovemen-tioned paintings of saints and assigned it to the 1620's. No date was suggested when the painting was exhibited in San Francisco, 1964–65, no. 121. (3) Moir, 1967, I, 163, n. 30.

MICHELANGELO MERISI DA CARAVAGGIO

1571/72–1610

Michelangelo Merisi, the son of a mason-architect, was born in 1571 or 1572, probably in Milan rather than in the Lombard town of Caravaggio. In 1584, he was apprenticed to Simone Peterzano for a period of four years, but there is no documentation to prove that he completed the apprenticeship (which nevertheless is likely) or to indicate when he left Lombardy. Bellori and Susinno write that Caravaggio visited Venice en route to Rome, but the earlier sources do not confirm this statement, nor is there a necessity to accept it on a stylistic basis. The date of Caravaggio's arrival in Rome, which is of great importance for establishing a chronology of his artistic development, often has been set at ca. 1588–89, but it is almost certain that he arrived later, probably near the end of 1592 or in early 1593.

During his early Roman years Caravaggio worked for an unknown Sicilian artist, "Lorenzo," and for Giuseppe Cesari, the Cavaliere d'Arpino, for whom he painted flowers and fruit, and he was in close touch with the painters Mario Minniti, Antiveduto Grammatica, and Prospero Orsi. His first important patron was Cardinal Francesco Maria del Monte, who later was joined in his deep admiration of Caravaggio's art by the Marchese Vincenzo Giustiniani and the Barberini, Borghese, Costa, Massimi, and Mattei families. In 1599 Caravaggio undertook his most important commission, the decoration of the Contarelli Chapel in San Luigi dei Francesi; he painted two large lateral canvases for it by mid-1600 and two versions of the altarpiece (the first was refused) in 1602. In the meantime (1600–1601), he completed two celebrated pictures for the Cerasi Chapel, Santa Maria del Popolo. Caravaggio's notorious police·records commence at this time (1600) and relate skirmishes that are both humorous (he throws a plate of improperly cooked artichokes in the face of a waiter) and serious (he wounds a guard of Castel Sant'-Angelo), but always reflective of a restless, volatile temperament. Testimony during the famous libel suit of 1603 brought by Baglione against Caravaggio, Orazio Gentileschi, Onorio Longhi, and Filippo Trisegni provides especially important evidence about Caravaggio as an artist, specifically his taste and "theory." A number of documented paintings stem from ca. 1603 to 1605, during which period he apparently made

a brief visit to the Marches (1604) and to Genoa (1605).

Late in May of 1606 Caravaggio was in a serious brawl that ensued from a ball game, and he killed one of his opponents, Ranuccio Tommasoni. Wounded, Caravaggio fled Rome and sought protection in the Colonna villas east of Rome, in the Sabine hills. By 1607 he traveled to Naples, and, still having failed to receive a pardon from Rome, he continued on farther to the south. He was in Malta in 1608, where he first was knighted, later imprisoned, and subsequently expelled from the Order of St. John after his escape. In 1609 he stopped in Messina and Palermo prior to returning to Naples by October of the same year. Ironically attacked in error and seriously wounded, Caravaggio remained in Naples for approximately nine months, until July of 1610 when he headed back northward, perhaps in anticipation of the pardon which finally was issued that month. But he never reached Rome. Struck by fever (probably malaria) at Porto Ercole (near Civitavecchia), Caravaggio died on July 18, 1610.

14 The Ecstasy of St. Francis, ca. 1594

The Wadsworth Atheneum, Hartford, Connecticut (the Ella Gallup Sumner and Mary Catlin Sumner Collection).
36-3/8 × 50-1/4 inches.
Collections: Ottavio Costa, Genoa, and Rev. Ruggero Tritonio da Udine, Pinerolo,[1] and/or Cardinal Francesco del Monte, Rome; private collection, Malta; Guido Grioni, Trieste; Arnold Seligmann, Rey and Co., New York.

As Pamela Askew has recently demonstrated,[2] Caravaggio's unusual interpretation of the ecstasy which accompanied Francis' stigmatization (the traditional seraph is absent, the Saint is in an unconventional prostrate position and he is supported by an angel) stresses Francis as *imitator Christi*. The illumination of the night sky, witnessed by shepherds in the fields, is recounted in *The Little Flowers of St. Francis*,[3] but Caravaggio's omission of the seraph and the stress on internalized ecstasy of the Saint find no literary precedent in Italy.[4] Caravaggio's painting predates Francis de Sales's *Traité de l'amour* (1616), which Askew has shown closely parallels Caravaggio's personal interpretation of Francis' mystical vi-

sion. Approximately six years later Caravaggio developed further this revolutionary attitude in *The Conversion of St. Paul* (Cerasi Chapel), for once again he omitted specific reference to the divine vision[5] and concentrated instead upon an internalized embracing of Christ.

The date of Caravaggio's arrival in Rome, long a disputed question, has been reasonably placed in 1592–93.[6] In a testament of 1597, Ruggero Tritonio da Udine bequeathed a *St. Francis* by Caravaggio, given to him by Ottavio Costa, to his nephew.[7] The Hartford painting, unquestionably far superior in quality to the copies in Udine[8] and New York,[9] logically belongs between those terminal dates on stylistic grounds.[10] On the one hand, the tenderness of the conception and the lyricism of the setting evoke Caravaggio's *Rest on the Flight into Egypt* and, more importantly, his Lombardic heritage. But on the other hand, the strong chiaroscuro—unusual for this early date—and simple composition of crossing diagonals foretell Caravaggio's later religious paintings.

An entry in an unpublished inventory of Cardinal Francesco del Monte's collection[11] complicates the question of the provenance of the Hartford painting. The Cardinal owned "Un S Francesco in estasi di Michel-Agnolo [sic] da Caravaggio con Cornici negre [sic] di Palmi quattro," which in description and measurements (35-1/4 inches high) corresponds very well with the Hartford picture.[12] Del Monte's *St. Francis* was sold after his death, on May 25, 1628, for 70 *scudi*. Unfortunately, there are no records of previous or later owners, and thus one can neither determine if this is the picture today in America, nor substantiate the tempting hypothesis that Cardinal del Monte bought his painting from Ruggero Tritonio's heirs.

Despite occasional unfounded rejections of the Hartford picture,[13] it is an excellent example of Caravaggio's early revolutionary attitude—stylistically and iconographically alike. In fact, every feature, from the dramatic chiaroscuro and sympathetic emotional content to the precise, naturalistic depiction of form and the controlled palette, reveals Caravaggio's orientation away from the Cinquecento *maniera*.[14]

In addition to the aforementioned copies of the Hartford painting, a "*Death*" of St. Francis, once in Spain, probably was a copy or variant of this composition.[15]

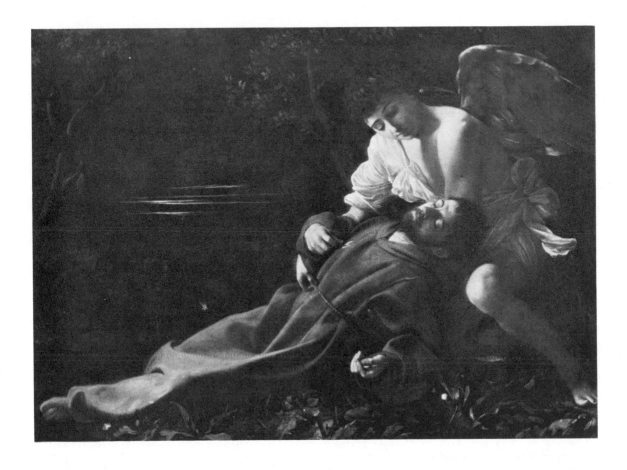

Voss has attributed to Georges de La Tour a *Saint Francis* that also is derived from Caravaggio's painting.[16]

Notes: (1) See Milan, 1951, no. 17; Friedlaender, 1955, pp. 148–49, no. 6; and Detroit, 1965, no. 2. (2) Askew, 1969, pp. 284–94. (3) Dowley, 1964, pp. 519–20, discusses this miracle. (4) See p. 6 above for reference to Juan de los Angeles. Askew, 1969, p. 287 ff., contends that compositionally Caravaggio's *St. Francis* is based on earlier representations of the *Mourning Over the Body of Christ*, the *Agony in the Garden*, the *Conversion of St. Paul*, and the *Dream of Elias* as well. (5) It should be noted that the Hartford painting originally referred to the stigmatization more explicitly. Whereas now only the wound of Longinus' spear is visible on Francis' breast, his right hand once bore the mark of a nail wound (see Askew, 1969, pp. 285–86, n. 20). (6) Borla, 1962. (7) See Friedlaender, 1955, p. 294, doc. no. 36. (8) Ill. in Friedlaender, 1955, pl. 60; for a summary of opinions, see Kitson, 1969, pp. 85–86, no. 7; first published by A. Venturi, 1928. (9) Coll. Donald McGlone, New York City; 37-3/8 × 51-1/2 inches. (10) Marangoni, who first published the Hartford picture (1929), recognized that it is an early work, which is unanimously accepted today. The angel often is compared with the lost *Boy Peeling Fruit* (known in copies) and the youth at the left in *Una musica* [15], two other early paintings. See Mahon, 1951, p. 227, n. 49, p. 233, and n. 105; and Mahon, 1952, pp. 7–8 *et passim*, for a detailed discussion of its chronological implications. Hinks, 1953, no. 5, and Jullian, 1961, p. 225, suggested ca. 1593, but Baumgart, 1955, p. 94, no. 3, preferred ca. 1590–91. (11) This information and that concerning the sale of the picture is kindly provided by Chandler Kirwin, who has discovered in the Archivio di Stato, Rome, and Archivio Segreto of the Vatican documents concerning Del Monte's collection (inventories and sales). For further on the collection, cf. cat. no. 16, nn. 3 and 5. (12) The measurements in the inventory refer to height and are approximate. (13) Most recently by Arslan, 1951, and again in 1959, p. 198; by Wagner, 1958, pp. 226–27; and by Hibbard and Lewine, 1965, p. 371 (with reservations). (14) See above, pp. 5-6. (15) See Ainaud, 1947, p. 388, no. 22. (16) Voss, 1965.

15 A Concert of Youths (Una musica), ca. 1595

The Metropolitan Museum of Art, New York (Rogers Fund).

36-1/4 × 46-5/8 inches.

Collections: Cardinal Francesco del Monte, Rome; David Burns, Whitehaven, Cumberland; J. Cookson, Kendal; W. G. Thwaytes, Maulds Meaburn, Penrith.[1]

There are many antecedents in northern Italy for portrayals of half-length musicians,[2] but Caravaggio's concert of youths is no simple genre scene. The strong undercurrent of melancholy that dominates this silent concert and reaches its peak in the tear-filled eyes of the lutist points to an allegorical intention, undoubtedly to one centered on love.[3] It is important in this context to note that the youth at the left originally was planned to have wings, quiver, and arrows and therefore was conceived as Cupid. A copy of the painting, recently in London, preserves these attributes, which now are invisible in the New York composition.[4] The effeminate figures, so closely paralleled in other early paintings by Caravaggio,[5] possibly reflect a homosexual or bisexual tendency on the part of the artist,[6] whose likeness has been recognized both in the lutist and, more convincingly, in the youth at the right with a horn.[7]

From the time of its discovery twenty years ago, it has been suspected that the *Concert of Youths* is identical with the "musical scene with some youths drawn from nature" which Baglione said was painted for Cardinal Francesco del Monte.[8] This hypothesis finds support in the Cardinal's inventory of 1627,[9] where there is listed "Una musica di mano di Michelangelo da Caravaggio con cornice negra di palmi cinque in circa" (five *palmi* is equivalent to 44 inches). The roughly approximated dimensions of the Cardinal's painting basically correspond with the canvas in New York, which unfortunately has suffered severe surface damage in addition to having been cut down.[10]

It is tempting to believe that the New York picture was one of Caravaggio's earliest efforts at figural composition, if not his very first. The piecemeal nature of the composition reflects inexperience in designing a gathering of figures, a challenge which taxed the artist even

more when he began the *Martyrdom of St. Matthew* (San Luigi dei Francesi). There is no doubt that during the 1590's Caravaggio's strength was in compositions of one or two figures, and only later in more complex groups. Nonetheless, the unexpected staccato rhythms (which led some critics to see this picture as a pastiche) and the extraordinary variety of postures (as if it were an essay on frontal, rear, and profile views) establish a poignant feeling of isolation that successfully complements the somber mood.

Mahon's dating of the New York picture, 1594–95,[11] is reasonable on stylistic grounds, for it allows sufficient time for Caravaggio to have completed many of his single-figure paintings of androgynous boys and at the same time takes into account numerous parallels with other youthful works.[12] If in error, this date is probably too early rather than too late,[13] for the biographers state that Caravaggio was patronized by Cardinal del Monte only after considerable hardship in Rome and lack of success with other patrons.[14] Furthermore, if the Cardinal's commissions postdate Caravaggio's stay with Monsignor Petrignani, then the *Concert* may have been painted as late as 1595–96, since Petrignani was still in Forlì in 1594.[15]

Two copies of Caravaggio's *Concert* are known: one, untraced today, was sold at Lepke's in 1901;[16] the second was in a private collection in London in the 1950's.[17]

Notes: (1) See a letter and editor's note in *The Burlington Magazine*, XCIV, 1952, 119–20. (2) See Wagner, 1958, pp. 22–23 (and notes), and Michałkowa, 1961, for discussion of earlier *Concerts*. (3) Friedlaender, 1955, p. 148, made this suggestion, which is convincing; music has a long tradition as an antidote to love. (4) This author has not been able to determine if a second copy (cf. n. 16 below) also has the wings, quiver, and arrows. Mahon, 1952, p. 4, n. 15, reconstructs a complicated history of restoration of the New York canvas, which, if correct, means that the wings now removed from the New York composition had been repainted by a restorer *before* the London copy was made. A related problem is raised by Paolini's youthful *Musicians* (ill. in Ottani, 1963, pl. 5c), which seemingly is based on Caravaggio's *Concert* but contains a winged figure in the background. (5) See the discussion in Mahon, 1952, pp. 4 and 7, and Friedlaender, 1955, pp. 147–48, no. 5. (6) There is no clear evidence that Caravaggio was homosexual; he had his share of female companions, but of course his relationship with them is unknown (some of them seem to have been loose women). (7) Longhi, 1952, p. 9, suggests through comparative illustrations that the boy with a horn is a self-portrait; Czobor, 1955, pp. 208–9, identifies both figures as self-portraits, which is difficult to accept. (8) Baglione,

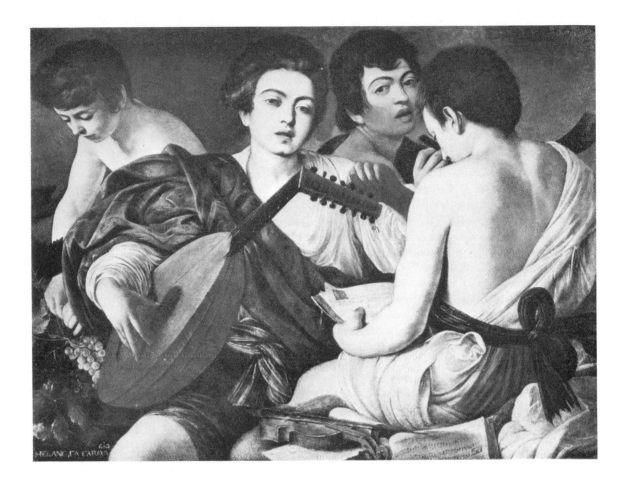

1642, p. 136; this is confirmed by Bellori, 1672, p. 204. Longhi, 1952, p. 19, and Baumgart, 1955, p. 94, no. 5, doubted that the New York picture is Del Monte's *Una musica*. (9) This information is kindly provided by Chandler Kirwin; see cat. no. 16, nn. 3 and 5, for further information on the inventory (also, see Kirwin, in press, and Frommel, in press). (10) See Mahon, 1952, pp. 3–4, and nn. 9–17, for extensive comments on the condition of the painting. It should be pointed out that the inscription in the lower left corner of the canvas is obviously not an original signature. (11) Mahon, 1952, *passim* (Mahon's article, in a different and shorter form, also appeared in *Paragone*, III, 1952, no. 25, 20–31). (12) The most thorough discussion is presented by Mahon, 1952. (13) Other scholars, however, have tended toward an earlier date: Baumgart, 1955, p. 94, no. 5, ca. 1590–92; Wagner, 1958, pp. 21–23, ca. 1590–92; Hinks, 1953, pp. 95–96, no. 6,

1593–94; and Longhi, 1952, p. 19, implicitly ca. 1590. Jullian (1961, p. 226) and Kitson (1969, p. 87, no. 12) prefer later dates, ca. 1595 and ca. 1596 respectively. Recently, Longhi (1968-a, p. 15) expressed the opinion that the New York picture is a copy. (14) Baglione, 1642, p. 136, and Bellori, 1672, pp. 202–4. (15) On Petrignani, see Hess, 1951, p. 193, n. 63, and notes by Salerno in Mancini, ed. 1956–57, II, 113, n. 887. However, Mancini's chronology of Caravaggio's early life is quite uncertain, and his reference to the "pictures done in Petrignani's house" are far from reliable. (16) Lepke, Berlin, cat. no. 1265, April, 1901, no. 74, as Nicolò dell'Abate; ex-collection Valdrighi, Modena (this author has not been able to consult the Lepke catalogue). (17) Photographs of this version are in the curatorial files of The Metropolitan Museum of Art.

16 *St. Catherine of Alexandria*, ca. 1597

Collection Thyssen-Bornemisza, Lugano-Castagnola, Switzerland.
68-$\frac{1}{8}$ × 52-$\frac{3}{8}$ inches.
Collections: Cardinal Francesco del Monte, Rome; Cardinal Antonio Barberini and heirs, Rome.

The recent discovery of an inventory of Francesco del Monte's collection[1] substantiates Bellori's statement[2] that Caravaggio painted *St. Catherine* for the Cardinal. The canvas is described in an inventory dated February 21, 1627, that is, approximately six months after Francesco's death:[3] "Una S Caterina della Ruota opera di Michel Agnolo da Caravaggio con Cornice d'oro rabiscata di Palmi setto [61-$\frac{1}{2}$ inches]."[4] On May 7, 1628, the picture was sold out of the Del Monte Collection, which then was in Alessandro del Monte's hands,[5] and it reappears in Cardinal Antonio Barberini's collection, as inventoried in April of 1644.[6] Thereafter, it remained in the Barberini family until it was sold to Baron Thyssen in 1935.[7]

Despite the presence of a halo, which rarely occurs in Caravaggio's art, the secular character of St. Catherine is manifest. She kneels gracefully beside the spiked wheel on which she was unsuccessfully tortured, as self-assured and composed as the young woman in Caravaggio's destroyed Berlin portrait. The marked emphasis on the volume of forms and the simple but effective spatial recession indicate that Bellori[8] was correct in stating that this picture reveals a stylistic change in Caravaggio's development. Of particular interest and remarkable consequence is the very dark background, a well-known hallmark of Caravaggesque painting which, paradoxically, was not typical of Caravaggio's own earlier work. *St. Catherine* belongs to an important phase when the master was abandoning his lighter, flatter, often lyrical early style and moving toward the monumentality of the Cerasi compositions. Catherine's resemblance to Judith in *Judith and Holofernes* (Fig. 4) and Mary in the lost *Martha and Mary* (known in various copies) is so close that a common model must be postulated. Together, these pictures should be assigned to the later 1590's.[9]

Once attributed to Orazio Gentileschi,[10] *St. Catherine* has been accepted as an autographic work of Caravaggio's ever since Marangoni (hesitantly) and Voss made the attribution[11] (a single rejection was made by Schudt).[12]

A copy of the painting is in the Church of San Jerónimo el Real, Madrid.[13]

Notes: (1) Chandler Kirwin kindly released the information regarding the Del Monte inventories and sales (see Kirwin, and Frommel, in press). (2) Bellori, 1672, p. 204. (3) Francesco died on August 27, 1626 (courtesy of Mr. Kirwin). (4) The measurements in the inventory refer to height and are approximate. (5) Mr. Kirwin has discovered that Francesco's collection was inherited by Uguccione, who died on September 4, 1626; Alessandro, the next heir, lived only until June 13, 1628. (6) Marilyn Aronberg Lavin will publish the complete references; she reports that dimensions first appear in an inventory of Cardinal Antonio's collection in 1671: "p[al]mi 8 inc[irc]a Alto." (7) The inscription "F. 12" in the lower right hand corner of *St. Catherine* refers to an inventory of the Barberini Collection drawn up by Vincenzo Camuccini in 1817 (see Mariotti, 1892, p. 127, no. 12). Pauwels, 1953-b, p. 196, misunderstood Bellori's text and consequently denied the Del Monte provenance of the Thyssen picture. For extensive bibliographical notes on the picture, see Castagnola, 1969, pp. 59–60, no. 55. (8) Bellori, 1672, p. 204. (9) Longhi, 1943, p. 10, dated the painting 1592–93, which was repeated at Milan, 1951, no. 20; Longhi, 1952, pl. XIV, revised his opinion and suggested 1592–95. However, a later date is required, as was recognized by Mahon, 1951, p. 234 (1598–99), and 1952, p. 19 (1596–97); Hinks, 1953, p. 101, no. 17 (ca. 1597); Friedlaender, 1955, pp. 157–58, no. 14 (ca. 1595); Baumgart, 1955, p. 98, no. 18 (ca. 1594–95); Rotterdam, 1959–60, no. 31 (ca. 1597); Jullian, 1961, p. 227 (ca. 1597). (10) Longhi, 1961 [1916], p. 278, and more recently by Wagner, 1958, pp. 227–28. (11) Marangoni, 1922–23, p. 222; Voss, 1923, pp. 80–81 (the painting had been exhibited in Florence, 1922, no. 206, as "School of Caravaggio"). (12) Schudt, 1942, p. 53, no. 74; Arslan, 1951, and 1959, pp. 214–15, n. 43, doubted that the drapery over the wheel hub was original. (13) See Ainaud, 1947, pp. 387–88, no. 21, ill. facing p. 372; and Madrid, 1970, p. 124, no. 33.

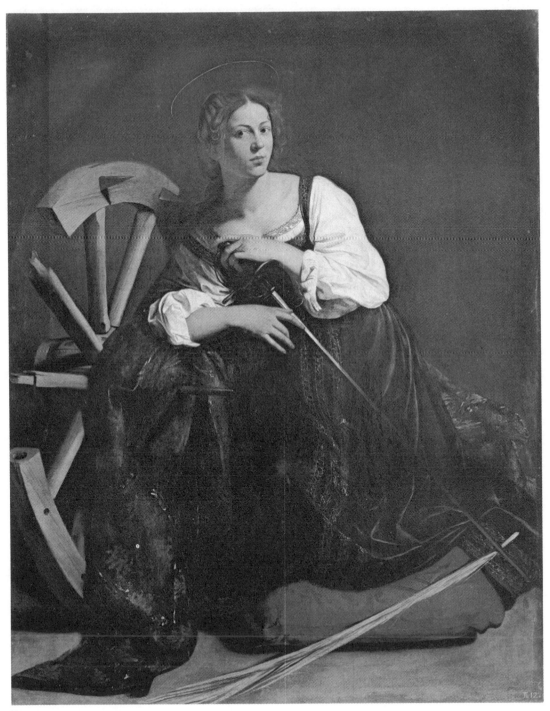

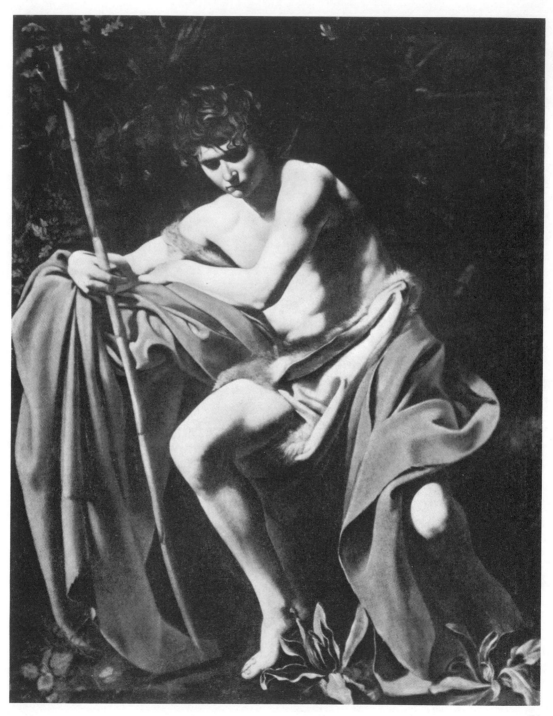

Figure 14. *The Conversion of St. Paul* (detail). Caravaggio. Santa Maria del Popolo, Rome.

Figure 15. *St. John the Baptist* (detail). Caravaggio. Nelson Gallery-Atkins Museum, Kansas City, Missouri.

I7 *St. John the Baptist in the Wilderness,* ca. 1604–5

Nelson Gallery-Atkins Museum, Kansas City, Missouri (Nelson Fund).
68-1/4 × 52 inches.
Collections: presumably Ottavio Costa, Conscente;[1] James, Lord Ashton of Forfar, Tixall, Staffordshire; Chicester-Constable Collection, Burton Constable;[2] Agnew and Sons, London.

No artist prior to Caravaggio, and very few after him, conceived of St. John the Baptist as a melancholic, introspective youth. Isolated from worldly and heavenly affairs, the Baptist is portrayed as a restless, brooding figure, brilliantly illuminated by a sharp raking light. The deep red cloth and black shadows isolate the Saint's firm body, while pinks and ivory whites are contrasted to differentiate its parts.

The broad, spirited handling of paint, in addition to the meditative character of the Saint, suggests that the Kansas City picture belongs to the period ca. 1604–5,[3] slightly later than the *Madonna di Loreto* (Fig. 5) and contemporary with *St. Jerome* (Galleria Borghese), in which the *fattura* is identical. Although the painting cannot be related with certainty to any one of the various seventeenth-century references to this subject,[4] it undoubtedly stems from Caravaggio's last years in Rome—and is fully autographic.[5]

A copy in Naples (Capodimonte) has long been known.[6] More recently, a second copy was discovered in a small church dedicated to St. John the Baptist, built by the Costa at Conscente (Liguria) in 1588.[7] Costa's name is well known among Caravaggio's principal patrons,[8] and the dedication of the Ligurian church indicates that Caravaggio's picture possibly was commissioned for Conscente itself. The date of the copy *in situ*

is unknown, but it undoubtedly was made to replace the Kansas City original when it was sold.

Longhi[9] first noted an important technical aspect of Caravaggio's procedures which has received insufficient attention. From ca. 1600 on, Caravaggio occasionally scored the priming of his pictures, blocking out what seem to be random contours but which actually must have served the artist as key points of reference while completing the composition on the canvas. This phenomenon appears in the Balbi-Odescalchi *Conversion of St. Paul*, in the second version of the subject in the Cerasi Chapel (Fig. 14), in the *Sacrifice of Isaac* in the Uffizi,[10] as well as the *Flagellation* in Rouen [18].[11] As stated in the introduction to this catalogue,[12] it undoubtedly is related to Caravaggio's rejection of traditional drawing procedures. It is unique to Caravaggio, and therefore in its own right strong evidence of a painting's authenticity, since a copyist never would repeat such incisions. It is important to note, therefore, that in a raking light the Kansas City painting reveals Caravaggio's hand in the scoring of the contours of John's left leg (Fig. 15).

Notes: (1) On the Costa at Conscente, see Matthiesen in Matthiesen and Pepper, 1970. (2) London, 1950–51, no. 323; lent by Brigadier R. C. J. Chichester-Constable. (3) See Milan, 1951, no. 23 (late 1590's); Mahon, 1951, p. 234 (1603–4) and 1952, p. 19 (1602–4); Longhi, 1952, pl. XXIII (late 1590's); Hinks, 1953, p. 110, no. 37 (ca. 1603); Friedlaender, 1955, pp. 171–72, no. 20 D; Wagner, 1958, pp. 108–9 and p. 207, n. 439 (1602–4); Jullian, 1961, p. 228 (ca. 1604); Seattle, 1962, no. 62 (ca. 1602–4); and Detroit, 1965, no. 3 (1604–5). Baumgart (1955, p. 101, no. 29), however, assigns the painting to 1598–99, which Longhi (1968-a, p. 32) reaffirms. (4) See Friedlaender, 1955, p. 169. (5) Rejected by L. Venturi, 1951, p. 41, n. 35; Friedlaender, 1955, p. 172, was doubtful, an opinion shared by Arslan, 1951. Also, see Dowley, 1964, p. 520, and a reply by Coe, 1966. (6) Milan, 1951, no. 56; Longhi, 1943, pp. 14–15, recognized it as a copy when he first published the Kansas City picture. (7) See Torre, 1962, and Matthiesen and Pepper, 1970; approximately 67-7/8 × 53 inches (dimensions courtesy Mr. Matthiesen). (8) The Costa family owned a *Judith*, a *Walk to Emmaus*, a *Magdalene* (none of which can be identified with certainty), and *The Ecstasy of St. Francis* [14]. On Ottavio Costa, the principal collector in the family, see Matthiesen and Pepper, 1970, pp. 452 ff. (9) Longhi, 1960, p. 27. (10) Isaac's head and mouth and the back contour of the angel's head are incised; this unnoticed detail is important evidence in support of a late dating of the painting (see Lavin, 1967). (11) See Rosenberg, 1966, p. 174. (12) Pp. ix–x above.

18 *The Flagellation of Christ*, ca. 1605–7

Musée des Beaux-Arts, Rouen.
53 × 69 inches.
Collections:[1] the Paris trade (ca. 1950); M. Stuart de Clèves; Georges Zezzos; Jean Descarsin.

The *Flagellation of Christ* was acquired by the Rouen museum in 1955 as a Mattia Preti, at which time two other versions of the painting already were known: one, formerly in a private collection in Lucca, recognized by Longhi[2] as a copy after a lost Caravaggio; and a second, in a private Swiss collection, published by Mahon[3] as the lost original. Despite initial doubts concerning the authenticity of the Rouen picture when it was discovered, recent opinion has generally, but not unanimously, endorsed Longhi's stylistic arguments[4] that the French painting is the original and the other two versions are copies based on it. Furthermore, the presence of scoring in the gesso of the Rouen version strongly argues against the possibility that it is only an excellent copy (cf. cat. no. 17 regarding this technical detail).

Whereas Longhi initially[5] maintained that the *Flagellation* should be dated in the late 1590's, Mahon's suggestion, 1605–7, is far more convincing. The broad handling and economy of color both belong to the last phases of the master's career, and the composition foretells the late *Salome with the Head of the Baptist* in London. While the executioners are eminently typical of Caravaggio's figure types, the design of Christ is unusual; it brings to mind the sharp delineation that is characteristic of Mannerist representations of this subject. Caravaggio's painting might be compared with a free copy after Sebastiano del Piombo's famous *Flagellation*[6] or with a picture in Sta. Prassede, Rome, which has been attributed to Simone Peterzano, Caravaggio's teacher.[7] One should point out, however, that in his later works Caravaggio not infrequently handled principal and secondary figures differently. The Rouen painting is also noteworthy for its asymmetrical, decentralized composition, which decidedly differentiates it from Caravaggio's more classic *Flagellation* in San Domenico, Naples.

Mahon noted[8] that a *Flagellation* attributed to Caravaggio was in the Borghese Collection in the seventeenth and eighteenth centuries, but there is no evidence that

76

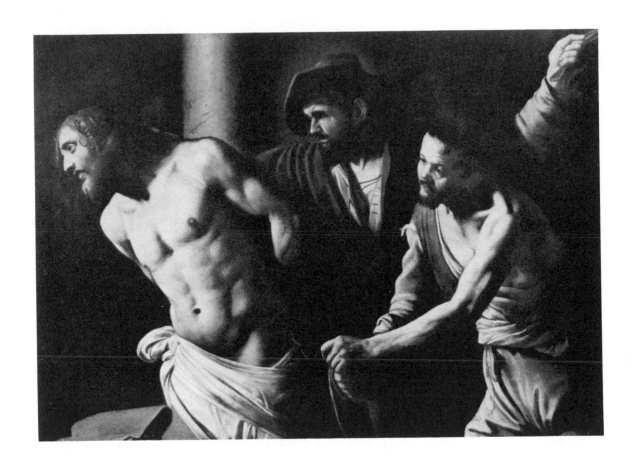

can link the Rouen painting with that picture or any other early references.

Notes: (1) See Rosenberg, 1966, p. 174, no. 194. (2) Longhi, 1951-b, pp. 28–29. (3) Mahon, 1956 (reprinted in *Paragone*, VII, 1956, no. 77, 25–34). (4) For a resumé of opinions, see Rosenberg, 1966, p. 174, no. 194; when the painting was exhibited in Paris in 1965, it was favorably received (see Rosenberg, in Paris, 1965–66, no. 61). (5) More recently (1968-a, pl. 72 [color]), Longhi accepted Mahon's dating. (6) The painting is in the Galleria Borghese; see Della Pergola, 1959, II, 135–36, no. 187 (ill.). (7) Traditionally attributed to Giulio Romano, Calvesi, 1954, pp. 115 ff., has argued for Peterzano's authorship. (8) Mahon, 1956, p. 228.

19 *David with the Head of Goliath*

Museo del Prado, Madrid.

43-$\frac{1}{4}$×35-$\frac{3}{4}$ inches.

Collections: Spanish royal collection at least since 1794.[1]

It is rare for an artist to depict David preparing to carry away the head of the Philistine (I Samuel, 17:54), completely absorbed in his task and unaware of any observers. The highly original composition depends upon a calculated play of profile and frontal views, an arrangement of limbs which squares off the space into the form of a cube. David's "fair countenance" (I Samuel, 17:42) is complemented by an unpretentious humility, strengthened through transparent shadows which engulf his youthful face.

Adolfo Venturi[2] initially attributed the *David* to Caravaggio, which opinion has been endorsed by Longhi,[3] Mahon,[4] Hinks,[5] Jullian,[6] and Pérez-Sánchez.[7] Ainaud[8] considered the painting to be a copy of a lost original, and Zahn,[9] Baumgart,[10] Friedlaender,[11] Battisti,[12] and Wagner[13] shared his doubts, some authors preferring to remove it from the master's work altogether. Indeed, conflicting elements of style and the absence of any reference to a full-length *David* in the sources make the decision difficult. *David* almost certainly is by the same hand as the *Narcissus* in Rome,[14] but because that painting is equally problematic and in very bad condition, no attribution can rest on it. In favor of Caravaggio's authorship is the originality of the *concetto*, which must be understood to include design and content alike. Of equal importance is the quality of execution, which precludes its being a copy and forces the perplexing question of an alternate attribution. Furthermore, various details, such as the foot of David in the foreground, can be satisfactorily compared with Caravaggio's works— the dexter foot of his *Baptist* (Capitoline, and Galleria Doria, Rome) is identical to David's. The painting surely stems from at least a very early date in the century, and if it is Caravaggio's, probably from ca. 1600.[15]

Nevertheless, disquieting features pose serious problems. The originality of the composition may be worthy of Caravaggio, but it is difficult to reconcile the design with the sentiment. Chiaroscuro is handled with great subtlety, but with the exception of some secondary figures, Caravaggio did not paint heads totally in shadows (as his followers often did), nor do his shadows have the transparency of those on David's face. And despite the beauty of the passage, the contrast of values at David's chin does not find correspondences in Caravaggio's work. The placement of the head of Goliath is much less inspired, for it threatens the unity of the composition, and David's garment is too obviously, pedantically "designed." Finally, the tender, almost sentimental, treatment of David would seem to stem from Caravaggio's earlier years, but the principle of design which supports the composition is closest to his later paintings.[16]

David undoubtedly was in Spain at an early date; Longhi noted[17] various old replicas in Spain, but no copies of it have been discovered in Italy.

Notes: (1) See Madrid, 1970, p. 122; the large "1118" in the lower right corner is the number of the Buen Retiro Palace inventory of 1794. (2) A. Venturi, 1927, p. 369. (3) Longhi, 1952, pl. XXVII; and 1968-a, p. 22, and pl. 27 (color). In 1943, p. 39, as circle of Saraceni. (4) Mahon, 1952, p. 18 (on the qualified basis of photographs). (5) Hinks, 1953, pp. 104–5. no. 25. (6) Jullian, 1961, p. 227 (with reservations). (7) In Madrid, 1970, p. 122, no. 32. (8) Ainaud, 1947, p. 385, no. 14. (9) Zahn, 1928, p. 56. (10) Baumgart, 1955, p. 102, n. 34. (11) Friedlaender, 1955, p. 203. (12) Battisti, 1955, p. 177 (as circle of Saraceni). (13) Wagner, 1958, pp. 229–30. (14) Milan, 1951, no. 18. (15) See Mahon, 1952, pp. 18–19; Hinks, 1953, pp. 104–5, no. 25; Jullian, 1961, p. 227—all ca. 1599; Longhi places it considerably earlier. Recently, Schleier (1970, pp. 345–46) discussed the question of the date and authorship of the *David*. (16) The *Supper at Emmaus* (National Gallery, London), the *Conversion of St. Paul* (Cerasi Chapel), and the *Adoration of the Shepherds* in Messina offer the closest analogies. (17) Longhi, 1951-b, p. 21

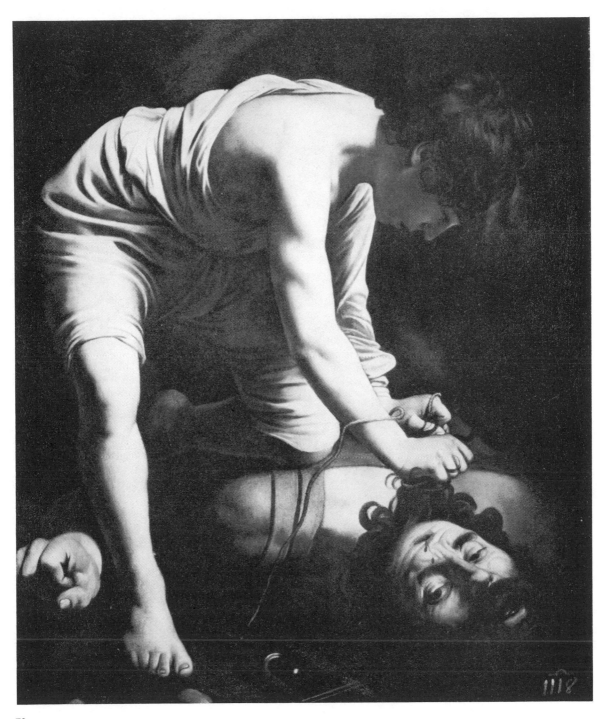

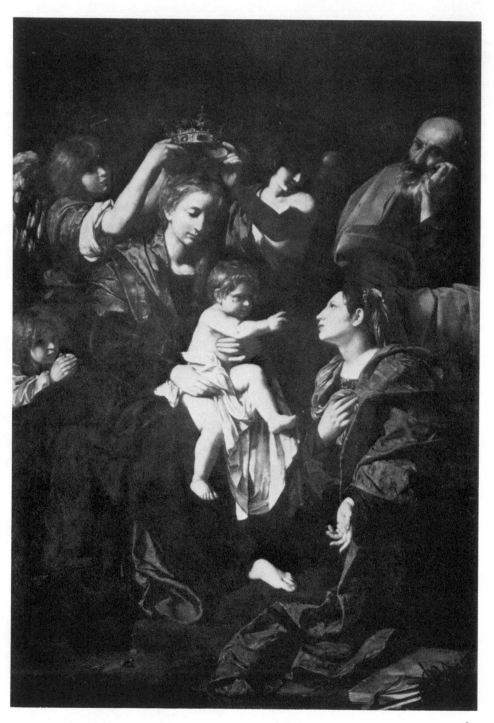

BARTOLOMEO CAVAROZZI

Ca. 1590–1625

Mancini, writing ca. 1620, states that Cavarozzi was then about thirty years old. Born in Viterbo, he settled in Rome at an early age, where he reportedly was trained by Tarquinio Ligustri and almost certainly by Cristoforo Roncalli (Pomarancio), whose influence is dominant in Cavarozzi's earliest known painting—a St. Ursula dated 1608. Apparently only later Caravaggio's art strongly impressed Cavarozzi, perhaps under the guidance of his close friend Giovanni Battista Crescenzi, with whom Cavarozzi traveled to Spain in 1617, returning to Italy, probably in 1619, for his few remaining years. He died in Rome in 1625. Cavarozzi's oeuvre is relatively small, especially in relation to the large number of copies after his Holy Family and Mystical Marriage of St. Catherine. Nevertheless, it reveals a distinctive personality, one that favored a somber, weighty naturalism with roots nourished by the later Roman paintings of Caravaggio and the art of Orazio Gentileschi.

20 The Mystical Marriage of St. Catherine, ca. 1617–19?

Museo del Prado, Madrid.

100-⁷/₈ × 67 inches.

Collections: Isabella Farnese, La Granja (as Guido Reni).

"Then our Blessed Lord took up his mother and said: Mother, that which pleaseth you, pleaseth me, and your desire is mine, for I desire that she be knit to me by marriage among all the virgins of the earth. And said to her: Katherine, come hither to me…. Come my spouse, and give to me your hand. And there our Lord espoused her in joining himself to her by spiritual marriage, promising ever to keep her in all her life in this world… and in token of this set a ring on her finger, which he commanded her to keep in remembrance of this…."[1]

Cavarozzi's representation of the *Mystical Marriage of St. Catherine* is among his most significant paintings. It clearly demonstrates his radical departure from the Roncalli-based *St. Ursula* of 1608,[2] and hence must be separated from it by a number of years. The presence of copies and variants in Spain has suggested the hypothesis that the *Mystical Marriage* was executed in Spain,[3] but it could have been sent there after his return to Rome just as well. In either event, it is a mature work, well exemplifying Cavarozzi's sense of strong, but not sharp, chiaroscuro, heavy, pensive, figures, and flesh tones enriched by a liberal use of red.

In his *Holy Family*[4] Cavarozzi repeated his conception of Joseph—markedly older than the Virgin, patient, but apparently bored. The elaborately designed deep red garment on Catherine undoubtedly was one of the factors that led to an attribution of this picture to Orazio Gentileschi.[5] His name was erroneously attached to a *St. Jerome* in Florence[6] as well, which now is also given to Cavarozzi and which includes two angels enveloped in shadows—very similar to the two who crown the Virgin.

A reduced version of this painting in New York[7] and a copy in the trade[8] should be added to the long list[9] of studio variants and copies based on this admired composition.

Notes: (1) Jacobus da Voragine, ed. 1900, VII, 14–15. (2) Toesca, 1960-b. (3) Pérez-Sánchez, 1964, p. 22; also, see Madrid, 1970, p. 170, no. 49. (4) Ill. in Moir, 1967, II, fig. 127 (and a list of versions, II, 66); Longhi, 1943, pp. 53–54, n. 69, stressed Cavarozzi's relationship with Fiasella primarily on the basis of this composition. (5) Longhi, 1961 [1916], I, 228, 233, 278 (but attributed to Cavarozzi by Longhi in 1943, pp. 53–54, n. 69). (6) Ill. in Moir, 1967, II, fig. 125. (7) Coll. Mr. and Mrs. John Hermann (sold at Christie's, July 17, 1964, lot 108; 62 × 49 inches; ill.). (8) Milan, 1969, n.p. Schleier (1970, p. 347) concurs that it is a copy. (9) See Longhi, 1943, pp. 53–54, n. 69; Pérez-Sánchez, 1964, p. 47, nos. 19 A, 19 B, and 20; Moir, 1967, II, 66; and Faldi, 1970, pp. 55–58.

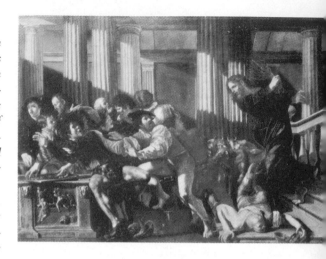

Figure 16. *Christ Expelling the Money Changers from the Temple.* $50^3/_8 \times 68^1/_8$ inches. Cecco del Caravaggio. Staatliche Museen, Berlin (East).

CECCO DEL CARAVAGGIO

Neither the birth and death dates nor nationality are known of an artist cited by Mancini (ca. 1620) among Caravaggio's followers as "Francesco detto del Caravaggio." It has been recognized, however, that "Cecco" is the nickname for a Francesco who was apparently so captivated with Caravaggio's work that he was dubbed "del Caravaggio." (A sobriquet of this type in Italy normally was given to foreigners.) Furthermore, in a rare contemporary document (1619), Cecco is cited as having roomed with Tassi at Bagnaia in 1613 together with numerous Frenchmen.

On the basis of an epigram in Sylos' Pinacotheca (1673), Longhi identified Cecco's Christ Expelling the Money Changers from the Temple *in Berlin (Fig. 16) as the pivotal work in reconstructing Cecco's oeuvre. Stylistically he has closest affinities with Finson and Ducamps, which argues for a French or Flemish nationality. He cannot be identified with Guy François, who was back in Le Puy in 1613.*

21 *The Resurrection of Christ*, ca. 1610

> The Art Institute of Chicago (Charles H. and Mary F.S. Worcester Collection).
> $133^{-1}/_2 \times 78^{-1}/_2$ inches.
> *Collections*: presumably Cardinal Francesco Barberini, Rome;[1] Galerie Sangiorgi, Rome; Joseph Brummer, New York; Mr. and Mrs. Charles Worcester, Chicago.[2]

According to St. Matthew (28:3), the angel who appeared at the tomb wore "raiment white as snow." Cecco emphasizes his whiteness amidst the colorful dress of the soldiers, whose reactions to the miracle are conveyed in facial expressions typical of Cecco in their forced, theatrical form. As in the art of Finson, to whom this picture was once attributed,[3] the light is clear, strong, and uniform, and a staged stiffness slows down all motion.

If conceptually Caravaggio's lost *Resurrection*[4] did not influence Cecco, stylistically the Chicago picture is intimately related to Caravaggio's work in general, from the sharp, raking light and solidity of forms to the style of dress and veracity of details. Cecco, however, like Ducamps [24], fails to achieve Caravaggio's perfected balance between particulars and the whole, and sacrifices visual and emotional unity for an impressive verisimilitude. The intricate folds of the angel's robe and Christ's loin cloth, the great attention paid to the reflection of light on armor and in the lantern, and the skillful rendition of an antique bas-relief (which represents the slaying of the Niobids)[5] are all eminently characteristic of Cecco.

The uncertainty of Cecco's career makes the dating of the Chicago painting difficult. Longhi's suggestion of ca. 1610 for the Berlin *Christ Expelling the Money Changers from the Temple* (Fig. 16)[6] seems likely for the *Resurrection* too, rather than ca. 1600;[7] the picture surely was painted early in the century,[8] conceivably during Caravaggio's lifetime.[9]

Notes: (1) Heretofore, there has been no evidence to support the Barberini provenance which has been suggested in the literature on this painting. However, Marilyn Aronberg Lavin has discovered in an inventory (dated 1679) of Cardinal Francesco Barberini's collection a *Resurrection*, unattributed, measuring 15×8 *palmi* ($132 \times 70^{-1}/_2$ inches). The unusual size of that painting and its correspondence with the Chicago Cecco make it likely that one picture is involved. (2) See Rich, 1938, pp. 19–20, no. 15 (as "School of Caravaggio"). (3) Isarlo, 1941, p. 135. (4) See Fried-

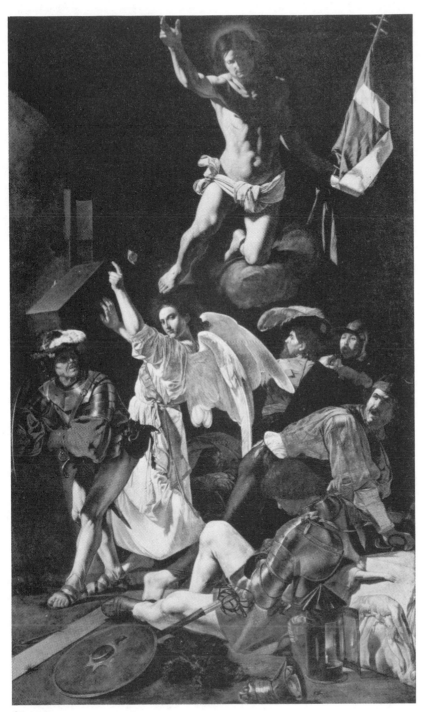

laender, 1955, p. 224, no. 50. (5) As Rich noted (1938, pp. 19–20), Cecco has incorporated into the *Resurrection* figures from a famous *Niobids* group (see Reinach, *Répertoire de reliefs*, III, 492, no. 3, for the Leningrad relief). (6) Longhi, 1943, p. 26 (the basic study on Cecco). (7) The date suggested in Chicago, 1961, p. 71. (8) The only firm date concerning Cecco is his activity at Bagnaia in 1613 (see Bertolotti, 1876, p. 208; and especially Salerno, 1960, pp. 157 ff.). A (lost) work of his is cited as early as 1635 in an inventory of the collection of the Duke of Savoy, Turin: "Un giovane a sedere con un fogliazzo in mano. Del Checco, allevo di Caravaggio. Mediocre" (see Baudi di Vesme, 1897, p. 45, no. 253). (9) Marini's attribution of a *Susanna and the Elders* (Wildenstein and Co.) to Cecco is as unconvincing as the suggestion that it reflects a lost painting by Caravaggio (Marini, 1970).

22 *The Guardian Angel with Two Saints,*

ca. 1610

Nelson Gallery-Atkins Museum, Kansas City, Missouri (Nelson Fund).

83-3/4 × 42 inches.

Collections: Francisco Morales, Madrid; Duveen, New York.[1]

The subject of this large canvas is uncertain.[2] The kneeling female martyr saint with an arrow through her neck and a banner may be St. Ursula; the male saint is probably an Apostle. The upper figures can be identified as the guardian angel and a naked Christian soul. More puzzling, however, is the relationship between the four figures and the unseen person before whom they kneel, conceivably an ascending Christ or Virgin. The Kansas City painting must have formed part of some larger iconographic program, but whether there once were pendant paintings, or this picture is a fragment, has not been determined. In either case, the original work must have been very large.

Although no attribution has heretofore been offered,[3] Cecco's authorship of the Kansas City painting seems to be certain. It is an important addition to his small oeuvre, despite the severe abrasion the canvas has suffered.[4] The angel's white robe is designed and executed in the same manner as in the *Resurrection* [21], and particularly distinctive of Cecco are the large, fleshy hands.[5] The better-preserved passages display his clear, sharp modeling of forms. Ursula's (?) manly features can be compared with Cecco's so-called *Narcissus* in Rome, as well as with figures in the documented Berlin painting (Fig. 16).

Notes: (1) The painting was acquired by the Museum in 1930. In 1947, Ainaud published a photograph of a picture as "Spanish private collection" (Ainaud, 1947, facing p. 396), which would appear to be a variant of the Kansas City painting, but very possibly is the identical picture. Cropping of the illustration and cleaning of the painting could account for the apparent discrepancies between the two; furthermore, the only record preserved in Kansas City reveals that the painting was purchased by Henry Duveen from Francisco Morales, Madrid, in 1930. (2) The traditional title is *St. Ursula, St. Thomas, Tobias and the Angel,* but there is no reason to accept these latter identifications. (3) The painting is catalogued as "attributed to Caravaggio" at Kansas City. Since completion of this catalogue entry, an unsigned advertising note in *The Burlington Magazine* (CXI, 1969, "Notable Works of Art now on the Market," pl. XXXV) refers to the Kansas City picture as by Cecco or as a copy after him. (4) Repainting is minimal, but the face of the angel is particularly rubbed, and the face of the Christian soul is totally lost. (5) See Cecco's "*Narcissus,*" Milan, 1951, no. 85, and the picture in Berlin (Fig. 16).

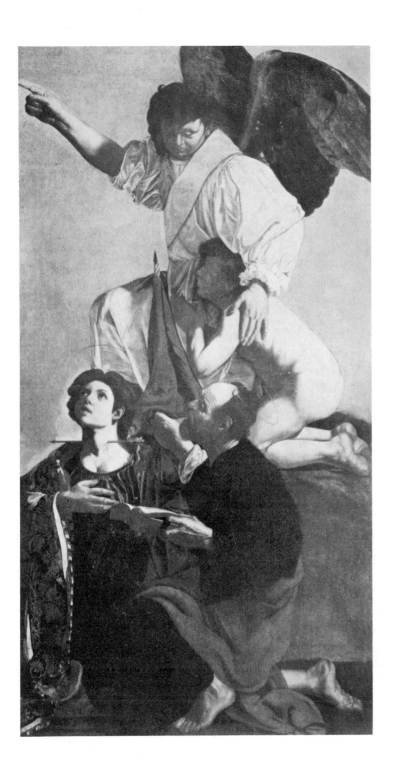

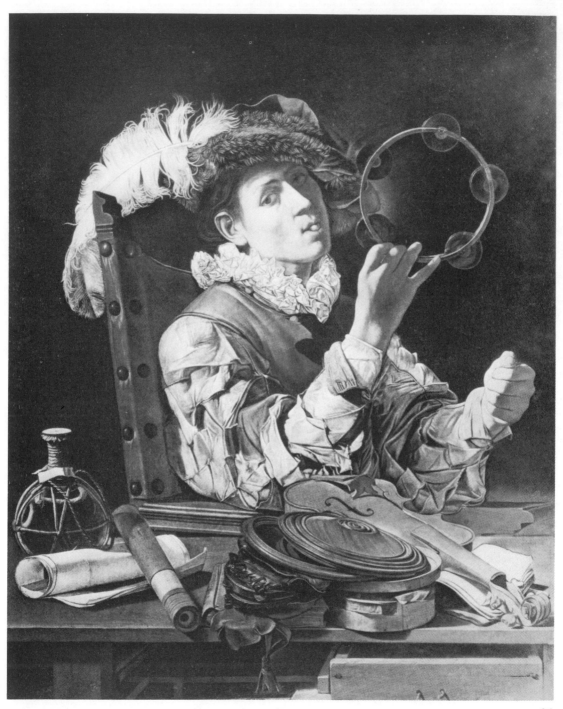

23 *A Musician*, ca. 1610

The Wellington Museum, Apsley House, London.
48-3/4 × 38-3/4 inches.
Collections: Burland, Liverpool (as Velázquez); Messrs. Henry Graves and Co.; the First Duke of Wellington and heirs.

Numerous objects and instruments, perhaps of an itinerant musician, allowed Cecco to vent his passion for depicting still-life accessories. In addition to the violin and jingles, the youth seems to hold in his left hand some type of clacker, and a whistle between his lips. Although it is difficult to identify with certainty all of the objects on the table, which may be primarily cases for instruments, the title here proposed seems to be more appropriate than "The Conjuror," the Museum's identification.

The attribution to Cecco[1] is confirmed through comparisons with his so-called *Narcissus*[2] and *Christ Expelling the Money Changers from the Temple* (Fig. 16),[3] which reveal a similar passion for carefully painted details and complexly designed garments. In every painting by Cecco some element of the composition extends to the very lower edge of the canvas, as here the drawer is opened toward the spectator's space. *Pentimenti* can be discovered throughout the picture, particularly around the ring with jingles, which initially was further to the left.

Another version of this painting with modifications in the figure is in the National Gallery of Athens.[4] On the basis of the accessories in that version and a picture in Oxford,[5] Carlo Volpe has attributed to Cecco a pair of still lifes in a Roman private collection.[6]

The *Musician* is very similar to an unpublished *St. Lawrence* (Fig. 17) in the main chapel of the Sanctuary of San Filippo Neri in the Oratory of the Filippini, Rome, which Luigi Salerno has rightly attributed to Cecco.[7] There, as in the Apsley House picture, browns, whites, and black, relieved only by St. Lawrence's deep wine-red robe, establish the principal color scheme, while many still-life accessories, dryly painted, are placed on display in the immediate foreground. Among these is a medallion at the very bottom edge of the canvas inscribed DAM/ASOPA/PA PRI/MO, that is, *Damaso*

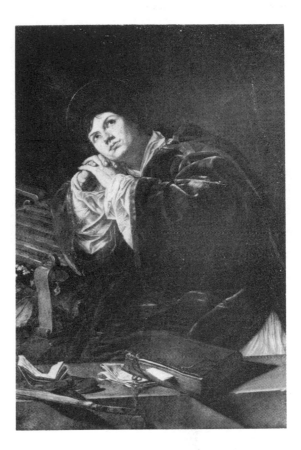

Papa Primo, a reference to Pope St. Damasus (366–84), who composed a panegyric for St. Lawrence's tomb.

Notes: (1) Salerno, 1960-a, p. 162. (2) See Milan, 1951, no. 85. (3) Longhi, 1943, p. 26 .(4) Acc. no. 133; 45-3/4 × 38-3/4 inches; bequest of A. Soutzos, 1900; ill. in Longhi, 1961, II, pl. 169. (5) Longhi, 1943, pl. 59 (incorrectly as Cambridge). (6) In Naples, 1964, nos. 35 and 36. (7) Professor Salerno generously granted permission for the *St. Lawrence* to be illustrated here for the first time, having initially called it to the attention of this author. Another version of the picture, in a Roman private collection, will be published by Professor Salerno in *Storia dell'arte*.

Figure 18. *Death Comes to the Table*. 39-³/₄ × 56-¹/₄ inches. Circle of Ducamps. Musée de Saint Denis, La Réunion.

Figure 19. *Death Comes to the Table*. 29-³/₄ × 38-¹/₂ inches. Ducamps. Whereabouts unknown.

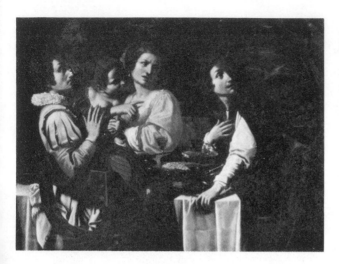

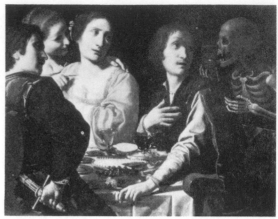

JEAN DUCAMPS *(Giovanni del Campo)*

Very little is known about Ducamps. Sandrart reports that he was from Cambrai and studied under Abraham Janssens in Antwerp. He was in Rome by 1623, when he became a founding member of the Bentvueghels, *the society of Netherlandish painters in Rome. Nicknamed "de Brave" because of his cooperative character, he was an active force in the Society and a close friend of Pieter van Laer. Sandrart mentions a St. Peter Freed from Prison (unidentified) and half-length apostles and evangelists as typical of Ducamps. Cecco del Caravaggio, an equally vague personality, seems to have been an important influence on him. Ducamps left Italy in 1638 for Spain, where he presumably died.*

Attributed to Jean Ducamps

24 *Death Comes to the Table*, ca. 1625?

Isaac Delgado Museum of Art, New Orleans.
47-¹/₂ × 68-¹/₂ inches.
Collections: J. Brummer, New York; Smith College Museum of Art, Northampton, Massachusetts; Hirschl and Adler Galleries, New York.

Numerous features reveal the Northern training of the artist of this picture. The subject, an elaborate *memento mori*, is more common in the Low Countries than in Italy; an extreme interest in details, linearly depicted, reflects the long heritage of verisimilitude in Flanders; and the abundant still life, "uncomposed" by Italian standards, finds its origins in artists like Aertsen, Beuckelaer, et al.

Initially catalogued as by Manfredi,[1] the picture has been exhibited as by Cecco del Caravaggio and Le Clerc;[2] the Museum's curatorial files also record the suggestion of Tournier; Zeri named Manetti, whereas another version (see below) has been attributed both to Caroselli and Paolini. Ducamps, however, is more probable, primarily on the basis of a painting recently in the trade in Milan,[3] which is a variant of a (lost) picture inscribed DC F, interpreted by Longhi to signify Del Campo fecit.[4] The Delgado *memento mori* reveals clear compositional analogies with the Milanese picture, where complicated human interactions also abound, figures appear in the background in half-obscurity, drapery patterns are very complex, and some of the women reflect Gentileschian types.[5]

This composition apparently enjoyed considerable success. One (weak) version (Fig. 18) deletes the youth

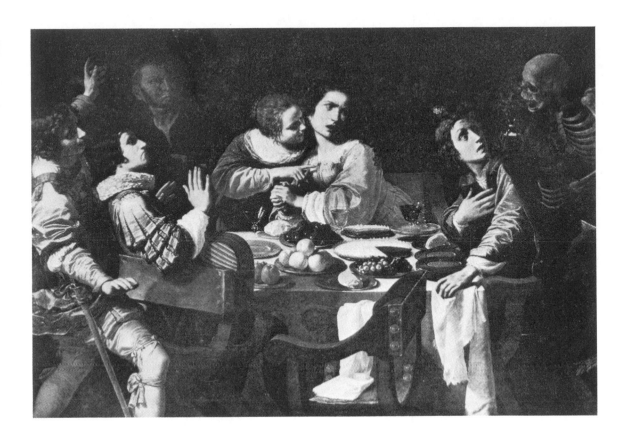

at the left and substitutes a flash of lightning for the figure of Death.[6] A second variant (Fig. 19), better in quality than the first, retains the two women in the center, the young man at the right, and Death, and adds at the left a *bravo* who holds a sword behind his back.[7] A third variant, formerly in a Florentine private collection, is closest to the Delgado composition, but lacks the youth at the far left.[8]

Notes: (1) Northampton, 1925, p. 25. (2) See Gilbert, 1960, no. 2; New Orleans, 1962–63, no. 25; and Jacksonville, 1970, no. 26. (3) Milan, 1963, pp. 14–15; *Cardplayers*, 47-5/8 × 60-1/4 inches (ill.). Several persons have suggested Ducamps' name to the Delgado Museum. (4) See Milan, 1963, pp. 14–15; the monogram-med picture unfortunately disappeared during the Second World War and apparently is unpublished. Thus there is little concrete evidence with which one can establish Ducamps' style. Hooge-werff's interpretation of the artist's activities in Rome (1926; and especially 1952, pp. 71 ff., 81 ff. *et passim*) is more justified than his two attributions to Ducamps (1952, pls. 1 and 9). An *Ecce Homo* in the Torlonia Collection was attributed to him (see Mariotti, 1892, p. 104, no. 13). (5) Compare the woman at the left in the Delgado picture with the woman stealing money in the Milan composition. (6) 39-3/4 × 56-1/4 inches; recently acquired by the Museum at Saint Denis, La Réunion (information kindly supplied by Pierre Rosenberg). (7) Sold at Sotheby's, November 29, 1961, lot 100, 29-3/4 × 38-1/2 inches, as Paolini (formerly Colnaghi's, as Caroselli); Nicolson, 1960-a, p. 226, suggests that this is the original, on which the Delgado picture is based. (8) Information kindly supplied by Professor Luigi Salerno.

ANIELLO FALCONE

1607–56?

Few facts are known about the activities of Aniello Falcone, who was born in Naples in 1607. Dominici says that he studied painting under Ribera, and that he died in 1665. Inasmuch as Falcone was sufficiently ill in the year of the great plague in Naples—1656—that he drew up his last testament, it is likely that the biographer erred in recording the date. There is no documentary proof that Falcone traveled, but Dominici reports that he visited Rome (which seems likely) and France as well. Falcone did enjoy international patronage, and was especially favored by the wealthy Flemish banker Gaspar Roomer. Even though relatively little is known about him today and only a small oeuvre has been reconstructed, it is clear that Falcone was an extraordinarily versatile artist. He painted in oils and fresco, specialized in battle scenes (which Salvator Rosa learned from him as his pupil), approximated the style of the Roman Bambotcianti, and possibly was a seminal figure in the rise of Neapolitan still-life painting (Paola Porpora is said to have been his pupil)—all in addition to his activities as a sculptor, about which nothing is known. It naturally follows that a wide range of artists interested him, from Leonardo, Tempesta, Ribera, and Velázquez to the Roman and Neapolitan schools of the 1620's and 1630's.

Attributed to Aniello Falcone

25 *The Supper at Emmaus*, ca. 1632–35?

Heim Galleries, Paris and London.
55 × 76-1/2 inches.
Collections: private collection, Nancy, France.

Cleophas and Simon Peter, accompanied by the turbaned host of the inn, recognize Christ by His blessing of the bread. Both iconographically[1] and stylistically, this painting is directly dependent upon Caravaggio's celebrated *Supper at Emmaus* in London: the eminently lucid figural grouping is a reversal of Caravaggio's design; the youthful, beardless Christ and the outstretched arms of Peter are derived from the London painting, as is the basket of fruit which, as in Caravaggio's picture, extends forward beyond the table's edge and contains grapes and pomegranates "out of season" (Bellori); even the pattern

of the oriental table covering is indebted to Caravaggio's prototype.

Of equal interest is the compositional transformation that has taken place. The dynamic play of recession and projection created in the London painting by Cleophas' chair, Christ's and Peter's extended arms, and the shadows on the background wall has been rejected. Spatially, the Heim picture is shallower, and a clearer sense of symmetry governs the work. Christ, although youthful, is less effeminate, and a blue cloth on Peter replaces the characteristic Caravaggio green of Cleophas' jacket in the London picture. All of these changes clearly point toward a classicizing temperament, even though the strength of chiaroscuro, firmness of modeling, and consistency of naturalism must stem from an artist who deeply admired Caravaggio's *Emmaus*, which was in Rome throughout the seventeenth century.

Carlo Volpe[2] has attributed the Heim painting to Aniello Falcone, and although the arguments supporting his conclusions are far from conclusive, the suggestion is worthy of consideration. The Heim *Emmaus* is painted over a thin ground on an open, reticulate canvas, which is repeatedly, but by no means exclusively, encountered in Neapolitan paintings of the 1630's. A classicistic approach to Caravaggesque naturalism is endemic to Naples in that period, and Falcone's art in general reveals a classicistic attitude.[3] His paintings in the style of the Bambotcianti[4] boast an inventive imitation that also characterizes the Heim picture. The men at the right of the composition, Cleophas and the innkeeper, belong to a peasant stock born in Spain and brought to Naples by Ribera and Velázquez (Rodriguez' Hispanic types are analogous, and the Fracanzano's figure types also come to mind). Velázquez' first journey to Italy closed with a visit to Naples in late 1631. The year earlier he had painted in Rome the *Forge of Vulcan* (Prado, Madrid) and *Joseph's Bloody Coat* (Escorial), which are brought to mind by the Heim *Emmaus*. Velázquez' influence on Falcone has often been noted,[5] and the square-faced men in the *Emmaus*, richly modeled with variegated but flat strokes, as well as the very broad garments with narrow, deep folds, are paralleled in Falcone's figural paintings.[6]

Of great interest is the excellent still life of fruit, greens, fish, bread, and wine. The fluid brushwork that

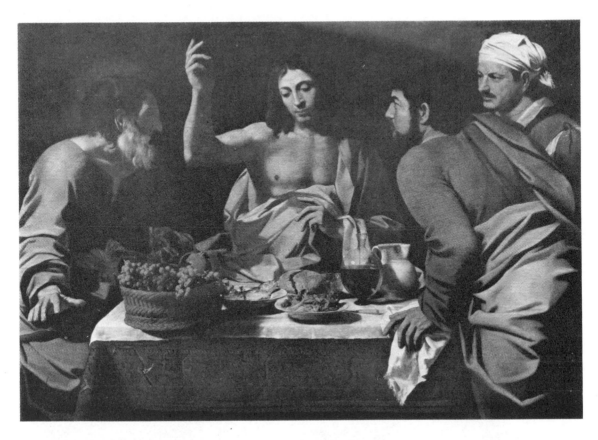

defines the fish, bread, and greens is not unlike the handling of the still-life details in Falcone's *Concert* and *Christ Expelling the Money Changers from the Temple* in Madrid,[7] and the basket of fruit is very close to the same motif in the *Still Life with Dove* in the Palazzo San Gervasio, Matera, formerly attributed to Porpora[8] but more recently assigned to Falcone.[9]

It must be emphasized, however, that despite these generic affinities, there is not a single preserved painting by Falcone which is as Caravaggesque as this *Emmaus*, and that Falcone is not known to have designed paintings with the monumental internal scale of this work. If he actually were responsible for it, which at the present remains only very hypothetical, he could be counted among the closest late followers of Caravaggio, assuming, of course, that the *Emmaus* is not stylistically unique in his youthful oeuvre. Furthermore, the origins of Neapolitan still-life painting may be partially clarified through this picture, which on the one hand is tied to Caravaggio's style, and on the other points toward Porpora, Forte, and their followers.[10]

Notes: (1) See Friedlaender, 1955, p. 164. (2) In an undated letter to François Heim. (3) See Saxl, 1939–40; Soria, 1954; and Ferrari, 1969, p. 216. (4) See Longhi, 1950-c, p. 33; Briganti, 1950, no. 53; Milan, 1951, nos. 90–91; Rotterdam, 1958, nos. 74-75; and Moir, 1967, I, 171-72. (5) Longhi, 1950-c, p. 33; Briganti, 1950, no. 53; and Volpe, *in letteris* (cf. n. 2). (6) For the figural types, see Soria, 1954, fig. 1 (*Gladiators*, Prado, Madrid), fig. 9 (*Concert*, Prado, Madrid), and fig. 10 (*Christ Expelling the Money Changers from the Temple*, Prado, Madrid); for the garments, see Milan, 1951, no. 90 (*The School Mistress*, Althorp). (7) See the illustrations in Bottari, 1966, pls. 57b, 58, and I. (8) Naples, 1964, no. 57 (with further bibliography), and Bottari, 1966. (9) Bottari, 1966, and Volpe, *in letteris*; also see Ferrari, 1969, p. 218. (10) After this catalogue had gone to press, the Heim *Emmaus* was exhibited in London, 1971, no. 4 (ill. in color), where Volpe has presented his opinion in brief form.

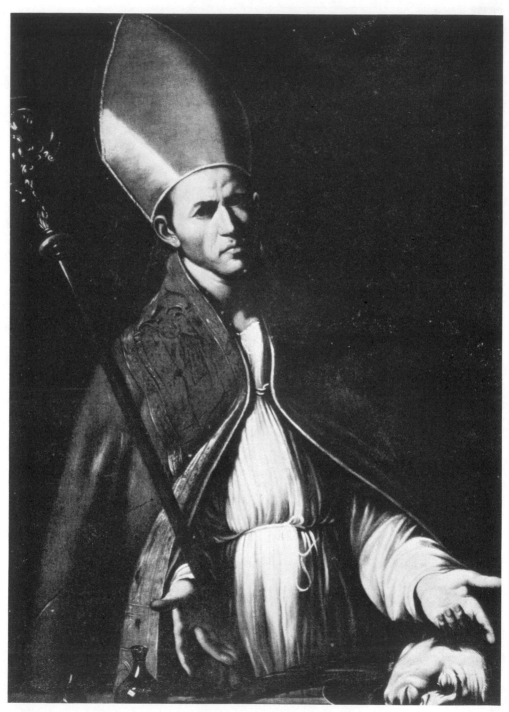

LOUIS FINSON (*Ludovicus Finsonius*)

Before 1580–1617

Finson was one of the earliest Northern followers of Caravaggio. Born in Bruges, he arrived in Italy during the first decade of the Seicento, worked in Rome and Naples, and settled in southern France by 1610. His Resurrection *in Aix-en-Provence of that year possibly reflects Caravaggio's lost* Resurrection *formerly in Sta. Anna dei Lombardi, Naples. He was back in Naples in 1612, again in Aix in 1613, in Arles in 1614, and in Aix in 1616, the year prior to his death in Amsterdam. Finson collected Caravaggio's works (a* Judith *and the* Madonna of the Rosary*) and copied Caravaggio's lost* Magdalene *of 1606 and probably the lost* Crucifixion *of St. Andrew. He specialized in religious paintings and portraiture, but occasionally turned to genre themes. Bigot may have developed his tenebrist style under Finson's influence.*

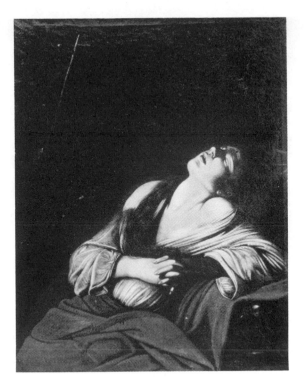

26 *San Gennaro*, probably 1612

Mr. and Mrs. Morton B. Harris, New York City.
49-¾ × 36-⅜ inches.
Collections: E. Moratilla, Paris; Paul Ganz, New York.

San Gennaro (Januarius in English), bishop and martyr, is identified by his miter and the glass phial, which refers to a miraculous relic in the Cathedral of Naples containing the Saint's periodically liquefying blood.

This unpublished painting is typical of Finson's style.[1] Forms are modeled with a primitive simplicity and severity in strong chiaroscuro. It appears that the eye sockets are chiseled out and the ear is inorganic, seemingly detached from the skull. The thin, white material of the Bishop's alb is found in Finson's copy of Caravaggio's lost *Magdalene* (Fig. 20).[2] And a rubbery quality of the skin, here relatively minimized, is encountered throughout his oeuvre.[3]

Iconographically and stylistically, *San Gennaro* can be assigned to 1612. It represents the patron saint of Naples, and almost certainly would have been painted during Finson's sojourn to that city.[4] Furthermore, there are strong stylistic affinities with the aforementioned *Magdalene*, dated 1612, and with his *Self Portrait* signed and dated 1613.[5]

Notes: (1) See Pointel, 1847, pp. 3 ff.; Michiels, 1877, pp. 453 ff.; Bredius, 1900 and 1918; Bautier, 1921; and Schneider, ed. 1967, pp. 86–88, 133–34. (2) Bodart, 1966, pp. 118 ff. (3) For example, the *Beheading of the Baptist* in Braunschweig (Milan, 1951, no. 92). Isarlo, 1941, pp. 121–38, has published the most complete list of Finson's work. (4) An *Annunciation* in Aix is signed *Lodovicus Finsonius fecit in Neapoli anno 1612*; stylistically the Ganz picture should be assigned to this journey to Naples rather than to Finson's first trip, prior to 1610. (5) Ill. in Bredius, 1918, facing p. 197.

Figure 21. *Sta. Francesca Romana.* 19-1/4 × 26-3/8 inches. Copy after Spadarino. Palazzo Rosso, Genoa.

Figure 22. *Sta. Francesca Romana.* 18-1/4 × 27 inches. Copy after Spadarino. Whereabouts unknown.

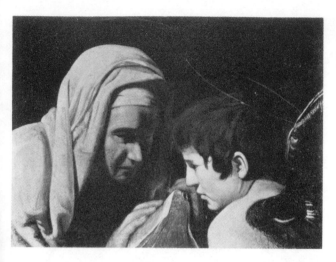

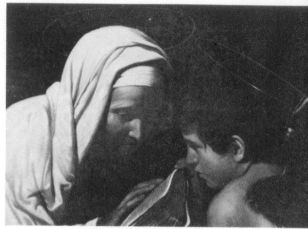

Figure 21. *Sta. Francesca Romana.* 19-1/4 × 26-3/8 inches. Copy after Spadarino. Palazzo Rosso, Genoa.

Figure 22. *Sta. Francesca Romana.* 18-1/4 × 27 inches. Copy after Spadarino. Whereabouts unknown.

GIACOMO GALLI (*"Lo Spadarino"*)
1580's?–after 1649

Spadarino's birth place and date are unknown, even though his name appears in Mancini's early list of Caravaggio's closest followers. He is first documented in Rome in 1597. In the middle of the second decade he participated in decoration of the Palazzo Quirinale with Saraceni, Lanfranco, and Tassi, and between 1625 and 1633 painted the Miracle of Sts. Valeria and Martial *for St. Peter's, his only documented preserved work. He is referred to as late as 1649. Longhi built around the documented altarpiece a group of paintings attributed to Spadarino, but it is not likely that one artist actually was responsible for all of them. On the basis of Longhi's reconstruction of Spadarino's style, Salini, Saraceni, and Orazio Gentileschi were closest to him, but until his oeuvre is better substantiated this remains hypothetical.*

27 *Santa Francesca Romana*

Ing. Dr. Edoardo Almagià, Rome.
16-1/2 (reduced) × 27-3/8 inches.
Collections: Cardinal Carlo Barberini and heirs, Rome (as Caravaggio); Colonna di Sciarra, Rome (as Saraceni).

Canonized by Paul V on May 9, 1608, Sta. Francesca Romana rapidly became a popular subject in Seicento painting. She was frequently represented together with her guardian angel, with whom she often conversed.

Longhi[1] first associated this composition with Spadarino, which is convincing if the *Charity of St. Omobonus* and *St. Thomas of Villanova* in Ancona are accepted as his work as well instead of Salini's.[2] These paintings reveal a particular tenderness in the treatment of the figures, whose humility is reinforced by the silence of broadly handled chiaroscuro. The youth receiving alms from Omobonus, for example, is designed and executed with a sensitivity that is paralleled in Francesca's angel but is foreign to the paintings definitely by Salini,[3] which compositionally tend to be fractured, spatially shallow, and awkward—confirming Caravaggio's own criticism of him as an artist.[4] It is reasonable to assume that *Sta. Francesca Romana* was painted relatively early in the century because it is closely allied with Caravaggio's art, but questions of chronology are premature so long as Spadarino (and Salini) remains poorly understood.[5]

Heretofore, three versions of this composition were known, in Perugia, Genoa (Fig. 21), and formerly in the Norris Collection, London (Fig. 22), the latter, according to Longhi, being the superior, but all three by

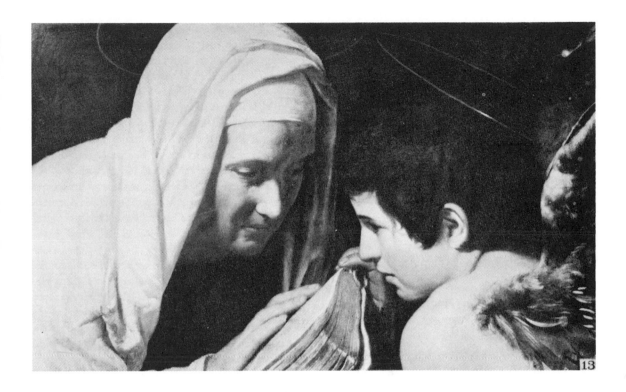

Spadarino himself.[6] (The Norris picture was recently sold at Sotheby's, March 4, 1970, lot 162.) The Almagià painting, however, presents a serious challenge to this thesis. Not only does it boast a distinguished provenance,[7] but in comparison with the other versions it is markedly superior, more subtly modeled in the skin and garments alike, raising the probability that all of the aforementioned paintings are copies[8] of the ex-Barberini, now Almagià, original.[9]

The Almagià canvas has been reduced by approximately two inches at the top.

Notes: (1) Longhi, 1943, p. 52, n. 60; and in Milan, 1951, no. 93. (2) Salerno, 1952, p. 30, attributed these pictures to Salini along with others of the "Spadarino group" (ill. in Moir, 1967, II, figs. 120–21). (3) There are only four: *St. Agnes* (lost), published by Zeri, 1955; *St. Nicholas of Tolentino*, S. Agostino, Rome (see Salerno, 1952, p. 29 and fig. 1); the *Four Martyr Saints* (see Salerno, 1952, pp. 29–30 and fig. 3, and 1954, pp. 254–55); and a recently discovered *St. Francis*, SS. Luca e Martina, Rome (see Rome, 1968, no. 32). Salerno's attribution of a *Baptism* in Rome to Salini is also convincing (Salerno, 1952, p. 30 and fig. 4). (4) See Cara-

vaggio's testimony during the 1603 libel case (Friedlaender, 1955, pp. 276–77). (5) In addition to Zeri's (1955) and Salerno's (1952, 1954) articles, for Salini see Longhi, 1950-b, Testori, 1954 (but also Naples, 1964, pp. 86–89); and Salerno in Mancini, ed. 1956–57, II, 48–49, n. 423, and 212, n. 1632. (6) Longhi, 1943, p. 52, n. 60, and 1959, p. 34. (7) Marilyn Aronberg Lavin kindly has pointed out that it appears in an inventory of Carlo Barberini's collection in 1692, as Caravaggio, 2 × 3-1/2 *palmi*. A complete description is found in a Barberini inventory of 1738, for which this author is indebted to Dr. Frances Vivian: "Altro largo pal. 2-1/2 alto 1-1/2 [22 × 13-1/4 inches] rapresentante due teste di Donna Vecchia, con panno bianco sopra il Capo in atto di leggere che si crede S. Fran^ca Romana, l'altra un Angelo, opera del Caravaggio, cornice antica intagliata a bottoncini, e dorata." The painting is cited in the Galleria Sciarra by various authors as Saraceni (e.g., Nibby, 1842, I, 32; Porcella, 1928, p. 411; and Ottani Cavina, 1968, p. 133, no. 113), which attribution it carried at the time of the Barberini-Sciarra division (see Mariotti, 1892, p. 136, no. 139 [the picture still bears this number in the lower right corner]). It passed to the Almagià Collection directly from the Sciarra's. (8) The version in Genoa unquestionably is much lower in quality. On the basis of photographs the other two also seem to be inferior and not by the same hand. (9) Since this catalogue has gone to press, Schleier (1971, pp. 91 ff.) has made a substantial contribution to our understanding of Spadarino.

ARTEMISIA GENTILESCHI

1593–1652/53

The daughter of Orazio, Artemisia was born in Rome in 1593, where she learned the art of painting during the decade of Caravaggio's maturity. In 1612 she was the subject of a scandalous lawsuit brought by Orazio against the painter Agostino Tassi, who was accused of "raping" Artemisia—"many, many times"! Nevertheless, she married a Florentine in late 1612 (later she lost track of him) and soon settled in Florence, where she is documented from 1614 to 1619. About 1620–21 she went to Rome, but probably traveled with Orazio to Genoa in 1621, returning to Rome by 1622. She remained there for an unknown number of years prior to moving to Naples before 1630. Except for a trip to England ca. 1638–40, she seems to have spent all of her last years in Naples, where she died in 1652 or 1653.

Artemisia's importance for the dissemination of Caravaggesque chiaroscuro and realism should not be underestimated. In addition to her influence in Rome (and especially upon Vouet, which in part remains to be clarified), she must be counted among the principal sources in the development of Florentine and Neapolitan painting in the second quarter of the century, even though her firmer, dramatic, more strictly Caravaggesque style of the early decades slowly gave way to a modified, Bolognese-oriented attitude.

28 *Judith and Holofernes*, ca. 1625

The Detroit Institute of Arts (gift of Leslie H. Green).

72-$\frac{1}{2}$ × 55-$\frac{3}{4}$ inches.

Collections: Prince Brancaccio, Rome.

"And [she] took hold of the hair of his head, and said, Strengthen me, O Lord God of Israel, this day. And she smote twice upon his neck with all her might, and she took away his head from him, and tumbled his body down from the bed, and pulled down the canopy from the pillars; and anon after she went forth, and gave Holofernes his head to her maid; and she put it in her bag of meat..." (Judith 12:7–10).

No subject attracted Artemisia Gentileschi more frequently than the story of this courageous woman. An early painting in the Palazzo Pitti[1] represents Judith and her maidservant, half-length, fleeing with the head of Holofernes in a basket. Artemisia's most violent conception,[2] also from the Florentine years but inspired by Caravaggio's painting of this subject in Rome (Fig. 4), is strikingly gory and labored in design. The Detroit painting, however, belongs to the mid-1620's,[3] when in Rome Artemisia achieved an excellent balance between her early melodrama of contrived movement and exaggerated expression on the one hand and her late détente in Naples on the other. Here Judith is in full command, watchful of intruders but sure of her actions. Earlier, in the painting in the Uffizi, Artemisia described in a forthright, realistic manner two women struggling with a difficult, disagreeable duty. In the Detroit painting, light becomes the primary bearer of drama. An evocative, strong chiaroscuro intensifies the momentary guarded silence, while broad passages of colored garments reminiscent of Orazio enrich the dark chamber. If the choice of candlelight may have been inspired by Honthorst, Artemisia's use of it is predictably bolder.

Artemisia's détente in Naples is exemplified by her late repetition of the Detroit composition,[4] where virtually every change lessens the impact of the earlier version.

Notes: (1) See Bissell, 1968, p. 155 and fig. 1. (2) See Bissell, 1968, p. 156 and fig. 2. (3) Bissell's chronology (1968) is basically convincing (see especially, pp 157–58). The Detroit painting was unknown at the time of Longhi's important article on the Gentileschi (1916). Richardson, 1952–53, suggested the early to mid-1620's, but in Detroit, 1965, no. 8, Moir proposed the late teens, which he reconfirmed in 1967. I, 101. (4) See Bissell, 1968, pp. 163–64 and fig. 24.

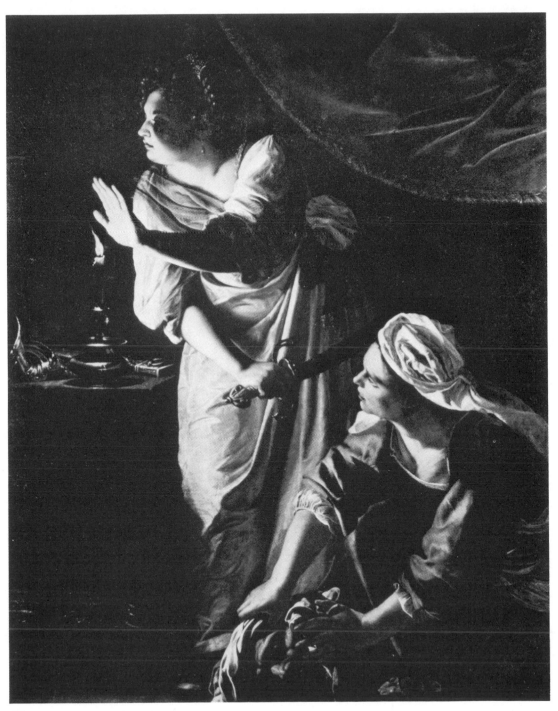

29 *Self-portrait as "La Pittura,"* ca. 1630

Her Majesty the Queen, Hampton Court.
38 × 29 inches.
Initialled A.G.F. on the table, center.
Collections: Royal English collections (with interruption) since Charles I.[1]

Michael Levey has demonstrated that this excellent painting is definitely a self-portrait of Artemisia, for it fully corresponds with two known likenesses of her; it also conforms to Ripa's instructions for representations of *La Pittura* (Painting) by including a golden chain, a mask pendant, untidy black hair, and "drappo cangiante" (garments with broken colors).[2]

Although once famous as a portraitist, Artemisia is little known today in this genre.[3] In addition to a signed and dated portrait of 1622 in Bologna,[4] only this *Self-portrait* is securely hers, and its date is uncertain. Artemisia's letters to the illustrious antiquarian Cassiano dal Pozzo[5] of 1630 and 1637 refer to a *Self-portrait*, but it is unknown if one, or two, paintings were involved, and there is no evidence that the Queen's painting is necessarily one of them.[6] On the basis of style and age of the artist (she cannot possibly be beyond her early thirties), Levey's hypothesis[7] that this is the picture painted—but not delivered—ca. 1630 for Cassiano is reasonable, and it is more convincing than Bissell's argument[8] that it may date ca. 1637 and falsify her appearance. Cassiano himself may well have dictated the Ripa-based allegory.

Notes: (1) See Levey, 1962, p. 79, and 1964, no. 499, for the provenance. (2) Levey, 1962, p. 80 (3) See Bissell, 1968, p. 157, n. 40. (4) Ill. in Bissell, 1968, fig. 8. (5) Published in Bottari and Ticozzi, 1822, I, 348–51. (6) See the discussions in Levey, 1962, and 1964, no. 499; and Bissell, 1968, p. 162. (7) Levey, 1962, and 1964, no. 499. (8) Bissell, 1968, p. 162. The portrait in the Palazzo Corsini (Bissell, 1968, fig. 19) does not appear to be a self-portrait of Artemisia.

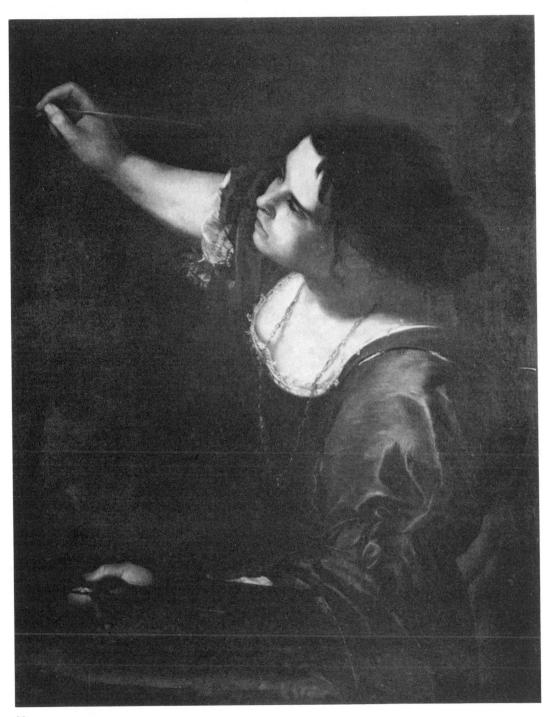

ORAZIO GENTILESCHI

1563–1639

*Pisan by birth (1563), Orazio was trained in the Florentine
tradition prior to settling in Rome in 1576 or 1578, that is,
approximately fifteen years before Caravaggio's arrival (in
which year, 1593, his first child, Artemisia, was born). Ora-
zio's personal friendship with Caravaggio is fully documented
in the testimony of the Baglione libel suit (1603), when Cara-
vaggio stated that he had not seen Orazio in three years, but
Orazio modified this to six or eight months and added that
he had lent Caravaggio some studio props. (Caravaggio, how-
ever, maintained that Orazio was not then speaking to him,
and that he, Caravaggio, did not consider Orazio to be among
the select* valentuomini [truly good painters]). Through his
interest in Caravaggio's work, Orazio developed a highly
personal style that combined a decorative Tuscan elegance with
Caravaggio's naturalistic clarity. His paintings from ca. 1605
to ca. 1615 occasionally employ a dramatic chiaroscuro as well.
Orazio may have made a brief trip to Florence in the middle
of the second decade, in addition to his well-known activity
in the Marches. He left Rome for good in 1621 and traveled
to Genoa, where he worked for one or two years; he probably
stayed briefly in Turin, then moved to France ca. 1623–24 for
two years, finally settled in London in 1626, and died there in
1639. Orazio's art has a significance that extends beyond its
very high quality, for it was influential on painters from var-
ious parts of Europe, transmitting a poetic, sometimes lyrical,
interpretation of Caravaggio's style that found its final ful-
fillment in Utrecht and Delft.*

30 *Judith with the Head of Holofernes,* ca. 1610–12

The Wadsworth Atheneum, Hartford,
Connecticut (the Ella Gallup Sumner and Mary
Catlin Sumner Collection).
52-1/2 × 61-3/4 inches (enlarged at top and left
side).
Collections: Pietro Gentile or Carlo Cambiaso,
Genoa;[1] Sir Hugh Cholmondeley, England;
David Koetser, New York.

Artemisia's predilection for this subject [28] may be ex-
plained on feministic grounds, but Orazio's superb early
interpretation of it certainly must have been the initial
stimulus.[2] The Hartford picture exemplifies Orazio's
talent for striking a series of perfected balances. Bulky,
expressive women are contained within a very simple
triangular design that expertly cradles the severed head
of Holofernes yet feeds the drama of keen watchfulness.
The strong illumination on the figures intensifies the
blackness beyond, reveals the brilliantly rich, compli-
cated garments, but also intensifies the figures' poignant
isolation.

The Hartford picture belongs to a relatively short
phase around 1610[3] when Orazio had assimilated into
his own vision—and not yet discarded—Caravaggio's
sense of space, light, and expression.

Two other versions of this *Judith* are known. One is
in the Vatican,[4] and a second, definitely a copy, was
on the Italian market in the 1920's.[5]

Notes: (1) See Bissell, 1966, II, 105 ff., no. 20, and 1967, p. 76, n.
11. Van Dyck sketched this composition, almost certainly when
he was in Genoa (Chatsworth sketchbook). (2) For Orazio's
paintings on this theme in general, see Bissell, 1966, II, 95 ff. (3)
See Bissell, 1966, I, 55 ff., and II, 105 ff., no. 20; and Moir, in
Detroit, 1965, no. 6, and 1967, I, 70–71. The Hartford painting
was unknown at the time of Longhi's important article on the
Gentileschi (1916). (4) See Redig de Campos, 1939. The Hartford
version is superior; it is doubtful that Orazio is responsible for the
Vatican picture. (5) Voss, 1924, p. 461 (Rome, Jandolo).

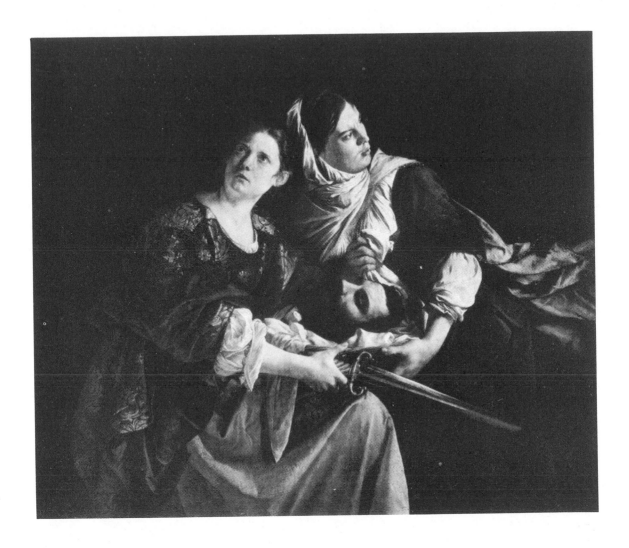

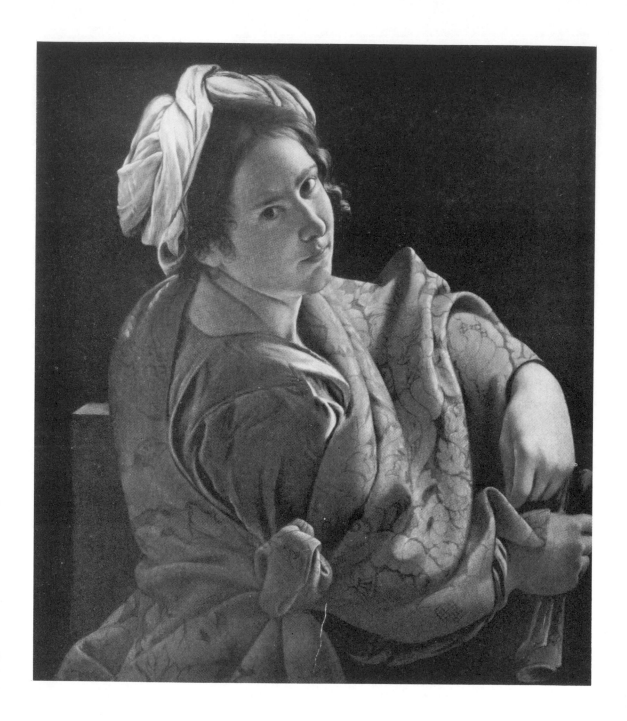

31 *A Sibyl*, ca. 1620?

The Museum of Fine Arts, Houston, Texas
(The Samuel H. Kress Collection).
$31-3/8 \times 28-1/4$ inches.
Collections: English private collection; Christie's,
June 22, 1951, lot 88 (as Artemisia); David
Koetser, New York; Kress Collection,
New York.

The presence of a slab inscribed with hieroglyphics indicates that this charming young woman may represent a sibyl.[1] The attribution to Orazio is confirmed by the richly designed golden-yellow and maroon embroidered cape and silver-blue blouse; the heavy, thick hands [cf. 30]; the facial type itself, gracefully drawn, with intense dark eyes (with only a hint of the eyelids visible), a fleshy cleft chin, slightly pursed, youthful lips, and an even, clear complexion; and, above all, by the subtle play of light and transparent shadows set off by unrelieved darkness.

A precise date for this picture is difficult to establish. Parallels with Orazio's late Italian years are found in such works as the *St. Cecilia* in Washington[2] and the "*Rosei*" *Madonna* in Urbino,[3] works that were executed shortly before Orazio's departure for Genoa.[4] The relatively light tonality, the freely brushed blouse, and the increased fleshiness of the young woman indicate that the painting may belong to Orazio's last years in Rome.[5]

The suggestion[6] that Artemisia served as the model for this *Sibyl* is not convincing.

Notes: (1) See the late *Sibyl* by Orazio at Hampton Court (Levey, 1964, no. 500). (2) Ill. in Moir, 1967, II, fig. 71; Bissell, 1966, II, 173–75, no. 33 (also as 1615–20). The forthcoming catalogue of Kress paintings by Fern Rusk Shapley assigns the *St. Cecilia* and the Houston *Sibyl* to the first decade of the century. (Mrs. Shapley kindly made available to this author the Houston entry.) (3) Ill. in Rosci, 1965, pls. VI–VII (color); Bissell, 1966, II, 168–71, no. 31. (4) Moir, 1967, I, 75 and n. 22, reached these same conclusions. (5) Bissell, 1966, tacitly rejects the Houston painting—at least as an "Italian period" Orazio. For the subsequent phase in France, see Sterling, 1958. (6) Houston, 1953, pl. 18.

32 *Danäe*, 1621–22

The Cleveland Museum of Art (John L. Severance
Fund).
$63-3/4 \times 90$ inches.
Collections: presumably Giovanni. Antonio Saoli
(Saulli), Genoa; private collection, England; Hazlitt Gallery, London.

In 1621, at the invitation of Giovanni Antonio Saoli (Saulli), Orazio Gentileschi traveled to Genoa, where he stayed for one or two years. (From Genoa he went on to Turin and then to France and England, never to return to Italy.) The Genoese biographer Soprani[1] records that Orazio's first work in Genoa consisted of three paintings for Saulli: a *Penitent Magdalene*, *Lot's Family Fleeing Sodom*,[2] and a *Danäe with Jove in a Shower of Gold*, which Soprani remarked was the most beautiful of the three. The many versions of the *Magdalene* and *Lot* that are known today stem from the French[3] and English[4] phases of the artist's activity, whereas Orazio's Genoese prototypes remain lost. (A *Lot* [Fig. 23] recently discovered in England and acquired by the Berlin Museum seemingly cannot be identified with Saulli's picture.)[5] There is no known mention of the *Danäe* after 1792, when Da Morrona saw it in the Palazzo Saulli[6] and stated that it alone of Orazio's three paintings remained in the Palace. It reappeared in England—without clear evidence of its provenance—and now has entered the collections of The Cleveland Museum of Art.

The popularity of the *Magdalene* and *Lot* was not shared by the *Danäe*, for no variations or copies of the painting are known. It is, however, a typical Genoese Gentileschi. Compositionally, its closest parallel is the *Penitent Magdalene* (Fig. 24), which was designed during the same phase of the artist's career. The general disposition of the bodies of the recumbent figures is surprisingly identical, and their "moon faces with broad cheeks, full chins…sturdy arms delineated in sluggish curves… [and] feet which subscribe to a classic norm, with…long toes and chiselled nails,"[7] unmistakably belong to a single instant in the painter's conception of the female body. Orazio's interest—and patience—in designing a sea of folds created by disarrayed sheets wrapped around a mattress again took form in the Turin *Annunciation*,

Figure 23. *Lot and His Daughters.* 64-3/4 × 76 inches. Orazio Gentileschi. Staatliche Museen Preussischer Kulturbesitz, Gemäldegalerie Berlin (West).

Figure 24. *The Magdalene.* 64-1/8 × 81-7/8 inches. Orazio Gentileschi. Kunsthistorisches Museum, Vienna.

which also was painted during his Genoese sojourn.[8]

For the subtle sense of line (Orazio never lets one forget that he was Tuscan), the bold clear colors, and the luminescent skin, *Danäe* perfectly summarizes Orazio's Italian years. But at the same time, it foreshadows the French and English pictures, where generalized forms and decorative patterns increasingly took precedence over meticulously painted details and logical body movement to an extent that the last paintings are embarrassingly stiff. The weighty monumentality of *Danäe* and the clarity of the narrative conception, verging as they do on histrionic drama, predictively touched the French sensibility, and thus painters like Philippe de Champaigne and Laurent de la Hyre, and even Louis Le Nain, were attracted to Orazio's art of the early 1620's.[9]

Notes: (1) Soprani and Ratti, ed. 1768, I, 452. (2) Sterling, 1958, p. 117, n. 36, points out that Soprani calls the painting *Lot's Family Fleeing Sodom* rather than *Lot and His Daughters*; but it is probable that Soprani used the former title, as imprecise as it may be, for

the latter subject (Bissell, 1966, II, 205, and 1969, p. 31, App. II, 1, reached the same conclusion). (3) See Sterling, 1958, pp. 117–18, and nn. 29–37; and Bissell, 1969. (4) As early as 1628, Sandrart saw paintings of these subjects in Orazio's London studio (Sandrart, ed. 1925, p. 166). In addition to Sterling (cf. n. 3 above), see Moir, 1967, I, 76, n. 24, and 197, n. 4, and the lists of versions and copies in II, 75–76, 77, and 78 (with further bibliography); and especially Bissell, 1969, pp. 30–33, App. I and II. (5) Saulli's picture probably was the lost version formerly in the Theophilathos Collection, Genoa (for which, see Bissell, 1969, p. 30, App. I, 1; App. II, 1; and p. 20, fig. 5). The picture in Berlin, to judge from photographs, cannot be identical with the ex-Theophilathos canvas (see Bissell, 1969, pp. 32–33, App. II, 7, for the Berlin *Lot*). It should be noted, however, that the Cleveland and Berlin pictures are both painted on two pieces of canvas joined by a vertical seam and that the fabrics could be identical. If this is the case, the *Danäe* and Berlin *Lot* logically should stem from the same phase of Orazio's career, but this question, as well as the full history of the paintings, remains to be clarified. (6) Bissell, 1969, p. 30, App. I, 1. (7) See Sterling's excellent characterization of Orazio's figure style (Sterling, 1958, p. 114 *et passim*). (8) Ill. in Rosci, 1965, pl. X (color); Baudi di Vesme says that the *Annunciation* was sent from Genoa (Moir, 1967, I, 75, n. 20). (9) See Sterling, 1958, for a provocative analysis of Orazio's influence in France.

104

Figure 25. *Concert*. 47-1/4 × 55-1/2 inches. Copy after Grammatica. Whereabouts unknown.

ANTIVEDUTO GRAMMATICA

Ca. 1571–1626

Born of Sienese parents, Grammatica spent his entire career in Rome, where first he was trained by Giovanni Domenico Angelini of Perugia before becoming an independent artist in the early 1590's. Grammatica undoubtedly knew Caravaggio and possibly employed him in his studio. His fame rests in part on youthful portraits which unfortunately have not been identified but probably were painted in a Caravaggesque style, although his earliest altarpiece (in S. Stanislao dei Polacchi, Rome) yields no hint of his friendship with Caravaggio. Grammatica was patronized by Cardinal del Monte and the Giustiniani— two of Caravaggio's principal supporters—and was busy with numerous public commissions, including his best-known altarpiece, the Dream of St. Romualdo *(Frascati) of ca. 1619– 20. Grammatica was in touch with many artists in the second and third decades of the century, among whom must be mentioned Borgianni and Vouet, Mao Salini (with whom he quarreled), and probably Saraceni. Early in the 1620's Grammatica became embroiled in the politics of the Accademia di San Luca. He died in Rome in 1626.*

33 *A Theorbo Player*, ca. 1610–15

Galleria Sabauda, Turin.

46-7/8 × 33-1/2 inches (fragment).

Collections: perhaps Cardinal Francesco del Monte, Rome; Marchesi Falletti di Barolo, Turin.

Long attributed to Caravaggio,[1] the *Theorbo Player* was first assigned to Grammatica by Longhi.[2] It is a fragment from a three-figured *Concert* (Fig. 25) in which the theorboist turned toward a woman harpsichordist and a youth playing a flute at the left.[3] Among a group of Grammatica's pictures owned by Cardinal del Monte[4] was "Un quadro con Una Musica di mano dell Antiveduto con Cornice negra longa Palmi sei alt[a] palmi cinque [52-7/8 × 44 inches]." The vertical height of Del Monte's *Una musica* corresponds well with the Turin fragment, and the width of the lost copy is close to the measurements cited in the inventory, raising the possibility that the *Theorbo Player* once belonged to Caravaggio's famous patron.

The clarity of light, precise depiction of details, en-

closing backdrop, and half-length design are all related to Caravaggio's genre paintings, but also to his lost *Portrait of a Woman*. One might reasonably hypothesize that Grammatica's early portrait style is reflected in the *Theorbo Player*, even though its date may be as late as ca. 1615.[5] It unquestionably is among Grammatica's finest preserved works, and if stylistically it is dependent upon Caravaggio's naturalism as exemplified in the *St. Catherine* [16], it nevertheless conveys a personal combination of ordered frontality, informal playing, and intelligent alertness.

There is a basic compositional similarity between the Turin picture and Ribera's lost *Sense of Hearing* (Fig. 37), which was painted in Rome about the same date as Grammatica's painting [cf. 55–56]. In fact, a copy of the lost Ribera has erroneously been attributed to Grammatica himself,[6] apparently without knowledge of the prototype.

Notes: (1) See Milan, 1951, no. 115. (2) Longhi, 1968-b [1928–29], p. 139, and pl. 196 (color). (3) See Voss, 1923, p. 79; this copy of the complete composition, attributed to Cantarini, was sold at the Michelsen sale, Bangel, Frankfurt a/M., 1922, no. 127 (Bangel cat. no. 1030): 47-1/4 × 55-1/2 inches. (4) Chandler Kirwin kindly has shown to this author an unpublished inventory of Cardinal del Monte's collection, dated 1627 (on which, cf. cat. no. 16, nn. 3 and 5, and Kirwin, and Frommel, in press). Marino, 1968, p. 79, n. 4, rejected the *Theorbo Player* as Grammatica's and

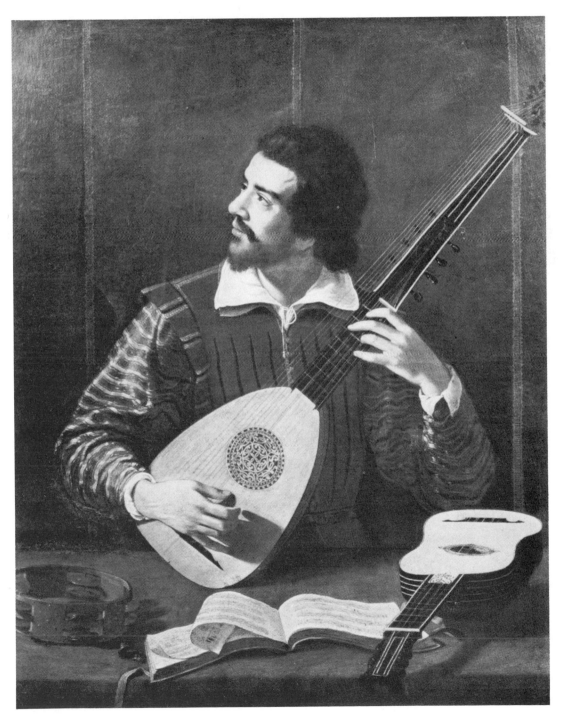

Figure 26. *St. Cecilia.* 39-3/8 × 49-5/8 inches. Grammatica. Museu Nacional de Arte Antiga, Lisbon.

34 *Judith with the Head of Holofernes,* ca. 1620–25

Nationalmuseum, Stockholm.
47-1/4 × 36-5/8 inches.
Collections:[1] M. G. de la Gardie (?); Sack, Bergshammar; King Gustav III (as Caravaggio).

Variously attributed to Fetti, Artemisia Gentileschi, or Caravaggio, *Judith* was recognized as Grammatica's work by Longhi,[2] who assigned it to the 1620's, when the artist was involved with the affairs of the Accademia di San Luca.[3] The robust conception of Judith and the chiaroscuro and drapery style are closely paralleled in Grammatica's *Mary and Martha* in Turin,[4] which has been assigned to Grammatica's early period[5] but seemingly should be placed in the 1620's as well.

The stylistic development of Grammatica remains to be traced, but on the basis of the meagre available evidence it is reasonable to assume that the stiffer, more sharply modeled forms belong to his earlier years and the softer, fuller ones to the later period. Like the *Judith* in Stockholm, the *Adoration of the Shepherds* in San Giacomo degli Incurabili—presumably one of Grammatica's last paintings[6]—retains a Caravaggesque clarity of design and chiaroscuro, but reveals an idealization of figure types and an interest in Caravaggio's followers, among whom Borgianni and Artemisia Gentileschi must be cited. Angela Marino's summary rejection[7] of the Stockholm *Judith* is completely unjustified, for it clearly is by the same hand as the *St. Cecilia with Angels* in Lisbon (Fig. 26), signed ANTIVEDUTUS DE GRAMMATICA. ROM. FECIT.

Notes: (1) See Stockholm, 1958, p. 82, no. 11. (2) Longhi, 1968-b [1928–29], p. 139, and pl. 197 (color). (3) For Grammatica's involvement in the Academy, see Bousquet, 1952, pp. 291 ff. (4) Ill. in Longhi, 1968-b, pl. 203. (5) Longhi, 1968-b [1928–29], p. 139. (6) Baglione, 1642, p. 293, suggests that it was painted at the end of his career (ill. in Longhi, 1968-b, pl. 201); Marino, 1968, p. 56 and p. 81, n. 28, argues for an "earlier" dating without providing a clear indication of her understanding of Grammatica's development. (7) Marino, 1968, p. 80, n. 8.

argued that there is no evidence that Grammatica painted such genre themes—a position now refuted by the Del Monte inventory. (5) See Moir, 1967, I, 93; Longhi first suggested ca. 1615. (6) Binghamton, 1969, no. 24 (ill.).

GERRIT VAN HONTHORST

1590–1656

Honthorst was born in Utrecht in 1590 and became a pupil of Abraham Bloemaert. Ca. 1610–12 he traveled to Italy, where he remained until 1620, profiting from the patronage of the Giustiniani, Borghese, and the Grand Duke of Tuscany. His famous Beheading of the Baptist in Santa Maria della Scala is a nocturne, characteristic of the works which led the Italians to call Honthorst "Gherardo delle Notti." In Rome, Honthorst undoubtedly would have been in touch with Terbrugghen (prior to his return to Utrecht in 1614), Baburen, a number of the Italian followers of Caravaggio, and perhaps the Frenchman Bigot.

After returning to the North in 1620, Honthorst remained in Utrecht through 1627 (the year Rubens visited him). In 1628 he worked in London for Charles I. The remainder of his life was spent primarily in The Hague and then in Utrecht from 1652 until his death in 1656.

Honthorst painted numerous portraits and introduced illusionistic ceiling decoration into Dutch interiors in addition to sharing with Terbrugghen—especially in the 1620's—the leadership of the Utrecht Caravaggisti.

35 *Samson and Delilah*, ca. 1618–20

The Cleveland Museum of Art (Mr. and Mrs. William H. Marlatt Fund).

50-7/8 × 37 inches.

Collections: private collection, Italy; Hazlitt Gallery, London.

Honthorst's Roman sojourn extended from ca. 1610–12 until 1620 and closed with a series of poetic nocturnes which include some of his finest paintings. His well-known *Beheading of the Baptist* in Rome (1618)[1] was a direct source for his *Samson and Delilah*,[2] but together both pictures owe a great debt to Caravaggio's *Judith and Holofernes* (Fig. 4), in which the youthful heroine quietly carries out her mission with a matter-of-fact objectivity and is assisted in her task by an old wrinkled servant.[3] If Samson's and the Baptist's silence is basically different from Holofernes' anguished but futile struggle, the psychological contrasts expertly established between the figures are nevertheless an essential part of both art-

ists' conceptions. Each painter also exploits the dramatic potential of strong chiaroscuro, but Honthorst's use of a visible candle is markedly different from Caravaggio's typical sharp raking light that cuts the darkness from an unrevealed external source. Furthermore, the dominant golden brown and red colors of *Samson and Delilah* are as characteristic of Honthorst's palette as they are atypical of Caravaggio's, just as Delilah's gentleness would fit more in the repertory of Bigot, La Tour, or Terbrugghen[4] than in that of the Italian master.

Samson and Delilah brings together a variety of artistic currents which stem from Northern, Venetian, and Roman sources[5] and which directed Honthorst to produce some of his most successful paintings in the years around 1620.[6] By understanding and absorbing the richnesses encountered during his travels, Honthorst became one of the essential links between Caravaggio and La Tour and Rembrandt.[7]

A second version of the Cleveland painting was recently in the trade in the Netherlands.[8]

Notes: (1) See Judson, 1959, p. 158, no. 30, and fig. 6. (2) See Lurie, 1969, pp. 336, 337–40; her dating of the painting between 1618 and 1620 (p. 340) is convincing. (3) Lurie, 1969, pp. 339–40, suggests that this figural type may be related to Ripa's "Silence." (4) Lurie, 1969, pp. 340, 342, compares the Cleveland picture with La Tour's *St. Peter Repentant* [39] and Terbrugghen's *St. Sebastian Tended by St. Irene* [68]; La Tour's *St. Sebastian* [38] also should be compared with the *Samson and Delilah*. (5) For a discussion of Honthorst's artistic heritage in the North and Venice, see Judson, 1959, pp. 1 ff. Lurie, 1969, pp. 333 and 343, n. 7, sees Rubens' *Samson and Delilah* as a source of Honthorst's picture as well as the influence of Saraceni (p. 339), d'Arpino, and Reni (pp. 343–44, n. 17). (6) For example, his pictures of a *Merry Company* and the *Procuress* (ill. in Judson, 1959, figs. 9, 17, and 37). (7) Jan Lievens was directly influenced by Honthorst's *Samson and Delilah* (see Lurie, 1969, pp. 333 and 334, fig. 3). (8) See Lurie, 1969, pp. 333 and 343, nn. 5 and 6; known to this author only in a poor photograph.

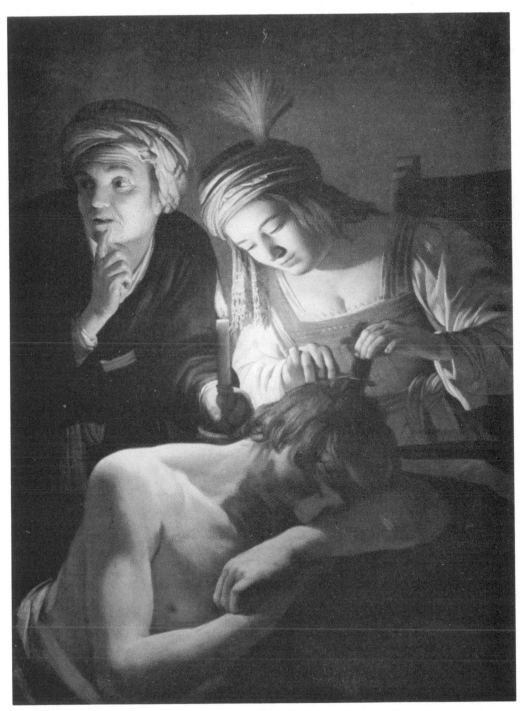

Figure 27. *Merry Toper.* 30-1/2 × 26-1/8 inches. Honthorst. Mayer Collection, Mexico City.

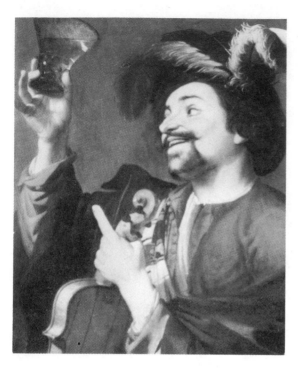

36 *The Merry Violinist*, ca. 1623

Earl C. Townsend, Jr., Indianapolis.
32-1/2 × 26-1/2 inches.
Signed upper right (partially reinforced).
Collections:[1] probably Auction Goll, Vienna, November 25, 1897, no. 18 (ex-collection: Arthaber); Porgés Collection; probably Lepke, Berlin, July 16–17, 1933, no. 306, and November 21, 1933, no. 117; Brocart Collection, Nice; Galerie Heim, Paris.

Typical of Honthorst's half-length figures,[2] this merry violinist, dressed in what resembles a Burgundian theatrical costume,[3] possibly represents "taste" and hence may have belonged to a series of the senses.[4] It is exceptionally similar in both style and iconography to a painting of the same title in the Rijksmuseum dated 1623;[5] and compositionally it is intimately related to a *Merry Toper* in Mexico City (Fig. 27).[6]

Pictures of this type are important links between the Caravaggio-Manfredi tradition [45] and later Dutch artists, especially Hals. Honthorst has completely transformed the sinister *bravo* type, or the equally well-known effeminate youth, into a hearty, gregarious toper-musician.

Despite a recent summary rejection of the Townsend picture,[7] there is little reason to question either its authenticity or its signature (only the letters *ont* are reinforced).

A copy of the *Merry Violinist* is in the Crocker Art Gallery, Sacramento, California.[8]

Notes: (1) Judson, 1959, pp. 231–32, no. 170, and Paris, 1956, no. 33. (2) See Judson, 1959, *passim*, and 1969. (3) Gudlaugsson, 1938, pp. 30, 68. (4) Judson, 1959, pp. 65 ff., and 1969; and Carter, in Indianapolis, 1958, no. 84. (5) Judson, 1959, fig. 26. (6) Judson, 1959, p. 232, no. 170a; rejected by Braun, 1966, p. 330, no. 32. (7) Braun, 1966, pp. 330–31, no. 33, lists the Townsend picture among false attributions, noting only that "Die Konstruktion der Geige sowie die Lage des Bogens sind ganz missverstanden." (8) Ill. in *Apollo*, XXXII, 1940, 136, fig. 1 (as Terbrugghen); see Nicolson, 1958-a, p. 127, no. E 112.

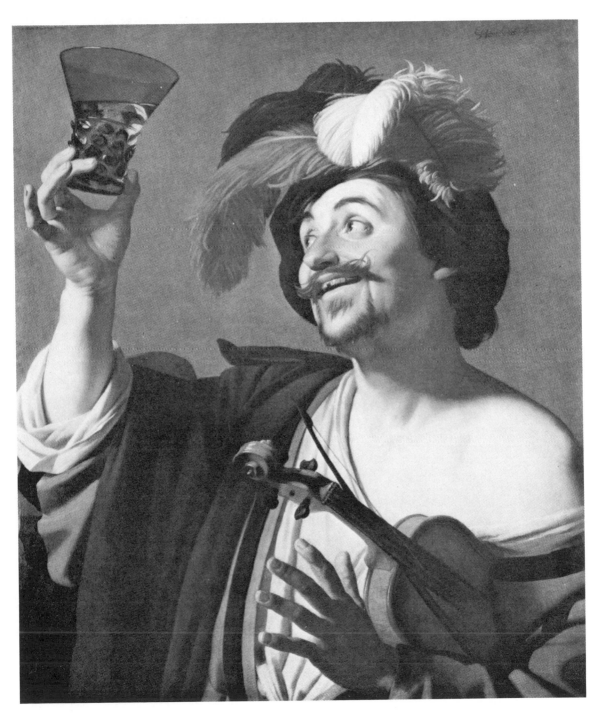

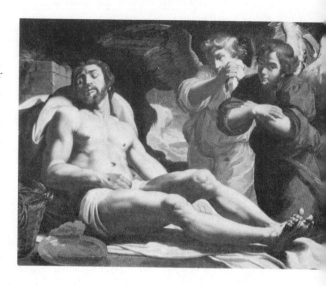

ABRAHAM JANSSENS

Ca. 1573/74–1632

Abraham Janssens was born in Antwerp in the earlier 1570's, and is documented in Rome in 1598. Although he is one of the earliest Northern artists of a Caravaggesque tendency to arrive in Italy (long before the Utrecht painters), his Diana and Callisto *of 1601 in Budapest is thoroughly Manneristic and Northern in spirit, without a trace of Caravaggio's influence. He was back in Antwerp by 1601, when he became a master painter, but since various pictures from the following years do show a generic relationship with Caravaggio, a second trip to Rome in the middle of the first decade of the century has been postulated. It is more probable, however, that his naturalism developed slowly in the North after an initial contact with Caravaggio's work in Rome.*

Janssens must be credited with developing a kind of naturalistic classicism that presaged Rubens' and Jordaens' early styles. His starkly modeled forms are immobile and very somber in countenance, often Caravaggesque per se but arranged with a Manneristic touch. Janssens' later works reveal a greater dependence upon Rubens, particularly as one approaches the end of his career in 1632. Prior to their departures for Italy, Ducamps, Renieri, Rombouts, and Stomer all studied under Janssens.

37 *Philemon and Baucis,* ca. 1615–20

Wellesley College Museum, Wellesley, Massachusetts.
58-1/2×90 inches.
Collections: the artist's widow (list of 1644); Joseph Bonaparte, Bordentown, New Jersey;[1] William Brett, London; Christie's, June 25, 1948, lot 137 (as M. Caravaggio); David Koetser, New York; Julius Weitzner, New York; Dr. and Mrs. Arthur K. Solomon, Cambridge, Massachusetts.

Two old peasants receive Mercury and Jupiter disguised as mortals and humbly offer them cordial hospitality. "Trembling old Philemon" (Ovid, *Metamorphoses*, viii, 682) reveals Janssens' typical conception of aged faces: full of deep, curving wrinkles, summarily modeled, and generalized to the point of resembling rubber masks.

A contrast of mortal age (Philemon and Baucis) and divine youth (Mercury and Jupiter) is cleverly established through the juxtaposition of tight and loose brushwork. Ovid (viii, 674 ff.) describes the fruits and nuts served to the gods, but it is clear that Janssens paid little heed to the text, preferring a still life derived from Caravaggio (Fig. 1) and a general composition related to the Italian's representations of the *Supper at Emmaus.*

The affinities with Italy, however, are not strict in Janssens' work. He is never a thoroughly Caravaggesque painter. The Wellesley picture probably represents a transitional phase when Janssens was passing from a very personal mixture of late Northern Mannerism and Caravaggio, to a kind of Rubensian Caravaggism.[2] The extremely hard modeling of his *Pietà*[3] and *Dead Christ Mourned by Angels* (Fig. 28)[4] is relieved, and the Mannerism of those pictures is gone. The lighting, however, remains relatively sharp, and the contrasts of values are greater than in his later, lighter pictures. Thus, ca. 1615–20[5] may be correct, although the chronology of Janssens' work remains highly problematical.

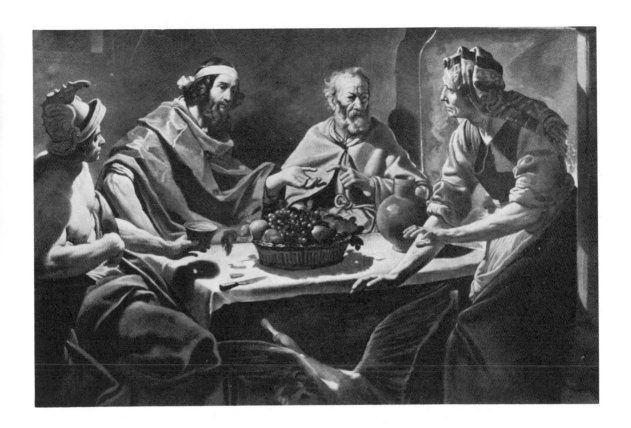

Notes: (1) See Shell and McAndrew, 1964, pp. 69–70. (2) See Oldenbourg, in Clemen (ed.), 1923, pp. 243 ff.; especially Pevsner, 1936, pp. 120 ff.; Longhi, 1965, pp. 51–52; and Müller Hofstede, in press. (3) Versions in Valenciennes and Vilvoorde (see Utrecht, 1952, no. 97), and, Bob Jones University, Greenville, S. Carolina (ill. in Longhi, 1965, pl. 45, as Viennese private coll.). (4) The Metropolitan Museum of Art, New York, Gift of James Belden in Memory of Evelyn Berry Belden (46 × 58-3/4 inches, ex-coll: Parker [Christie's, May 9, 1958, as Caracciola (sic), bought in, and December 12, 1958]); this unpublished picture probably precedes the aforementioned *Pietà* by a year or two, and the *Burdens of Time* (ill. Held, 1952, fig. 3) of 1609 by approximately four or five years. (5) Held suggested 1615–25 (1952, p. 12), with which Gilbert later concurred (1960, no. 11).

GEORGES DE LA TOUR

1593–1652

The definitive biography of Georges de La Tour remains to be written. It is known that he was born in Vic-sur-Seille in 1593, and that in 1620, the year before his son Étienne was born, he settled in Lunéville, where he spent his mature career. La Tour was patronized by the Duke of Lorraine in 1623–24, and in 1639 he was cited as "Peintre du Roi." Numerous documents refer to Georges de La Tour or his family through-out the decades of the 1620's and 1630's, but from 1636 until 1642 they are erratic and very infrequent, with lapses long enough that a trip to Paris or the Low Countries has been hypothesized for this period. Except for a documented visit to Nancy (whose artistic heritage must be taken into account for an understanding of La Tour, as must be Le Clerc's presence there after ca. 1621), La Tour spent his last ten years in Lunéville, where he and his wife died in an epidemic of 1652. His son Étienne, with whom he probably collaborated and who un-doubtedly is responsible for a number of paintings attributed to Georges today, survived him. In addition to the problematic journeys to Paris or the Low Countries, it is unknown if La Tour visited Italy; if so, his visit logically would have oc-curred prior to his settling in Lunéville, although a late trip also has been hypothesized. The Dutch Caravaggisti un-questionably influenced La Tour most directly, but two argu-ments support an Italian sojourn: it was usual for young Lor-raine artists to visit Italy, and, more importantly, the pro-fundity of expression that is characteristic of mature La Tour finds its only true parallel in the art of Caravaggio himself. Equally problematic are the questions of chronology—La Tour dated only two known pictures (St. Peter Repentant [39] of 1645 in Cleveland and the Denial of St. Peter in Nantes, dated 1650)—and of authenticity, for Étienne's work, school pieces, and countless later replicas still carry the name of the master.

38 *St. Sebastian Tended by St. Irene,* ca. 1632–33?

Nelson Gallery-Atkins Museum, Kansas City, Missouri (Nelson Fund).
41-1/4 × 54-7/8 inches.
Collections: the Amsterdam trade (1950).

La Tour's representation of Sts. Sebastian and Irene is comparable to Terbrugghen's [68] in the pyramidal ar-rangement of the three figures and especially in the em-phasis on silent, patient care administered by the holy women. La Tour, however, characteristically chooses a nighttime setting and allows generalized shapes to be-come primary bearers of meaning. A comparison of hands alone in the two pictures could serve to emphasize the differences between La Tour's and Terbrugghen's artistic attitudes.

La Tour simplified and generalized what the average academically trained Baroque painter accurately de-scribed. Thus, La Tour's Sebastian, as opposed to Ter-brugghen's, reflects an artist whose interest in detailed anatomical study was minimal. Comparisons within La Tour's own oeuvre reveal that his *St. Peter Repentant* of 1645 [39] is still more abstracted, foretelling the se-verely generalized *Denial of St. Peter* dated 1650.[1]

It is known that La Tour painted a *Sebastian* for an early patron, Charles IV, Duke of Lorraine; that he pre-sented another to Louis XIII;[2] and that a third was re-quested by the governor of Nancy in 1649.[3] Pariset has shown that circumstances allowed a meeting between the King and La Tour in 1632 or 1633 and that those years were especially appropriate for representations of St. Sebastian (a principal protector against epidemics) because a plague struck Lorraine in the early 1630's. A second composition by La Tour on this theme[4] is sty-listically similar to the *St. Peter Repentant* of 1645 and the *Denial of St. Peter* dated 1650, and hence can tenta-tively be identified with the documented *Sebastian* of 1649.[5] The Kansas City composition is comparatively more descriptive; the decorative motifs on the woman's garments, for example, and their elaborate pleats, despite their beauty, appear to be too anecdotal for the late 1640's and early 1650's.

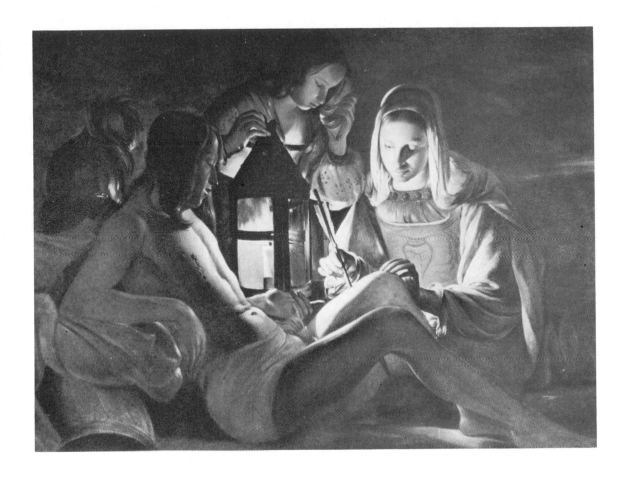

If, with all reservations due to La Tour's extremely difficult chronology, this composition can be assigned to ca. 1632–33, the authenticity of the Kansas City painting requires equally cautious acceptance. At least seven other versions of the composition are known,[6] ranging from coarse copies to a painting of nearly comparable quality.[7] The Kansas City picture is unquestionably among the best versions, and probably is the finest.[8] The highlights on Irene's left hand, the points of white impasto abstracted from the form as her nails touch Sebastian's knee, the richness of colors around the arrow, and the subtle interplay of reds and magentas are masterful and worthy of La Tour himself.

Notes: (1) Ill. in Pariset, 1948, pl. 43 (autographic, but probably with assistance). (2) See Pariset, 1935, and Pariset, 1948, pp. 55 ff., and 200 ff., for these two pictures. (3) Pariset, 1948, p. 80. (4) Berlin and Bois-Anzeray (Pariset, 1948, pls. 26, 27[1]), the latter being superior. (5) However, Bloch, 1950, p. 70, follows Sterling (1935, p. 36, and especially in Paris, 1934, p. 62 and pp. 63–65, no. 43) in placing the Berlin composition early and the Kansas City composition late. Jamot, 1948, pp. 43–45, decided that neither composition was likely to be an early work. Sterling, 1951, p. 154, states that the costumes of the Berlin composition are late Louis XIII, which, however, is not a conclusive argument for an early date. (6) The most complete list is provided by Rosenberg, 1966, p. 77. (7) Musée d'Orléans. (8) Although the Kansas City painting was exhibited in Montreal, 1961, no. 37, and San Francisco, 1964–65, no. 144, it has not been viewed together with the other versions of *St. Sebastian Tended by St. Irene.*

Figure 29. *St. Peter Repentant* (detail).

39 *St. Peter Repentant*, 1645

The Cleveland Museum of Art (Hanna Fund).
45-1/8 × 37-3/8 inches.
Signed in full and dated 1645, upper right
(Fig. 29).[1]
Collections: Dulwich College, Dulwich,
England(?);[2] Rev. William Lucas Chafy, Dulwich,
and heirs; Knoedler and Co., New York.

As Christ had prophesied, the cock crowed three times
and Peter refused Him as often. For this weakness and
guilt the Apostle wept bitterly. The spiritual conse-
quences of denial are symbolized in the vine which
hangs at the upper left of the Cleveland painting, a ref-
erence to the verses of John 15:5–6: "I am the vine,
you are the branches. He who abides in me, and I in
him, he it is that bears much fruit, for apart from me
you can do nothing. If a man does not abide in me, he
is cast forth as a branch and withers; and the branches
are gathered, thrown into the fire and burned."

La Tour's "tableau de l'image saint Pierre,"[3] referred
to in 1624, probably is identical with a painting once
in Archduke Leopold Wilhelm's collection,[4] but which
is known today only through prints. Albeit lost, this
latter picture is an extremely important work, for it is
intimately tied to Terbrugghen's earlier representation[5]
of the same subject, and hence confirms unequivocally
the hypothesis that Utrecht played a significant role in
La Tour's development.

However, if La Tour's early depiction of *St. Peter
Repentant* was primarily determined by a Dutch artistic
climate, his later one in Cleveland dated 1645 was not.
Details such as the lantern, the choice of colors, and
system of lighting may be derived from the North in
general and Honthorst in particular, just as Terbrug-
ghen's early picture remained an active influence on the
physiognomy of Peter. But the basic sense of form and
the dominant spiritual message were foretold only in
Rome and were not transmitted by Caravaggio's fol-
lowers. It is difficult to assume that La Tour arrived at
this solution without a personal familiarity with Cara-
vaggio's art of 1600–1605.[6] The Cleveland painting, like
the canvases in the Cerasi Chapel, is based on a reduction
of parts to primary volumetric shapes.[7] The pathetic,

eminently human statement is especially rare among
Caravaggio's followers, and even Terbrugghen, who
approached the master most closely in this regard, ar-
rived at his solution through different—more Northern
—means. La Tour's poignant conception is related to
his own *Job* in Epinal and is possibly based on the same
model,[8] which appropriately associates Peter's touching
remorse with Job's profound grief. Caravaggio's extra-
ordinarily original interpretation of Peter on the cross
(Cerasi Chapel), stressing the Apostle's helplessness, his
fear, and misgivings, finds its worthy heir in the Cleve-
land picture.

St. Peter Repentant must serve as the pivotal picture
in any future considerations of La Tour's chronology,
for it is his only known dated, unquestionably auto-
graphic work.[9]

Notes: (1) *Georg de la Tour Inve et Pinx.* The reading *Inve* is un-
certain but likely; it is a logical complement to *Pinx*, which is
equally unexpected in a painting, but apparently La Tour was
influenced by engravers' inscriptions. For an important note on
signatures, see Wright, 1969 (however, the Cleveland form is
wrongly cited as "George..."). (2) Although a descendant of W.
L. Chafy stated that the picture belonged to a small group given
to the Reverend by the College, there is no record of the *St. Peter*
in the College's documents. It is possible, therefore, that it was
never an official acquisition of Dulwich, or that in fact it came
to Chafy from a different source altogether. (3) See Pariset, 1948,
p. 40. (4) See Grossmann, 1958. (5) Ill. in Nicolson, 1958-a, pl.
2b (now Centraal Museum, Utrecht); perhaps a copy, but cer-

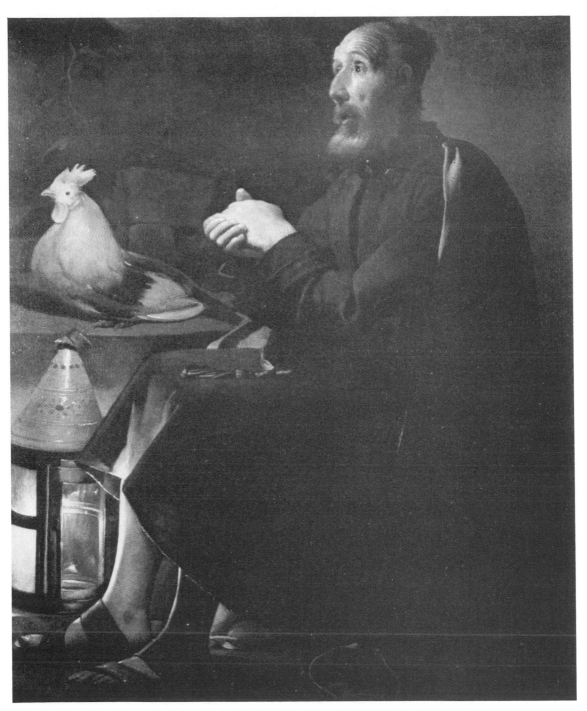

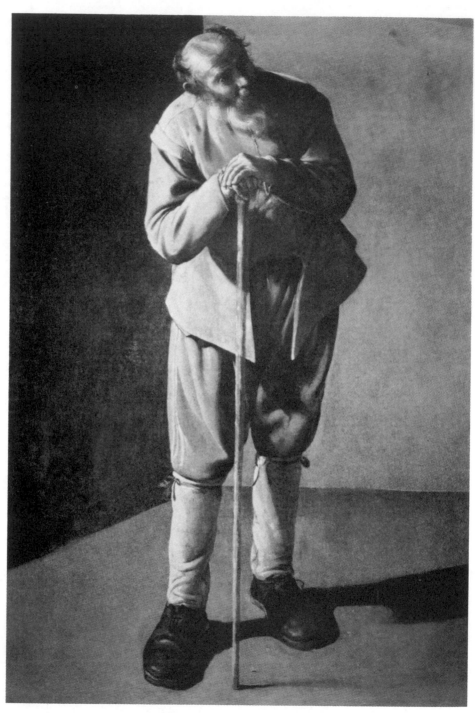

tainly after an original early Terbrugghen. (6) It is important to recall that La Tour was absent from Lunéville around 1640—when various authors believe he visited Italy. (7) See Grossmann's relevant comments, 1958, pp. 90–91. (8) Sterling, 1951, p. 154, already noted this connection. The figure type possibly was influenced by the physiognomy of St. Peter Fourier (see Bougier, 1958, esp. fig. 1). (9) The other dated painting, the *Denial of St. Peter* in Nantes (1650), reveals the likely intervention of another hand. Because the Cleveland painting was rediscovered only recently, it does not appear in the main studies on La Tour; among the brief publications and references concerning it are Bloch, 1950, p. 53, no. 18; Pariset, 1951; Sterling, 1951, p. 154; and Francis, 1952.

Attributed to Georges de La Tour

40 *A Peasant Man*

Roscoe and Margaret Oakes Foundation, M. H. de Young Memorial Museum, San Francisco.
35-3/4 × 23-1/2 inches.
Collections: Holzcheiter Collection, Meilen, Switzerland.

41 *A Peasant Woman*

Roscoe and Margaret Oakes Foundation, M. H. de Young Memorial Museum, San Francisco.
35-3/4 × 23-1/2 inches.
Collections: Holzcheiter Collection, Meilen, Switzerland.

Isarlo[1] has suggested that perhaps these highly original paintings were part of some kind of theatrical screen at a fair, figures flanking a central spectacle and beckoning an audience. The floor lines of unequal height create an optical tension which Isarlo would resolve by seeing each canvas as a fragment of this larger, hypothetical scheme. But because there is no evidence that the paintings have been cut down,[2] and because of the highly conjectural nature of Isarlo's reconstruction, as well as the smallness of the figures, it seems preferable to see the *Peasants* as self-contained compositions without any utilitarian purpose.

Despite the frank plainness of the figures and apparent naïveté of execution, the paintings are extremely so-

phisticated works. The bold, strong colors emphasize the isolation of the peasants, whose postures, expertly designed to contrast open and closed forms, convey the man's simple understanding and sincerity and his wife's resolute confidence. The play of chiaroscuro is especially successful, juxtaposing light against dark throughout each composition. Indeed, few Seicento pictures foretell with such accuracy nineteenth-century realism.

Various critics[3] accepted La Tour's authorship of the two peasants when they became known in the 1950's, and an "early" date within the artist's career was suggested.[4] Their quality and originality are undeniable. However, the achievement of monumentality on a small scale is not typical of La Tour as he is known today, nor are the specific colors and boldly free technique. Each painting reveals a keen knowledge and understanding of the master's *St. Jerome Penitent*[5] and *Hurdy-gurdy Player*,[6] and thus it is unlikely that anyone beyond the immediate circle of La Tour could have been responsible for them. Resolution of the problem depends upon identification of a brilliant student of the master or expansion of our own understanding of La Tour's oeuvre.

Notes: (1) Isarlo, 1957. (2) Information provided by the Department of Paintings of the M. H. de Young Memorial Museum. (3) Most notably, Bloch, 1954; Fiocco, 1954; Blunt, 1957, p. 270, n. 165; and at the exhibition *Il Seicento Europeo*, Rome, 1956–57, nos. 158–59. (4) Fiocco, 1954, believes that they were painted by La Tour ca. 1618; in Bloch, 1954, and Rome, 1956–57, nos. 158–59, "youthful" La Tour was suggested. (5) Ill. in Pariset, 1948, pl. 28. (6) Ill. in Pariset, 1948, pl. 45.

JUAN BAUTISTA MAINO

1578–1649

Only recently Maino's birth date (1578) and native city were discovered (Pastrana), proving that he was Spanish born and not Italian, as an eighteenth-century tradition related. His father, however, was Milanese. At an early age Maino probably visited northern Italy, since in 1611 it is mentioned that he had had to look after his property in Milan, and although there is no proof that he traveled to Rome, stylistic evidence strongly supports this supposition. He settled in Toledo probably late in the first decade of the century (definitely before 1611). Although according to tradition Maino initially studied under El Greco, and Martinez says he was a pupil of Annibale Carracci and friend of Guido Reni, his first major works (for the Dominican monastery of San Pedro Mártir, Toledo, datable 1612–13) reveal a definite Italian and specifically Caravaggesque orientation. Those paintings suggest that Maino is the earliest Spanish artist known to have worked in a truly Caravaggesque style in Spain. He joined the Dominican Order in 1613, but continued to paint, serving Philip III and, according to Pacheco, teaching drawing to the young Philip IV. His later works, mostly painted in Madrid where he settled prior to 1621 and where he died in 1649, are less dependent upon Italian antecedents and instead reveal an awareness of Spanish court painting.

42 *Adoration of the Shepherds, 1612–13*

Museo Balaguer, Villanueva y Geltru (Barcelona), on deposit from the Prado Museum, Madrid.

$124 \times 69\text{-}1/2$ inches.

Collections: San Pedro Mártir, Toledo.

Maino's commission for the high altar of San Pedro Mártir was contracted in February of 1612, with the stipulation that work be completed within eight months.[1] The four large paintings, today divided between the museums of Madrid and Villanueva y Geltru,[2] have always been dated 1611 or, more reasonably, 1612. But since the *Adoration of the Magi* is signed F. IOⁿ BATista maino F.,[3] and the first initial F. clearly abbreviates the title Fray (Frater), at least this one canvas must have been completed sometime after July of 1613, when Maino was professed into the Dominican Order.[4]

The four paintings from San Pedro Mártir are extremely important evidence that Caravaggesque painting was definitely practiced in Spain at an early date. If compositionally the *Pentecost* is basically tied to a well-known sixteenth-century tradition and in general the four pictures reveal broad relationships with pre-Caravaggesque Brescian art,[5] the veracity of details and clarity of modeling indicate a new, Roman, outlook. The *Adoration of the Magi*, the best known of the commission, rightly has been linked with the art of Orazio Gentileschi;[6] the *Resurrection* (Fig. 30) and *Adoration of the Shepherds*, however, reveal a stricter relationship with Caravaggio himself. In each of these paintings a large, sprawling man, semi-nude,[7] evokes one of the *repoussoir* figures in the Contarelli *Martyrdom of St. Matthew*, even though the Bassani, whose influence on Spain was profound, also utilized analogous devices. Still more significant are the black-haired angels in the *Adoration of the Shepherds*, whose origins are certainly in Caravaggio—and seemingly the second *St. Matthew* in particular. But the *Adoration of the Shepherds*, like the *Magi*, also refers to the decorative qualities of Orazio, whose graceful women [cf. 30, 31, 32] determined Maino's Madonna type.

The basic elements of style which are common to the four San Pedro Mártir paintings—the sharply focused

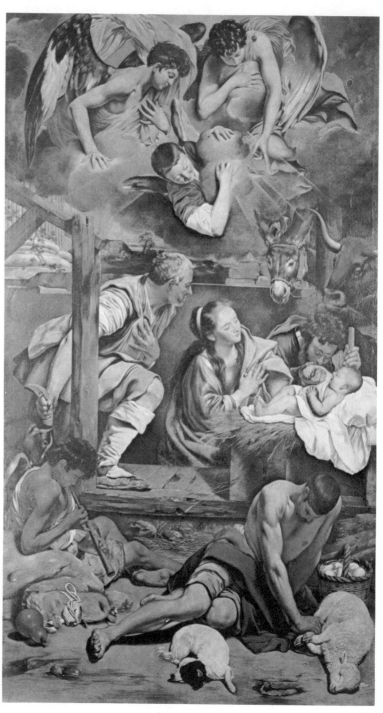

Figure 30. *The Resurrection.* 116-1/8 × 68-1/2 inches. Maino.
Museo Balaguer, Villanueva y Geltru (Barcelona).

chiaroscuro effects combined with a keen verisimilitude
—indicate that Maino had a first-hand knowledge of
Caravaggesque painting in Rome during the first decade
of the century, and very shortly thereafter introduced
it into Spain.

Notes: (1) Harris, 1934–35, p. 334, and doc. II, pp. 338–39. (2)
The *Adoration of the Shepherds* and *Resurrection* are in the Museo
Balaguer, Villanueva y Geltru (Barcelona), on loan from the
Prado Museum, which has in its galleries the *Adoration of the Magi*
and the *Pentecost.* (3) Incorrectly transcribed in the Prado cata-
logue. (4) Figar, 1958, p. 8. (5) See Harris, 1934–35, p. 335. (6)
By Longhi, 1961 [1916], I, 269, and various subsequent authors.
(7) The figure in the *Resurrection* was apparently preserved by
Maino in drawings, for he repeated it later, completely un-
changed, in an *Adoration* in the Hermitage (no. 142).

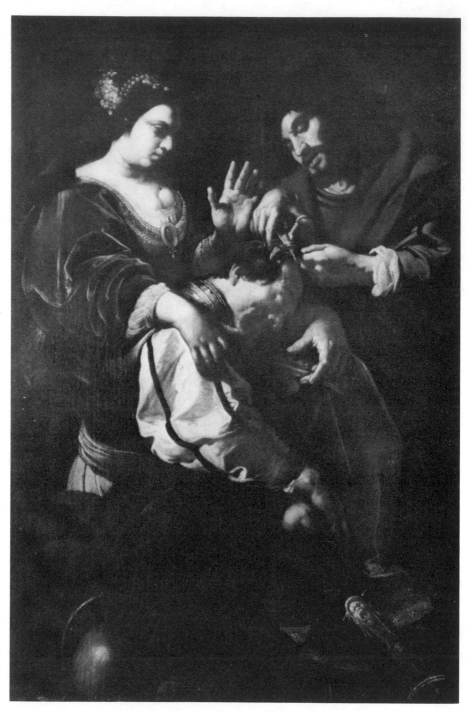

RUTILIO MANETTI

1571–1639

Manetti's life was spent almost exclusively in Siena, where he was born in 1571 and where he died in 1639. From a beginning in the local Manneristic tradition of Vanni and Salimbeni, and apparently with some knowledge of Florentine and Roman Mannerism, he developed an erratic Caravaggesque style whose origins are very complex. He probably visited Rome in the last years of the second decade of the century, and in addition to falling under the influence of the Italian Caravaggisti (Manfredi, Orazio Gentileschi, Grammatica), Baburen and Honthorst—among the Northerners—also attracted him. Artemisia Gentileschi's influence is important too, as is that of Rustici and Jacopo Vignali and later the school of Bologna. Furthermore, throughout his life Manetti never fully rejected Mannerism, which adds another ingredient to his complicated mature style. He painted many large altarpieces and a number of genre scenes as well—in particular of concerts and gaming—which drew heavily upon the Manfredi-Valentin tradition for their compositions but are unmistakably Manetti's for their awkwardness and naïveté. His principal follower was the Sienese painter Nicolò Torniolo, whose extravagant style owes a great deal to Manetti.

43 *Samson and Delilah*, ca. 1625–27

Museo de San Carlos, Instituto Nacional de Bellas Artes, Mexico City.
69-1/4 × 44-1/8 inches.
Collections: the London trade; Alberto J. Pani, London and Mexico City.

Enzo Carli[1] is responsible for the discovery of Manetti's painting in Mexico City. It is a typical example of the artist's mature style,[2] for the extreme contrasts of value and the heavy fleshy features appear in his work in the 1620's (Carli assigns the painting to the period 1621–28), particularly in the *Birth of the Virgin* of 1625,[3] the *Martyrdom of St. Catherine* of 1627,[4] and *St. Anthony of Vienna Exorcising a Possessed Woman* of 1628.[5]

The crowding of figures one upon another characterizes Manetti's lingering Mannerism,[6] and the thick features and slow rhythms bring to mind the work of Baburen [1, 2], whom Manetti could have known in Rome.[7] Caravaggio's *bravi* were often dressed in costumes similar to Samson's, but the Gentileschi's treatment of fabrics led Manetti to a more decorative attitude toward clothing. The deep chiaroscuro and compressed space of *Samson and Delilah* are also found in Manetti's *Lot and His Daughters*,[8] a painting which reveals Manetti's affinities with the Tuscan artist Rustici and his dependence upon G. F. Guerrieri, whose *Lot and His Daughters* of 1617 was a direct inspiration.[9]

Notes: (1) Carli, 1963. (2) For a summary of Manetti's development, see Moir, 1967, I, 215–19, but also Del Bravo, 1966. (3) See Brandi, 1931, pp. 105–6, ill. pl. XVI. (4) Ill. in Del Bravo, 1966, p. 49, fig. 11; see Brandi, 1931, pp. 113–14. (5) Ill. in Moir, 1967, II, fig. 280; see Brandi, 1931, pp. 114–15. (6) For Manetti's early style and sources, see Voss, 1932, and Del Bravo, 1966. (7) Longhi, 1943, p. 55, n. 71; Carli, 1963; Del Bravo, 1966, p. 48, n. 1. (8) See Madrid, 1970, p. 354, no. 114. (9) See Della Pergola, 1959, II, 94–95, no. 134, ill.

BARTOLOMEO MANFREDI

Ca. 1587–1620/21

Manfredi was born in Ostiano near Mantua and as a youth visited Cremona, Milan, and Brescia (Mancini). According to Baglione he studied art in Rome under Cristoforo Roncalli, il Pomarancio. The date of his arrival in Rome is unknown, but since Pomarancio left the city in 1606, Manfredi presumably had arrived well before that year. Mancini lists him among Caravaggio's early close followers, and all subsequent authors confirm this classification. Manfredi worked for the Giustiniani and the Grand Duke of Tuscany, but he apparently received virtually no public commissions. Recorded in Rome from 1610 to 1619, he was alive ("aged about 33 or 34") when Mancini wrote his biography ca. 1620, but he died, according to Baglione, during the Pontificate of Paul V (d. 1621). Manfredi's oeuvre is even more uncertain than his biography. Despite descriptions, engravings, copies, and even photographs, there is not a single preserved documented work from his hand. A small group of paintings has nevertheless been brought together on the basis of circumstantial evidence; it represents an artist steeped in Caravaggio's naturalistic tenebrism, with a predilection to secularize religious themes, often depicting them with knee-length, relatively immobile figures composed in a shallow space around a table. Sandrart referred to the "Manfredi manner" of painting, undoubtedly having in mind a kind of naturalistic attitude that favored genre themes, and which was extremely influential upon the Italian Caravaggisti as well as Valentin, Tournier, Renieri, Seghers, and the painters from Utrecht.

44 *The Chastisement of Cupid,* ca. 1605–10?

The Art Institute of Chicago (Charles H. and Mary F. S. Worcester Collection).
$67 \times 48\text{-}^1/_4$ inches.[1]
Collections: possibly Chigi Collection, Rome; Armando Brasini, Rome; Wildenstein and Co., New York; Mr. and Mrs. Charles Worcester, Chicago.

Formerly attributed to Caravaggio himself,[2] the Chicago painting was first assigned to Manfredi by Longhi, whose opinion has been accepted by later authors.[3] Nevertheless, Mars' dynamic posture—only momentarily arrested by the crouching Venus—the fleeing pair of doves at the right, and Cupid's twisted pose create a strong sense of movement that is very rare in Manfredi's art. Equally unusual is the shifting diagonal recession, which spatially is analogous to Caravaggio's *Conversion of St. Paul* (Cerasi Chapel).

If in a general sense the picture is based on Caravaggio's work of around 1600,[4] numerous features reveal Manfredi's personality. The heaviness of the figures and especially their thick, fleshy features are discovered in Manfredi's *Allegory of the Four Seasons*[5] and *Cardplayers*,[6] which also employ a dramatic chiaroscuro. Unlike Caravaggio, Manfredi uses the raking light in the Chicago picture for evocative effects which isolate themselves in broad areas of darkness (this is most apparent in the illumination of Mars' and Venus' noses). The painting is tightly executed, except for occasional passages of impasto at the areas of maximum whiteness (the highlights on knees and shoulders). The lively design of Cupid, which so successfully stresses the impending blow from Mars' whip, is exceptional in Manfredi's oeuvre.

It is tempting to surmise that the Chicago *Chastisement* represents the artist's early Caravaggesque style, when he was closest to the master and not yet firmly set in his own course.[7]

Late in the eighteenth century Lady Miller saw in the Palazzo Chigi in Rome "an extravagant Picture, by Caravaggio, the subject Mars whipping Cupid in the presence of Venus."[8] Lady Miller possibly was referring to the Chicago painting.

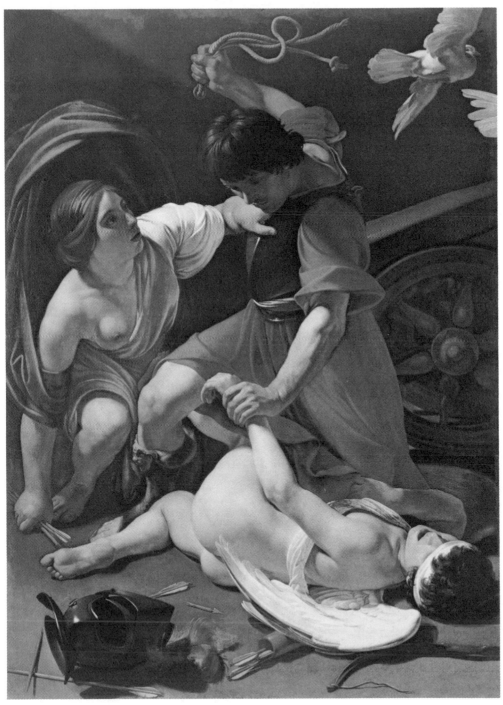

Notes: (1) The painting was cleaned and relined on the occasion of this exhibition. Although some of the fabric which had been added to the original canvas was turned back (the former dimensions were 69 × 51-3/8 inches), there still is approximately one inch of the later addition visible at each edge. (2) Sestieri, 1937; Voss, 1938; San Francisco, 1941, no. 13; Isarlo, 1941, p. 93 (see Milan, 1951, no. 62). (3) Longhi, 1943, p. 25; see Chicago, 1961, p. 273; Moir, 1961, p. 13, and 1967, I, 42; and Nicolson, 1967, pp. 110–11. (4) Caravaggio painted a *Divine Love Conquering Profane Love* (Baglione, 1642, p. 136), which is lost today, but there is no evidence that it influenced Manfredi's painting in Chicago as suggested by Moir (1967, I, 30, n. 31); Voss (1938) thought that the Chicago picture *is* Caravaggio's lost *Divine Love*. (5) Formerly in the Shaliapin Coll., Paris (ill. in Longhi, 1943, pl. 52); the versions in Dayton and formerly in Rome are copies (see Dayton, 1969, pp. 80 and 134). (6) Formerly in the Grundherr Coll., Rome (ill. in Longhi, 1943, pl. 54); a copy is in the Vassar College Museum of Art, Poughkeepsie, New York. (7) See Chicago, 1961, p. 273; Moir, 1961, p. 13; and Nicolson, 1967, p. 111. (8) Miller, 1776, III, 97. As recorded in the Museum's curatorial files, Anthony Blunt first noted this passage in connection with the Chicago painting.

45 *Bacchus and a Drinker*, ca. 1610–15 ?

Galleria nazionale d'arte antica (Palazzo Corsini), Rome.

50-3/4 × 37 inches.

Collections: Torlonia Collection, Rome.[1]

Caravaggio's well-known representations of Bacchus undoubtedly influenced this picture, but Manfredi rejects Caravaggio's usual frontality (Fig. 1) and enlivens the activity of an informal encounter through numerous artistic means. In addition to placing the bodies at oblique angles, the movemented gestures, the momentary expressions, and the broad handling of paint—especially in Bacchus' face—place this painting in an important position midway between Caravaggio and his Utrecht followers, on the one hand, and Velázquez' *Triumph of Bacchus* (Prado), on the other.

As early as 1624 Manfredi is cited as having painted two half-length *Drinkers* in the D'Este Collection, yet the paintings today in Modena which correspond to the descriptions have been assigned with reason to Tournier.[2] The Corsini *Bacchus* is first recorded in a painting by Panini of 1749[3] which supposedly represents the collection of Cardinal Gonzaga in Mantua; but the actual history of the Corsini picture cannot be traced back beyond the Torlonia family. All modern authors,[4] nevertheless, accept Manfredi's authorship, and Moir's suggested dating,[5] early in the second decade, is reasonable, if inevitably tenuous until more documentation on Manfredi is brought to light.

Notes: (1) See Mariotti, 1892, p. 107, no. 206 ("Bacco ed un giovane del secolo XVI, del Caravaggio"). (2) By Longhi, 1943, p. 49, n. 42; Nicolson, 1967, p. 109, concurs. But also see Spear, 1971, p. 109, no. 12. (3) Wadsworth Atheneum, Hartford, Connecticut; ill. in Moir, 1967, II, fig. 101. (4) For example, Voss, 1924, p. 452; Milan, 1951, no. 133; Carpegna, 1955, no. 23; Naples, 1963, no. 46; Moir, 1967, I, 85–86; Nicolson, 1967, p. 110. (5) Moir, 1967, I, 85–86.

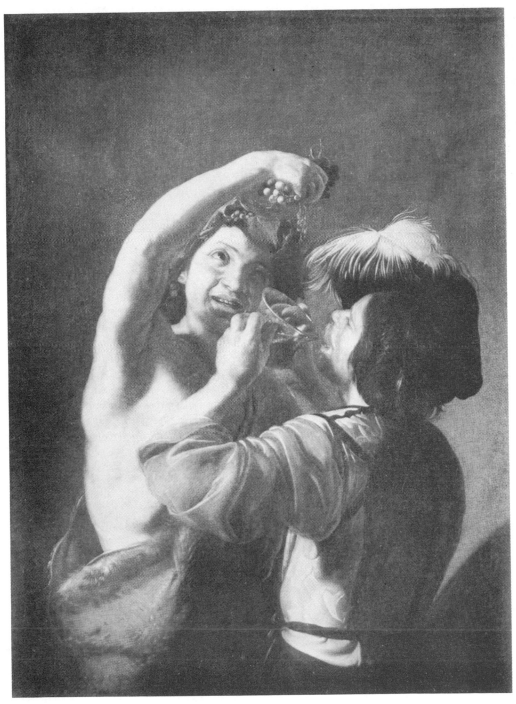

Figure 31. *The Tribute Money.* 51-1/8 × 74-7/8 inches. Manfredi. Galleria degli Uffizi, Florence.

Figure 32. *The Denial of St. Peter.* 65-3/8 × 91-1/4 inches. Manfredi. Herzog Anton Ulrich-Museum, Braunschweig.

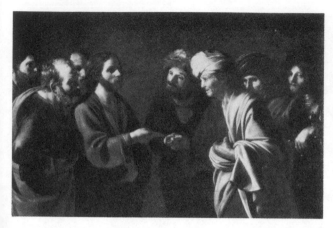

46 *Christ Disputing with the Doctors in the Temple,* ca. 1615?

Galleria degli Uffizi, Florence.

51 × 74-3/4 inches.

Collections: Carlo de'Medici (before 1666) and heirs.[1]

The earliest recorded attribution of this picture dates to 1666, when it was cited as "said to be by Caravaggio."[2] Together with its pendant, *The Tribute Money* (Fig. 31),[3] it fell into oblivion until Hermann Voss reassigned both pictures to Manfredi,[4] an attribution which has been accepted by subsequent scholars.[5]

Manfredi's influential predilection for placing knee-length figures within an intensely dark setting is perfectly exemplified by the Uffizi paintings. Together, they point to numerous developments in later Caravaggesque art. *The Tribute Money* depends upon a relief-like setting that was to become especially important for Serodine [cf. 62], whereas the staccato organization of *Christ Disputing with the Doctors in the Temple* found its greatest survival in the art of Valentin. The figure of the twelve-year-old Christ in the Uffizi painting also was influential on Valentin's semi-neurotic, agitated figures,[6] while the soldier at the far right of *The Tribute Money* clearly opened a path for Tournier[7].

Both paintings boast highly inventive types, whose wrinkled, aged faces, raised brows, and uninhibited curiosity are traceable to Caravaggio's work—to pictures such as his *Judith and Holofernes* (Fig. 4) and *Doubting Thomas* (Potsdam). Frequently, Manfredi designed his paintings so that figures alternately project and recede in space. At the same time, a complementary regular rhythm of rise and descent is created by standing and seated figures. These principles of organization govern Manfredi's late *Denial of St. Peter* (Fig. 32)[8] and the *Christ Disputing with the Doctors in the Temple*, which probably belongs to the middle of the second decade.

Notes: (1) See Borea, 1970, no. 13. (2) "Dicesi di mano del Caravaggio…" (Borea, 1970, p. 22). (3) See Borea, 1970, no. 12. (4) Voss, 1924, p. 453. (5) Longhi, 1943, p. 49, and Nicolson, 1967, p. 111. (6) For example, see the young boys in the *Concert* in the Louvre (ill. in Ivanoff, 1966, pl. IV [color]) and the *Four Ages of Man* in the National Gallery of London (no. 4919). (7) In addition to the *Musical Party* in St. Louis [69], see Tournier's painting of the same subject in Bourges (Mesuret, 1957, no. 33, and Milan, 1951, no. 176) and the paintings of a *Drinker* in Modena (for which, cf. cat. no. 45, n. 2). (8) *The Denial of St. Peter* almost certainly is a mature painting, characteristic of what Sandrart called the "Manfredi Manier." A *Denial* in Madrid, often ascribed to Valentin but closer to Tournier, and a *Denial* by the Master of the Judgment of Solomon in the Palazzo Corsini, Rome, exemplify the many variations that are based on Manfredi's work. (Moir's suggestion [1967, I, 88, n. 58] that the Braunschweig *Denial* may be an early work by Valentin is unconvincing.) Caravaggio's *Denial of St. Peter* (see Bellori, 1672,

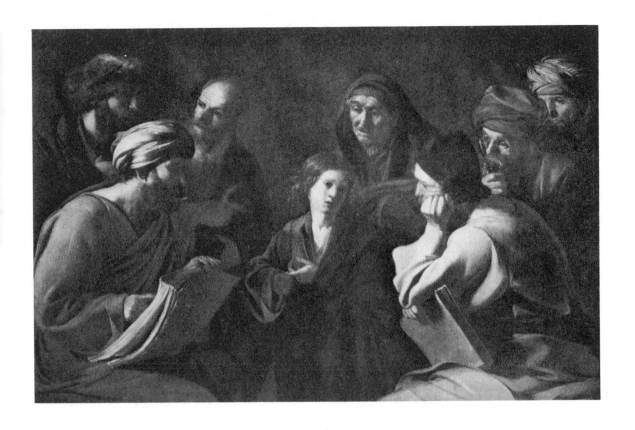

p. 209)—which must not be confused with the picture today in
the Certosa of San Martino (see Naples, 1963, no. 40, and Naples,
1967, no. 24)—undoubtedly was the ultimate inspiration for
many of the Caravaggisti.

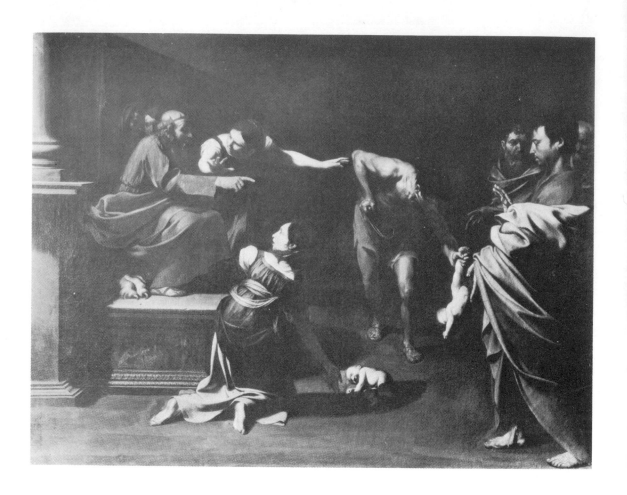

MASTER OF THE JUDGMENT OF SOLOMON

In 1943 Longhi abandoned all previous attributions for the Borghese Judgment of Solomon *and dubbed the artist simply the Master of the Judgment of Solomon. The Master's generally accepted oeuvre is small, but of high quality, including the Borghese picture, a* Denial of St. Peter *in the Palazzo Corsini, Rome;* Apostles *in the Longhi Collection, Florence; a* Prophet *in the museum of Catania;* Christ Among the Doctors *in a church at Langres; and a pair of* Apostles *in the Museo di Capodimonte, Naples. In addition, a second* Denial of St. Peter *in the Certosa di San Martino, Naples, is probably his, for it shares many features with the Corsini picture. The artist was active in Rome, almost certainly in the second and third decades of the Seicento, following the Manfredi-Valentin tradition with a classicizing tendency. It is agreed that he was not an Italian, but it is disputed whether he was French or Netherlandish. Longhi's early hypotheses that he is Guy François or the young Valentin have been abandoned and replaced by a tentative but tempting proposal that the Master may be Gerard Douffet.*

47 *The Judgment of Solomon*, ca. 1620

Galleria Borghese, Rome.

$62-^1/_4 \times 78-^3/_4$ inches.

Collections: Borghese Collection, Rome, since at least 1693.[1]

On the basis of this picture, a small oeuvre has slowly been defined that reflects a Northern artist in Rome in the later 1610's and earlier 1620's, in touch with Vouet, Valentin, and Baburen.[2] The fundamentally Caravagesque chiaroscuro, masterfully designed broad garments, sienna complexions, fleshy lips, and classic profiles are typical of this artist, although the calculated, classicistic composition, with figures moving parallel to and at right angles to the picture plane, is not as apparent in his other paintings.

Nicolson[3] first noted affinities with Baburen's heavy figures and slow rhythms in the Master's *Christ Among the Doctors* at Langres[4] and added his support to Bologna's,[5] and then Longhi's,[6] suggestion that perhaps

the artist is Belgian instead of French, the earlier general assumption.

The Borghese picture has been attributed to Lanfranco (1693), Guercino (1700), and Passignano (1790); Voss introduced Stanzione's name, whereas Longhi, prior to assigning the work to the anonymous Master, initially said Orazio Gentileschi, then Guy François, and thirdly Valentin.[7] Today it is recognized that none of these artists is the author of the Borghese *Judgment of Solomon*. The prevalent hypothesis which remains to be proven is that the Master could be Gerard Douffet of Liège.[8] On a stylistic basis, ca. 1620 is an acceptable date for the picture.[9]

Although a specific source has not been discovered for the relief on Solomon's throne, it almost certainly represents the death of Pentheus. Compositionally there are analogies with ancient representations of that story,[10] and iconographically it is an eminently suitable parallel, for Pentheus was torn to pieces by a group of women led by his mother.

Notes: (1) See Della Pergola, 1959, II, 85–86, no. 119. (2) See Longhi, 1943, p. 58, n. 80; Nicolson, 1958-b, p. 98; Slatkes, 1965, p. 61, n. 27. (3) Nicolson, 1958-b, p. 98. (4) Exh. London, 1958, no. 15; ill. in Longhi, 1958, fig. 3. (5) Bologna, 1953, p. 51. (6) Longhi, 1958, pp. 64–65. (7) For the history of the attributions, see Della Pergola, 1959, II, 85–86. (8) In addition to the articles cited above in notes 2, 5, and 6, for Douffet, see Schneider, ed. 1967, pp. 114–16; Brussels, 1965, pp. 50–51 (with further bibliography); Philippe, 1945, pp. 12–16, and 1964, pp. 99–102; and Gevaert, 1947–48. (9) At Milan (1951, no. 130), ca. 1615–20 was suggested; however, the former date seems to be too early, unless one assumes that the Master developed his style concurrently with Vouet, Valentin, and Baburen. Douffet apparently was in Rome from 1614 to 1623. (10) E.g., see Reinach, *Répertoire de reliefs*, III, 259, no. 2.

PIETRO PAOLINI

1603–81

Paolini was born in Lucca in 1603. He arrived in Rome ca. 1619 and remained there for more than a decade—until his return to Lucca in the very early 1630's. Through Angelo Caroselli, his Roman teacher, he was led not only to practice a Caravaggesque naturalism, but to develop a repertoire of various styles as well. The art of Valentin played a significant role in Paolini's work, and Caracciolo's and Bassetti's influence have also been sensed. In addition to Paolini's Tuscan heritage (Orazio Gentileschi attracted him too) and the Roman milieu of the 1620's, Venice should be taken into account, for he visited that city for two years in the early 1630's (before settling in Lucca) and almost certainly was impressed with Saraceni's work. According to Baldinucci, his colorful bravo *personality was reflected in his predilection for "tragic and cruel" themes. Paolini spent all of his mature life in Lucca, where he founded the Academy of Painting in 1640, steadily moving away from the Caravaggesque orientation of his earlier years. He died in Lucca in 1681.*

48 *A Concert,* ca. 1625–30

The Hoblitzelle Foundation, Dallas, Texas (on loan to the Dallas Museum of Fine Arts).
48 × 68-¹/₂ inches.
Collections: Ortiz de Zevallos, Paris, and Lima, Peru; Torre Tagle Palace, Lima, Peru; Clarence Hoblitzelle, St. Louis, Missouri.

Ultimately indebted to Caravaggio, Paolini's *Concert* in Dallas reflects many of the complex crosscurrents of Caravaggesque painting in Rome in the 1620's. As the earlier attributions to Manfredi, Finsonius, Guercino, and Velázquez suggest, it is tied to the Manfredi-Valentin genre tradition, but also to the more carefree, boisterous drinkers popular with the Northern painters. The figure of Bacchus brings to mind Velázquez' famous *Topers (Los Borrachos),* and the rather melancholic lutist is indebted to Caravaggio's paintings, such as the *Lute Player* in Leningrad.[1] Furthermore, the woman isolated from the group at the far left, holding the score of a love song ("Morse una... il mio Cor Vago"), is a spiritual descendant of figures in Caravaggio's *Una musica* in New York [15].

Anna Ottani[2] has proposed a date late in Paolini's Roman sojourn for the Dallas picture, which is more convincing than Moir's suggestion[3] that it was painted in Lucca in the 1630's. In fact, the young woman with a recorder and grapes at the right is closely allied to a distinctive physical type favored by Caroselli,[4] and which Paolini imitated during his Roman years. She should be compared with the figure of Mary in Paolini's early *Martha and Mary*[5] and with the woman in a very early unpublished *Allegory* (Fig. 33),[6] which must stem from the same period as the monogrammed *Musicians.*[7]

136

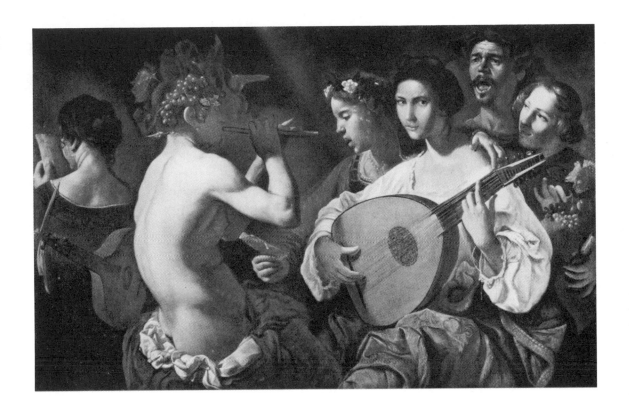

Notes: (1) Ottani, 1965-a, p. 182. (2) Ottani, 1965-a, pp. 181–82.
(3) Moir, 1967, I, p. 223, n. 49. (4) On Caroselli, see Ottani,
1965-b. (5) Ill. in Ottani, 1963, pl. 5a. (6) 43-$^1/_2$ × 32 inches; M.
H. de Young Memorial Museum, San Francisco; ex-colls: Dr.
and Mrs. T. E. Hanley, Bradford, Pennsylvania; Le Roy Ireland,
Philadelphia; Arnold Seligmann, Rey and Co., New York (1949).
(7) Ill. in Ottani, 1963, pl. 5c (currently Wildenstein, New York).

THE "PENSIONANTE DEL SARACENI"

Active 1610's–1620's

Longhi created the "Pensionante del Saraceni" ("Roomer of Saraceni") in 1943, recognizing in a small group of paintings an artist close to Saraceni but with a distinctive personality. His works are mostly genre scenes of very high quality; they are more strictly Caravaggesque than Saraceni's and undoubtedly stem from the second and third decades of the century. He probably was French, and although Moir has tried to identify him with Jean Le Clerc of Nancy, with whom he shares certain features, his name remains to be discovered.

49 *The Fruit Vendor,* ca. 1615–20

The Detroit Institute of Arts (gift of Edsel B. Ford).

51-1/4 × 38-1/2 inches.

Collections: Duke of Pembroke, 1696 (?);[1] Count V. P. Zubow, Riga, Latvia (U.S.S.R.);[2] Jacob Heimann, Milan.

With the exception of the awkwardly placed left hand of the vendor, which appears on casual glance to belong to the girl, this painting reveals a sensitive and original artist steeped in the tradition of Caravaggio but familiar with Saraceni's painting as well [cf. 60]. Specializing in genre scenes, he is distinctive for his very soft definition of form, an anecdotal approach to genre, and an underlying calm which, despite frequent movemented gestures, speaks for a likely French origin.[3]

If the Detroit basket of fruit is ultimately derived from paintings like Caravaggio's famous still life in Milan, the interest in ripe opened melons is not. Instead, it is paralleled in the *Still Life* in Washington (Fig. 34), erroneously attributed to Caravaggio himself, but also by the "Pensionante," as Ottani Cavina has recently suggested.[4]

The *Fruit Vendor* was initially assigned to Caravaggio,[5] until Longhi related it to the "Pensionante,"[6] whose *Chicken Vendor* in Madrid is closely related to the Detroit picture.[7] Recently, Moir[8] reattributed it to Jean Le Clerc of Nancy, which is logical on historical grounds, but not convincing stylistically.[9] Le Clerc's figures are more

insistent in their movements; they are angular where the "Pensionante" is delicately soft, and the light which models them is sharper.

Saraceni, who according to Baglione[10] dressed in the French manner, clearly was in close touch with artists other than Le Clerc.[11] Until new evidence can be advanced that links the Detroit painting and its companions with a known personality, Longhi's sobriquet remains the only reasonable attribution.

Notes: (1) See Richardson, 1937, p. 90; the identification is very tenuous. (2) Longhi, 1943, p. 23, stated that the picture was in the London trade ca. 1930, which provenance has been frequently repeated. However, a notarized affidavit (copy in the files of the Detroit Institute of Arts) dated December 30, 1935, states that Heimann acquired the picture from Count Zubow. It is possible, if unlikely, that the picture had been in the trade as recently as ca. 1930. (3) See Longhi, 1943, pp. 23–24. (4) Still assigned to Caravaggio by the Museum and by Longhi (e.g., 1968-a, pl. 19); see Ottani Cavina, 1968, p. 68, n. 48 (also, Nicolson, 1970-b, p. 315). (5) Richardson, 1937. (6) It was subsequently exhibited as the "Pensionante" in Milan, 1951, no. 136; Sarasota (Gilbert, 1960, no. 3); New Orleans, 1962–63, no. 58; and Detroit, 1965, no. 5. (7) Ill. in Longhi, 1943, pl. 49; also see Madrid, 1970, p. 414, no. 134. (8) In Detroit, 1965, p. 28. (9) On Le Clerc, see Pariset, 1955 and 1958; Venice, 1959, pp. 27–28; Ivanoff, 1958 and 1962; and Ottani Cavina, 1968, p. 68, n. 48. (10) Baglione, 1642, p. 147. (11) E.g., Antonio Girella of Verona and Giambattista Parentucci of Camerino (see Martinelli, 1959-b, pp. 682–83, and Ottani Cavina, 1968, pp. 65–66, n. 34, and pp. 67–68, n. 47).

MATTIA PRETI

1613–99

Born in Taverna (Calabria) in 1613 and probably first trained by his brother Gregorio, Preti assimilated a wide variety of artistic currents via his extensive travels in the 1630's and 1640's. Dominici, his principal biographer, relates that he arrived in Rome ca. 1630, having briefly—but significantly— stopped in Naples. Subsequent journeys took him to Florence, Emilia, and Venice, but he is documented in Rome in 1633, 1636, 1641–43, and from 1646 until 1651, the year his frescoes in Sant'Andrea della Valle were unveiled. Shortly later he worked in Modena and, according to Dominici, visited France, Belgium, and even Spain. He spent almost all of the last five years of the 1650's in Naples, finally settling in Malta after a return to Rome (Valmontone) in 1661. He died in Malta in 1699. On the basis of an early attachment to Caravaggesque, Bolognese, and neo-Venetian art, and to Roman painting of the 1630's, Preti developed a forceful, dramatic style which at once combines with great success and individuality the tenebristic naturalism of the Caravaggisti and Neapolitan art and the compositional means of the Roman-Bolognese school. It must be recognized, however, that the chronology of Preti's early work remains to be fully understood.

50 *A Concert*, early 1630's?

Park Ridge Public Library, Park Ridge, Illinois.
35-$^1/_{16}$ × 49-$^{15}/_{16}$ inches.
Collections: Frederick and Adele Pfeifer,
Arlington Heights, Virginia.[1]

A homogenous group of genre paintings represents an important aspect of Preti's early style.[2] Each painting is Caravaggesque in its simple concentration on half-length figures which are gaming or making music. Dressed in the romantic costumes popularized by Caravaggio, the figures are engulfed by very deep shadows. A strong light tends to pick out their faces, hands, and shoulders, enlivening the surfaces of ostensibly quiet scenes with a broken play of chiaroscuro. Compositionally, Preti's *Card Players*[3] is nearly identical to this unpublished *Concert*, for only the slightest alterations were necessary to transform one subject into the other. On a stylistic basis, however, a scene of gaming in Benedict

Nicolson's collection (Fig. 35)[4] is still closer to the *Concert* (where again three figures are seated around a central table), for it shares with the *Concert* a marked dryness that is typical of Preti's early style. Two additional representations of a *Concert* (in Leningrad [no. 1241] and Roberto Longhi's collection)[5] are analogous to these works, even though Longhi's painting appears to be slightly later.

Whereas Refice Taschetta[6] has assigned the paintings of this type to the early 1650's and attempted to find their origins almost exclusively in Guercino's art, Caravaggio's genre paintings as well as those by Manfredi and Valentin are more relevant to Preti's formation. The stiff postures and tight brushwork, which tend to make these paintings resemble copies, undoubtedly belong to an early phase in the artist's career, perhaps before he assimilated Emilian painting during his travels in the 1630's.[7]

Notes: (1) It is assumed that the picture was formerly in the collection of Frederick Pfeifer's parents, who in 1834 emigrated to America from France. An old label for the picture reads: "A Concert in the 16th Century by Caravaggio, brought to New Orleans in 1796 by Louis Phillip." (2) On early Preti, see Longhi, 1961 [1913], and 1943, pp. 34 and 60–62, n. 86; Frangipane, 1929, pp. 21 ff.; Refice Taschetta [1959], pp. 29 ff. and 41 ff.; and Moir,

1967, I, 145–48. The attribution to Preti of a *Concert* in Turin
(see Valletta, 1970, no. 380), generally considered to be the
artist's earliest known painting, is very uncertain. (3) See Flor-
ence, 1922, no. 796 (ill. pl. 72), and Moir, 1967, I, 147. (4) See
London, 1960, no. 365, and Valletta, 1970, no. 401. (5) Longhi,
1961, I, 418, and II, pl. 174. (6) Refice Taschetta [1959], pp. 46
ff. (7) For a documented chronology of Preti's life, see Frangi-
pane, 1953; also, see Bergonzoni, 1954, and Montalto, 1955.

51 *A Youth*, ca. 1635

Wellesley College Museum, Wellesley, Massachusetts.

$39\text{-}^7/_8 \times 29\text{-}^3/_8$ inches.

Collections: Philadelphia, Pennsylvania (in the trade); Julius Weitzner, New York; Dr. and Mrs. Arthur K. Solomon, Cambridge, Massachusetts.

The Wellesley painting has not received laboratory examination. It seems unlikely, however, that the canvas has been cut down, at least not in the vertical dimension, since tacking distortion in the weave of the fabric is discernible at the upper and lower edges. The original brown background is partially overpainted with brownish-black paint, which approaches, but does not fully correspond with, the contours of the figure. Preti's original profile is therefore partly preserved, and a stronger contrast of value results, intensifying the relief effect of the youth's head.

Preti's early essays in Caravaggesque genre scenes seem to reveal an internal development from a finished, dry brushwork, strong, clear light, and tightly painted forms, to a freer *fattura* that consists of an atmospheric setting and light that slightly but noticeably erodes the surfaces it strikes. The Wellesley painting exemplifies the latter tendency. In design and style it is very close to the *Singers* in Alba,[1] in particular to a youth seated in the right foreground. It must be noted that the attribution of the Alba painting to Preti has recently been questioned,[2] which could cast doubts on the attribution of the Wellesley canvas as well. To this author, however, the internal evidence of the *Youth* consistently points to Preti's own hand.

The *Youth* is listed under "anonymous follower of Caravaggio" in the Wellesley catalogue,[3] where it is noted that Zeri first suggested Preti's authorship.

Notes: (1) Longhi, 1943, p. 34, and p. 61, n. 86; Milan, 1951, no. 139; Moir, 1967, I, 147; and Valletta, 1970, no. 381. (2) Kruft, 1970, p. 206. (3) Shell and McAndrew, 1964, pp. 42–43.

52 St. Catherine of Alexandria Visited in Prison by the Empress, ca. 1640–43

The Dayton Art Institute, Dayton, Ohio.
170 × 100 inches.
Collections: Don Taddeo Barberini, Rome;[1] Maffeo Barberini and heirs, Rome;[2] Don Tommaso Corsini, Florence;[3] Barberini Collection, Rome;[4] Julius Weitzner, London.

Catherine of Alexandria, refusing to renounce Christianity, refuted all of the arguments of the Emperor Maximinus Daia's philosophers and was subsequently imprisoned. "And the emperor went out of the country for certain causes, and the queen was esprised with great love of the virgin, and went by night to the prison with Porphyry, the prince of knights, and when the queen entered, she saw the prison shining by great clearness, and angels anointing the wounds of the holy virgin Katherine. And then S. Katherine began to preach to the queen the joys of Paradise and converted her to the faith...."[5]

The original location of Preti's monumental canvas remains to be discovered, but it certainly was in Rome prior to 1647 when Taddeo Barberini, the first owner, died. It probably was painted in Rome ca. 1640–43, when Preti had returned from his travels in northern Italy.[6] (That Urban VIII Barberini nominated him to the Order of the Knights of St. John in 1642, undoubtedly as a reward for excellent work, conceivably is related to this commission.) The sharp, dramatic chiaroscuro and the angel above the Empress are reminiscent of Caravaggio, but Caracciolo's paintings in Naples—which Preti surely had seen by this date—and Lanfranco's altarpieces must be kept in mind as well.[7] Still more important is Guercino's influence,[8] which played a very significant role in Preti's art but is often difficult to separate from Caravaggio's. The figure types *per se*, especially their gestures, are eminently more Emilian than Caravaggesque; and the sentiment in general, as well as the way light isolates itself in numerous pools across the spacious setting, immediately brings to mind Guercino's *Martyrdom of St. Petronilla*, which Dominici says Preti greatly admired.[9]

Stylistically the Dayton painting marks a crucial period in Preti's career, when the artist was moving away from his earlier Caravaggesque phase toward a more personal combination of tenebristic naturalism and Bolognese classicism. The broken shadows on the powerful executioner sprawling in the right foreground foretell many of Preti's later works (and his posture brings to mind a beggar in Preti's *St. Charles Borromeo Giving Alms*, San Carlo ai Catinari),[10] just as the mother and child at the left and the woman between Catherine and the Empress prophesy Luca Giordano's typical figure types.[11]

Notes: (1) Marilyn Aronberg Lavin has traced the painting in inventories of Maffeo's collection of 1655, in an undated inventory between 1672 and 1686, and in the inventory of Maffeo's collection at the time of his death, 1686; the painting was inherited by Maffeo from Taddeo, whose device, bees and towers, was on the original (lost) frame. (2) Dr. Frances Vivian reports that the painting is listed in a Barberini inventory of 1844, no. 42, 19 × 10 *palmi*; earlier, in 1817, it was cited in a list compiled by Vincenzo Camuccini (see Mariotti, 1892, p. 128, no. 31—which number the painting still carries in the lower left corner). (3) Photographed at that time by Alinari, neg. no. 49643. (4) See Zeri, 1954, no. 62. Refice Taschetta [1959], p. 47, cites the picture (pl. 17) as collection Raggi, Rome, which apparently is a confusion with the *Bacchanal* in the Raggi Collection, illustrated in pl. 15 of the same book. (5) Jacobus da Voragine, ed. 1900, VII, 22. Incorrectly identified in the literature as Empress Faustina or Elisabeth, it appears that there is no name known for a wife of Maximinus Daia (he unsuccessfully sought Valeria's hand). (6) See Refice Taschetta [1959], pp. 46–47, pp. 50 ff., *et passim*, for a discussion of Preti's stylistic development in the 1640's and 1650's, which is now contradicted by the discovery of the documents for the Dayton painting. Longhi's thesis (1943, pp. 34 and 60–62, n. 86), on the other hand, receives new support. See Frangipane, 1953, for Preti's presence in Rome. (7) For Preti in Naples, see Montalto, 1920; Causa, 1952; and Refice Taschetta [1959], pp. 29 ff. and 56 ff. (8) Refice Taschetta [1959], pp. 46–47; Dayton, 1969, p. 100. (9) Dominici, ed. 1840–46, IV, 7–9, stresses Preti's attachment to Guercino and states that he traveled to Cento to study under him. (10) Ill. in Refice Taschetta [1959], pl. I. (11) On Preti and Giordano, see Causa, 1952, and Refice Taschetta [1959], pp. 28, 32–34, *et passim*.

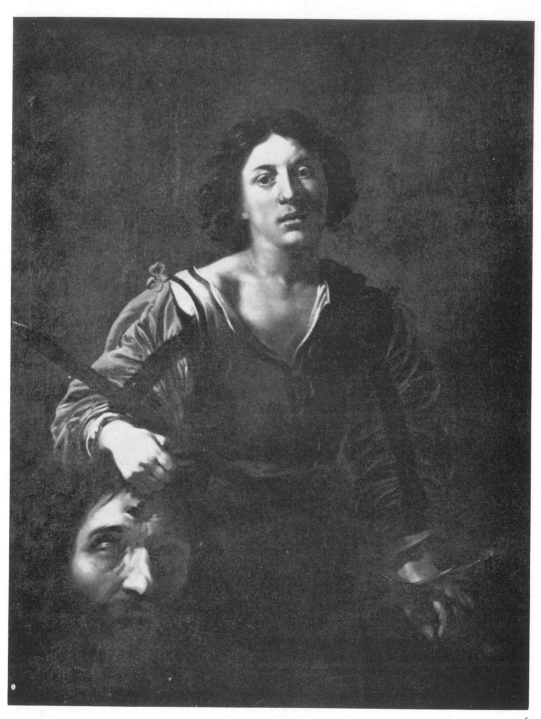

NICOLAS RENIERI (REGNIER)

Ca. 1590–1667

According to Sandrart, Renieri was from Maubeuge and studied painting under Abraham Janssens in Antwerp. He arrived in Rome sometime around the middle of the second decade of the century and followed the "Manfredi manner" (Sandrart). In Rome he received the patronage of the Marchese Giustiniani, for whom he made a copy of a lost Magdalene *by Caravaggio. Contact with Vouet, prior to Renieri's departure from Rome, is certain.*

Renieri spent his mature life in Venice, where he settled by 1626, developing a colorful palette, enamel-like textures, and an emotional sentiment derived from Bolognese painting. He was in touch with many artists in Venice, including Desubleo, his half-brother, and Pietro della Vecchia, his son-in-law. Renieri died in Venice in 1667.

53 *David*, ca. 1615–20

Galleria Spada, Rome.
52 × 39 inches.
Collections: Spada Collection, Rome (at least since 1765).[1]

Formerly attributed to Poussin, Guercino, and Orazio Gentileschi, *David* was recognized by Longhi as an early work of Renieri dating from the period shortly after his arrival in Rome.[2] Affinities with Manfredi are striking, for the fleshy facial type, the abrupt play of chiaroscuro across the bridge of the nose, and the quiet, withdrawn mood are all paralleled in that master's work. If the physical type as well as the garment style are basically derived from models such as the seated man in Manfredi's *Denial of St. Peter* (Fig. 32), Renieri's touch is softer, and transitions of chiaroscuro create peculiar effects of slightly moist surfaces. A figure similar to David appears in Renieri's *Cardplayers* in Budapest,[3] a picture which like *David* underscores the artist's importance for Tournier and Vouet alike.

Renieri's *Judith* in Munich[4] shares with *David* a countenance of melancholic misgiving, which undoubtedly originates in Caravaggio's late *David* in Rome where the young hero expresses an unprecedented, remorseful pathos. In contrast, Renieri's David is clearly more alert, fully aware of the spectator; nevertheless, the psychological interpretation as well as the composition are strongly indebted to Caravaggio.

A comparison between the anonymous *Summer* in Busiri Vici's collection [77] and Renieri's *David* reveals numerous stylistic similarities; however, the chiaroscuro in the former is more generalized, and the depiction of details is more summary.

A second representation of *David* by Renieri[5] is markedly different in conception, further removed from Caravaggio and Manfredi, and undoubtedly some years later than the Spada painting.

Notes: (1) See Zeri, 1954, no. 202. (2) See Zeri, 1954, no. 202. (3) Pigler, 1968, I, no. 610 (as "Manfredi?"). (4) See Ivanoff, 1965, p. 14 and fig. 5a. (5) See Bottari, 1965, p. 58 and fig. 24a.

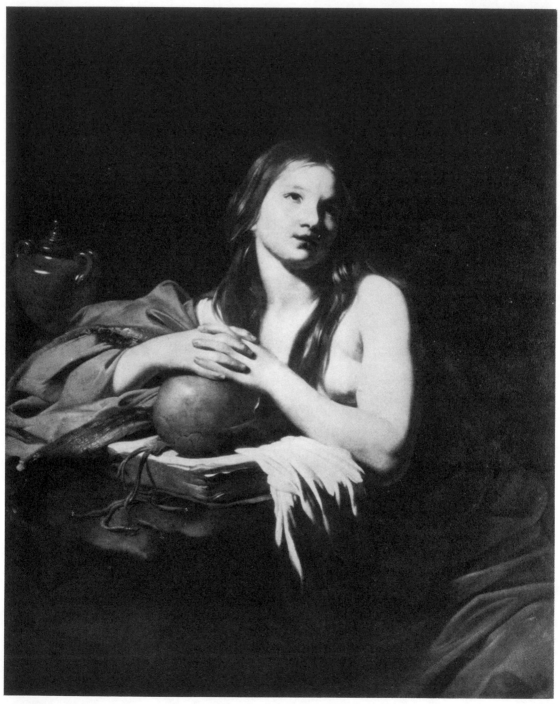

54 *The Magdalene*, ca. 1620–25

The Detroit Institute of Arts (gift of Mrs. Trent McMath).

48 × 38 inches.

Collections: Julius Haass, Detroit.

Renieri copied a full-length *Magdalene* by Caravaggio,[1] but it is impossible to determine the relationship between it and this composition. Nevertheless, the deep red garment played against a nearly achromatic scheme of whites, browns, and black is decidedly derived from Caravaggio, as is the naturalistic depiction of the skull and jar, despite the hint of Bolognese ecstasy in the Saint's languishing face. Vouet's Roman paintings of female saints also impressed Renieri, and they must be counted among the primary sources of the Detroit picture.

Stylistically, the *Magdalene* should be placed after Renieri's more strictly Caravaggesque, Manfredi-inspired phase [53],[2] in the years approaching the *Vanity* of 1626 in Turin.[3] However, it has no traces of his typical later Venetian decorative style[4] as exemplified in the full-length *Magdalene* in Birmingham[5] or the half-length variation on it in Genoa.[6] The figure in the Detroit painting conceivably is modeled after one of the artist's daughters,[7] which also would necessitate a late date within the Roman years or early in the Venetian period.[8]

Notes: (1) See Salerno, 1960, p. 101, no. 155. (2) Documented by Sandrart, ed. 1925, p. 368. (3) Ill. in Ivanoff, 1965, fig. 7a (the basic study on Renieri); also, see Voss, 1924–25, pp. 122 ff., and 1925, pp. 479–80; and Richardson, 1939, and 1942. (4) See Venice, 1959, pp. 55–58. (5) See Venice, 1959, no. 88. (6) Ill. in Torriti, 1967, p. 113, fig. 95. (7) Suggested by Richardson, 1939, p. 3. (8) The picture is assigned to the Roman period by Donzelli and Pilo, 1967, p. 342.

JOSÉ DE RIBERA

1591–1652

Ribera was born in Játiva near Valencia in 1591 and according to Palomino studied under Ribalta. There is no evidence to substantiate this assertion, nor to indicate when Ribera arrived in Italy. Mancini reports that he first visited Lombardy and Parma prior to settling in Rome, and recently discovered documents prove that he approached the German border shortly before 1630. It is also known that he was in Rome in 1615 and a member of the Accademia di San Luca by 1616. He settled in Naples in the autumn of 1616 when he married; and he spent his mature life there, except for the trip to northern Italy and perhaps an additional stay in Rome. In Naples he was patronized by various Spanish Viceroys and the monastery of San Martino. His last years were dimmed by ill health prior to his death in 1652.

In addition to Ribera's pupils (Juan Do, Passante, the Fracanzanos, Hendrick van Somer), numerous Neapolitan artists (and still others—like Langetti) were profoundly impressed by the Spaniard's interpretation of Caravaggio's naturalism and chiaroscuro. Indeed, the tenebristic strain in Neapolitan art, apparent in masters like Stanzione, Vaccaro, and Giordano, was significantly determined by Ribera's work, which also had a strong impact on Spanish painting of the seventeenth century.

55 *The Sense of Taste*, ca. 1612–15

The Wadsworth Atheneum, Hartford, Connecticut (the Ella Gallup Sumner and Mary Catlin Sumner Collection).

44-9/16 × 33-3/16 inches.

Collections:[1] Prince F. F. Youssoupov, Moscow and St. Petersburg; Duveen, New York.

56 *The Sense of Touch*, ca. 1612–15

The Norton Simon Foundation, Fullerton, California.

45 × 34-3/4 inches.

Collections:[1] Prince F. F. Youssoupov, Moscow and St. Petersburg; Duveen, New York.

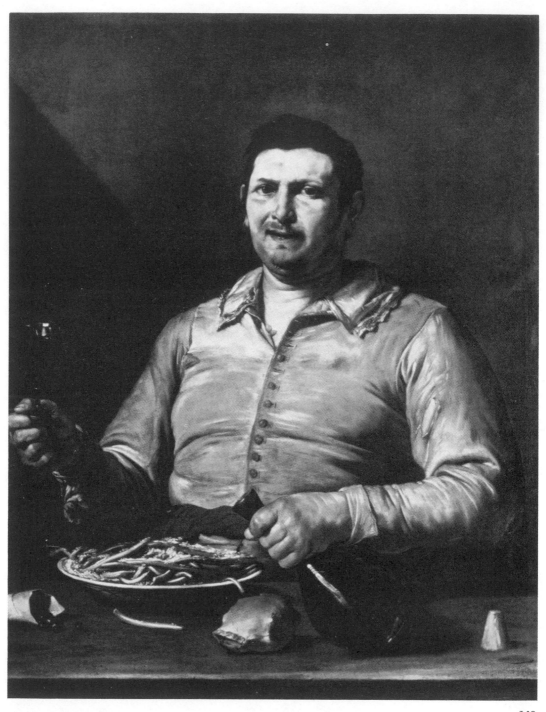

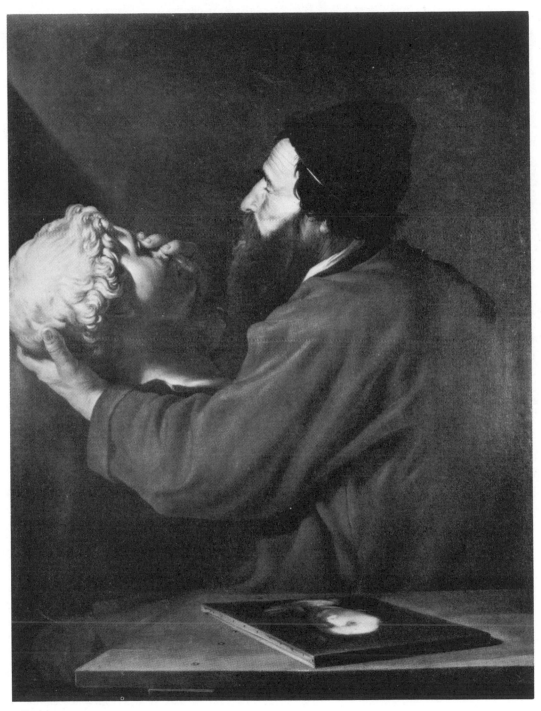

Figure 36. *The Sense of Smell.* 44-¹/₂ × 31-¹/₂ inches. Copy after Ribera. Whereabouts unknown.

Figure 37. *The Sense of Hearing.* 44-¹/₂ × 31-¹/₂ inches. Copy after Ribera. Whereabouts unknown.

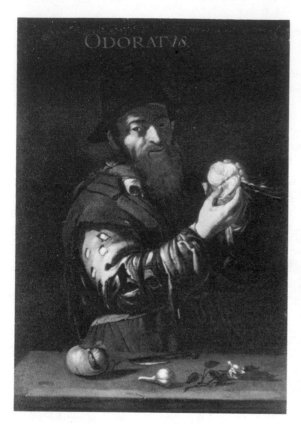

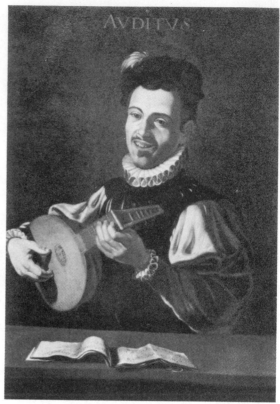

Writing ca. 1620, Mancini mentioned "five half-length figures of the five senses"[2] which Ribera had painted in Rome. Nothing was known of this early series until recently when Longhi discovered in a Parisian collection five paintings inscribed TACTVS, ODORATVS (Fig. 36), AVDITVS (Fig. 37), VISSVS (Fig. 38), and GVSTVS, which he identified as copies of the early Riberas.[3] Rejecting the old attributions to Velázquez, Puga, and Pietro Novelli, Longhi assigned the Hartford picture to Ribera himself, recognizing it as the source of the inferior GVSTVS. The second original painting from the series, Norton Simon's *Touch*, was published by Erich Schleier shortly later,[4] but the other three senses remain lost.[5]

Figure 38. *The Sense of Sight.* 44-1/2 × 31-1/2 inches. Copy after Ribera. Whereabouts unknown.

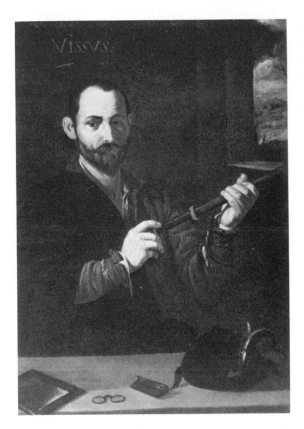

the senses in unmistakable, mundane terms. The dark, rather coarse figure types, built up in earthen hues with forceful, direct brushwork, stand mid-way between Caravaggio's rustic Apostles and Ribera's own saints and philosophers who, like these two men, are eminently more Spanish. Nevertheless, the raking light, revealed in oblique shadows on the enclosing walls, and the bold scale of form tie these paintings to the Italian master. Ribera's strong sense of naturalistic detail undoubtedly was nourished by Caravaggio's art, but it is important to recognize that already in these early paintings Ribera's handling of oils is much more painterly, and his attitude toward naturalism is decidedly more aggressive.

In addition to the aforementioned complete series discovered in Paris, there are copies of the Hartford picture in the Hermitage[8] and formerly in the Rossi Collection, Forlì;[9] moreover, there is a later (1632) variation on *Touch* in the Prado Museum.[10] A second series of copies reported by Martin Soria to be in the Academia de San Fernando, Madrid,[11] cannot be traced.[12]

Notes: (1) See Schleier, 1968, p. 80, n. 3, for a possible earlier provenance. (2) Mancini, ed. 1956–57, I, 251. (3) Longhi, 1966-a; the paintings were subsequently sold at the Dorotheum, Vienna, on January 14, 1966, as "Baburen after Ribera." (4) Schleier, 1968. (5) *Sight* was reportedly in the trade in New York in 1945 (see Schleier, 1968). (6) Chenault, 1969. (7) Longhi, 1966-a, pp. 76–77. (8) Inv. no. 5348; 40-1/8 × 33-1/2 inches; ex-coll: O. Braz. (9) Ill. in Longhi, 1966-a, pl. 47; the Rossi picture subsequently passed to Rampini, Florence. (10) Trapier, 1952, fig. 47 (also see pp. 234–36 and fig. 156 for a variation on *Sight*). Ferrari, 1969, p. 218, raises the question of the influence of Ribera's early *Touch* on later serial paintings of philosophers. (11) See Schleier, 1968, p. 79. (12) Dr. A. E. Pérez-Sánchez reports that there never has been such a series in the Academy's collection; only a *Luteplayer* (inv. no. 529), catalogued as close to Novelli, is possibly related to the series.

Although Ribera's early years are poorly documented, recent archival discoveries[6] prove that he was in Rome in 1615 and still there in May of 1616, apparently just prior to traveling to Naples for his own marriage. Hence it is reasonable to assign the *Five Senses* to the period immediately preceding his departure from Rome, when the young artist, in his early twenties, undoubtedly was familiar with the activities of Caravaggio's followers as well as with the art of the master himself.

Representations of the five senses had a firm tradition by 1600, but, as Longhi noted,[7] Ribera's are markedly different from a well-known earlier type. Instead of relying on sophisticated allegories and recondite symbolism, his series is grounded in explicit depictions of

57 *St. Jerome*, ca. 1640–42

The Cleveland Museum of Art (Mr. and Mrs. William H. Marlatt Fund).
50-³/₄ × 39-⁵/₈ inches.
Signed in full, lower right, on the book.
Collections: private collection, Italy; Kleinberger and Co., New York.

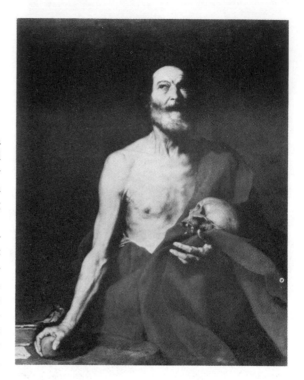

Jerome was among the most popular penitent saints in the seventeenth century, and both the Bolognese and Spanish artists were frequently called upon to portray some moment in his life. Ribera often depicted him with skull, stone, and cross in hand, and with a book resting nearby as a symbol of the Saint's scholarly writings.

The sentiment of Ribera's painting in Cleveland is derived primarily from Bolognese art. The restrained but strong emotional concentration finds numerous parallels in the work of Reni and Guercino (whom Ribera deeply admired) and not in Caravaggio, whose saints are never conceived in the traditional attitude of religious repentance. Yet many of Caravaggio's artistic means were influential upon this picture: the somber colors, relieved only by a broadly designed, deep red cloth; the use of light to create a sense of silent isolation; and especially the naturalistic treatment of form, striking in the dry, aged flesh.

Although the Cleveland painting has been assigned to Ribera's last years, ca. 1651–52,[1] there are good reasons to suggest an earlier date. The *St. Jerome* in Naples,[2] dated 1651, admittedly presents certain analogies, but that painting was begun as early as 1638.[3] Pictures of the 1640's, such as *St. Simeon and the Christ Child* (1647)[4] and a *St. Jerome* (1644)[5] in the Prado, reveal similarities of technique and conception. The *St. Jerome* of 1640 in Cambridge (Fig. 39) is especially comparable, whether one considers color, technique, or composition. Furthermore, the model Ribera used for the Cleveland and Harvard paintings almost certainly was the same.

A seventeenth-century copy of the Cleveland picture is in the Magisterial Palace, Valletta, Malta.

Notes: (1) Indianapolis, 1963, no. 68. (2) Ill. in Trapier, 1952, fig. 147. (3) Trapier, 1952, p. 225. (4) Ill. in Trapier, 1952, fig. 131. (5) Ill. in Trapier, 1952, fig. 127.

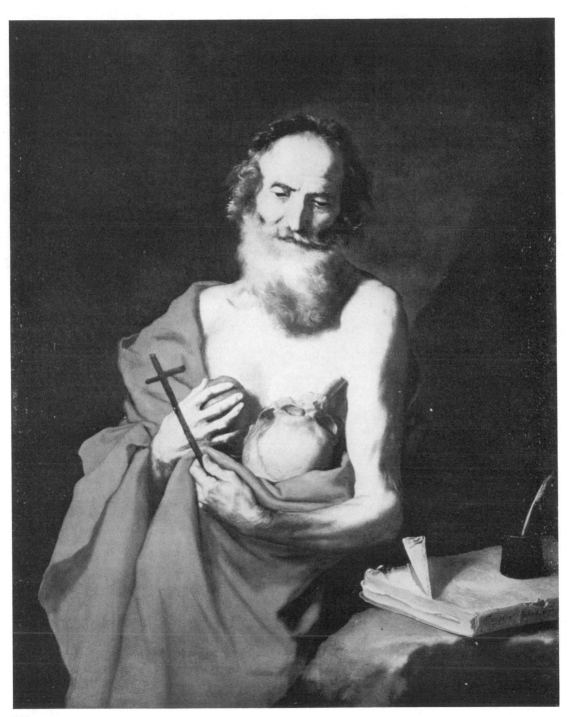

THEODOR ROMBOUTS

1579-1637

Rombouts, born in Antwerp in 1579, was trained by Frans Lanckvelt and Abraham Janssens. In 1616 he departed for Italy, where he remained for approximately a decade, visiting Rome, Florence, and Pisa (1622). By 1625 he was back and permanently settled in Antwerp and a member of the city's guild of painters. A number of documented works are known from the second Antwerp period, but not from the earlier years.

From a Manneristic Northern background, Rombouts developed a Caravaggesque style which is basically allied to Manfredi's and Valentin's; later he moved toward a more painterly technique and lighter palette, primarily under the influence of Rubens and Van Dyck. Nevertheless, genre scenes of musicians, smokers, and gaming played an important role throughout his entire career.

58 *The Musicians,* 1620–25

Museum of Art, University of Kansas,
Lawrence.
78-³/₄ × 47-³/₄ inches.
Signed bottom center.
Collections: The Earl of Plymouth, Oakley Park, Ludlow; Sotheby's, July 13, 1949, lot 159; Kleinberger and Co., New York.

The guitar, large lute, and part book are characteristic of the earlier seventeenth century;[1] the representation of standing, full-length musicians, however, is not frequent in the circle of Caravaggio, even though broad relationships exist with the more usual half-length compositions popularized by Manfredi. The animated guitarist may bring to mind Honthorst's boisterous musician-drinkers [36], but the hard, saturated colors and firm modeling bespeak Rombouts' direct contact with Rome, as does the decided interest in strong chiaroscuro based on raking light. Strolling entertainers undoubtedly inspired this staged conception, for the low point of view and curtain must be intended to evoke a raised theatrical platform.

Banti[2] first suggested that the *Musicians* belongs to Rombouts' Italian phase, when Caravaggio and his followers were most influential upon him,[3] and subsequent authors[4] have accepted this reasonable hypothesis. The closest stylistic parallel is Rombouts' *Concert* (Fig. 40),[5] which (it has never been noted) is dated 162[5?] on the edge of a book—and is monogrammed in ligature TF—presumably Theodor fecit.

Notes: (1) For a detailed study of the musical accessories, see Mirimonde, 1965. (2) Banti, 1951. (3) See Schneider, ed. 1967, pp. 105–9, and Roggen, 1935, pp. 175 ff. (4) See Milan, 1951, no. 146; Utrecht, 1952, no. 108; and Brussels, 1965, no. 179. (5) See Carpegna, 1955, no. 27.

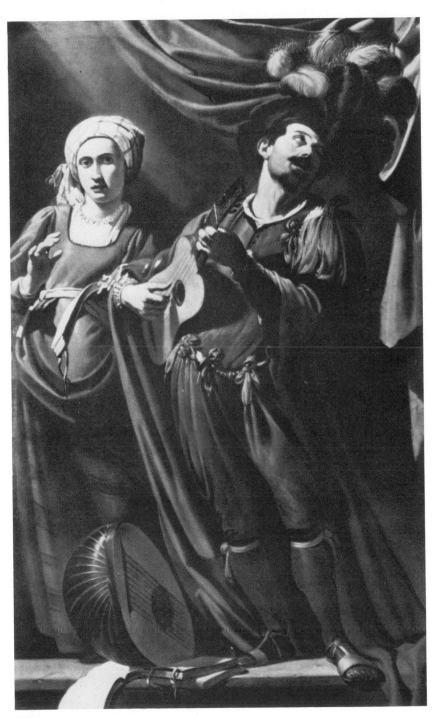

CARLO SARACENI

1579-1620

Venetian by birth, Saraceni spent his active career in Rome, where he arrived as a youth in 1598. According to Baglione, he studied there under Camillo Mariani, but the crucial influences on his formation were his Venetian heritage, the German Elsheimer (with whom he has been actually confused), and later, Caravaggio and his followers, in particular Orazio Gentileschi. Saraceni seems to have specialized in small paintings during the first decade—except for his Rest on the Flight into Egypt of 1606 in Frascati—and to have shown relatively little interest in Caravaggio's work. In the middle of the second decade he was active in the Palazzo Quirinale with Orazio, Tassi, Lanfranco, and Spadarino and was corresponding with the Duke of Mantua, although there is no evidence that he visited his city. In 1617 he lived with Jean Le Clerc, Antonio Girella, and Giambattista Parentucci; in 1618, the year he married, he was paid for his paintings in Santa Maria dell'Anima; in 1619 he returned to his native city, where he died of typhus in mid-1620. His large painting for the Sala del Maggior Consiglio in the Doge's Palace was finished and signed by his French follower, Jean Le Clerc. Saraceni's pictures from the second decade, especially between ca. 1615 and his death, are among the most poetic Caravaggesque works ever painted and were, along with Orazio Gentileschi's, of considerable importance for the Northern Caravaggisti, Dutch and French alike.

59 *The Virgin, Child and St. Anne, ca. 1611–14*

Galleria nazionale d'arte antica (Palazzo Corsini), Rome.
61 × 51-1/4 inches.
Collections: formerly in the Roman church S. Simeone dei Lancellotti.

Mancini[1] and Baglione[2] cite this famous altarpiece of Saraceni's,[3] which must be among the earliest known paintings that reveal his interest in Caravaggio. On the one hand, it can be related to his lyrical *Rest on the Flight into Egypt* of 1606,[4] but on the other, it eliminates nearly all traces of Elsheimer's influence[5] and concentrates instead on an enclosed setting and naturalistic details that are ultimately derived from Caravaggio. The unassuming domestic tenor and crumpled white draperies find parallels in Borgianni's *Holy Family*;[6] but Saraceni's light singles out the figural group as a whole without creating any sharp shadows, differentiating his conception from that of Caravaggio, Borgianni, and numerous other followers whose lighting schemes more immediately reveal their directional source. The Christ Child exemplifies Saraceni's very characteristic chubby infant with a long, flat forehead; the Virgin's smooth complexion, small mouth, and silent pose are equally typical of the painter.

Suggestions for this picture's date have ranged from 1610 to 1614 or later;[7] in any case, it must have been painted after 1610, when Cardinal Lancellotti remodeled and redecorated S. Simeone.[8]

Copies exist in the Church of the Gesù, Cortona,[9] and in a private collection in Milan.[10]

Notes: (1) Mancini, ed. 1956–57, I, 254. (2) Baglione, 1642, p. 146. (3) First published by Voss, 1912, p. 67; also, see Porcella, 1928, pp. 382, 403; Longhi, 1943, p. 24; and Ottani Cavina, 1968, pp. 47–48 and 114, no. 58. (4) Ill. in Ottani Cavina, 1968, pls. 45–46. (5) On Saraceni's early style, see Ottani Cavina, 1967, and 1968 *passim*. (6) Ill. in Moir, 1967, II, fig. 85. (7) See Longhi, 1943, p. 24; Milan, 1951, no. 151; Rome, 1955, no. 28; Venice, 1959, no. 22; Naples, 1963, no. 58; Paris, 1965, no. 104; Moir, 1967, I, 82, n. 44; and Ottani Cavina, 1968, p. 114, no. 58. (8) Salerno, in Mancini, ed. 1956–57, II, 155, n. 1129. (9) Photo Soprintendenza alle gallerie, Florence, no. 31641. (10) Ottani Cavina, 1968, p. 114, no. 58.

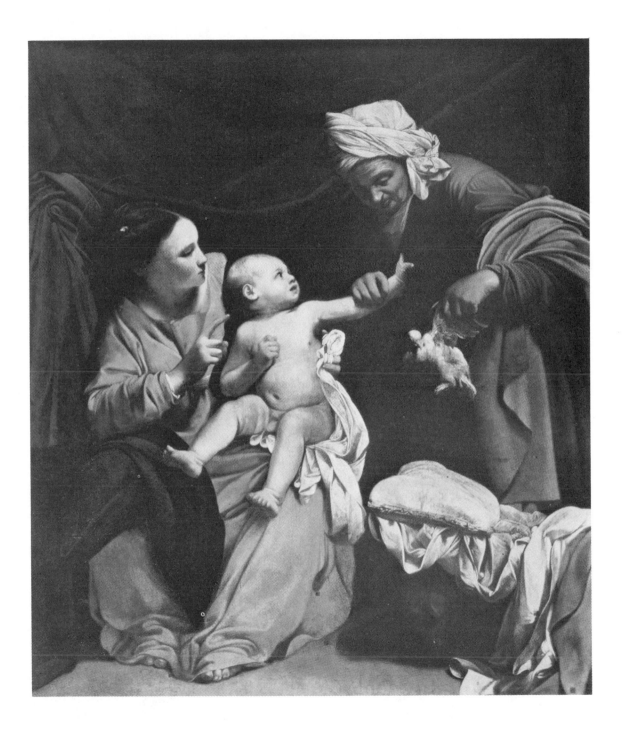

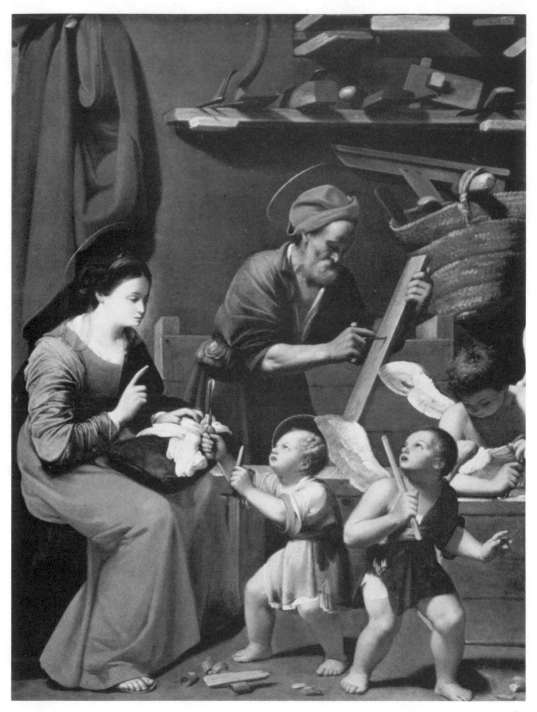

60 *The Holy Family in the Carpenter's Shop,* 1615–20

The Wadsworth Atheneum, Hartford, Connecticut (the Ella Gallup Sumner and Mary Catlin Sumner Collection).
44-$\frac{1}{2}$×33-$\frac{3}{16}$ inches.
Collections: French private collection; Frederick Mont, Inc., New York.

Saraceni's finest paintings belong to the last years of his life,[1] when often, as in the work of Georges de La Tour, an eminently lucid design of tranquil figures conveys an impression of perfect harmony. The rotund faces of the *putti* and unblemished complexion of the Virgin in the Hartford painting, as well as the strength of Her red robe, the clarity of the colors, and the simplified forms, establish an unusual accord between Caravaggesque naturalism—so apparent in the carefully observed and rendered tools—and an ideal classicism, which undoubtedly in part attracted French artists to Saraceni. Especially noteworthy are the violet and soft blue robes on the Child at the left, contrasted with the deep blue of the sash around His waist and with the garments of the adjacent *putto*. The silver blues and greyed whites of the feathers, enlivened by passages of dark blue and yellow, are coloristically among the most beautiful passages in all of Saraceni's work.

The Hartford picture has been dated as early as ca. 1608[2] and more plausibly ca. 1615–16,[3] but it is possible that it stems from a moment still closer to the end of the artist's life. The most obvious affinities are with the *Virgin, Child and St. Anne* [59], but the clarity of the interior setting, constructed entirely in browns, and the quality of the light are very similar to the late *St. Francis in Ecstasy*.[4] In this latter painting the broadly designed garments and thin features of the angel are echoed in the Holy Family's dress and the Virgin's solemn face, just as Saraceni's mature luminosity and simplified forms are dominant in each work. If the *Annunciation* of Santa Giustina[5] surprisingly foretells the art of Philippe de Champaigne and Charles LeBrun, the Hartford painting has equally strong affinities with Saraceni's actual French followers: Jean Le Clerc; the "Pensionante del Saraceni," whose vendor in Detroit [49] is closely related to Joseph; and Jean Tassel,[6] who through Le Clerc developed variations on Saraceni's female type.

Moir[7] has attributed the *Holy Family in the Carpenter's Shop* to Le Clerc himself, but there is no evidence that the artist from Nancy ever achieved either the sense of design that supports this picture or the quality of its execution. If it reveals relationships with the last works by Saraceni which Le Clerc finished,[8] this is only because it belongs to a phase when the artists were close together.

Notes: (1) See Ivanoff, 1964, for the late works of Saraceni. (2) Proposed in Hartford, 1964, p. 23. (3) Ottani Cavina, 1968, pp. 48–49, and 103, no. 20 (also see Nicolson, 1970-b, p. 312). (4) See Venice, 1959, no. 28, and Ottani Cavina, 1968, p. 107, no. 36, and p. 125, no. 86. (5) Published by Pallucchini, 1963; ill. in Ottani Cavina, 1968, pl. 109. (6) On Tassel, see Dijon [1955]. (7) Moir, 1967, II, 135. (8) See Pallucchini, 1963, and Ottani Cavina, 1968, pp. 69–70, n. 57.

GERARD SEGHERS

1591–1651

Born in Antwerp in 1591 and by tradition a pupil of Abraham Janssens, Seghers is one of the very few Flemish artists of stature who closely followed the Italian and Dutch Caravaggisti. He is not documented in Antwerp between the years 1611 and 1620, during which period he visited Italy (and possibly Spain), that is, while the three principal Utrecht painters were in Rome. There are extremely few works known from his Italian sojourn, but Sandrart tells us that he imitated Manfredi, and it is clear from the extant paintings that he also was in close touch with Honthorst.

After 1620 Seghers spent his life in the Low Countries (principally Antwerp). Beginning ca. 1630 he, like virtually every Flemish artist, fell under the powerful influence of Rubens; but even in his earlier paintings, a marked predilection for robust types and movemented compositions can be sensed. Seghers died in Antwerp in 1651.

61 *The Denial of St. Peter*, ca. 1620–25

North Carolina Museum of Art, Raleigh.
73 × 101 inches.
Collections:[1] Deyne, Ghent; Jean-Baptiste Lebrun, Paris; Cardinal Fesch, Paris and Rome; French and Co., New York.

As a soldier and a maid insist that Peter was with Christ, and the Apostle emphatically denies it, a group of card-players, uncalled for in the Biblical text, pause in wonderment. Earlier, Manfredi (Fig. 32) conceived this subject amid a gaming scene, and his composition, with Peter and the maid pushed to the far left, a helmeted soldier seen in profile, and a long spear held at the right, certainly influenced Seghers, confirming Sandrart's contention[2] that Seghers followed the "Manfredi manner."

Seghers, however, has minimized the sharp compositional dichotomy of Manfredi's prototype, and added two internal hidden light sources as well as a figure in the foreground silhouetted against the brightness—all under Honthorst's spell. The rich brushwork would have interested Stomer, but the beautiful pinks moving into grey-blues on the shirt of the man grasping Peter's left hand are unique to Seghers and quite remarkable.

The date of this composition cannot be determined. An engraving after it by Schelte à Bolswert[3] tells that Seghers made the picture for the Antwerp sculptor André de Nole, called Colin, whose death in 1638 is a clear *terminus ante quem.* A painting convincingly attributed to the Master of the Judgment of Solomon in the Certosa di San Martino at Naples[4]—certainly painted in Italy and probably the one attributed by Bellori to Caravaggio himself—seems to fall midway between Manfredi's and Seghers' conceptions, which indicates again that Seghers had Italy fresh in mind when painting the *Denial.* Bigot's representation of the same subject[5] is not similar enough to complicate further this series of works, except that Seghers' choice and use of colors on the face and hand of the maid—especially the carmine red—raise the possibility of artistic contact between the two painters.

Until more information is available concerning these related works and Seghers' development, the Raleigh composition must be placed imprecisely in the 1620's, probably towards the beginning rather than the end, and surely before Seghers' turn towards Rubens in the 1630's.[6]

Numerous copies and versions of Seghers' *Denial of St. Peter* testify to its fame.[7] Indeed, few pictures can boast the distinction of having influenced both Georges de La Tour[8] and Rembrandt.[9]

Notes: (1) Roggen and Pauwels, 1955–56, pp. 278–79, question the certainty of the early provenance of the Raleigh picture. (2) Sandrart, ed. 1925, p. 170. (3) Ill. by Roggen and Pauwels, 1955–56, p. 277. L. Vorstermans and I. Fagnion also engraved the composition (see Valentiner, 1956, no. 135, with further bibliography). The engraving by Schelte à Bolswert probably was made after 1630, when Seghers received a patent to make engravings after his works (Roggen and Pauwels, 1955–56, p. 258), but the painting itself must be earlier on stylistic grounds. (4) See Naples, 1963, no. 40, for a summary of attributions and dating, and Naples, 1967, no. 24, where it is attributed to the Master of the Judgment of Solomon. (5) Nicolson, 1964, p. 131, no. 24, fig. 31; now coll. Jitkow-Ploschek, Montville, New Jersey. (6) When exhibited in Utrecht (1952, no. 114) no date was suggested; Gilbert (1960, no. 12) offered ca. 1620. Schneider, ed. 1967, pp. 103–4, was familiar only with the engraving. Roggen and Pauwels, 1955–56, p. 278, say "Antwerp Caravaggesque period." See Roblot-Delondre, 1930, for Seghers' development in general, and Glück, 1933, pp. 211 ff., for his relationship to Rubens. (7) According to B. Nicolson, there is an autograph version in the collection of Lord Mansfield (Nicolson, 1960-a, p. 226); there are versions in the Walker Art Gallery, Minneapolis; colls: P. Fønss-

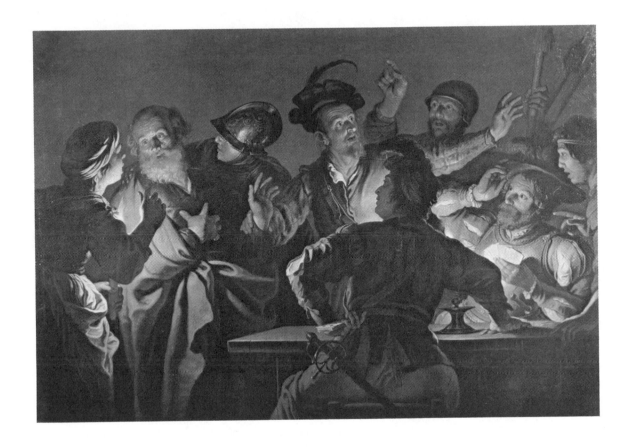

Pech, Copenhagen; Mrs. Delia Tally, Los Angeles; J. E.
Davies, Little Brington, Northampton, England; and a weak
partial copy in the Bober Coll., New York (published as an ori-
ginal [!] La Tour, Bober, 1962). Copies of the composition in
reverse are in the coll. Th. Cornely, Aachen; the Cathedral of
Namur; and in the Pastorie O. L. Vr. van Altijddurende Bijstand,
Lindenheuvel. Drawings related to this composition and variants
are in Haarlem, Vienna, and Leningrad (Wurzbach, 1910, II, 615;
and Roggen and Pauwels, 1955–56, pp. 277 ff. and figs. 5 and 6).
(8) La Tour's painting in Nantes of 1650 quotes directly Segher's
composition (see Pariset, 1948, pp. 283 ff. for a full discussion).
(9) Henkel, 1934; however, the relationship is not strict (also, see
Judson, 1964, pp. 141 ff.).

GIOVANNI SERODINE

1600–1630

Born in Ascona in 1600, Serodine led a short—and poorly documented—life. He arrived in Rome sometime prior to the third decade (perhaps as early as ca. 1615); and all of his paintings can be assigned to the 1620's. His public commissions in Rome include altarpieces for San Lorenzo fuori le mura, San Pietro in Montorio, and San Salvatore in Lauro; but the paintings for the latter two churches are lost, and altogether his preserved works number only about fifteen, four of which have found their way back to Ascona. If documents on Serodine's life and oeuvre are meagre, equally problematic are the sources and cross-influences contributing to his style. Caravaggio's work undoubtedly attracted him, as did that of Guercino. Borgianni, who died while Serodine was still quite young, seems to have contributed more to Serodine's formation than any single painter. But the role Terbrugghen played is an open and perplexing question, since it is difficult to establish the mode of contact, even though their work is sufficiently similar that it has actually been confused. Serodine died in Rome in 1630 and very quickly was forgotten—until his rediscovery in this century.

62 *The Tribute Money*, ca. 1625

The National Gallery of Scotland, Edinburgh.
57 × 89-$^1/_2$ inches.
Collections: Marchese Asdrubale Mattei, Rome;[1] William Hamilton Nisbet and heirs, Edinburgh (as Rubens and later as Ribera).

Fiocco[2] first attributed the Edinburgh picture to Serodine and rightly noted its stylistic affinities with the *Almsgiving of St. Lawrence*, formerly in San Lorenzo fuori le mura and now at Valvisciolo. More recently, Longhi[3] discovered its pendant, the *Meeting of Sts. Peter and Paul* in the Palazzo Mattei, Rome, where the *Tribute Money* also originally hung.[4] Longhi assigned them both to the period 1620–25,[5] while Schönberger placed them in the years 1626–28.[6]

The *Tribute Money* is typical of Serodine's work for its bulky forms in shallow space, the emphasis on emotive gestures, and especially for the agitated surface modeling that was learned from Borgianni. The rough, forthright treatment of the men's hostile faces is paralleled in Guercino's work around 1620,[7] as are the voluminous robes and the energetic movement across the picture plane. If the concentration on human drama is ultimately derived from Caravaggio's paintings, such as the *Doubting Thomas*, Borgianni's art [cf. 6] was a crucial intermediate step. Serodine's transformation of Caravaggio's early Seicento vision is not unlike Stomer's, and it exemplifies the updating Caravaggio's style underwent in the 1620's.[8]

Notes: (1) See Panofsky-Soergel, 1967–68, p. 185, doc. XLII; and Longhi, 1969, and Edinburgh, 1970, p. 90, no. 1513. (2) Fiocco, 1929. (3) Longhi, 1950-a, p. 20, and Milan, 1951, nos. 157–58. The Edinburgh and Mattei pictures were also exhibited at the Serodine *mostra* in Isole di Brissago, 1950. (4) Longhi, 1969. (5) Longhi [1955-b], p. 31, no. 7. (6) Schönberger, 1957, pp. 10, 59–60, and 79–80. (7) For example, see Mahon, 1968, nos. 32, 46–47. (8) See Moir, 1967, I, 142–44.

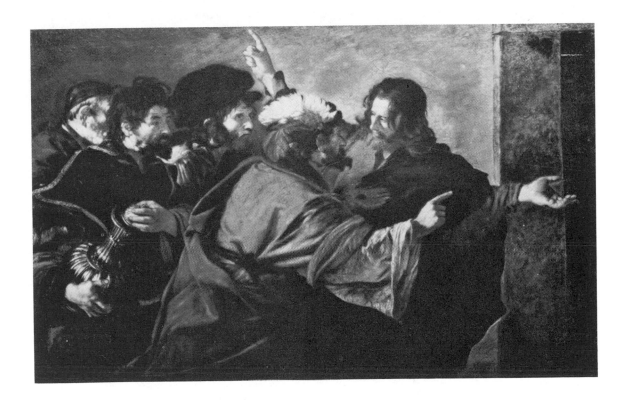

LIONELLO SPADA

1576–1622

Born in Bologna in 1576, Spada began his career amidst the activities of the Carracci circle. He worked both as a frescoist (in Pieve di Cento, San Michele in Bosco, etc.) and as an oil painter, and he received early training in quadratura *from Girolamo Curti, called Dentone. Spada's orientation toward the art of the Carracci and their followers was interrupted when he fell under the influence of Caravaggio, whom Malvasia states Spada knew personally in Rome and followed to Naples and Malta. But Spada is documented in Emilia from 1603 to 1607, and thus he could not have left Rome with Caravaggio when the latter fled the city in 1606. Inasmuch as Spada is said to have worked in Valletta (Malta) and in Rome—and Malvasia's report probably is founded on some degree of fact— it is reasonable to assume that Spada's trip to the South occurred ca. 1608–9. Although he is referred to by the sources as the "Scimmia del Caravaggio" ("Ape of Caravaggio"), his actual attachment to the master was erratic. Spada's work of the second decade (he returned to Bologna prior to 1614) includes some pictures strongly indebted to Caravaggio, but others which combine naturalism with classicism and are strictly Emilian in character. Thus Spada cannot be classified as a follower of Caravaggio in a strict sense, but nevertheless he was the only Bolognese painter who was seriously affected by Caravaggio and, more importantly, who introduced Caravaggesque naturalism into Emilia. Having worked in Ferrara, Modena, and Reggio, he died in Parma in 1622.*

63 *A Concert*, ca. 1615

Musée du Louvre, Paris.
$55-7/8 \times 68-1/8$ inches.
Collections: Cardinals Alessandro and Ludovico Ludovisi (?);[1] Sieur de Nogent, Paris; Jabach, Paris; Louis XIV, Versailles.[2]

Throughout the eighteenth and nineteenth centuries this *Concert* was attributed to Domenichino[3] and was engraved as that artist's work by Picard, Chauveau, Morel, and Lerouge and Géraut. Villot[4] restored it to Spada, whose authorship is unanimously accepted today.[5]

In fact, the *Concert* is one of Spada's most Caravaggesque paintings. The subject itself, as well as the grouping of half-length figures around a table, is indebted to Caravaggio and his followers, just as the raking light and fancy costumes are further indications that Spada was familiar with their genre scenes. However, the anecdotal character of the young boy at the right, the decorative handling of the fabrics, and the general mood of lighthearted informality differentiate the *Concert* from Caravaggio's melancholic works and place it instead in a more traditional vein of genre painting.

Calvesi[6] assigned this picture to the period 1615–22, but the stylistic affinities with Spada's documented *Miracle of the Fire* of 1614–16 (San Domenico, Bologna)[7] are so strong that a more precise date in the middle of the second decade seems to be justified. It confirms Calvesi's thesis that despite Spada's early contact with Caravaggio, his influence emerged only slowly in the second decade.

A small copy of the *Concert* attributed to Hippolyte Poterlet is deposited from the Louvre at the Château de Saint Germain.[8]

Notes: (1) Lépicié (II, 1754, 289–90) states that the *Concert* was painted for Cardinal Alessandro Ludovisi and passed to his nephew Ludovico, which Serra (1909, pp. 62–63, n. 5) confirms on the basis of an inscription in an engraving after the painting. (Lépicié's opinion could be based on the same information.) If Alessandro actually was the patron while a Cardinal, a date later than 1615 is necessary (Alessandro was elevated to the Cardinalate in 1616). (2) The King acquired the painting in 1671 (inventoried by Le Brun in 1683, no. 52); from Versailles it was sent to the Duc d'Antin, Paris (1715–36); returned to Versailles (1737); sent to the Luxembourg Palace (1750), and finally to the Louvre, from where it had been deposited at Maisons Lafitte from 1919 to 1970. (3) See Lépicié, 1754, II, 189–90; at least as early as 1709 it was

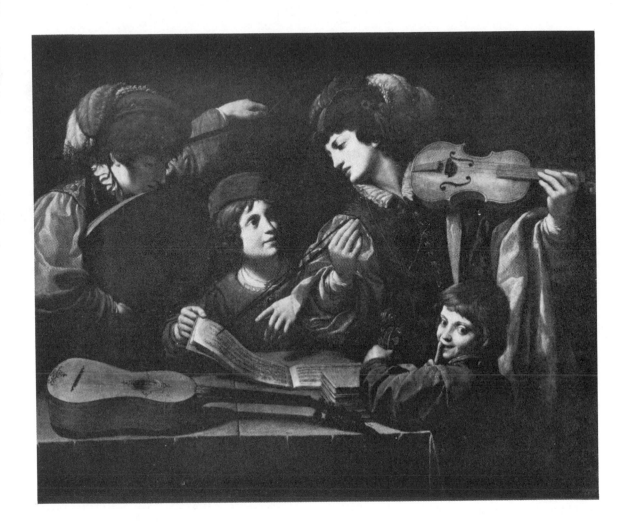

attributed to Domenichino in the inventory of Nicolas Bailly.
(4) Villot, 1876, no. 410. (5) Voss, 1909, p. 361, challenged Serra's
attribution of the picture to Domenichino (Serra, 1909, pp. 62–
63, n. 5). (6) In Bologna, 1959, pp. 93–94. (7) See Alce, 1958,
pp. 398–402, 405. (8) 9-⅞ × 12-½ inches; cited by Delacroix in
a letter of October 23, 1818 (see *Correspondance générale de Eugène
Delacroix*, ed. Joubin, Paris, 1936, I, 30; attributed to Géricault
by Charles Clement, *Géricault, Étude biographique et critique*, Paris,
1868, p. 320, no. 168).

MATTHIAS STOM(ER)

Ca. 1600–after 1650

Stomer, whose real name according to his few signed works is Stom, was born in Amersfoort, The Netherlands, probably in 1600, since in 1630 he is cited in Rome as being thirty years old. Bloemaert's and Wtewael's influences have been sensed in his art, suggesting a training in Utrecht, which is confirmed by his great similarities with Honthorst (whose work, however, he could have seen in Rome).

Very little is known about Stomer's career. He was in Rome in 1630 (which does not preclude an earlier arrival), in 1631, and 1632, in Naples in 1631, and in Sicily probably by 1641 —the date of a painting in Caccamo (Sicily) inscribed with his name. A group of his works in Naples suggests an extended stay there, perhaps in the 1630's. There is no evidence that he returned to Rome or to the North; nor is the date of his death known. His Sicilian paintings are extraordinarily mannered and free in handling, further removed from Caravaggio, Honthorst, and Bigot—with whom he has been confused. The influence of Rubens, in addition to that of Caravaggio's followers, must also be recognized.

64 *The Arrest of Christ,* early 1630's

The National Gallery of Canada, Ottawa.
59-5/8 × 80-7/8 inches.
Collections: J. Smith Barry, Marbury Hall,
Northwich, Cheshire; Sotheby's, June 21, 1933,
lot 19; R. E. A. Wilson, London.

The Ottawa painting has been identified as the *Mocking* and *Betrayal of Christ*, but apparently it represents the *Arrest*, for there is no reference to ridiculing, nor to Judas' kiss. It is significant that it frequently has been attributed to Honthorst,[1] which underscores its dependence upon that master—in color as well as form—and also suggests a relatively early date in Stomer's career, at least before his brushwork became broad, composed of angular, flat, disconnected strokes. The *Arrest* was possibly painted in Rome in the early 1630's,[2] but Stomer's stylistic development remains uncertain.[3]

An *Agony in the Garden* by Stomer, recently acquired by the Staatliche Museen, Berlin (West), a *St. Peter Delivered from Prison,* and a *Christ before Pilate by Candle-*

light once hung at Marbury Hall together with the Ottawa *Arrest.*[4] Whereas the *St. Peter* is completely untraced today, a "*Christ before Caiaphas*" (Fig. 41) sold as a Honthorst at Christie's in 1936 perhaps was the third Stomer from Marbury Hall.[5] On the basis of style and composition it is strictly analogous to the *Arrest of Christ;* furthermore, its dimensions are nearly identical, and it repeats the distinctive figure in the Ottawa painting who holds out the rope toward Christ.[6]

Notes: (1) In the Marbury Hall sale, and in Ottawa, 1957, p. 84. (2) Nicolson, 1960-c, pp. 151–52, reached this conclusion on the basis of a hypothetical chronology of Bigot, which, however, is too uncertain to be taken as evidence. Nevertheless, an early date in Stomer's career is reasonable, as is argued by Nicolson in 1969, p. 398, on the basis of a pendant *Agony in the Garden* (see below); also, see Pauwels, 1953-a, p. 160, where the picture is first attributed to Stomer. (3) See Pauwels, 1953-a, pp. 185–86, for a list of the rare signed and/or dated and documented works by Stomer. (4) See London, 1969-a, no. 26, and Sotheby's, June 21, 1933, lots 18–21. (5) Christie's, December 18, 1936, lot 77; 60 × 80 inches. It must be noted that in the Marbury Hall sale (Sotheby's, June 21, 1933, lot 20) the *Christ before Pilate* was described as 56-1/2 × 75-1/2 inches, a "composition of four figures," whereas the picture at Christie's three years later has five figures. It is certain, however, that the Marbury Hall paintings were neither accurately described nor measured in the 1933 catalogue, for the Ottawa composition is listed there as 57 × 78 inches and "of seven figures." (6) See Pauwels, 1953-a, p. 160, and Voss, 1908, p. 991, for a similar figure in another *Arrest* in Naples, which is approximately the same size as the Ottawa picture (60-1/2 × 79-1/2 inches).

65 *Christ at the Column,* ca. 1635–40

Museum of Art, Rhode Island School of Design, Providence.

72 × 45-¹/₁₆ inches.

Collections: private collection, Dublin; private collection, London; David Koetser, New York.

The Providence picture is related to another Stomer in Palermo[1] depicting the figure of Christ tied to the short column of His flagellation (a relic now in Sta. Prassede, Rome), but in the company of men whipping Him and a youth holding a candle (who stylistically is reminiscent of Honthorst). The Palermo painting has rightly been compared with Caravaggio's *Flagellation* in Naples,[2] and probably was painted by Stomer in that city (ca. 1635) rather than in Sicily.[3]

This *Flagellation* appears to be somewhat later.[4] The more fluid brushwork (note especially the hands and faces) approaches Stomer's work in Sicily, and compositionally the design is a logical reduction from, and development out of, the Palermo version, rather than *vice versa*, since the latter is more closely dependent upon Caravaggio's model.

Notes: (1) Ill. in Fokker, 1929, p. 12. Waterhouse, 1955, p. 222, calls attention to a third (unpublished?) variant in the Castel Ursino, Catania. (2) Schneider, ed. 1967, p. 119; and Pauwels, 1953-a, p. 148. (3) Schneider, ed. 1967, p. 119. (4) The "mid-1630's" has been suggested previously (London, 1955, no. 73).

HENDRICK TERBRUGGHEN
1588–1629

Terbrugghen's career is not well documented. He was born of a Catholic family in the province of Overijsel (probably near Deventer) in 1588 and later settled in Utrecht, where he reportedly studied under Abraham Bloemaert, the leading painter of the city. The sources agree that he spent ten years in Italy, where he must have arrived ca. 1604 (while Caravaggio was still in Rome), since he returned to Utrecht in 1614.

Unfortunately, there is no known composition by Terbrugghen which definitely stems from his Italian sojourn, when he undoubtedly was in touch, if briefly, with Honthorst, Baburen, and Borgianni. The relationship between Terbrugghen and Serodine remains highly problematic, but may be settled if one discovers that Terbrugghen in fact returned to Italy for a second visit. He definitely was among the earliest Northern followers of Caravaggio to arrive in Rome and also the first important Dutch painter to return to his native country with an understanding of Caravaggio's innovations.

During the period 1622–23 he probably shared a studio with Baburen, who influenced a number of his works. Terbrugghen died in 1629, his forty-second year.

66 *The Beheading of St. John the Baptist,* probably 1622

Nelson Gallery-Atkins Museum, Kansas City, Missouri (Nelson Fund).
$58\text{-}^1/_2 \times 34\text{-}^3/_8$ inches (reduced).
Signed in full (partially illegible) and dated 162[2?], lower left.
Collections: Horton Collection; Col. G. H. Anson, Burton-on-Trent; Rosenberg and Stiebel, New York.

St. John's neck and nearly all of the figure of Salome were lost from the right side of the composition when the picture was reduced.[1] Nevertheless, Terbrugghen's inventive poignancy is manifest even in this large fragment. A matter-of-fact directness and sense of duty motivate the executioner, while the young boy unbinds John's hands with compassion, releasing the Saint's body from its humiliating, kneeling position. As in the Oberlin *St. Sebastian* [68], hands and especially the subtle color harmonies are of primary importance in establishing the tragically still mood of death.[2]

Some years earlier[3] Terbrugghen dealt with this same theme in a picture now in Edinburgh which superficially has stronger affinities with Caravaggio. When particulars of style are dismissed, however, the Kansas City painting reveals a much more profound understanding of Caravaggio's mature Roman work.[4] Like Caravaggio's, Terbrugghen's figures react with feelings that are touchingly human—although the fears and misgivings of Caravaggio's martyrs yield to calm resignation.

Notes: (1) Nicolson, 1958-a, p. 52, estimates a loss of about 13-$^1/_2$ inches. (2) See the excellent analysis by Nicolson, 1958-a, pp. 52–53, no. A 12. (3) Nicolson, 1958-a, pl. 5; Slatkes (Dayton, 1965, no. 1), in cataloguing the Kansas City picture, argues that the Edinburgh painting is ca. 1618, "the earliest certain Terbrugghen that has come down to us." A recently discovered *Adoration* (Longhi, 1966-b), now owned by the Rijksmuseum, Amsterdam, probably predates it by a couple of years, although Longhi believes that it stems from the Italian period. (It is important to note that later additions [16 inches at the top, 6 inches at the bottom] have been made to the *Adoration*.) (4) Nicolson, 1958-a, pp. 52–53, discusses the relationship with Caravaggio as well as with Baburen (also, see Slatkes, Dayton, 1965, p. 12). Judson (1961, p. 346) cites an engraving by Lucas van Leyden as a source.

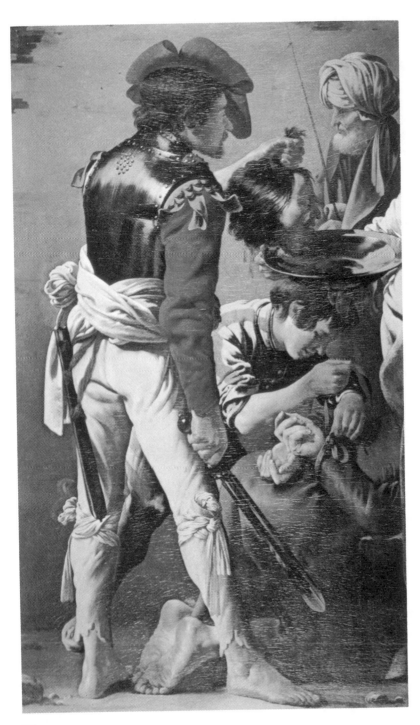

173

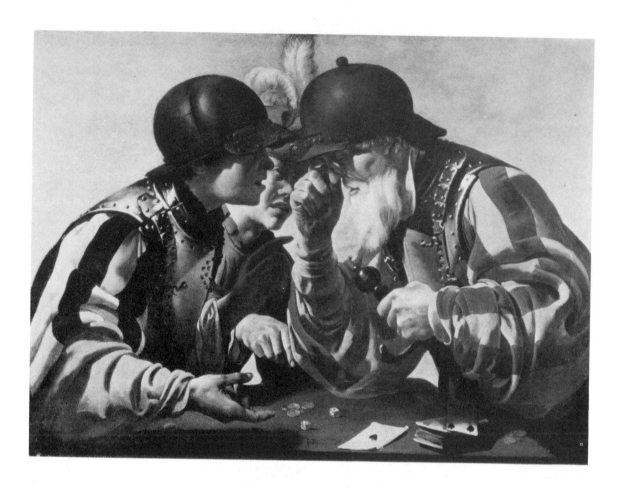

67 *The Gamblers, 1623*

The Minneapolis Institute of Arts (Dunwoody Fund Purchase).
33×44-$7/8$ inches (enlarged).
Signed with monogram, and dated 1623, lower center.
Collections: Christie's, November 12, 1943, lot 36 (as Honthorst); A. Scharf; Matthiesen Gallery, London; E. Speelman, London; Germain Seligman, New York; Jacques Seligmann, New York.

Painted while Terbrugghen and Baburen probably shared a common studio,[1] *The Gamblers* is conceptually indebted to Baburen's *Backgammon Players* [2].[2] Nicolson[3] has also suggested an ultimate relationship with scenes of gambling at the foot of the Cross, with a Northern moralizing-genre tradition, but in particular with Caravaggio's lost *Card Sharps* (Fig. 3) and related compositions. In the North, *The Gamblers* almost certainly was understood to have a moralizing purpose.[4]

A variant of the Minneapolis picture in the Utrecht Museum by a follower of Terbrugghen[5] transforms gambling into a scene of backgammon playing, set before a wall and partial landscape. Although the aqua-blue background of the Minneapolis painting is not Terbrugghen's original paint, it is not clear what his intentions were. It should be noted that strips of canvas about two inches wide have been added (at a later date) onto each side of the original fabric.

A copy of the *Gamblers* in Stockholm has been noted by Nicolson.[6]

Notes: (1) Slatkes, 1965, pp. 94–98, and in Dayton, 1965, p. 18. (2) Nicolson, 1958-a, pp. 84–85, no. A 52, and Slatkes in Dayton, 1965, no. 4. (3) Nicolson, 1958-a, p. 84. A copy of a painting by Valentin (see Borea, 1970, no. 19) confirms the conceptual relationship between gambling for Christ's robe and genre scenes such as the Minneapolis painting. (4) Nicolson, 1958-a, pp. 15 ff. *et passim*; Slatkes, in Dayton, 1965, pp. 18–19, and 1965, pp. 72 ff. (5) Nicolson, 1958-a, pp. 128–29, no. E 116 (ill. pl. 33c). (6) Nicolson, 1960-b, p. 469.

68 *St. Sebastian Tended by St. Irene,* 1625

Allen Memorial Art Museum, Oberlin College, Oberlin, Ohio.

58-⁹/₁₆ × 46-⁷/₈ inches.

Signed in full and dated 1625, upper left.

Collections: Pieter Fris, Amsterdam; Jan de Waale; French private collection; Frederick Mont, Inc., New York.

The attempted martyrdom of St. Sebastian was frequently represented in the seventeenth century,[1] but rarely—if ever—with the compassion of Terbrugghen's conception. Lengthy attention has been paid to this picture,[2] and its historical position—midway between Caravaggio and La Tour—has been recognized. Numerous compositional parallels (Caravaggio, Honthorst, Bylert, Baburen, Baglione, Dürer, and problematic pictures in Valencia and Moscow),[3] however, cannot explain Terbrugghen's subtly balanced pyramidal group, nor the perfected expressiveness of faces, hands, and feet. Yet, a recently discovered picture of the same theme merits attention. Baburen's late *St. Sebastian Tended by St. Irene* (Fig. 42),[4] neither signed nor dated but earlier than the Oberlin painting (since Baburen died in 1624), reveals significant similarities. The two Saints and maidservant are arranged pyramidally, with Sebastian's and the servant's hands at the apex. As in Bylert's *Sebastian* of 1624,[5] which probably was painted in Italy (and in that case unknown to Terbrugghen),[6] a long diagonal is established by Sebastian's arm. But unlike Bylert's picture, Baburen's, like Terbrugghen's, is set before a landscape that opens on only one side.

If, in fact, Terbrugghen was familiar with Baburen's painting, which appears to be very likely, the transformation of a commonplace first-aid rescue into an act of spiritual motivation is infinitely more important, and demonstrative of Terbrugghen's "profound yet melancholy meditation"[7] that rivaled Caravaggio's.

Notes: (1) See Stechow, 1954, pp. 70 ff., and Carr, 1965. (2) Especially by Stechow, 1954, and 1967, pp. 148–50; Nicolson, 1958-a, pp. 86–87, no. A 54; and Slatkes, in Dayton, 1965, no. 10. (3) Summarized by Slatkes in Dayton, 1965, pp. 31–32. (4) Kunsthalle, Hamburg, 42-⁷/₈ × 60-¹/₂ inches; ex-colls: Broek, Antwerp, and Gazan, Dilbeek. (5) Harrach Gallery, Vienna (ill. in Hoogewerff, 1965, p. 12, fig. 2). (6) Bylert married in Utrecht in May of 1625; Hoogewerff, 1965, p. 4, states that he returned to Utrecht in 1624, but provides no supporting documentation. 7) Sandrart, ed. 1925, p. 178.

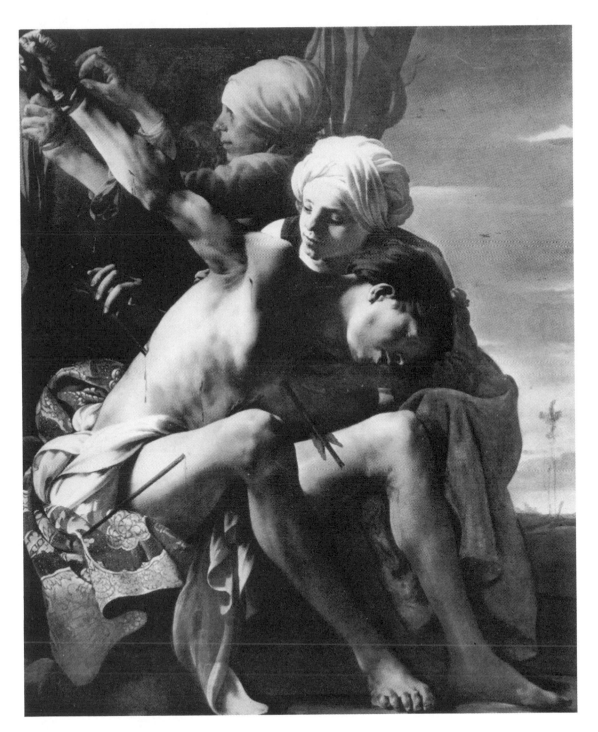

NICOLAS TOURNIER

1590–1638/39

Tournier, a French Protestant, was born in Montbéliard in 1590. He is documented in Rome from 1619 to 1626, and in 1619 is reported to have lived with the Caravaggesque painter from Liège, Gerard Douffet, but little else is known about his Italian activities. It is clear, nevertheless, that he followed the "Manfredi manner," especially as interpreted by Renieri and his compatriot Valentin, with whom he almost certainly studied and whose works, as well as Manfredi's, he seemingly copied.

Tournier returned to France, to Carcassonne, by late 1627, and by 1632 was settled in Toulouse, the city with which he is usually identified. He continued to paint modified concert-gaming scenes in the Manfredi-Valentin tradition, but devoted more time to religious paintings which—like Caravaggio's—often achieve a spiritual intensity through dignified restraint.

69 *A Musical Party*, ca. 1622–25

City Art Museum of St. Louis.
47-7/16 × 65-1/8 inches.
Collections: Francis de Colloredo, Vienna.[1]

According to tradition, Tournier was Valentin's (only) pupil.[2] His relationship with Valentin is clear when the *Musical Party* is compared with Valentin's *Soldiers and Bohemians* in Indianapolis [71] or especially a *Concert* in the Louvre,[3] which is similar in the basic arrangement of figures around a centrally placed woman on whose left is a seated lute player. Furthermore, the man at the far left in the St. Louis picture, with a fixed and penetrating gaze trained on the observer, finds its source in Valentin's masterful *Four Ages of Man*.[4] Nevertheless, Tournier's *Musical Party* should not be confused with Valentin, even though it once bore that attribution.[5] A quietness prevails, and there is a subtle self-consciousness in the figures, which are developed from, but beyond, Valentin. Furthermore, the generalized forms and clarity of arrangement bring to mind the simplicity and calm so typical of Georges de La Tour.

Tournier's *Musical Party* almost certainly was painted in his later Roman years. Strong affinities with the picture of the same subject in Bourges,[6] definitely among Tournier's Italian works, place it in the 1620's. But whereas the picture in Bourges is closer to Valentin's —and ultimately Manfredi's[7]—method of composing, the St. Louis canvas foretells Tournier's *Concert*[8] in the Louvre, of ca. 1630–35,[9] which reveals the artist's more formal, classicistic tendencies during his years in France.[10]

Two other versions of the St. Louis picture are known: one of slightly lower quality is in the Museum of Budapest;[11] a second, definitely a copy, was sold in 1912 as Valentin.[12]

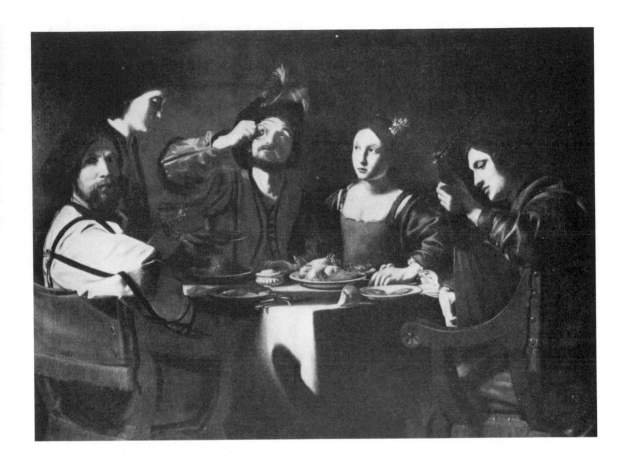

Notes: (1) According to an inscription on the back of the canvas.
(2) Dezallier d'Argenville, 1762, IV, 47. See Mesuret, 1951, re-
garding Tournier's youth. (3) Ill. in Ivanoff, 1966, pl. IV. (4) Na-
tional Gallery, London, no. 4919. (5) See Montreal, 1961, no. 75.
Charles Sterling first attributed the picture to Tournier (see New
York, 1946, no. 48). (6) Mesuret, 1957, no. 33; see Milan, 1951,
no. 176. (7) For Tournier's relationship with Manfredi, see Lon-
ghi, 1935, and 1943, p. 50, n. 46. (8) Mesuret, 1957, no. 32, ill.
p. 337, fig. 7. (9) See Mesuret, 1957, no. 32 (Charles Sterling as-
signs the costumes to this period). (10) Tournier's artistic person-
ality remains partly unclear, despite his documented and dated
works from the French period (see, e.g., Nicolson, 1958-b, pp.
97–98). (11) Pigler, 1968, no. 624 (as "Replik oder alte Kopie").
(12) Grimaldi sale, Muller, Amsterdam, December 4–5, 1912, no.
68, as Valentin; 43 × 65-3/8 inches; later (1938) in the possession
of D. Katz, Dieren.

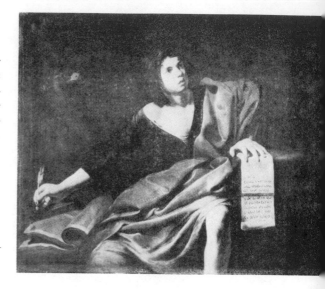

VALENTIN DE BOULOGNE

1591–1632

Valentin remains an enigmatic figure. "Moïse," an often-cited given name, is only a misunderstanding for the common Italian form of Monsieur, "Monsù." (His first name possibly was Philippe.) The origin of his family could be either in Boulogne-sur-Mer (Pas-de-Calais) or Bologna (the former is more likely), but he was born in Coulommiers, Brie, in 1591. Sandrart reports that he arrived in Rome before Vouet, that is, ca. 1612. He never left the Eternal City, where he seems to have been immediately attracted by the work of Manfredi, and then Vouet, prior to sharing a studio with Douffet in 1620. Cardinal Francesco Barberini, his principal patron in the late 1620's, secured him his most important commission, The Martyrdom of Sts. Processus and Martinian *for St. Peter's (payments are recorded in 1629). The biographers agree that Valentin led an irregular, bohemian life, which reportedly led to his demise in 1632; overheated from tobacco and wine, he plunged into the* Fontana del Babuino, *took cold, and died. His paintings, which number among the finest Caravaggesque works, were collected by Cardinal Mazarin, and thus today are most numerous in the Louvre and at Versailles. Tournier and the Master of the Judgment of Solomon were his closest followers.*

70 *St. John the Evangelist*, ca. 1620–25

The William Hayes Ackland Memorial Art Center, University of North Carolina, Chapel Hill.

37-$^3/_4$ × 52-$^3/_4$ inches.

Collections: Colonna Collection, Rome;[1] Paul Vogel-Brunner, Lucerne, Switzerland; Frederick Mont, Inc., New York.

Among Valentin's earliest recorded work is a series of the four Evangelists, acquired by the French State in 1670[2] and today preserved at Versailles. The picture in Chapel Hill is intimately related to the *St. John* at Versailles (Fig. 43), where the placement of the eagle and the codex, the general disposition of garments, and the posture of the Evangelist are analogous.

Valentin's use of strong red and deep black robes in the Chapel Hill painting, the implied heaviness of the garments, and the relative tightness of the brushwork suggest that this picture probably predates the French series, which appears to belong to the later years of the artist's career. The mature sense of motivated action and compositional unity in the *St. John* at Versailles supports

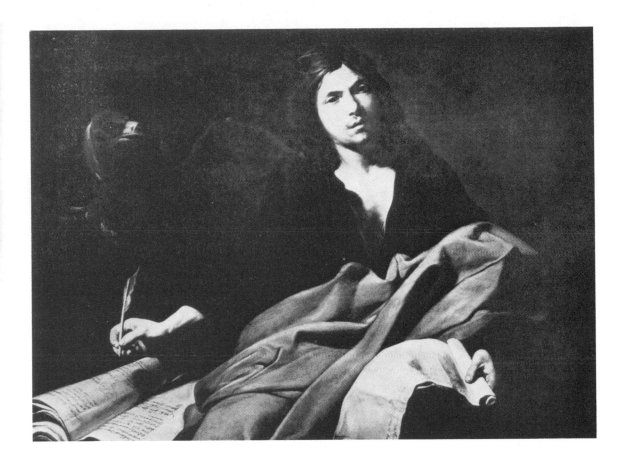

this assumption, for there the Evangelist's upturned head symbolizes the divine guidance that prompts his writing. At the same time, however, it reflects a definite departure from Caravaggio's religious conceptions, as well as from Valentin's own early—sometimes violent and always urgent—mood.

If in the Chapel Hill version the placement of John's right arm is more contrived, the inquisitive expression, knit brow, and cocked head are rewarding variations, lending to the work a candid informality that is reinforced by the absence of any reference to divine inspiration.

Notes: (1) A Colonna seal remains affixed to the stretcher of the painting. (2) See Hoog, 1960, pp. 267–69; each canvas, enlarged from its original dimensions, presently measures 47-$^1/_4$ × 57-$^1/_2$ inches.

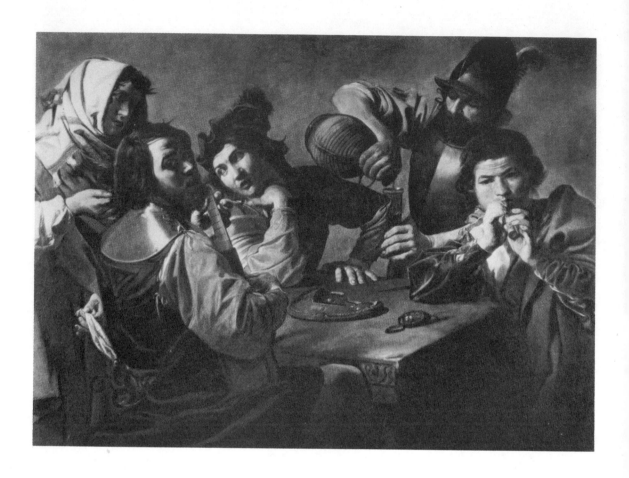

7 I *Soldiers and Bohemians*, ca. 1625–28

> Indianapolis Museum of Art (William A. Zumpfe
> Memorial Fund).
> 47 × 62-¹/₂ inches.
> *Collections*: Galerie Heim, Paris.

Frequently, Valentin represented groups of figures ar-
ranged around an ancient marble fragment that serves
as a table, with no ostensible subject other than merry-
making and, as here, thievery.[1] Paintings by Manfredi,
such as the *Concert* in the Uffizi and the *Denial of St.
Peter* (Fig. 32), were Valentin's principal source.

It is generally assumed that this category of pictures
represents Valentin's early style, theoretically when his
works were closest to Manfredi—rather tightly painted
and basically airless.[2] However, Valentin is known to
have accepted commissions for these subjects very late
in his career,[3] and stylistically *Soldiers and Bohemians* an-
ticipates the *Samson* of 1630–31 [72]. On the basis of
the free technique and variegated drapery surfaces, one
can place this picture in the later 1620's.[4]

A copy of the Indianapolis painting with one less fig-
ure was sold at Sotheby's, March 6, 1957, lot 128, 55 ×
59-¹/₂ inches. Another version (60 × 72 inches), lacking
the woman at the left, is reportedly signed and dated:
Caravaggio, 1603 or 1605.[5]

Notes: (1) Coley, 1960, notes, but dismisses, the possibility that
we deal with the five senses; also, see Indianapolis, 1970, p. 67.
(2) See Longhi, 1958, pp. 59 ff. (3) Costello, 1950, pp. 239, 250–
51, 254–55, 264–65, and Valentin's own testimony on pp. 278–
79. (4) Earlier dates have been suggested: ca. 1620 by Gilbert,
1960, no. 8; ca. 1625 by Coley, 1960; and ca. 1620 by Carter,
1968, p. 2, and p. 4, n. 1; and 1620–25 in Indianapolis, 1970, p.
67. Longhi, in Paris, 1965, no. 1, had suggested a later date, be-
tween 1625 and 1630. The damaged, repainted areas of the In-
dianapolis painting should not mislead one to deny its authen-
ticity. (5) A photograph is filed in the Witt Library, London (as
owned by W. Duff Murdoch, London).

Figure 44. *David*. Valentin. Whereabouts unknown.

72 *Samson*, 1630–31

Ing. Dr. Edoardo Almagià, Rome.
70-$^1/_2$ (enlarged) × 39-$^1/_2$ inches.
Collections: Cardinals Francesco and Antonio
Barberini and heirs, Rome; Colonna di Sciarra,
Rome; Galerie Sangiorgi, Rome.

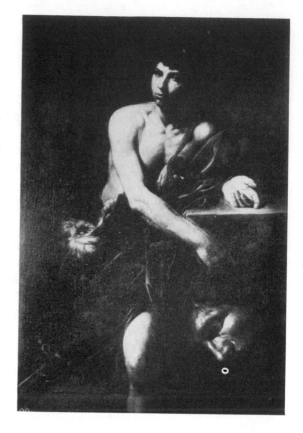

In 1627 Cardinal Francesco Barberini paid Valentin for painting a *David* (Fig. 44); in December of 1630 he paid 5 *scudi* for the canvas of a *Samson*, which was completed as a pendant to the *David* in 1631.[1] Two years later, in 1633, *Samson* was inventoried in Antonio Barberini's collection, but in 1649 *David* and *Samson* were cited as again in Francesco's possession, each measuring 6 × 5 *palmi*.[2] There are no other references in the Barberini archives (except that *Samson* was erroneously inventoried in 1631 [!] as Poussin)[3] until the initial Barberini-Sciarra division in 1812, when the picture was attributed to Angelo Caroselli.[4] The *David* remained in the Barberini Collection, whereas *Samson*, together with at least two other Valentins,[5] became part of the famous Galleria Sciarra.[6] *Samson* was auctioned in Rome in 1899 as Angelo Caroselli,[7] and entered the Almagià Collection.

Heretofore, only Valentin's Vatican altarpiece, whose payments are recorded in 1629, could be dated precisely.[8] On the basis of it and related works, it was assumed that late in his career Valentin turned toward a more classicistic, "grand manner" style. The *Samson*, however, offers important evidence that he continued to paint eminently Caravaggesque pictures after 1629, even if the color scheme is more "French" than in some of his earlier pictures. The handling of paint and the tonality of the red mantle and blue cuirass (fastened with Barberini bees) find similarities in the *Judith* in Toulouse,[9] which undoubtedly should be assigned to the same years. The relatively tightly drawn, though thin, garments, as well as the more painterly definition of form, also are characteristic of late Valentin. In quality of conception and brilliance of execution, *Samson* rivals Caravaggio's powerful, brooding depictions of *David* and *St. Jerome*.

Notes: (1) Marilyn Aronberg Lavin kindly provided the information from the Barberini archives concerning the *David* and *Samson* prior to her publication of the seventeenth-century Barberini inventories. *David* was listed by Zeri, 1954, no. 87, and published by Thuillier, 1958, p. 28; its present location is unknown. Also, see Vivian, 1969, pp. 721–22. (2) Strips of canvas have been added to the top (11-$^3/_8$ inches wide) and bottom (6-$^1/_8$ inches wide) of *Samson*; without them, the picture is 53 inches high, which corresponds very well with the inventory's approximate dimensions (6 × 5 *palmi* or 52-$^3/_4$ × 43-$^7/_8$ inches). (3) See Blunt, 1966, p. 158, no. L 4, and Vivian, 1969, pp. 721–22. (4) Vivian, 1969, p. 721; it appears in an unpublished list as fourth class, no. 73, "Caroselli," and was cited again in the 1818 list published by Mariotti, 1892, p. 135, no. 46. (5) *The Beheading of the Baptist* (lost) and enormous *Rome Triumphant* (Thuillier, 1958, p. 31. (6) Various guidebooks of Rome cite the *Sansone* of "Caroselli" (e.g., Nibby, 1842, I, 34, and Pistolesi, 1846, p. 94). (7) Rome, 1899; fifth sale, March 28, no. 363: "A. Caroselli, *Samson au repos, couvert d'une cuirasse*, 1.01 × 1.25 [meters]." (See n. 2 above regarding the vertical dimensions; the addition clearly was made after 1899.) (8) Pollak, 1928–31, II, 541–42. (9) Ill. in Ivanoff, pl. I.

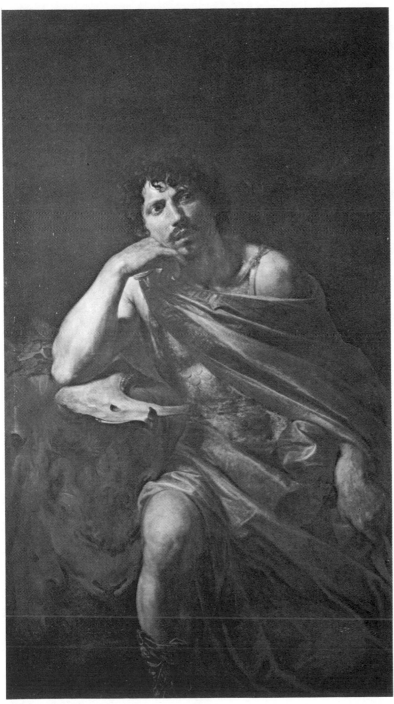

SIMON VOUET

1590–1649

Born in Paris in 1590, Vouet traveled to Constantinople in 1611, continued on to Venice in 1612, and departed for Rome at the end of 1613. There he settled in the parish quarter of San Lorenzo in Lucina, popular with numerous painters, including Lanfranco and Borgianni, with whom he shares many artistic parallels. His compatriots Vignon, Tournier, and Valentin all resided nearby, and he certainly was in close touch with Renieri too. He remained in Rome (except for a trip to Genoa in 1620–21) until departing for France in 1627, having enjoyed Barberini patronage, numerous important public commissions, and the presidency of the Accademia di San Luca (1624). Stylistically, his Italian paintings reveal a great variety of influences, ranging from Caravaggio and his followers to the Bolognese painters to the High Renaissance masters of Venice and Rome. In Paris he was immediately distinguished with the title "Premier Peintre du Roi." In addition to royal patronage and numerous commissions decorating the hôtels of Paris, Vouet headed an atelier that trained a distinguished group of French artists. He died in Paris in 1649, a year after the founding of the Royal Academy of Painting and Sculpture (to which he did not belong). His Parisian style reveals few traces of the Caravaggesque elements that were important during his Italian years.

73 *The Fortune Teller*, ca. 1619–20

The National Gallery of Canada, Ottawa.
47-1/4 × 67 inches.
Collections: possibly Cassiano dal Pozzo, Rome;[1] French private collection; Galerie Heim, Paris.

The traditional title, *The Fortune Teller*, properly relates this composition to Caravaggio's painting of the same subject in the Louvre (Fig. 2), but it was Caravaggio's lost *Card Sharps* (Fig. 3) that specifically seems to have popularized the play of secretive finger signals. However, Vouet's frankly posed victim at the left, the contrived interplay of gestures, and the theatric exaggeration of facial expressions at once differentiate this work from Caravaggio's and suggest that perhaps an actual comedy farce in the tradition of the *Commedia dell'arte* was its source.[2]

Of the numerous paintings by the Caravaggisti generically related to this picture, a composition in two versions attributed to both Manfredi and Grammatica[3] is best known and exemplifies the more usual candid conception. Various paintings by Valentin[4] also approach Vouet's interpretation of the theme, and it is known that Manfredi represented a fortune teller at least twice.[5]

Demonts[6] first identified this composition as by Vouet on the basis of an anonymous engraving in the Bibliothèque Nationale, Paris, long classified as Vouet.[7] Nevertheless, when the painting itself reappeared it was attributed to Manfredi and subsequently exhibited as Renieri.[8] Longhi made the correct attribution to Vouet[9] and suggested a date of ca. 1620, which Manning[10] accepted. Crelly[11] and Moir[12] prefer to place it slightly earlier, which corresponds with the proposal of Dargent and Thuillier, "antérieure au voyage à Gênes [1620–21]."[13]

An oil painting representing the woman at the left (half-length), once in a Roman private collection, is probably only a good old copy.[14] An extremely weak (eighteenth-century?) copy of the entire composition is in a French private collection.[15]

Notes: (1) See Ottawa, 1957, p. 105, and Crelly, 1962, pp. 190–91, no. 92. (2) This was suggested by Myron Laskin. (3) Florence, Palazzo Pitti (ill. in Longhi, 1968-b, pl. 205), and Rome, Palazzo Corsini (photo G. F. N. E-35568); the Corsini version was exhibited as Manfredi (Carpegna, 1955, no. 24), but is rejected by Nicolson (1967, p. 111, n. 34). For the attribution to Grammatica, see Longhi, 1968-b [1928–29], p. 139. (4) See, for example, the well-known picture in the Louvre, no. 8254 (ill. in Ivanoff, 1966, pl. VII), and a picture, probably based on an original Valentin, in Avignon, Musée Calvet (photo Archives Photographique, BAP 7535). (5) Nicolson, 1967, p. 108. (6) Demonts, 1913, p. 342. (7) Ill. in Dargent and Thuillier, 1965, fig. 14; catalogued as Valentin by Robert-Dumesnil, 1844, VII, 163–64, and 1871, XI, 312. (8) Paris, 1955, no. 13, and Bordeaux, 1955, no. 103; also, see Nicolson, 1955, p. 124. (9) Longhi, 1955-a, p. 63. (10) Manning, 1959, p. 294. (11) Crelly, 1962, p. 191. (12) Moir, in Detroit, 1965, no. 10. (13) Dargent and Thuillier, 1965, p. 51, no. V 4. The Ottawa picture was recently exhibited at the University of Maryland Art Gallery (Simon Vouet, 1590–1649, February-March, 1971, checklist no. 2), but at the time this catalogue is going to press the Vouet catalogue is not yet available. (14) Published as Vouet by Longhi, 1955-a, p. 63, but doubted by Dargent and Thuillier, 1965, p. 51. (15) 9 × 12-5/8 inches; coll. F. Leclerc, Arlan (?). A photograph is filed in the Rijksbureau voor Kunsthistorische Documentatie, The Hague ("Arlan" has not been successfully identified).

74 *Portrait of a Gentleman*, ca. 1622–25?

Mr. and Mrs. Henry H. Weldon, New York City.

30-$\frac{1}{4}$ × 24 inches.

Collections: Count Czernin, Vienna; Galerie Sanct Lucas, Vienna; Alfred Brod Gallery, London.

Caravaggio's and Manfredi's genre figures are the spiritual antecedents to Vouet's highly original Italian portraits. As in the contemporary work of Vignon, Vouet usually portrayed his sitters bust-length, placed against a dark, undefined background; shoulders are in three-quarter profile and faces are turned toward the viewer with expressions that often, as in the Weldon portrait, seem to demand an explanation for the viewer's presence; dark hair falls free to the shoulders, and a slight tilt of the head or bend of the shoulders animates the sitter, whose enigmatic character is heightened by an evocative *non-finito* and slightly parted lips.

The date of this portrait, like all of Vouet's Italian portraits, is difficult to establish.[1] It would seem to post-date the brilliantly free portraits in Arles,[2] Braunschweig,[3] and Rome,[4] reasonably assigned to the years ca. 1615–19,[5] and to predate his self-portrait in Lyon, which may be of ca. 1627,[6] that is, at the very close of Vouet's Italian period. The impasto here is less vigorously applied than in the earliest portraits, but freer than in the later 1620's.[7]

Notes: (1) Blunt, 1946, first studied the portraits; no date was suggested for the Weldon portrait either time it was exhibited (Providence, 1964, no. 28, and New York, 1966, no. 45), nor in Manning, 1959, p. 294, or Crelly, 1962, p. 189, no. 89. Weldon, 1966, pp. 23–24, assigns it to the late 1620's and suggests that it could be a self-portrait. The Weldon portrait was recently exhibited at the University of Maryland Art Gallery (Simon Vouet, 1590–1649, February–March, 1971, checklist no. 14), but at the time this catalogue is going to press the Vouet catalogue is not yet available. (2) Crelly, 1962, fig. 1. (3) Crelly, 1962, fig. 2. (4) Dargent and Thuillier, 1965, fig. 1. (5) Crelly, 1962, pp. 24–25, and Dargent and Thuillier, 1965, nos. A 1, A 2, and V 2. (6) Crelly, 1962, fig. 40, and especially Dargent, 1955. (7) Since this catalogue has gone to press, the Weldon portrait has been cleaned; Mrs. Weldon writes that with the removal of surface dirt, "it is clear that the artist set the figure in an oval background and painted the corners darker in order to set off the oval. What is rather interesting is that Mrs. Blumel [the restorer] pointed out to us that in the upper right corner, Vouet apparently dabbed off the color from his brush as he finished using a particular color. Traces of these original colors now reappear under the dark brown covering color used in the corners. This would seem to indicate that Vouet intended from the beginning to make the corners darker than the rest of the background and to make an oval form within the rectangle." Unfortunately, it was not possible to reproduce here a photograph of the portrait after cleaning.

75 *St. Peter Visiting St. Agatha in Prison,* ca. 1625–26

The Estate of Hamilton Smith, III.
$51\text{-}^{1}/_{8} \times 72\text{-}^{1}/_{8}$ inches.
Collections: private collection, New Orleans;
William Dickinson Griswold (grandfather of
Hamilton Smith, III).

Agatha of Catania suffered the torture and humiliation of having her breasts cut off at the order of Quintianus, whose advances she refused. Her story is told by Jacobus da Voragine,[1] who writes: "And when she was fast closed in the prison [following her torture], there came an ancient noble man, and tofore him a child bearing a light, and divers ointments in his hand." The man miraculously healed her breasts and revealed himself as Christ's Apostle.

The early sources do not cite a large *Peter and Agatha* among Vouet's works, nor is there a known engraving of it. However, an inventory of 1635 of the Duke of Savoy's collection at Turin, drawn up by the painter Antonio della Cornia, lists a painting on copper[2] which was possibly a variation on, or copy after, the Smith picture. In fact, the description specifies that St. Peter, accompanied by an angel ("half-length" figures) is "on the way" to heal St. Agatha, differentiating the moment depicted from the act of healing itself.

On the basis of style, the Smith painting can be assigned to Vouet's late Roman period. (It is important to stress that the pronounced "ironed" appearance of the canvas must not affect one's judgment of the quality of the picture.) Nocturnes with an internal light source interested Vouet around the year 1625.[3] The *Temptation of St. Francis* in San Lorenzo in Lucina[4] slightly precedes the Jubilee Year; Mellan's engraving after the *Allegory of the Human Soul* is dated 1625;[5] and the *Cupid and Psyche* in Lyon can be assigned to ca. 1625–26.[6] The Smith painting has strongest affinities with the latter picture, for together they reveal an understanding of light as a positive, unifying element, clearly and poetically handled. In the earlier nocturnes light tends to isolate itself in various pools across the canvas, creating an active, if somewhat disjointed, effect.

The angel with the candle is so similar to the so-called *St. William of Aquitaine* in Algiers[7] that they must be derived from the same model, which would suggest, but not prove, that the latter may belong to this same phase in Vouet's career, and not to the pre-Genoese years.[8]

Of special interest are the linear purity of Agatha's profile, nearly *perdu*; her eminently quiet, withdrawn character; and the contrast between the crisply defined, deep shadow cast by her own head and the softer passages of chiaroscuro giving form to her arm and hands. If there are broad affinities with Lanfranco and the Utrecht painters, the most striking relationship is with Georges de La Tour, for no other figure by Vouet so clearly approaches the Lorraine master.

Notes: (1) Jacobus da Voragine, ed. 1900, III, 32 ff. (2) Baudi di Vesme, 1897, p. 36, no. 27: "S. Pietro che va a medicar Santa Agata, con un angelo, mezze figure in rame. Di Monsù Voet. Mediocre." (3) For Vouet's Roman style, see Voss, 1924–25; Crelly, 1962, pp. 19 ff.; and Dargent and Thuillier, 1965. (4) Crelly, 1962, fig. 18. (5) Crelly, 1962, pp. 212–13, no. 132, and figs. 21–22. (6) Crelly, 1962, p. 176, no. 60, and fig. 26; Dargent and Thuillier, p. 48, no. A 33. (7) Crelly, 1962, fig. 32. (8) Crelly, 1962, p. 147, no. 1, suggests a date in the late Roman period, but Dargent and Thuillier, pp. 51–52, no. V 7, have assigned it to ca. 1618–20.

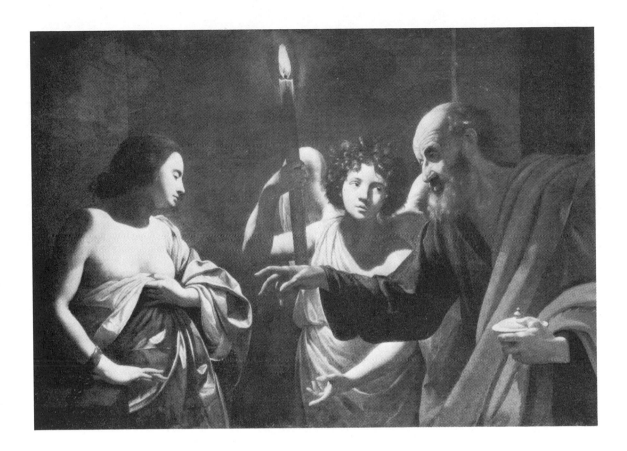

ANONYMOUS

76 *St. Jerome*, ca. 1615?

Worcester Art Museum, Worcester,
Massachusetts (Austin S. Garver Fund).
28-3/4 × 38-3/8 inches.
Collections: said to come from Malta; Pico
Cellini and Giuliano Briganti, Rome; Julius
Weitzner, New York.

Despite the marked revival of Hieronymite activity in
Italy and Spain in the early seventeenth century and the
subsequent renewed popularity of St. Jerome in art, a
thorough study of the iconography of the Saint remains
to be made. Two non-narrative scenes, Jerome working
in his study and Jerome contemplating the skull, raise
no problems of interpretation, for they are symbolic of
the Saint's long devotion to a religious, scholarly life
and are based on no single textual source. By way of
contrast, Jerome's vision is fully recounted in his letter
to Eustochium ("On the Virgin's Profession," dated
384), where he tells of being whipped for his "Cicero-
nian" rather than Christian interests. However, that spe-
cific incident does not explain the more popular repre-
sentation of him hearing the angel's trumpet. The paint-
ing in Worcester seems to be a variant on the last judg-
ment theme, but because not even a flared bell of a horn
is portrayed to indicate the presence of the divine,[1] in-
spiration—rather than judgment—may be the meaning
of the vision. As in Caravaggio's own paintings, light
alone signifies holy intervention. The candle in Jerome's
study is extinguished, a skull is broken in two, and the
book on which the Saint had been working is marked
with a large letter N.[2]

The attribution (and consequently the dating) of the
Worcester painting is highly problematic.[3] Longhi once
suggested the name of Johann Ulrich Loth, which is not
convincing but rightly points to the presence of North-
ern elements in an Italianate picture. Certain features
undeniably are reminiscent of Caravaggio's late style,
but Caravaggio's fluid brushwork and strong sense of
form are lacking. The Worcester picture is more ner-
vous, the *fattura* more pasty, and the arrested movement
is especially foreign to Caravaggio's late style. The

handling of paint and coarseness of figure type might
be Northern, but the composition could be French or
Italian just as well; the still life seems to be Southern—
all of which complicates the origins of the painting.

Notes: (1) Laboratory inspection suggests that the painting has
not been cut down to any appreciable extent. (2) For a provoca-
tive discussion of the picture in general and notes on the pos-
sible meaning of the letter N, see Martin Davies in the forth-
coming catalogue of European paintings in the Worcester Mu-
seum. For comparable representations of St. Jerome, St. Matthew,
et al., see Waal, 1964, p. 34 *et passim*. (3) Other than Longhi's
mention of J. U. Loth, the only attribution recorded in the Mu-
seum's files is one to Caravaggio himself, proposed by Maurizio
Marini (Marini believes that the picture could be the lost *St. Jer-
ome* cited by Bellori, 1672, p. 210, as painted for the Capuchin
Monks in Messina). The Worcester painting was exhibited as
"School of Caravaggio (Italian)" in *Problem Pictures: Paintings
without Authors*, Vassar College Art Gallery, Poughkeepsie, New
York, 1965, no. 6.

ANONYMOUS

77 *Summer*, ca. 1620–25

N. U. l'Architetto Andrea Busiri Vici, Rome.
22-7/8 × 66 inches.
Collections: Drury-Lowe Collection, Locko Park,
Derbyshire.[1]

The unidentified master responsible for this picture was
in close contact with Manfredi (as Benedict Nicolson
first recognized)[2] and with Renieri. Two allegories of
Autumn and *Winter* in Nicolson's own collection have
been assigned with some reservations to Manfredi him-
self, and are seen as the compositional and iconographic
source of Busiri Vici's picture[3] (which Nicolson has sug-
gested is French instead of Italian).

It is not entirely certain, however, that two artists nec-
essarily are involved in these three paintings, or that
the picture in Rome is iconographically a conflation of
two seasons, summer and autumn.[4] The three long can-
vases, probably designed as over-door decoration, were
once all in England; they are the same size, and stylisti-
cally there are few serious discrepancies among them. A
moist fleshiness is typical of them all, and the use of light
is uniform even though the pictures in London have

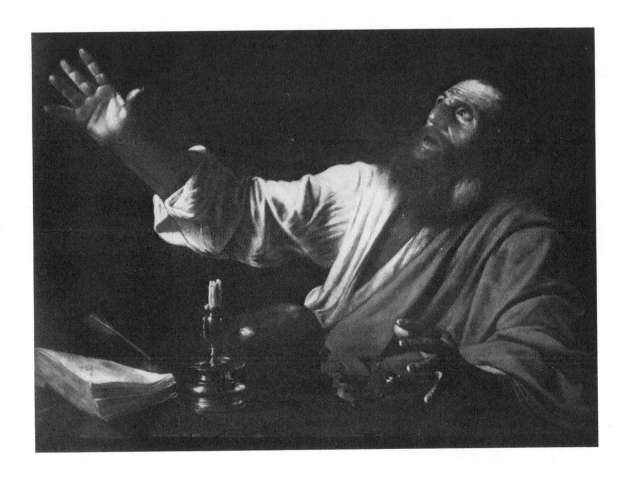

darkened much more than the one in Rome. The fruits and drinker at the left of the latter allegory could be interpreted with reference to autumn, but with the presence of a young woman bearing wheat, that is, Ceres, and within the context of the other two paintings, it seems reasonable to assume that *Summer* is the correct and full title. The specific fruits are not characteristically autumnal (as are the grapes, for example, in *Autumn*), and the motif of drinking probably refers to the thirst of summer.

The hand of the artist responsible for *Summer* can be recognized in a little-known *Concert* in a Roman private collection [78].[5] A *Denial of St. Peter*[6] also seems to be by this master, as is a *Fruit Seller* unconvincingly attributed to Manfredi.[7] The figure types—note especially the liquid eyes, parted full lips, and moist skin—and method of composing are alike in all of these works. The still life in the *Fruit Seller* is sufficiently similar to the one in Busiri Vici's painting that one may assume a common author, while the same straw-covered *fiasco*

appears in *Summer*, the *Concert*, and the *Denial of St. Peter*.

Even this small corpus of high quality works[8] makes the question of authorship pressing, but for the present a name cannot be offered. The artist probably was French or Flemish, active in Rome ca. 1620, and familiar with the art of Manfredi, Tournier, and Renieri [53]. In the realm of pure speculation "Balduino il fiamingo"[9] may come to mind, but nothing is known about this Flemish follower of Manfredi.[10]

Notes: (1) Richter, 1901, pp. 90–91, no. 228. (2) Nicolson, 1967, p. 111. (2) Nicolson, 1967, p. 111. (4) Suggested by Nicolson, 1967, p. 111, who believes that it is therefore one of a pair of pictures representing the four seasons. (5) Publ. by Waddingham, 1961, p. 315 and pl. 140b, as anonymous French, but related to Manfredi and Tournier. (6) Waddingham, 1961, pp. 314–15 and pl. 140a; probably in collaboration with Codazzi. (7) Bauch, 1956-a, p. 232 and fig. 5. (8) Nicolson, 1967, p. 111 and n. 37, refers to a picture in Le Mans by the same hand as the *Summer*. (9) See Nicolson, 1967, p. 109, n. 13. (10) Since this catalogue has gone to press, Schleier (1971, p. 90) has suggested an attribution of the Seasons to early Renieri.

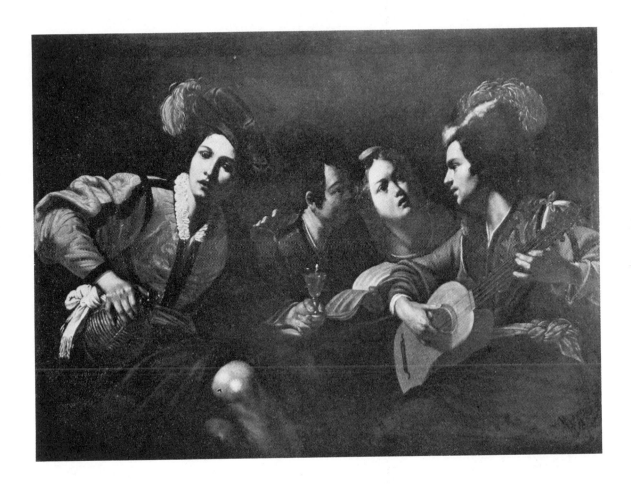

ANONYMOUS

78 *A Concert*, ca. 1620–25

Private collection, Rome.
44 × 58-¹/₄ inches.
Collections: unknown provenance.

As noted in the discussion of Busiri Vici's *Summer* [77], a small group of highly attractive paintings can be assigned to the anonymous master of this *Concert*.[1] The genre works of Manfredi[2] are the primary compositional source, but the handling of paint and the figure types are more closely related to Renieri [cf. 53].[3] Representations of concerts by Valentin also come to mind, for in addition to similarities in postures and expressions, Valentin repeatedly favored a group of musicians and drinkers composed of many men and only one woman.

The tradition of depicting half-length seated musicians was popularized in Renaissance Venice and widely disseminated by Caravaggio's *Una musica* [15]. It found particular favor with the Northern Caravaggisti, who must have considered the subject to be analogous to sixteenth-century Flemish allegorical paintings. Their pictures repeatedly convey the sense of carefree merriment, whether based on the portrayal of single figures [36] or an informal gathering of friends [69]. But by no means was the subject unique to the Northerners, as the paintings of Grammatica [33], Paolini [48], Preti [50], and Spada [63] indicate.

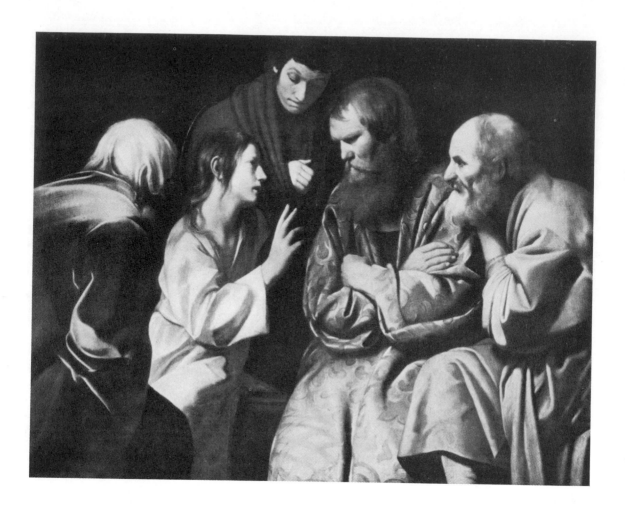

Notes: (1) Published by Waddingham, 1961, p. 315. (2) In particular, see Manfredi's *Concert* in the Uffizi (Borea, 1970, no. 9). (3) Since this catalogue has gone to press, Schleier (1971, p. 90) has assigned works by the same hand to early Renieri.

ANONYMOUS

79 *Christ Disputing with the Doctors in the Temple*, ca. 1620?

Palazzo Reale, Naples.

46 × 77 inches.

Collections: Palazzo Reale since at least 1803.[1]

Once attributed to Baburen,[2] later to Saraceni,[3] the circle of Saraceni,[4] and most frequently to Spadarino,[5] this painting is tied to two perplexing problems: the style and oeuvre of Spadarino and the art of Saraceni's followers. Baburen's authorship, or that of any Dutch artist, is out of the question; and unless one assumes that Spadarino was profoundly influenced by Saraceni, for which there is no firm evidence, his authorship cannot be sustained either. The closest parallels that one can cite are linked to mature Saraceni,[6] the art of Jean Le Clerc, and especially the mysterious "Pensionante del Saraceni" [49]. However, Le Clerc's characteristic angular modeling of quasi-caricatural forms, in which a chiseled, cubistic conception is mixed with Saraceni's softer, idealized types, is not found in *Christ Disputing with the Doctors*. The soft beards and wrinkled brows of the doctors in the Naples painting, as well as the basic figural types; the drapery style and chiaroscuro; and the sense of arrested, informal activity do find strong parallels in the "Pensionante's" work. The suggestion that Saraceni himself painted this picture early in his career[7] may be tantalizing, but the softened contours and generalized forms, as well as the Venetian composition, seem to point to someone in Venice familiar with his mature work, ca. 1620.

Clarification of Spadarino's oeuvre[8] could shed light on a variety of problems stemming from the second and third decades of the century, including the art of Mao Salini,[9] the authorship of this painting, and perhaps the identity of the "Pensionante del Saraceni."

Notes: (1) See Milan, 1951, no. 98. (2) See Milan, 1951, no. 98. (3) Longhi, 1961 [1917], p. 369. (4) Porcella, 1928, p. 409. (5) Longhi, 1943, pp. 28–29; Milan, 1951, no. 98; Naples, 1963, no. 63; Moir, 1967, I, 95. (6) Nicolson, 1963, p. 210, stressed the connection with Saraceni, rejecting Spadarino's authorship. (7) See Nicolson, 1963, p. 210; rejected by Ottani Cavina, 1968, p. 137. (8) Cf. cat. no. 27, and Schleier (1971, pp. 91 ff.). (9) Cf. cat. no. 27, nn. 2, 3, 5.

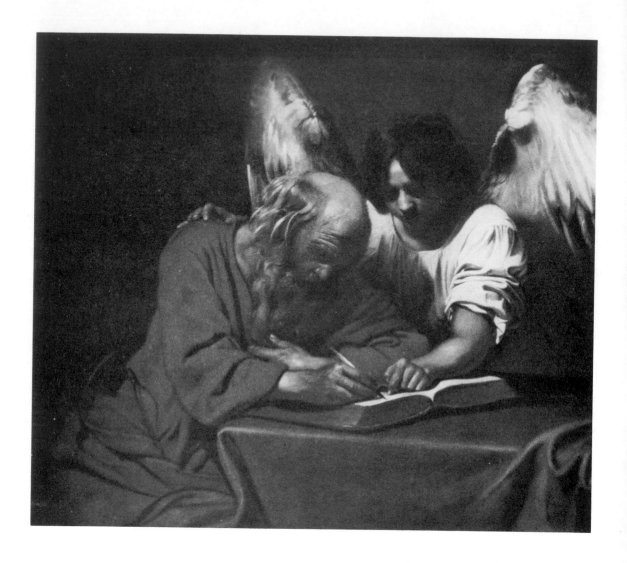

ANONYMOUS

80 *St. Matthew and the Angel*, ca. 1620–30

John and Mable Ringling Museum of Art,
Sarasota, Florida.
42-1/2 × 48-3/4 inches.
Collections: the New York trade (ca. 1930).

An old tradition[1] stands behind this representation of
Matthew with an angel, but Caravaggio's "first" *St.
Matthew* (destroyed; formerly Berlin) was the imme-
diate inspiration. In each painting the angel is directly
involved in assisting the Apostle, whose balding head
is cradled by large, outstretched wings. Caravaggio's
unorthodox angel, however, is transformed into a dec-
orous type in the Sarasota painting, and Matthew's il-
literate clumsiness is suppressed. The deep red and green
fabrics, as well as the strong chiaroscuro, are clearly de-
rived from Caravaggio, but the quality of the light ca-
ressing the angel's face—soft and atmospheric—and the
free brushwork defining its wings and sleeve are decid-
edly different.

Initially catalogued as "Orazio Gentileschi?"[2] this
painting has received numerous attributions, including
the Frenchman Vouet, the Flemings Douffet and Re-
nieri, and the circle of Jacob van Oost.[3] Affinities with
Renieri and Van Oost[4] are sufficiently strong to accept
a Flemish origin for the picture, but a convincing at-
tribution remains to be made.

A reduced version of the painting, slightly lower in
quality, is in the Art Museum of Princeton University.[5]

Notes: (1) The iconography of St. Matthew with the angel is dis-
cussed in Waal, 1964, pp. 38 ff. (2) Suida, 1949, p. 97, no. 109
(on the basis of the *St. Jerome* in the Palazzo Pitti which no longer
is given to Orazio, but to Cavarozzi instead). (3) Vouet and Douf-
fet were suggested by visitors to the Ringling Museum, as re-
corded in the curatorial files; Voss, in a letter of 1952 to the Mu-
seum, named Renieri, which attribution was accepted by Gilbert,
1960, no. 6. Longhi introduced Van Oost's name (see Suida, 1949,
p. 97). (4) On Jacob van Oost, see Bautier, 1945; Hulst, 1951;
and Held, 1955. Perhaps the closest parallel is a *St. Jerome* attri-
buted to Van Oost in Bruges, C.O.O. Burgelijke Godshuizen
(photo A.C.L. 112467B); also, see *Boys Blowing Bubbles*, Seattle
(Washington) Art Museum (exh. London, 1953–54, no. 468). (5)
Acc. no. 31.39; 32-1/4 × 40 inches.

81 *St. Peter Freed from Prison*, ca. 1630?

North Carolina Museum of Art, Raleigh.
47-1/2 × 38 inches.
Collections: Sir Edward Richardson, Pitfour Castle, Perth, Scotland; Christie's, May 6, 1949, lot 153 (as A. Carracci).

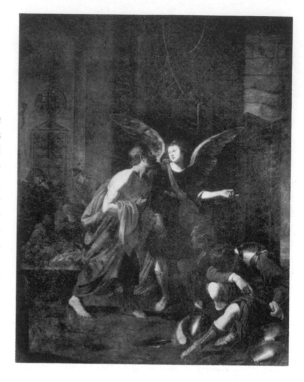

It is not uncommon that the textual source of this scene has been closely followed. In Acts 12:6–7, one reads that "Peter was sleeping between two soldiers, bound with two chains, and sentries before the door were guarding the prison... an angel of the Lord appeared, and a light shone in the cell...." The angel then instructed the Apostle to dress and to follow him to freedom. Artists of varying temperaments developed the dramatic potentiality of the Biblical reference to a miraculous light shining into the prison. Raphael's and Domenichino's representations, for example, prove that chiaroscuro in this scene had a classicistic tradition and was not necessarily Caravaggesque.

The clarity and force of raking light in the Raleigh painting are ultimately related to Caravaggio, as are the broad, simple color areas and carefully observed accessories. The figure types, however, as well as the spatial design, the drapery style, and the colors *per se* do not find analogies in the Italian master's oeuvre, but are much closer allied with Saraceni's.[1]

The author of the Raleigh picture is unknown. Even though the Museum's tentative attribution to Jean Le Clerc finds no support in that painter's authentic works,[2] it properly points to an artist familiar with the art of Saraceni.

A second, much larger, version of *St. Peter Freed from Prison* (Fig. 45) is in the church of St. Peter's, Ghent. It appears to be by the same hand, and has been attributed to Jan Janssens,[3] but understandably with reservations, for Janssens never achieved the refinement or quality of these pictures, and he was not dependent upon Saraceni. The possibility remains, however, that we deal with a Belgian-based artist who had visited Italy in the second decade of the century.

Notes: (1) Especially his paintings of the *Death of the Virgin* (Santa Maria in Aquiro, Rome, and formerly in London [ill. in Ottani Cavina, 1968, figs. 66, 67, and pl. VI]); a second composition of the same subject (ill. in Ottani Cavina, 1968, figs. 83, 84, and 121); and his *San Carlo Borromeo Giving Communion to the Plague Stricken* (ill. in Ottani Cavina, 1968, fig. 100). (2) For Le Clerc, see Pariset, 1958; Ivanoff, 1958, and 1962; and Ottani Cavina, 1968, pp. 69–70, n. 57. The Raleigh picture was recently exhibited as Le Clerc (Jacksonville, 1970, no. 27). (3) Roggen, Pauwels, and De Schrijver, 1949–50, p. 284.

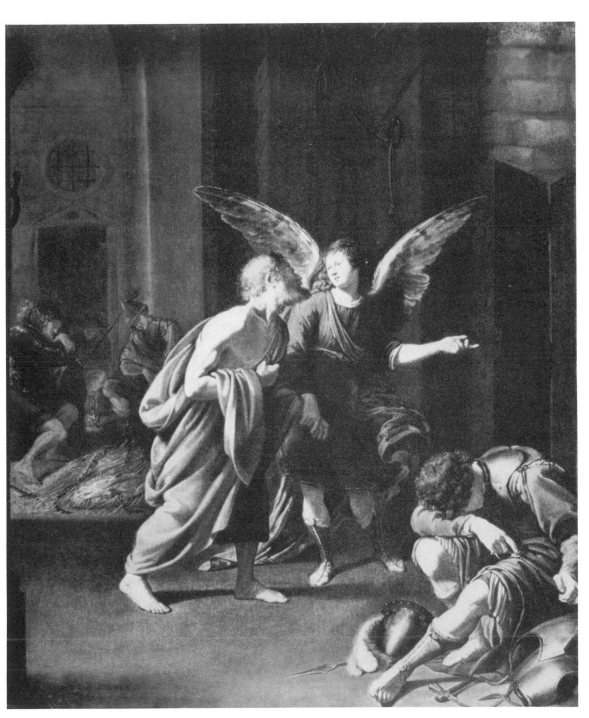

APPENDIX: UNKNOWN PICTURES BY THE CARAVAGGISTI (WITH NOTES ON *CARAVAGGIO AND HIS FOLLOWERS*)

I

An increased appreciation of Seicento art during the past decades has led to the reappearance of countless paintings by the Caravaggisti. Nevertheless, considerable research remains to be completed before the anonymous painters of Caravaggesque genre scenes can be identified. Because a significant portion of the religious paintings by the Caravaggisti (which are much less common) also continues to defy attribution, those paintings that can be assigned to specific followers of Caravaggio assume special importance, for they broaden our still-narrow foundation on which further research will be based. It thus seems worthwhile to make known a group of disparate unpublished pictures that can be linked to established early seventeenth century artists who worked in Italy under the strong influence of Caravaggio.

It is well-known that as a youth in Rome, Ribera executed a series of paintings of the Five Senses[1]. Copies of these five half-length figures were first identified by Longhi[2], who further recognized that a painting of *Taste* in Hartford was one of the lost originals. Schleier[3] subsequently published a second original from the series, the *Touch* in the Norton Simon collection; but the other three compositions remained lost, even though *Sight* reportedly was in the New York trade at least until 1952 and in the London trade as recently as 1955[4]. Rediscovery of the original of *Sight* [1][5] should dispel any uncertainties that may have lingered in anyone's mind regarding the authorship of the series, for it is quite typically Riberesque, much more so than either the sense of *Touch* or *Taste*. The painting was acquired from an undisclosed source by Franz Mayer and only recently presented to the Museo de San Carlos, Mexico City, together with the entire Mayer collection. There is no question that it is identical with the « lost » canvas once in New York and London, because the damages that are visible in a photograph of the lost version[6] reappear, restored, in the Mexican painting. (This is most evident in the zig-zag tear just above the man's head.)

Sight now bears an attribution to Gerard Douffet[7], but examination of the original, which in size corresponds perfectly with the Hartford and Norton Simon canvases[8], leaves no doubt that we deal with a youthful work by Ribera. The color scheme is very limited. Browns dominate, with touches of green in the lining of the collar and the cuff of the sinister sleeve, while golden rings enrich the telescope. Generously, one can say « satisfactory » with regard to the condition, since the many repairs are concentrated in the landscape and near the edges, leaving the face and hands basically intact. The background and window are grey in tonality, setting off the richly modelled skin which at once reveals Ribera's distinct touch. Warm browns, siennas, whites, and creams are sensitively intermixed, evoking the organic nature of seasoned flesh. The rugged face and robust hands tellingly contrast with the flaccid features in the copy [2]. Likewise, the brownish-black mirror and frame and the glasses with a carrying case have a tactile solidity that is lacking in the lifeless copy. The

[1] See Roberto Longhi, « I ' Cinque Sensi ' del Ribera », *Paragone,* XVII, no. 193, 1966, pp. 74-78, and Richard E. Spear, *Caravaggio and His Followers,* Cleveland, 1971, pp. 149-53, nos. 55-56.
[2] Longhi, loc. cit.
[3] Erich Schleier, « Una postilla per i ' Cinque Sensi ' del giovane Ribera », *Paragone,* XIX, no. 223, 1968, pp. 79-80.
[4] See Schleier, loc. cit., and Craig Felton, « The Earliest Paintings of Jusepe de Ribera », *Wadsworth Atheneum Bulletin,* V, 1969 [1972], no. 3, p. 3; p. 8, n. 16; and fig. 8.
[5] 114.5 x 89 cm. I am indebted to the late Enrique F. Gual, Director of the Museo de San Carlos, for bringing this picture to my attention and for facilitating my study of it. Lubomír Konečný (« Another ' postilla ' to the Five Senses by Jusepe de Ribera », *Paragone,* XXIV, no. 285, 1973, pp. 85-91) independently published the same painting shortly after my *Storia dell'arte* article appeared.
[6] See Felton, loc. cit. Dr. Felton kindly lent me a photograph of the « lost » New York version.
[7] The picture was presented to the Museo de San Carlos with this attribution.
[8] The Hartford canvas measures 116.3 x 88.3 cm. and the Norton Simon painting 114.3 x 88.3 cm.

variegated flesh colors of the Mexico City painting can be compared with the modelling of *Taste*, for the same fascination with depiction of a ruddy complexion is evident, just as the swollen hands of *Sight* reappear in both *Taste* and *Touch*.

Mancini informs us that Ribera's five paintings of the Senses were made in Rome prior to the artist's arrival in Naples [9]. They clearly reflect an awareness of Caravaggio's style, but at the same time they have a quite individual character. There is an extraordinary directness of depiction, whether the physical types or the still-life objects are considered. Nothing is equivocal, nothing is beautiful. Ribera's matter-of-fact naturalism, as Spanish as it is Caravaggesque, was destined to play a major role in Neapolitan art during the subsequent decades.

The influence of Simon Vouet on Neapolitan painting deserves further investigation. His two known Neapolitan pictures probably were sent to Naples from Rome rather than having been painted in the city itself, but they nonetheless clearly served as a source of inspiration. A representation of the *Madonna Adoring the Christ Child* [3] is particularly interesting in this context, for it has been attributed to the Neapolitan artist Paolo Finoglio (ca. 1590-1645), but in my opinion is by Vouet instead [10]. If Finoglio's paintings of the later 1620's and earlier 1630's share general features with the *Madonna Adoring the Christ Child*, they also provide adequate stylistic evidence that he did not execute this picture. Finoglio's earliest documented commission, the *Circumcision* of 1626 in San Martino [4] [11], confirms De Dominici's contention that Finoglio studied under Caracciolo [12]. The sharp differentiation of light and shadow brings to mind Caracciolo, whose influence is clearest in the nude youth seated in the right foreground. The naturalism of the *Circumcision* is altogether more agressive than in the *Madonna Adoring the Christ Child*; fabrics are more metallic, and the crowded composition indicates that we deal with an artist who understood little of the aesthetic potential of the void.

The same characteristics appear in Finoglio's *Immacolata* of 1629-30 [13]. His *Annunciation* and *Adoration of the Shepherds* [5] in Santa Maria della Salute, Naples, probably from the mid-1620's [14], are more related to Stanzione's sensibility than to Caracciolo's. But again these paintings are eminently Neapolitan in morphology of figure types, their rather dry, precise rendition of still-life details, and in their admixture of dramatic, earthy tenebrism and supernatural apparitions (a combination that was so dear to the Spaniards). The *Adoration of the Shepherds* is especially relevant here, for its composition is closely tied to that of the *Madonna Adoring the Christ Child*. Nevertheless, a comparison of the two pictures serves to dismiss the possibility that one artist is involved, for the picture by Finoglio is comparatively stiff in articulation of form, dry in texture, and more fussy in rendition of details, particularly fabrics.

One final comparision with Finoglio is in order, since I believe that he is the only alternative to Vouet for the authorship of our picture. A painting in the Capodimonte Museum of *St. Bruno with the Virgin* [6], which is a copy of Vouet's San Martino painting [7], traditionally has been assigned to Finoglio. Except for minor variations and the addition of cherubs above, it is a prosaic and direct copy, admittedly analogous in style to Finoglio's earlier paintings, but quite lacking the supple modelling of Vouet's original. If by Finoglio, which remains only conjectural at best, this copy testifies to his awareness of Vouet but also to his comparative weakness. While Finoglio's art provides no convincing parallels with the *Madonna Adoring the Christ Child* (his other pictures are less similar), Vouet's art of the mid-1620's is strikingly analogous. His *Circumcision* in S. Angelo a Segno, Naples [8], dated 1622 or 1623 [15], includes a Virgin and Child who are so similar

[9] Giulio Mancini, *Considerazioni sulla pittura*, eds. Marucchi and Salerno, Rome, 1956-57, I, p. 251.

[10] 116 x 121 cm. The attribution to Finoglio is Giuliano Briganti's (written expertise, dated 29 September, 1971). The painting was recently exhibited in *Religious and Biblical Themes in French Baroque Painting*, Heim Gallery, London, 1974, no. 1 (with color ill.); there attention is drawn to a « similar composition » attributed to La Hyre in the Palazzo Pitti (no. 984).

[11] See Francesca Marangelli, « Paolo Finoglio », *Archivio storico pugliese*, XX, 1967, p. 195.

[12] Bernardo De Dominici, *Vite de' pittori, scultori ed architetti napoletani*, Naples, ed. 1840-46, III, p. 115.

[13] Marangelli, op. cit., p. 195. It should be noted that the chronology of Finoglio's works as presented by Mario D'Orsi (« Paolo Finoglio, pittore napoletano », *Iapigia*, IX, 1938 [and Bari, 1938]) is outdated.

[14] For a bibliographical summary regarding these paintings, see *La Madonna nella pittura del '600 a Napoli*, Naples, 1954, p. 43, nos. 33-34. It should be noted that Longhi attributed the *Adoration of the Shepherds* to Grammatica (Roberto Longhi, « Ultimi studi sul Caravaggio e la sua cerchia », *Proporzioni*, I, 1943, p. 54, n. 70).

[15] See Georgette Dargent and Jacques Thuillier, « Simon Vouet en Italie », *Saggi e memorie di storia dell'arte*, IV, 1965, p. 43, no. A12.

in morphology to the figures in our painting that a common model could be postulated to have existed. The narrow pleated white fabrics are found in the *Circumcision* and *Madonna Adoring the Christ Child* alike, as are his broadly-folded, more Caravaggesque robes. Although the figures are large in Vouet's compositions, the void assumes a significant role as well. In each picture, simple architectural planes effectively serve as backgrounds. The Christ Child in our painting reappears in Vouet's second Neapolitan work [7], *St. Bruno* (1626?)[16], where even the handling of His fuzzy hair is noticeably similar. The pictures by Vouet of 1623-24 in the Alaleoni Chapel in S. Lorenzo in Lucina, however, indicate that a slightly earlier date, ca. 1624, is preferable for the *Madonna Adoring the Christ Child*. The contrast of greyish tonalities with warm, pinkish highlights appears in much of Vouet's Italian art, yet coloristically our picture finds its closest kin in the Alaleoni Chapel. In the *Temptation of St. Francis* a severely limited palette dominates, for warm earthen tones completely envelop the two figures. *The Clothing of St. Francis* offers additional parallels, whether one compares the white fabric held out behind the kneeling Saint with that under the Christ Child; the greyed yellow loincloth of St. Francis with the Madonna's scarf and the Child's loincloth; or the deep, unrelieved red of Her dress and that of the woman seated in the right foreground of the Alaleoni painting.

Vouet's compatriot Valentin, about whom we unfortunately know so little[17], was reaching the peak of his fame in Rome during the later 1620's. Although cited in Barberini inventories as being by Vouet[18], a quite characteristic painting by Valentin [9][19] is today in the private collection of Prince Augusto Barberini[20]. It well could have been commissioned by Cardinal Francesco Barberini, Valentin's principal Roman patron, who bought a lost *David* and Cleveland's *Samson*, in 1627 and 1630-31, respectively[21]. I believe that on stylistic grounds *Christ and the Samaritan Woman* stems from those years too (perhaps ca. 1628-30), and that it profitably can be compared with Valentin's *Christ Driving the Money Changers from the Temple* in the Galleria nazionale d'arte antica, Rome [10][22], where the same melancholic, « bohemian » Christ appears. But the latter composition is much more movemented; its principles of design, based as they are on intersecting diagonals and the avoidance of stabilizing vertical or horizontal elements, are sufficiently different so as to postulate some separation in time between the two paintings, dispite the similarity of figure types.

Earlier in his career, Valentin favored dramatic action and anecdotal details, often at the expense of convincing human expression. *Christ and the Samaritan Woman* characterizes a profound change in his mature sensibility. The single figures (He wears a red shirt and blue robe, she a redder dress and white blouse) quietly enact a Biblical story in a language that is as classicistic in its reliance upon explicit rhetoric and stable, symbolic poses, as it is naturalistic in its tenebrism and dependence on unidealized, earthy actors (the Samaritana's decolletage so obviously commands Christ's attention!). It has the calm clarity and monumentality that make the *Samson* such a powerful image. The Samaritan woman's troubled expression is wonderfully effective in conveying a sense of uncertainty as she tries

[16] *Ibid.*, p. 47, no. A31, and Erich Schleier, « Un chef-d'oeuvre de la période italienne de Simon Vouet », *Revue de l'art*, II, 1971, pp. 69-70.
[17] See Roberto Longhi, « A Propos de Valentin », *La Revue des arts*, VIII, 1958, pp. 58-66, Spear, op. cit., pp. 180-85 and *I Caravaggeschi francesi*, Villa Medici, Rome, 1973-74, pp. 122ff., and Grand Palais, Paris, 1974, pp. 124ff.
[18] Information courtesy Marilyn Lavin (see Marilyn Aronberg Lavin, *Seventeenth Century Barberini Inventories and Documents of Art*, New York, in press).
[19] 143 x 189 cm. (approximate sight size); the inventory number « 7 » appears in the lower left-hand corner. A very small photograph of the painting, with the correct attribution, appears in *Catalogo del Gabinetto fotografico nazionale: 1. La Galleria e la collezione Barberini*, ed. Federico Zeri, 1954, no. 86. Recently, the picture was exhibited with a proposed date of ca. 1628 (*I Caravaggeschi francesi*, Villa Medici, Rome, 1973-74, p. 166, no. 51, and *Valentin et les caravaggesques français*, Grand Palais, Paris, 1974, p. 172, no. 54).
[20] I am grateful to Prince Barberini for permission to publish his picture and to Principessa Barberini for facilitating my study of it.
[21] See Spear, op. cit., p. 184, no. 72, and Richard E. Spear, *Renaissance and Baroque Paintings from the Sciarra and Fiano Collections*, Rome and University Park, Pa., 1972, p. 32, no. 14.
[22] To my knowledge, it has not been recorded that this picture belonged to Cardinal Fesch prior to the Monte di Pietà. See *Catalogue des tableaux composant la galerie de feu son eminence le Cardinal Fesch*, Rome, 1841, p. 78, no. 1863: 6 pieds, 2 pouces, by 8 pieds, 9 pouces, « Jesus Christ Chassant les marchands du Temple; l'ensemble de cette belle scène est d'une grande hardiesse, et d'un puissant coloris: les expressions en sont admirables. Ce tableau est du Valentin ». The picture has been exhibited in Rome, 1973-74, pp. 132-34, no. 38, and Paris, 1974, pp. 134-36, no. 39, as a youthful work.

to understand the stranger's prophetic discourse. Aside from these evocative figures, the water falling from the bucket onto a large, reflective vase is noteworthy as a particularly beautiful and rather atypical passage in Valentin's art, for he rarely dealt with transparency and reflection in such a poetic way.

Documentary evidence establishes the fact that Honthorst spent a large portion of 1628 in London [23], working in the service of the English court. His allegorical *Apollo and Diana*, signed and dated 1628 and still in the English Royal collection [24], has been the only painting other than a portrait of Charles I [25] definitely from that year (although its extravagant size, more than six meters wide, partially compensates for this slim output). Another picture of 1628 can now be added to Honthorst's oeuvre: a *Venus Punishing Cupid* [11], signed and dated on the stone base at the right, *G. Honthorst 1628* [26]. The history of the painting has not been established, so it is not known whether it was executed during the first months of the year, while Honthorst was still on the Continent, or after the spring when he arrived in London (where he remained until December).

The buxom figure of Venus, so typical of Honthorst's mature art in her slow movement, broad mouth, full, carmine lips, and in her peasant-like character, wears a greenish blue-grey apron, yellow-orange sash, and a transparent silvery scarf, which is the most striking passage in a generally stiff, yet coloristically interesting painting. For Honthorst, a goddess well might be born of peasant stock, as his *Shepherdesses* of 1627 [27] clearly indicates, for the pastoral women in that picture are interchangeable with our Venus. The *Musical Scene* in Leipzig, painted shortly later (1629) [28], also shares many stylistic features with *Venus and Cupid*. All of these paintings retain aspects of Honthorst's early naturalism, just as they reveal his love for shimmering, luxurious costumes. Their decorative, motionless qualities are very closely allied to Bylert's art, which, like so much Utrecht painting, was deeply indebted to Honthorst's work of the 1620's. *Venus Punishing Cupid* belongs to a well-established iconographic tradition that was broadly diffused in Italy during the Cinquecento [29]. The subject of Honthorst's painting is not simply the *Chastisement of Cupid*, for there are two Cupids present — one wide-eyed and fearful in the background, and a second in the foreground who receives punishment with eyes tightly shut. Here we encounter an echo (the transformation has been too extreme to call it anything more) of the myth of Eros and Anteros. Eros (or Cupid), in the foreground, is portrayed with reference to « blind » love, whereas his companion, Anteros, stands for « seeing » love.

It is ironical that Caravaggio's art was transformed by a number of the Caravaggisti into an overtly decorative style. Honthorst's post-Italian pictures increasingly tend to depend on beautiful fabrics and coloristic effects at the expense of psychological content and inventive compositions. Orazio Gentileschi set many Italian artists on a similar path, one that led to no uncharted territory, but rather to well-trodden if still fertile soil. A classic example of a provincial Caravaggesque painter of this ilk is Giovan Francesco Guerrieri, born in Fossombrone in 1589, twice in Rome (1610-1611 and 1615-18), but primarily active in the Marches [30].

A *Salome with the Head of the Baptist* in a private collection [12] [31] I believe can be attributed to Guerrieri with reasonable confidence (it is worth noting that I know of

[23] For a summary of the information, see J. Richard Judson. *Gerrit von Honthorst*, The Hague, 1959, p. 182; and Hermann Braun, *Gerard und Willem van Honthorst* (Georg-August-Universität Dissertation), Göttingen, 1966, pp. 352-53, docs. 38-43.
[24] See Oliver Millar, « Charles I, Honthorst, and Van Dyck », *The Burlington Magazine*, XCVI, 1954, pp. 36-39.
[25] Exhibited and illustrated in Oliver Millar, *The Age of Charles I* (exh. cat.), The Tate Gallery, London 1972, p. 54, no. 78 (also, see Braun, op. cit., p. 224, no. 80).
[26] 127.5 x 146 cm.; acquired from the Paris trade. I am indebted to Dr. Mario Lanfranchi for permission to publish this picture. Benedict Nicolson (« Caravaggio and the Caravaggesques: Some Recent Research », *The Burlington Magazine*, CXVI, 1974, p. 615) subsequently has written that the picture « is so typical of Bylert that I can only imagine the signature [of Honthorst] is false, though I admit I have not seen the picture ». Evelina Borea independently has published the same painting as an authentic Honthorst (« Considerazioni sulla mostra 'Caravaggio e i suoi seguaci a Cleveland' ». *Bollettino d'arte*, LVII, 1972, p. 161).
[27] Judson, op. cit., pp. 218-19, no. 142.
[28] *Museum der bildenden Künste zu Leipzig: Katalog der Gemälde*, Leipzig, 1967, p. 84, no. 1616, p. 27.
[29] For discussion of this subject, see Erwin Panofsky, *Studies in Iconology*, New York and Evanston, ed. 1962, pp. 95 ff.; and Erwin Panofsky, *Problems in Titian: Mostly Iconographic*, New York, 1969, pp. 129 ff.
[30] The basic study is Andrea Emiliani, *Giovan Francesco Guerrieri da Fossombrone*, Urbino, 1958.
[31] 109.2 x 77.6 cm.; bought in London early in this century. The photograph here reproduced is old, but the very poor condition of the picture precluded the taking of a new one. Mr. Howell kindly allowed me to examine and publish this picture.

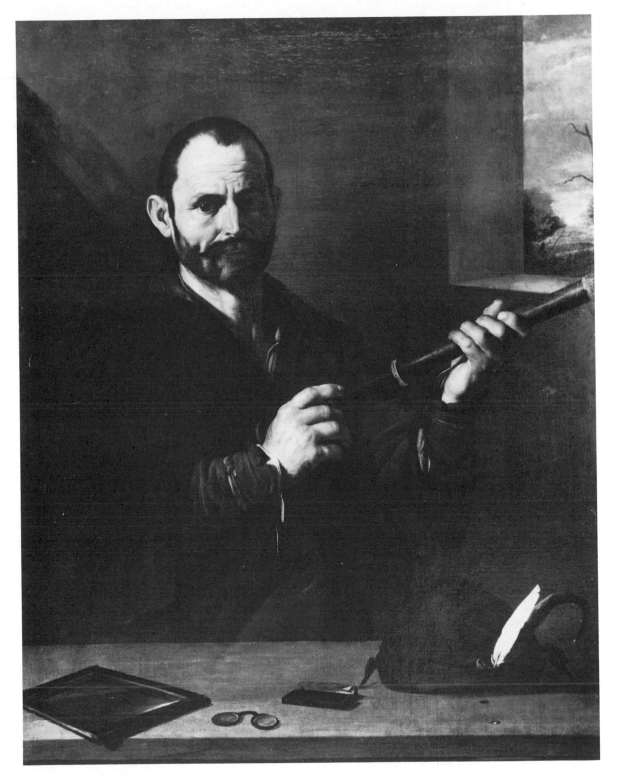

208

1. Ribera, *The Sense of Sight,* Franz Mayer collection, Museo de San Carlos, Mexico City.
2. Copy after Ribera, *The Sense of Sight,* private collection.
3. Simon Vouet, *The Madonna Adoring the Christ Child,* Heim Galleries, Paris and London.

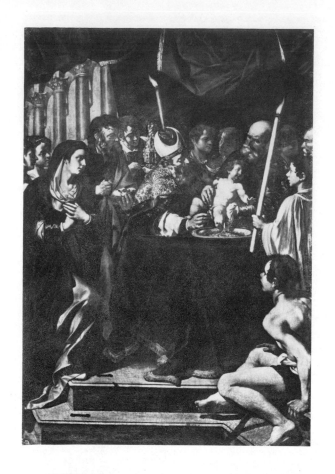

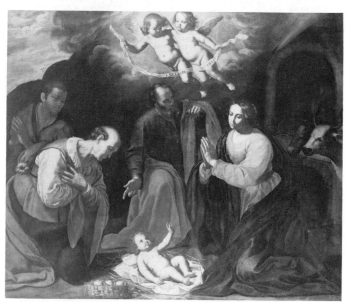

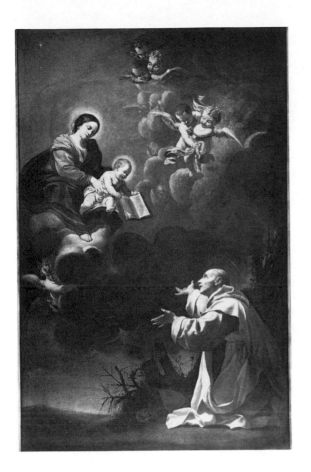 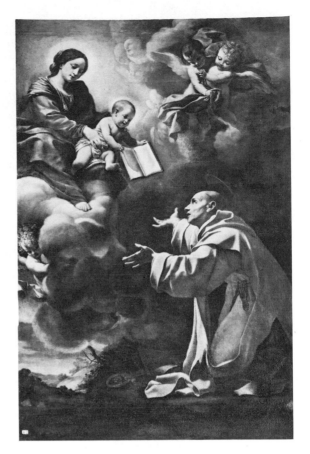

4. Paolo Finoglio, *The Circumcision,* S. Martino, Naples.
5. Paolo Finoglio, *Adoration of the Shepherds,* S. Maria della Salute, Naples.
6. Attributed to Paolo Finoglio, copy of Vouet's *St. Bruno with the Virgin,* Museo di Capodimonte, Naples.
7. Vouet, *St. Bruno with the Virgin,* S. Martino, Naples.

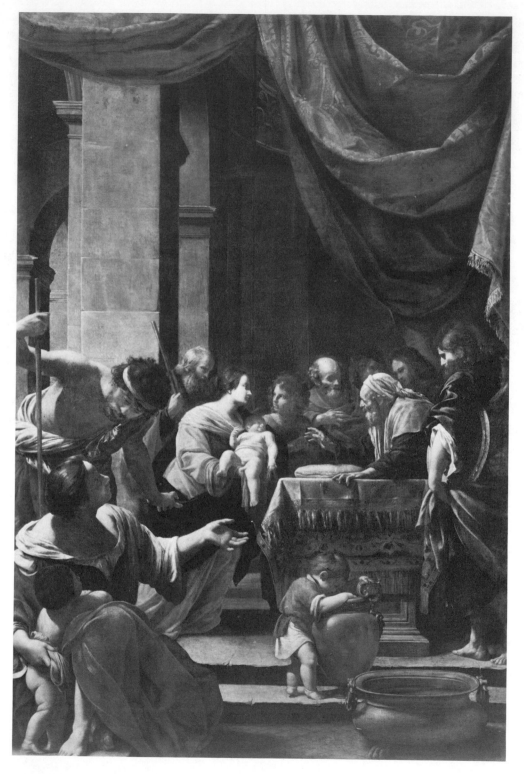

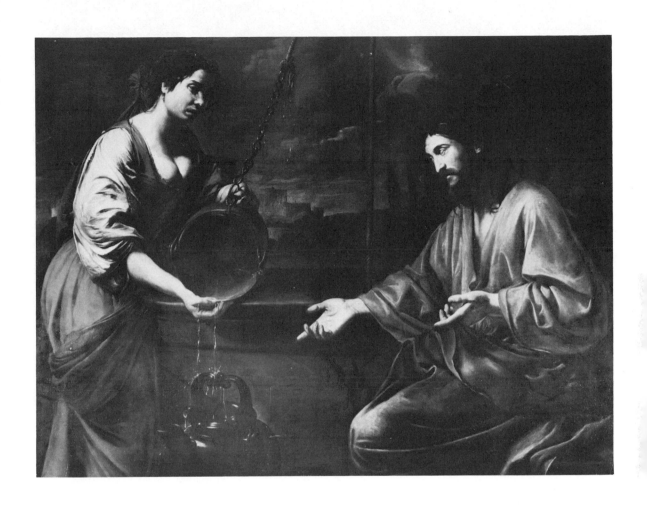

8. Vouet, *The Circumcision,* S. Angelo a Segno, Naples.
9. Valentin, *Christ and the Samaritan Woman,* collection Prince Augusto Barberini.

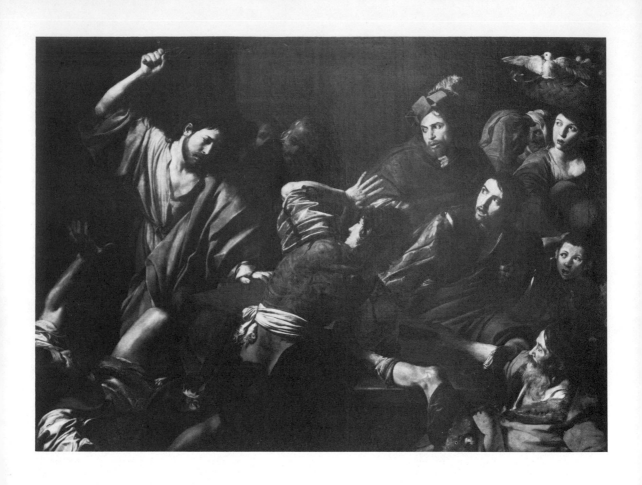

10. Valentin, *Christ Driving the Money Changers from the Temple,* Galleria nazionale d'arte antica, Rome (photo G.F.N.).
11. Honthorst, *Venus Punishing Cupid,* collection Mario Lanfranchi-Anna Moffo, Rome.

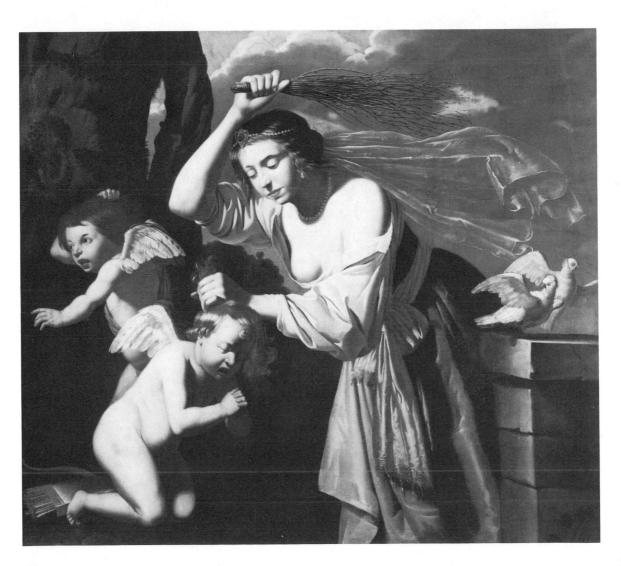

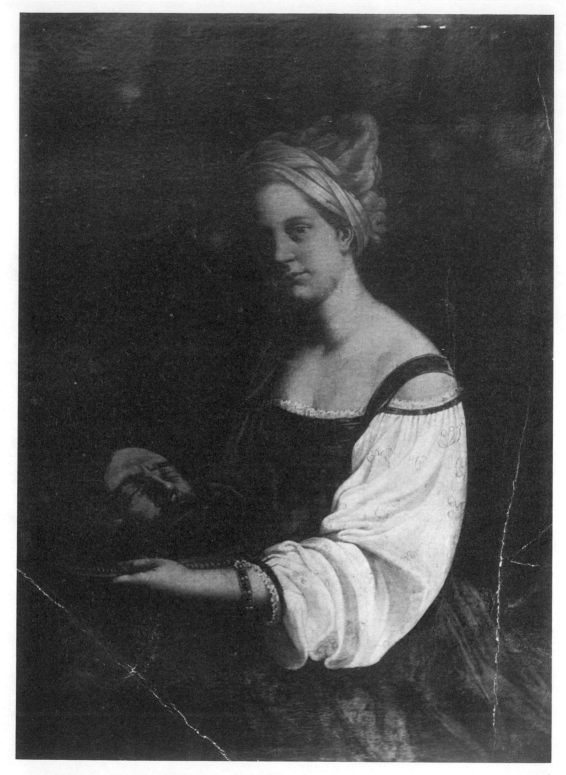

12. G. F. Guerrieri, *Salome with the Head of the Baptist,* Alfred Howell, Chagrin Falls, Ohio (U.S.A.).
13. Mattia Preti, *A Blind Man, Youth, and Servant,* collection T. P. Grange, London.

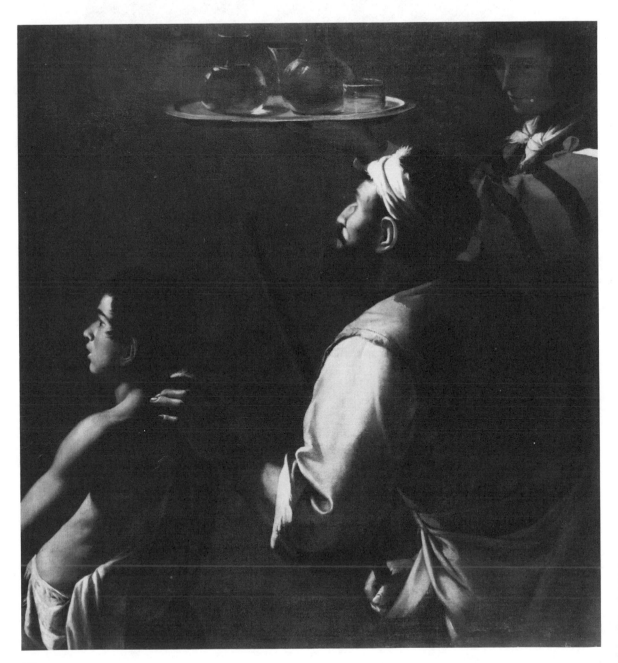

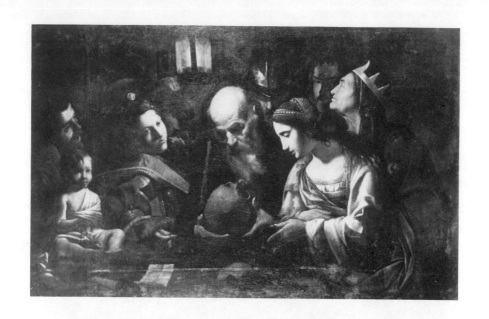

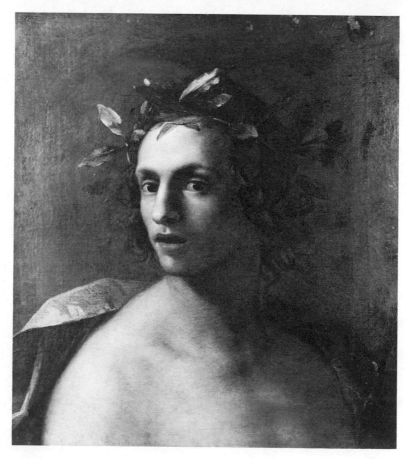

14. Pietro Paolini, *An Allegory,* Museo Cerralbo, Madrid.
15. Tuscan (Pietro Paolini?), *Portrait of a Poet,* Mrs. Alan Curtis, Berkeley, California.
16. Trophime Bigot, *A Man Holding a Paper,* Museo Cerralbo, Madrid.

17. Trophime Bigot, *A Doctor Examining Urine,* private collection.
18. Neapolitan, copy of Caravaggio's *Madonna di Loreto,* collection M.se Paolo Sersale, Rome.

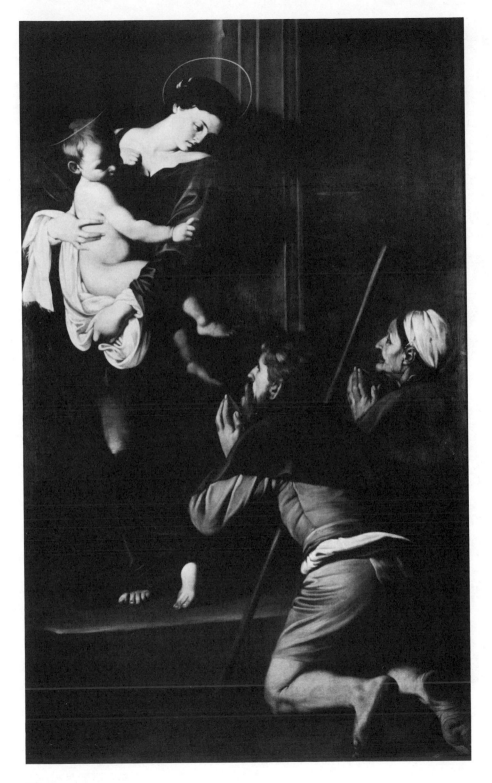

19. Neapolitan, copy of Caravaggio's *Madonna di Loreto* (detail), collection M.se Paolo Sersale, Rome.
20. Grammatica, *St. Cecilia* (detail of signature), Museu Nacional de Arte Antiga, Lisbon.

no other painting by this artist outside of Italy). The Gentileschian influences on the picture are obvious. Salome herself is a sister of Orazio's and Artemisia's well-known heroines, while the concern for fancy dress and the elaborately pleated sleeve are telling signs of an artist attracted to those Tuscan Caravaggisti. However, our painting is drier; its design is more prosaic, and it lacks the masterful *fattura* that brings to life Orazio's canvases. It is very similar in all respects to Guerrieri's paintings in San Pietro in Valle in Fano, especially to his *Miracle of the Blind Baby*[32]. The analogies in figure types and costume are immediately apparent, and even more detailed comparisons tend to support our attribution. Salome's ear is markedly reddish in tonality, as is true in so many of Guerrieri's paintings; her flesh tints are a mixture of greys and pinks, as at Fano; and the handling of her face tends to be planar (Guerrieri's *fattura* rarely is fluid and curvilinear).

A precise date is not known for the Fano paintings, but Emiliani's suggestion, « fra secondo e terzo decennio »[33], is acceptable. This date is equally appropriate for our painting. *Salome with the Head of the Baptist* reveals no signs of Guercino's influence, which later overtook the Caravaggesque, Gentileschian aspects of Guerrieri's art.

Mattia Preti seems to have specialized in Caravaggesque genre pictures during the earlier and mid-1630's[34]. He is known for half-length *Concerts* and *Gamblers*, which often have three or more persons seated around a table. Dressed in fancy costumes, they tend to imitate Caravaggio's famous lost *Card Sharps* (*I Bari*), although Preti's strong tenebrism decisively separates his paintings from Caravaggio's more lyrical, blonde, genre scenes.

A large fragment in the Grange collection, London [13][35], is readily attributable to Preti, to his period ca. 1630-35. (It should suffice to compare it with the *Youth* at Wellesley College, the *Gamblers* in the Nicolson collection, and the *Concert* in the Longhi collection[36]). More challenging is the question of subject matter: a young boy with cup in hand leads a blind beggar, while a servant bearing drinks enters from the right. The story of Belisarius comes to mind, especially since Preti himself depicted it later in his career[37], but here there is no reference to the former military glories of the beggar, which would be prerequisite for any representation of Belisarius. To the contrary, this beggar is portrayed as a man completely down and out, whose blindness is poignantly stressed through an effective and original use of *profil perdu*. Because primary attention has been paid to the dependence of the beggar on the youth, I suspect that the painting belongs to the iconographic tradition that was established by the picaresque novel *Lazarillo de Tormes*. Popular in Spain, the many episodes of a blind man with his *lazarillo* clearly were known in Naples too, as Ribera's art proves[38]. Preti's painting cannot be connected with any specific incident in *Lazarillo de Tormes*, and even familiarity with the complete composition well may have provided no further clues. Representations of blind old beggars led by young boys became subjects in themselves, with no ostensible connection to specific literary sources.

Like the fragment in the Grange collection, so an anonymous painting in the Museo Cerralbo, Madrid [14][39], presents no problems of attribution, although its specific meaning remains enigmatic. Once assigned to Caravaggio, it is a typical example of Pietro Paolini's mature work, probably of the 1640's[40]. Every

[32] See Emiliani, op. cit., pp. 83-84, no. 19, and pl. XXVIII.

[33] *Ibid.*, p. 82.

[34] See Spear, *Caravaggio and His Followers*, pp. 49 ff. for bibliographical references.

[35] 120 x 110 cm. Mr. Grange kindly called his Preti to my attention, had it photographed, and consented to my publication of it.

[36] See Spear, *Caravaggio and His Followers*, p. 50, no. 51, for the Wellesley canvas; *The Order of St. John in Malta* (exh. cat.), Valletta, 1970, p. 325, no. 401, pl. 75, for Nicolson's painting; and *La Collezione Roberto Longhi*, Florence, 1971, no. and pl. 77, for Longhi's *Concert*.

[37] Collection Walter P. Chrysler, Jr. (see *Art in Italy, 1600-1700* [exh. cat.], Detroit, 1965, pp. 138-39, no 152).

[38] See Paul Rogers, « The Blind Man and His Boy », *Allen Memorial Art Museum Bulletin*, XIV, 1957, pp. 49-58.

[39] 113 x 176 cm., inv. no. 1918, formerly attributed to Caravaggio. An attribution to Paolini was independently reached by the Directress of the Museum, Consuelo Sanz-Pastor y Fernández de Piérola, who kindly allowed me to study this picture and the Bigot (see below), and provided me with photographs.

[40] For general discussion of Paolini's career, see Anna Ottani, « Per un caravaggesco toscano: Pietro Paolini (1603-81) », *Arte antica e moderna*, no. 21, 1963, pp. 19-35; Ottani, « Integrazioni al catalogo del Paolini », *Arte anti-*

hallmark of the Lucchese painter's style is present in the Cerralbo picture, from the moist, tightly-drawn skin of Paolini's figures to their characteristic full lips, almond eyes and inverted, tear-drop heads, to the dramatic use of an internal light source. The composition of many half-length figures finds numerous parallels in his oeuvre, too, as does the bizarre iconography. Baldinucci, in fact, maintained that Paolini's eccentric personality led to « tragic and cruel » themes in his art [41], but Paolini's no-less extravagant teacher, Caroselli, certainly was a major influence on his taste. While fortune telling and allegories of life and death attracted many of the Caravaggisti, it really was Caroselli and Paolini who brought to these subjects a sense of the occult [42].

Frequently, Paolini's figures, which in their own right can be haunting, gather for mysterious purposes, as in the Cerralbo picture where incantations seem to be in the offing. A lengthy inscription on the piece of paper on the table unfortunately is indecipherable (altogether the painting has suffered much damage), but there seems little doubt that we deal with an allegory of death as ultimate victor. The Ages of Man probably is part of the conception here (Paolini's similar picture with that theme in the Mazzarosa collection, Lucca, comes to mind [43]), just as death's ultimate triumph over military and courtly lives also is incorporated into the painting. The Vanitas theme is part of the iconographic tradition behind Paolini's invention as well; yet further speculation seems idle so long as the painting's inscription remains illegible.

Paolini was even more inventive as a portraitist, to judge from the small group of portraits assigned to him [44], which contains certain constant features: momentary expressions, achieved by turned heads and shoulders; eye contact with the viewer, although the sitter's head never is frontal; and a predilection for portrayal of intellectual and artistic personalities, be they musicians, actors, or authors. A *Portrait of a Poet* in Berkeley [15] [45] fits well this group of pictures, although the attribution to Paolini is here suggested only with considerable caution, since I have not seen the original painting. To judge from a photograph, there seems to be little doubt that the portrait is Tuscan [46]; it appears that the physical type is particularly characteristic of Paolini, as are the evocative use of raking light, the poet's taut skin, and his hauntingly mysterious expression. This portrait especially recalls Paolini's *Portrait of a Man* in the Wildenstein collection, which is assigned by Ottani Cavina to the period ca. 1637 [47]; that date should be approximately right for the Berkeley painting too, assuming that an attribution to Paolini is correct.

Whereas Paolini occasionally favored nocturnes for creating a mood of drama and isolation, Trophime Bigot consistently exploited night scenes for their poetic effects. Another painting in the Museo Cerralbo in Madrid [16] [48], catalogued as « attributed to Honthorst », is a small yet very characteristic painting by the Aixois artist famous for candle-light scenes. It portrays a man holding a sheet of paper in front of a candle flame, and in every regard, even dimensions, is similar to the four pictures in the Doria Gallery representing figures with candles or lanterns [49]. In its own right, one could consider the Cerralbo canvas to be a fragment, but the Doria paintings suggest instead that Bigot had a predilection for depicting life-size heads in such a candid fashion. The Cerralbo figure is analogous in physical type to Bigot's conception of Christ,

ca e moderna, no. 30, 1965, pp. 181-187; and Alessandro Marabottini, « Il ' Naturalismo' di Pietro Paolini », *Scritti di storia dell'arte in onore di Mario Salmi,* Rome, III, 1963, pp. 307-24. Nicolson (1967, p. 110, n. 26) independently had attributed the Cerralbo *Allegory* to Bigot, which escaped my attention when the *Storia dell'arte* version of this material was published.

41 See Filippo Baldinucci, *Notizie dei professori del disegno da Cimabue in qua,* Florence, ed. 1847, V, p. 109.

42 On Caroselli, see Anna Ottani, « Su Angelo Caroselli, pittore romano », *Arte antica e moderna,* nos. 31-32, 1965, pp. 289-97; and for a discussion of the occult in Seicento painting, see Luigi Salerno, « Il dissenso nella pittura: Intorno a Filippo Napoletano, Caroselli, Salvator Rosa e altri », *Storia dell'arte,* no. 5, 1970, pp. 34-65.

43 Exhibited and illustrated in *Mostra dei tesori segreti delle case fiorentine,* 1960, p. 34, no. 72, pl. 56.

44 See Ottani, « Per un caravaggesco toscano: Pietro Paolini (1603-81) », pp. 24-25 *et passim.*

45 54.5 x 48 cm.; acquired in Venice; to judge from the photograph, the painting has been damaged and considerably repainted. I am grateful to Professor Curtis for sending to me a photograph of this painting.

46 An especially provocative comparison can be made with a *Muse of Painting* attributed to G. B. Lupicini (see *Florentine Baroque Art from American Collections* [exh. cat., by Joan Nissman], The Metropolitan Museum of Art, New York, 1969, p. 27, no. 16, fig. 6).

47 Ottani, « Per un caravaggesco toscano: Pietro Paolini (1603-81) » p. 26.

48 50 x 40.5 cm., inv. no. 4611; ex-coll. José Madrazo.

49 See Benedict Nicolson, « Un Caravaggiste Aixois: Le Maître à la Chandelle », *Art de France,* IV, 1964, p. 132, nos. 36-39, pls. 17-20. The Doria canvases measure 45/47 x 38/39 cm.

while the idea of using white paper, crumpled fan-like in a fist, as the dominant reflective source, is found in Bigot's *St. Sebastian* in Bordeaux [50]. Nevertheless, in neither the Spanish picture not the Doria paintings is any identifiable subject involved. All five pictures probably were painted just to satisfy a demand for relatively inexpensive, dramatic nocturnes. Bigot apparently did not hesitate to repeat himself, since multiple versions of his works are known. A second and virtually identical version of the *Doctor Examining Urine* in the Ashmolean Museum, Oxford, recently appeared in the Roman trade [17] [51]. To judge from the brushwork and colors, especially the carmine on the lips and face, it may be an autograph replica. Admitedly, the dexter eye is weak in drawing and the handling in places is schematic (notably the candlestick), but Bigot was no great master, as close study of even his best paintings indicates.

While few copies of Caravaggio's paintings merit scholarly attention, one in the Sersale collection in Rome is particularly noteworthy [18] [52]. A direct and generally literal copy of the *Madonna di Loreto* of ca. 1604-05, it is sufficiently strong — convincing in its respect for the original and equally individual in its own more painterly manner [19] — that I believe it is an early copy by a good artist who admired and understood Caravaggio's art.

Copies of this sort are notoriously difficult to attribute with any reasonable degree of confidence. In this instance, certain stylistic characteristics point towards Naples, which is supported by the picture's history [53]. My own inclinations, upon first seeing the Sersale painting, were to think of Caracciolo. But one must not forget that Vaccaro made copies of the master's work, and that the rather stark chiaroscuro of the Virgin's face in this version is scarcely alien to his sensitivity.

II

Caravaggio and His Followers, the exhibition which I organized for the Cleveland Museum of Art (30 October, 1971 - 2 January, 1972), generated a number of scholarly reviews [54], in addition to more popular articles [55] and some essays written on the occasion of the show by authors who did not see the exhibition itself [56]. The opportunity of seeing eigthy-one pictures together raised questions in the mind of this author, too. For those persons still engaged in Caravaggio studies, it may be useful to summarize here the state of certain controversial issues (limiting references to published opinions of scholars who were in Cleveland). I also should like to take this opportunity to add my own observations and a few minor corrections to the Cleveland catalogue [57].

Most discussion regarding *Caravaggio and His Followers* centered on individual exhibits. The broader question of defining « Caravaggism » and who were the Caravaggisti was taken up only by Borea, Held and Pepper [58], whose more « permissive » attitude, as Held himself recognizes, really deals with another problem, i.e., with Caravaggio's influence. « Yet we do a disservice to Caravaggio's historical role », Held writes (p. 46), « if we narrow his influence to a restricted number of men when it might be more illuminating to see the various ways his ideas were absorbed — and bore fruit ». It is not my intention to review here an issue which already was discussed at length in my introductory essay. But it evidently is

[50] *Ibid.*, p. 131, no. 28, pl. 38 (coll Seligmann). Mr. Nicolson kindly called this correspondence to my attention.

[51] 71.2 x 90 cm. See Nicolson « Un Caravaggiste Aixois ... », p. 132, no. 33, pl. 13, for the Oxford version.

[52] 250 x 146 cm. I am indebted to M.se Sersale for bringing this painting to my attention, for having it photographed, and for allowing me to study and publish it.

[53] According to M.se Sersale, it was long in the possession of the family of Prince Ruffo di Calabria in Naples.

[54] Evelina Borea, « Considerazioni sulla mostra 'Caravaggio e i suoi seguaci' a Cleveland », *Bollettino d'arte*, LVII, 1972, pp. 154-64; Robert Enggass, « Review of *Caravaggio and His Followers* by Richard E. Spear », *The Art Bulletin*, LV, 1973, pp. 460-62; Julius Held, « Caravaggio and His Followers », *Art in America*, LX, 1972, no. 3, pp. 40-47; Benedict Nicolson, « Caravaggesques at Cleveland », *The Burlington Magazine*, CXIV, 1972, pp. 113-17; D. Stephen Pepper, « Caravaggio riveduto e corretto: la mostra di Cleveland », *Arte illustrata*, V, 1972, pp. 170-78; Herwarth Röttgen, Review of *Caravaggio and His Followers* at Cleveland, *The Art Quarterly*, in press; and Carlo Volpe « Annotazioni sulla mostra caravaggesca di Cleveland », *Paragone*, XXIII, no. 263, 1972, pp. 50-76.

[55] Notices of the exhibition, without substantial contributions, appeared in *Apollo*, XCV, 1972, pp. 60-62 (Mahonri Sharp Young); *Bolaffiarte*, no. 14, II, November, 1971, pp. 9-10 (Mina Gregori); and *Pantheon*, XXX, 1972, pp. 69-71 (Alfred Werner), to cite some of the popular articles prompted by the show.

[56] In particular, see Mina Gregori, « Caravaggio dopo la mostra di Cleveland », *Paragone*, XXIII, no. 263, 1972, pp. 23-49; also, see Oreste Ferrari, « Caravaggio e i caravaggeschi », *Il Veltro*, XV, 1971, pp. 587-94.

[57] *Caravaggio and His Followers*, Cleveland, 1971.

[58] These and all subsequent references to authors' opinions refer to their articles cited in n. 54 above.

necessary to repeat that « the various ways his ideas were absorbed » already was treated in the exhibitions in Milan (1951), Naples (1963), Paris (1965), and Florence (1970). I refer the reader to Nicolson's conclusion « after Cleveland », i.e., that the pan-Caravaggesque principle that guided those earlier exhibitions « is one of the main reasons why our understanding of the movement has remained so hazy » (p. 114).

Nicolson and Röttgen, rightly in my opinion, saw the Wellesley picture by Janssens (37) [59] as belonging to a different artistic culture, despite its superficial connections with Caravaggio. I cannot agree with Röttgen, however, that La Tour, too, should be taken from the ranks of the Caravaggisti, since the Paris exhibition [60] made still more persuasive the argument that the Lorraine master was intimately familiar with Caravaggesque art, whether he was stimulated by it in Italy or (as I now tend to believe) in the Netherlands. Röttgen and Nicolson also disclaim youthful Preti as a Caravaggesque artist, and Röttgen excludes Honthorst as well. But such strict attitudes surpass mine, for were we to omit those painters from the Caravaggisti, then all Utrecht artists and young Vouet; certainly Spada, Serodine and Rombouts; Seghers, Saraceni, Paolini, Maino, Finson, Cavarozzi, Borgianni, and the Gentileschi — that is, nearly everyone — must go, too. The early works of Preti are, in my view, strictly Caravaggesque paintings and much more closely tied to the master than anything Guercino ever produced (Nicolson equates them with Guercino's pre-Roman pictures). But it is clear that personal visual interpretations are in question here, since I cannot see how one could exclude Preti and Borgianni on the one hand, as Nicolson prefers to do, and then include early Vignon, Jan Moreelse, and Bor on the other, as he proposes. One only can touch upon the complex questions raised in Pepper's review, where aside from comments on individual paintings and a general preference to expand my definition of the Caravaggisti to embrace Caravaggio's « influence » (Pepper sees Rembrandt as the

logical product of Caravaggio's innovations), Caravaggism is analyzed as the product of socio-economic changes in Europe around 1600. The investigation that Pepper suggests is highly provocative and valid, but I, for one, fail to see that he carried it to a convincing conclusion. The rise of cities and working classes clearly could foster a new kind of mobility that could find an expression in art. Pepper's interpretation that the growth of mercantile capitalism was the source of Caravaggio's art fails to deal with the fact that the *subjects* of Caravaggesque art were not new in their own right, for they already had a long tradition in the North. Furthermore, the question of population is no clear-cut matter. It should suffice to note that Maland [61] puts Italy's Seicento population at about 13,000,000 while Ogg says « five or six millions » for as late as 1700 [62]. What is more important, however, is that during the seventeenth century, despite the scientific revolution, methods of production (and hence distribution, and mobility as a consequence) remained basically static. Had Caravaggio lived in Amsterdam or Antwerp, a better case could be made for Pepper's thesis.

One also would have to investigate the attitude of the collectors of Caravaggesque art toward the lower classes. The Bamboccianti caught on like wildfire in Rome, more, I believe, because their Northern-based vision and mundane attitude struck a cord of Seicento romanticism than because current socio-economic factors had brought peasants to the connoisseur's attention.

For the sake of brevity and clarity, most problems raised by the exhibition can be dealt with by listing the relevant paintings according to their exhibition numbers.

2. Baburen, Akron. Volpe proposes that this is a shop picture — an idea that is not new (Slatkes and I already expressed reservations); but until a superior version comes to light, I believe the problem remains open (one might note Volpe's decided antagonism toward pictures in American collections) [63].

[59] The numbers in parentheses refer to the Cleveland exhibition and catalogue numbers.

[60] *Georges de La Tour* (exh. cat.), Orangerie, Paris, 1972. I might take this opportunity to note my opinion that the Stockholm *St. Jerome* (11) probably preceded the Grenoble version (10) ; that the Berlin *St. Sebastian* (27) is only a good copy of the superior Bois-Anzeray painting (28) ; that the much-heralded *Dice Players* from Teesside (31) is very disappointing ; that the Lwow painting (32) is by La Tour ; and that *Le Vielleur* from Remiremont (44), catalogued as a « doubtful » picture, is a damaged but original La Tour.

[61] David Maland, *Europe in the Seventeenth Century*, London, 1966, p. 4.

[62] David Ogg, *Europe in the Seventeenth Century*, 9th ed., Edinburgh, 1971, p. 2, n. 1.

[63] It may be worth warning the unwary reader that Volpe's review reflects attitudes of the Longhi circle, which tends to cling to Longhi's opinions, even when outdated, and resents other scholars' "intrusion" in Caravaggio studies.

4. Baglione, private collection, Rome. No painting in the exhibition prompted more response than this, and I agree with Borea, Nicolson, Pepper and Röttgen that Baglione's name should be dropped (I, myself, was initially very doubtful of Longhi's attribution, but then I was persuaded it was correct). Only Röttgen suggests an alternative, early Borgianni (but with strong reservations), which seems as hard to accept as Baglione. Volpe argues that a « third » *Amor* by Baglione simply never existed, whereas Pepper believes that it did, and that the picture published by Martinelli is a copy of that lost, « third » original.

5. Bigot, Ottawa. I see no reason to accept Volpe's contention that this is a copy. Bigot repeated himself on various occasions, so the existence of two pictures need not preclude the authenticity of one. The Ottawa painting is as fine as any of Bigot's known works.

7. Borgianni, Isabelle Renaud-Klinkosch, Switzerland. Röttgen prefers to date this earlier than the Almagià picture [6], but he provides no arguments. A third, initialed version, published by Nicolson [64], was recently discovered; it is fully convincing as an autograph replica.

8. Attributed to Borgianni, Prado. Röttgen may be right in favoring Tristán; but Volpe's implication that it could be by neither Borgianni nor Tristán unduly complicates the question, since both on stylistic and iconographic grounds that alternative is entirely unnecessary.

11. Caracciolo, Uffizi. I inadvertently failed to cite an important parallel to this painting: the version in the Palacio Real, Madrid [65]. Pepper (p. 170) assigns a painting in Avignon to Caracciolo, but to judge from the reproduction (Pepper's fig. 7), there is little basis for that attribution.

14. Caravaggio, Hartford. In retrospect, I am convinced (along with Röttgen and Volpe) that this picture probably was not in the Costa collection and that the Costa-Udine version was a copy — the one in Udine today. Frommel now has published del Monte's inventory in its entirety [66].

15. Caravaggio, New York. Volpe publishes another copy of this version, but his insistence that the New York picture is a copy is based on a misinterpretation of the painting's bad condition. Held also expresses doubts.

16. Caravaggio, Thyssen-Bornemisza collection, Lugano. Röttgen places this about two years later, ca. 1599.

17. Caravaggio, Kansas City. At last, no one (at least in print) has expressed doubts about this entirely-convincing picture. Since the exhibition, I have found a sales reference that possibly could be to this painting, but there seems to be no way to establish a connection: Christie's, Francis Morland and George Duckett collections, 19 May, 1832, no. 31, Caravaggio, *St. John in the Desert* (no dimensions are given).

18. Caravaggio, Rouen. Röttgen's proposal for a still later date, i.e., the second Neapolitan trip, should not be ruled out, but I cannot agree with Enggass, Pepper and Held that the attribution to Caravaggio is in question. (Nicolson, too, strongly supports the attribution to the master).

19. Attributed to Caravaggio, Prado, Nicolson, Volpe, and Röttgen accept this as by Caravaggio; Borea, Pepper and Enggass remain unsure, as do I. (The painting was subsequently exhibited as an authentic Caravaggio in Seville, *Caravaggio y el naturalismo español,* 1973, no. 2, where its provenance is discussed in further detail.)

21. Cecco del Caravaggio, Chicago. The correspondences between this picture and the others by Cecco with Maino's *Adoration of the Shepherds* (42) were so strong and apparent at Cleveland that I now believe Cecco must be Spanish. Röttgen reached similar conclusions. The catalogue should record that an (unidentified) inventory number, 539, appears in the lower left-hand corner. Identification of Christ's banner (a white cross on a pale burgundy field) may shed light on the circumstances of the commission.

22. Cecco del Caravaggio, Kansas City. Nicolson, quoting Slatkes, notes that the lower right corner retains traces of the glow of a fire, presumably the flames of Purgatory which would have been visible in the original composition before it was cut down. I noted in the catalogue, on the strength of conservation reports, that « the face of the Christian soul is totally lost ». But this same kind of brown face, completely unmodelled, appears in the sleeping soldier in the Chicago painting (21),

(Borea's review of 1972, which unhappily confirms these observations [see Nicolson, 1974, p. 603, n. 2], appeared after this note was in press with *Storia dell'arte.*)

[64] Benedict Nicolson, « A New Borgianni », *The Burlington Magazine,* CXV, 1973, p. 42.

[65] See *Pintura italiana del siglo XVII* (exh. cat.), Casón del Buen Retiro, Madrid, 1970, p. 114, no. 29.

[66] Christoph Luitpold Frommel, « Caravaggios Frühwerk und der Kardinal Francesco Maria Del Monte », *Storia dell'arte,* nos. 9-10, 1971, pp. 5-52.

and that face is not abraded. Cecco apparently liked this short-cut for depicting a face in shadows.

23. Cecco del Caravaggio, The Wellington Museum, London. Nicolson notes that the upper margin has been increased at a later time, but that same addition appears in the Athens replica. Volpe's attribution (p. 63) to Cecco of the well-known *Holy Family* in the Galleria Spada is unconvincing, pace Borea. The *St. Lawrence* I published as fig. 17 was exhibited in Rome, 1973–74, p. 30, no. 7, and Paris, 1974, p. 30, no. 7.

24. Attributed to Jean Ducamps, Delgado Museum, New Orleans. Volpe publishes the lost Longhi picture, which reportedly bore the initials DC F (Del Campo fecit); Borea, however, reads CI on the photograph and disassociates the ex-Longhi painting from the New Orleans one. (The Florentine version I referred to on p. 89 is illustrated by Borea, fig. 10.) I now agree that the New Orleans painting is Tuscan, as proposed by Borea, Volpe, Pepper, and Röttgen (following Zeri, who named Manetti). See Bodart's recent book for a summary of what is known about Ducamps [67].

25. Attributed to Falcone, Heim Galleries, Paris and London. Although little has been written about this perplexing picture, it generated considerable discussion in Cleveland. A number of scholars speculated on a French origin because of its classicizing features, but it is difficult to find any candidate among the known French Caravaggisti. There does seem to have been unanimous agreement, however, that Volpe's attribution to Falcone is « no more than an uninspired guess » (Nicolson). The painting is now in the collection of the J. Paul Getty Museum, Malibu.

26. Finson, Harris collection, New York. Nicolson and Röttgen doubt the attribution to Finson, which Volpe tends to accept. Borea implausibly named Tanzio. A more recent suggestion, which merits close consideration, is that Sellitto painted the Harris picture (see Wolfgang Prohaska, « Carlo Sellitto, » *The Burlington Magazine,* CXVII, 1975, p. 10).

30–32. Orazio Gentileschi. Pepper proposes some adjustments in my chronology for Orazio's paintings in the exhibition; Volpe and Nicolson prefer a post-Italian date for the *Danae* (32), which to me seems less probable than believing that this is the Genoese painting. Pepper places the *Sibyl* (32) as early as 1610–15.

33. Gramatica, Turin. Nicolson doubts Longhi's attribution to Grammatica, but Röttgen, in re-

sponse, strongly reaffirms it. Differences from the far superior *Judith* (34) were apparent in Cleveland, but I still tend to believe that this is Grammatica's painting, much earlier than the *Judith.*

34. Grammatica, Stockholm. Nicolson questions that the Lisbon Grammatica is signed, as I stated in the catalogue; the full signature appears on the edge of the upper section of the theorbo [20].

36. Honthorst, Townsend collection, Indianapolis. The Mayer painting, comparative fig. 27, now is in the collection of the Museo de San Carlos, Mexico City.

38. La Tour, Kansas City. It was the general opinion at Cleveland (with which I now fully agree) that this is an old copy after a lost La Tour. Additional copies have been identified of this famous composition (see the La Tour exhibition, no. 47).

40–41. Attributed to La Tour, San Francisco. Already at Cleveland, as Nicolson and Volpe wrote, these paintings were convincing as originals, but the Paris La Tour exhibition clinched the question since there they fit so perfectly into the master's youthful style. The backgrounds, however, seem to be considerably overpainted.

42. Maino, Madrid. The painting was subsequently exhibited in Seville, *Caravaggio y el naturalismo español,* 1973, no. 72.

44. Manfredi, Chicago. Borea doubts that Manfredi (or any Italian) painted *The Chastisement of Cupid.*

49. The Pensionante del Saraceni, Detroit. This picture can be identified with a painting listed in two nineteenth-century sales: Christie's, Champernowne sale, 30 June, 1820, no. 61, « Caravaggio, A Girl Buying a Water Melon from a Fruiterer »; and again at Squibb's, London, 15 February, 1832, no. 101, « M. A. Caravaggio, Melon Seller. » Nicolson (1974, p. 611) cites an 1816 description of the Champernowne painting, which clinches the identification with the Detroit canvas.

50. Preti, Park Ridge Public Library. This picture does not come up to Preti's standards, as Borea, Nicolson, Röttgen, and Volpe also feel.

55–56. Ribera, Hartford and Norton Simon Foundation. Volpe's suggestion that the former picture should be dated in the 1620's and particularly that the latter is an eighteenth century copy are unfounded. (Borea also questions the Norton Simon picture.) See above, pp. 203-204 for the original of the lost *Sense of Sight,* which further confirms Longhi's identification of the series as Ribera's.

58. Rombouts, Lawrence. It should be recorded

that an (unidentified) inventory number, 10, appears in the lower left-hand corner.

60. Saraceni, Hartford. Volpe prefers Ottani Cavina's date, ca. 1615.

61. Seghers, Raleigh. Nicolson first rejected this painting as a copy[68], but at Cleveland found its quality somewhat higher[69]. I have not seen the version in Lord Mansfield's collection and therefore am unable to judge the merits of the two versions. The Raleigh picture well may be a second, less-inspired, autograph replica (it is disappointing in parts, notably at the far right, and therefore could have some shop intervention).

63. Spada, Louvre. Nicolson notes that it has been enlarged at the top. This painting was somewhat disappointing within the context of the exhibition and did not represent Spada's early (rather fickle) devotion to Caravaggio as well as one had hoped it would.

64. Stomer, Ottawa. Nicolson (1974, p. 615) notes that the *Christ before Caiaphas* which I illustrated as Fig. 41 is now in an English private collection and appears to belong to Stomer's « Neapolitan, not Roman, phase ».

66. Terbrugghen, Kansas City. It has been discovered that the Amsterdam *Adoration* is signed and dated 1619[70].

72. Valentin, Almagià collection, Rome. In note 7, I hypothesized that the upper and lower addition to the fabric were relatively modern. They actually were old and turned back at the time of the Sciarra sale[71]. *Samson* now is in the collection of the Cleveland Museum of Art and the additions recently have been removed.

73. Vouet, Ottawa. This painting has recently been exhibited in Rome, 1973–74, pp. 201–04, no. 61, and Paris, 1974, pp. 207–10, no. 64, as ca. 1618.

75. Vouet, Smith collection. I continue to support the attribution to Vouet himself, as does Nicolson. Borea and Volpe were misled by the condition of the picture when they called this a studio work. (I am told that another version of the Smith canvas recently passed through the London auction rooms, but I have seen neither the picture nor a photograph of it.)

76. Anonymous, Worcester. Nicolson suggests a Sicilian origin for the artist of this mysterious picture, whereas Röttgen (and, he reports, Zeri) accepts Marini's attribution[72] to Caravaggio himself. Volpe is doubtful; Borea and I remain unconvinced of Marini's attribution. It is not Marini's opinion, however, that this could be the lost *St. Jerome* cited by Bellori as painted in Messina (see my n. 3).

77–78. Anonymous, Busiri Vici collection, Rome, and private collection, Rome. There was no doubt, upon seeing these two paintings together, that one artist is in question. Schleier's suggestion of Renieri is rejected by Nicolson for these two pictures, but he nevertheless feels that his own *Autumn* and *Winter* perhaps are early Renieri. I remain convinced that all of these paintings are by the same hand, probably Renieri's. The coherency of the group of pictures I associate with this hand is questioned by Brejon and Cuzin in the Rome-Paris exhibition catalogue (1973-74, pp. 82–84, no. 21, and 1974, pp. 84–86, no. 22), where *Summer, Autumn,* and *Winter* were all exhibited.

79. Anonymous, Palazzo Reale, Naples. Borea and Volpe confirm Longhi's attribution to Spadarino, which Röttgen implicitly favors. While I am not fully convinced that this is Spadarino's, it does have much stronger affinities with his Vatican painting than I previously recognized.

[67] Didier Bodart, *Les peintres des Pays-Bas méridionaux et de la Principauté de Liège à Rome au XVII.e siècle*, Brussels and Rome, 1970, I, pp. 93-95.

[68] Benedict Nicolson, « Gerard Seghers and the 'Denial of St. Peter' » *The Burlington Magazine*, CXIII, 1971, p. 304. Nicolson notes some copies (p. 304) not listed in my catalogue entry.

[69] As stated in his review of the exhibition (cf. n. 54).

[70] See P. J. J. van Thiel, « De aanbidding der koningen en ander vroeg werk von Hendrick ter Brugghen », *Bulletin van het Rijksmuseum*, XIX, 1971, pp. 91ff.

[71] See Spear, *Renaissance and Baroque Paintings from the Sciarra and Fiano Collections*, p. 32, no. 14.

[72] Maurizio Marini, « Tre proposte per il Caravaggio meridionale », *Arte illustrata*, IV, 1971, pp. 56-65.

BIBLIOGRAPHY

Agnello, Santi Luigi. "M. Minniti e A. Maddiona nelle 'Vite' di Francesco Susinno," *Archivio storico siracusano*, X, 1964, 75–95.

Ainaud, J. "Ribalta y Caravaggio," *Anales y Boletín de los Museos de Arte de Barcelona*, V, 1947, 345–413.

Alce, P. Venturino, O.P. "Cronologia delle opere d'arte della Cappella di San Domenico in Bologna dal 1597 al 1619," *Arte antica e moderna*, 1958, no. 3, pp. 291–95, no. 4, pp. 394–406.

Arslan, Edoardo. "Appunto su Caravaggio," *Aut aut*, 1951, no. 5.

Arslan, Edoardo. "Nota caravaggesca," *Arte antica e moderna*, 1959, no. 6, pp. 191–218.

Baglione, Giovanni. *Le vite de'pittori, scultori et architetti*, Rome, 1642.

B[anti], A. "Theodor Rombouts: 'I musicanti'," *Paragone*, I, 1950, no. 3, 56–57.

Battisti, Eugenio. "Alcuni documenti su opere del Caravaggio," *Commentari*, VI, 1955, 173–85.

Bauch, Kurt. "Aus Caravaggios Umkreis," *Mitteilungen des Kunsthistorischen Institutes in Florenz*, VII, 1956[a], 227–38.

Bauch, Kurt. "Zur Ikonographie von Caravaggios Frühwerken," *Kunstgeschichtliche Studien für Hans Kauffmann*, Berlin, 1956[b], pp. 252–61.

Baudi di Vesme, Alessandro. "La regia pinacoteca di Torino," *Le gallerie nazionali italiane*, III, 1897, 3–68.

Baumgart, Fritz. *Caravaggio, Kunst und Wirklichkeit*, Berlin, 1955.

Bautier, Pierre. "Les portraits de Finsonius," *Actes du Congrès d'Histoire de l'art*, Paris, 1921 [1924], pp. 324–28.

Bautier, Pierre. *Les peintres Van Oost*, Brussels, 1945.

Bellori, Giovanni Pietro. *Le vite de'pittori, scultori et architetti moderni*, Rome, 1672.

Benedetti, Michele de. "Un Caravaggio già della Borghese ritrovato," *Emporium*, CX, 1949, 3–14.

Benesch, Otto. "Ein Bild von Orazio Borgianni," *Belvedere*, IX, 1930, 220–21.

Bergonzoni, Sandro. "Documenti per Mattia Preti ed il tempo di Modena," *Emporium*, CXIX, 1954, 30–33.

Berkeley, California. *Selection 1968: Recent Accessions to the University Art Collections* (exh. cat.), University Art Museum, 1968.

Bertolotti, A. "Agostino Tassi, suoi scolari e compagni pittori in Roma," *Giornale di erudizione artistica*, V, 1876, 193–223.

Binghamton, New York. *The Lynch Collection* (exh. cat.), University Art Gallery, State University of New York, 1969.

Bissell, Raymond Ward. "Dipinti giovanili di Orazio Gentileschi a Farfa (1597–1598)," *Palatino*, VIII, 1964, 197–201.

Bissell, Raymond Ward. "The Baroque Painter Orazio Gentileschi: His Career in Italy" (unpublished doctoral dissertation), University of Michigan, 1966.

Bissell, Raymond Ward. "Orazio Gentileschi's *Young Woman with a Violin*," *Bulletin of the Detroit Institute of Arts*, XLVI, 1967, 71–77.

Bissell, Raymond Ward. "Artemisia Gentileschi: A New Documented Chronology," *The Art Bulletin*, L, 1968, 153–68.

Bissell, Raymond Ward. "Orazio Gentileschi and the Theme of Lot and His Daughters," *Bulletin of The National Gallery of Canada*, XIV, 1969, 16–33.

Bloch, Vitale. *Georges de La Tour*, Amsterdam, 1950.

Bloch, Vitale. "Georges de la Tour once again," *The Burlington Magazine*, XCVI, 1954, 81–83.

Blunt, Anthony. "Some Portraits by Simon Vouet," *The Burlington Magazine*, LXXXVIII, 1946, 268–71.

Blunt, Anthony. *Art and Architecture in France, 1500 to 1700*, Harmondsworth, 1957.

Blunt, Anthony. *The Paintings of Nicolas Poussin: A Critical Catalogue*, London, 1966.

Bober, Phyllis. "A Painting by Georges de La Tour," *Art Journal*, XXII, 1962, 28–32.

Bodart, Didier. "Intorno al Caravaggio: la Maddalena del 1606," *Palatino*, X, 1966, 118–26.

Bodart, Didier. "Études sur Caravage et le Caravagisme parues depuis 1965," *Revue des archéologues et historiens d'art de Louvain*, III, 1970, 175–83.

Bologna, Ferdinando. "Un'altra opera del 'Maestro del Giudizio di Salomone'," *Paragone*, IV, 1953, no. 39, 49–51.

Bologna. *Maestri della pittura del seicento emiliano* (exh. cat.), Palazzo dell'Archiginnasio, 1959.

Bordeaux. *L'âge d'or espagnol* (exh. cat.), Galerie des Beaux-Arts, 1955.

Borea, Evelina. *Caravaggio e i Caravaggeschi* (I maestri del colore, no. 264), Milan, 1966.

Borea, Evelina (ed.). *Caravaggio e Caravaggeschi nelle Gallerie di Firenze* (exh. cat.), Palazzo Pitti, Florence, 1970.

Borla, Silvino. "1593: arrivo del Caravaggio a Roma," *Emporium*, CXXXV, 1962, 13–16.

Borla, Silvino. "L'ultimo percorso del Caravaggio," *Antichità viva*, VI, 1967, no. 4, 3–14.

Boschetto, Antonio. "Di Theodoor van Loon e dei suoi dipinti a Montaigu," *Paragone*, XXI, 1970, no. 239, 42–59.

Bottari, Giovanni, and Stefano Ticozzi. *Raccolta di lettere sulla pittura, scultura ed architettura*, Milan, ed. 1822–25.

Bottari, Stefano. "Appunti sui Recco," *Arte antica e moderna*, 1961, nos. 13–16, pp. 354–61.

Bottari, Stefano. "Fede Galizia," *Arte antica e moderna*, 1963[a], no. 24, pp. 309–18.

Bottari, Stefano. "Una traccia per Luca Forte e il primo tempo della 'natura morta' a Napoli," *Arte antica e moderna*, 1963[b], no. 23, pp. 242–46.

Bottari, Stefano. "Aggiunte al Manfredi, al Renieri e allo Stomer," *Arte antica e moderna*, 1965, no. 29, pp. 57–60.

Bottari, Stefano. "Un ipotesi per Aniello Falcone," *Arte antica e moderna*, 1966, nos. 34–36, pp. 141–43.

Bougier, Annette. "Georges de La Tour et Saint Pierre Fourier," *Gazette des Beaux-Arts*, LII, 1958, 51–62.

Bousquet, Jacques. "Documents sur le séjour de Simon Vouet à Rome," *Mélanges d'archéologie et d'histoire*, École française de Rome, LXIV, 1952, 287–300.

Boyer, Jean. "Un caravagesque français oublié: Trophime Bigot," *Bulletin de la Société de l'Histoire de l'Art Français*, 1963 [1964], pp. 35–51.

Boyer, Jean. "Nouveaux documents inédits sur le peintre Trophime Bigot," *Bulletin de la Société de l'Histoire de l'Art Français*, 1964 [1965], pp. 153–58.

Braun, Hermann. *Gerard und Willem van Honthorst* (Georg-August-Universität dissertation), Göttingen, 1966.

Bredius, A. "Le peintre Louis Finson (Ludovicus Finsonius)," *Annuaire international d'histoire*, Congrès de Paris, 1900, pp. 29–44.

Bredius, A. "Iets over de schilders Louys, David en Pieter Finson," *Oud Holland*, XXXVI, 1918, 197–204.

Briganti, Giuliano (ed.). *I Bamboccianti* (exh. cat.), Palazzo Massimo alle Colonne, Rome, 1950.

Brussels. *Le siècle de Rubens* (exh. cat.), Musées Royaux des Beaux-Arts, 1965.

Calvesi, Maurizio. "Simone Peterzano, Maestro del Caravaggio," *Bollettino d'arte*, XXXIX, 1954, 114–33.

Cannizzaro, Liliana. "Un pittore del primo Seicento: Orazio Borgianni," *Studi Salentini*, XIII, 1962, 75–127.

Carpegna, Nolfo di (ed.). *Caravaggio e i Caravaggeschi* (exh. cat.), Palazzo Barberini, Rome, 1955.

Carr, Carolyn. "*Saint Sebastian Attended by Irene*, an Iconographic Study" (unpublished master's thesis), Oberlin College, 1964.

Carter, David. "Rencontres avec Valentin," *L'Oeil*, 1968, nos. 162–63, pp. 2–4.

Castagnola. *The Thyssen-Bornemisza Collection*, Villa Favorita, 1969.

Causa, Raffaello. "Per Mattia Preti: Il tempo di Modena ed il soggiorno a Napoli," *Emporium*, CXVI, 1952, 201–12.

Causa, Raffaello. "Un avvio per Giacomo Recco," *Arte antica e moderna*, 1961, nos. 13–16, pp. 344–53.

Causa, Raffaello. "Luca Forte e il primo tempo della natura morta italiana," *Paragone*, XIII, 1962, no. 145, 41–48.

Causa, Raffaello. *I seguaci del Caravaggio a Napoli* (I maestri del colore, no. 222), Milan, 1966.

Chenault, Jeanne. "Ribera in Roman Archives," *The Burlington Magazine*, CXI, 1969, 561–62.

Chicago. *Paintings in the Art Institute of Chicago*, 1961.

Clemen, Paul (ed.). *Belgische Kunstdenkmäler*, II, Munich, 1923.

Coe, Ralph T. "Letter," *The Art Quarterly*, XXIX, 1966, 103.

Coley, Curtis. "Soldiers and Bohemians by Valentin de Boullogne," *Bulletin of the John Herron Art Institute*, XLVII, 1960, 60–63.

Costello, Jane. "The Twelve Pictures 'Ordered by Velazquez' and the Trial of Valguarnera," *Journal of the Warburg and Courtauld Institutes*, XIII, 1950, 237–84.

Cozzi, Gaetano. "Intorno al Cardinale Ottavio Paravicino, a Monsignor Paolo Gualdo e a Michelangelo da Caravaggio," *Rivista storica italiana*, LXXIII, 1961, 36–68.

Crelly, William. *The Painting of Simon Vouet*, New Haven and London, 1962.

Cutter, Margot. "Caravaggio in the Seventeenth Century," *Marsyas*, I, 1941, 89–115.

Czobor, Agnes. "Autoritratti del giovane Caravaggio," *Acta Historiae Artium*, II, 1955, 201–14.

Dargent, Georgette. "A Propos du Portrait de Simon Vouet au Musée des Beaux-Arts de Lyon," *Bulletin des Musées Lyonnais*, IV, 1955, 25–36.

Dargent, Georgette, and Jacques Thuillier. "Simon Vouet en Italie," *Saggi e memorie di storia dell'arte*, IV, 1965, 25–63.

Dayton, Ohio. *Hendrick Terbrugghen in America* (exh. cat.), Dayton Art Institute, 1965. (Also Baltimore Museum of Art, 1965–66.)

Dayton, Ohio. *Fifty Treasures of the Dayton Art Institute* (exh. cat.), 1969.

Del Bravo, Carlo. "Su Rutilio Manetti," *Pantheon*, XXIV, 1966, 43–51.

Della Pergola, Paola. *Galleria Borghese*, Rome, 1959.

Della Pergola, Paola. "Nota per Caravaggio," *Bollettino d'arte*, XLIX, 1964, 252–56.

Demonts, Louis. "Essai sur la formation de Simon Vouet en Italie," *Bulletin de la Société d'Histoire de l'Art Français*, 1913, 309–48.

Dempsey, Charles. Review of *The Italian Followers of Caravaggio* by Alfred Moir, *The Art Bulletin*, LII, 1970, 324–26.

Detroit. *Art in Italy, 1600–1700* (exh. cat.), Detroit Institute of Arts, 1965.

Dezailler d'Argenville, Antoine Joseph. *Abrégé de la vie des plus fameux peintres*, Paris, 1762.

Dijon. *Les Tassel, peintres langrois du XVIIe siècle* (exh. cat.), Musée des Beaux-Arts, [1955].

Dominici, Bernardo de. *Vite de'pittori, scultori ed architetti napoletani*, Naples, ed. 1840–46.

Donzelli, Carlo, and Giuseppe Maria Pilo. *I pittori del Seicento Veneto*, Florence, 1967.

Dowley, Francis H. "Art in Italy, 1600–1700, at the Detroit Institute of Arts," *The Art Quarterly*, XXVII, 1964, 519–26.

Edinburgh. *Shorter Catalogue*, The National Gallery of Scotland, 1970.

Enggass, Robert. "'La virtù di un vero nobile': L'Amore Giustiniani del Caravaggio," *Palatino*, XI, 1967, 13–20.

Faldi, Italo. *Pittori viterbesi di cinque secoli*, Rome, 1970.

Faraglia, N. F. "Il testamento di Aniello Falcone," *Napoli nobilissima*, XIV, 1905, 17–20.

Ferrari, Oreste. "Pittura napoletana del Seicento e Settecento," *Storia dell'arte*, I, 1969, 213–20.

Ferrari, Oreste. "Le arti figurative," *La storia di Napoli*, Naples, 1970, VI, 1223–1363.

Figar, Antonio Garcia. "Fray Juan Bautista Maino Pintor Español," *Goya*, 1958, no. 25, pp. 6–12.

Fiocco, Giuseppe. "A Masterpiece by Giovanni Serodine," *The Burlington Magazine*, LV, 1929, 190–95.

Fiocco, Giuseppe. "Due quadri di Georges de la Tour," *Paragone*, V, 1954, no. 55, 38–40.

Florence. *Mostra della pittura italiana del Seicento e del Settecento* (exh. cat.), Palazzo Pitti, 1922.

Fokker, T. H. "Nederlandsche schilders in Zuid-Italië," *Oud Holland*, XLVI, 1929, 1–24.

Francis, Henry S. "*The Repentant St. Peter* by Georges de La Tour," *The Bulletin of the Cleveland Museum of Art*, XXXIX, 1952, 174–77.

Frangipane, Alfonso. *Mattia Preti*, Milan, 1929.

Frangipane, Alfonso. "Nuovi contributi alla biografia di Mattia Preti," *Brutium*, XXXII, 1953, nos. 9–10, pp. 5–7; nos. 11–12, pp. 5–8.

Friedlaender, Walter. "Zuccari and Caravaggio," *Gazette des Beaux-Arts*, XXXIII, 1948, 27–36.

Friedlaender, Walter. *Caravaggio Studies*, Princeton, 1955.

Friedlaender, Walter. *Mannerism and Anti-Mannerism in Italian Painting*, New York, 1957.

Frommel, Christoph. "Caravaggio und der Kardinal Francesco Maria del Monte," *Storia dell'arte*, in press.

Gevaert, Suzanne. "A propos d'un tableau de Gérard Douffet conservé à Liège," *Revue Belge d'Archéologie et d'Histoire de l'Art*, XVII, 1947–48, 51–56.

Gilbert, Creighton (ed.). *Figures at a Table* (exh. cat.), *Bulletin of the Ringling Museums, Sarasota, Florida*, I, 1960, no. 1.

Gilbert, Creighton (ed.). *Baroque Painters of Naples* (exh. cat.), *Bulletin of the Ringling Museums, Sarasota, Florida*, I, 1961, no. 2.

Glück, Gustav. *Rubens, Van Dyck und ihr Kreis*, Vienna, 1933.

Gowing, Lawrence. "Light on Baburen and Vermeer," *The Burlington Magazine*, XCIII, 1951, 169–70.

Gregori, Mina. "Avant-propos sulla pittura fiorentina del Seicento," *Paragone*, XIII, 1962, no. 145, 21–40.

Grossman, F. "A Painting by Georges de La Tour in the Collection of Archduke Leopold Wilhelm," *The Burlington Magazine*, C, 1958, 86–91.

Gudlaugsson, Sturla. *Ikonographische Studien über die holländische Malerei und das Theater des 17. Jahrhunderts*, Würzburg, 1938.

Guglielmi, Carla. "Intorno all'opera pittorica di Giovanni Baglione," *Bollettino d'arte*, XXXIX, 1954, 311–26.

Harris, Enriqueta. "Aportaciones para el estudio de Juan Bautista Maino," *Revista española de arte*, IV, 1934–35, 333–39.

Hartford, Connecticut. "Purchases for the Museum's Collections," *Wadsworth Atheneum Bulletin*, Spring, 1964, pp. 23–24.

Haskell, Francis. *Patrons and Painters*, New York, 1963.

Heikamp, Detlef. "La Medusa del Caravaggio e l'armatura dello Scià 'Abbâs di Persia," *Paragone*, XVII, 1966, no. 199, 62–76.

Heinz, Günther. "Zwei wiedergefundene Bilder aus der Galerie des Erzherzogs Leopold Wilhelm," *Jahrbuch der Kunsthistorischen Sammlungen in Wien*, LVIII (XXII), 1962, 169–80.

Held, Julius. "A Supplement to Het Caravaggisme te Gent," *Gentsche Bijdragen tot de Kunstgeschiedenis*, XIII, 1951, 7–12.

Held, Julius. "*The Burdens of Time*, A Footnote on Abraham Janssens," *Musées Royaux des Beaux-Arts, Bulletin* [Brussels] I, 1952, 11–17.

Held, Julius. "Notes on Flemish Seventeenth Century Painting: Jacob van Oost and Theodor van Loon," *The Art Quarterly*, XVIII, 1955, 147–56.

Henkel, M. D. "*The Denial of St. Peter* by Rembrandt," *The Burlington Magazine*, LXIV, 1934, 153–59.

Hess, Jacob. "The Chronology of the Contarelli Chapel," *The Burlington Magazine*, XCIII, 1951, 186–201.

Hibbard, Howard, and Milton Lewine. "Seicento at Detroit," *The Burlington Magazine*, CVII, 1965, 370–72.

Hinks, Roger. *Caravaggio's Death of the Virgin* (Charlton Lectures on Art), University of Durham, Newcastle upon Tyne, 1952 (published London, 1953).

Hinks, Roger. *Michelangelo Merisi da Caravaggio*, New York, 1953.

Hoog, Michel. "Attributions anciennes à Valentin," *La Revue des Arts*, X, 1960, 267–78.

Hoogewerff, G. J. *De Nederlandsche Kunstenaars te Rome in de XVIIe Eeuw en hun Conflict met de Academie van St. Lucas*, Amsterdam, 1926.

Hoogewerff, G. J. *De Bentvueghels*, The Hague, 1952.

Hoogewerff, G. J. "Jan van Bijlert," *Oud Holland*, LXXX, 1965, 3–33.

Houston. *The Samuel H. Kress Collection at the Museum of Fine Arts of Houston*, 1953.

Hulst, R. A. d'. "Caravaggeske Invloeden in het Oeuvre van Jacob van Oost de Oude, Schilder te Brugge," *Gentsche Bijdragen tot de Kunstgeschiedenis*, XIII, 1951, 169–92.

Indianapolis. *The Young Rembrandt and His Times* (exh. cat.), John Herron Art Museum, 1958. (Also The Fine Arts Gallery, San Diego, California, 1958.)

Indianapolis. *El Greco to Goya* (exh. cat.), John Herron Museum of Art, 1963. (Also Museum of Art, Rhode Island School of Design, Providence, 1963.)

Indianapolis. *Catalogue of European Paintings*, Indianapolis Museum of Art, 1970.

Isarlo, George. *Caravage et le Caravagisme Européen*, Aix-en-Provence, 1941.

Isarlo, Georges. "Le scandale des La Tour," *Combat Art*, February 4, 1957.

Ivanoff, Nicola. "Jean Le Clerc et Venise," *Actes du XIXe Congrès International d'Histoire de l'Art*, Paris, 1958 [1959], pp. 390–94.

Ivanoff, Nicola. "Giovanni Le Clerc," *Critica d'arte*, IX, 1962, 62–76.

Ivanoff, Nicola. "Intorno al tardo Saraceni," *Arte veneta*, XVIII, 1964, 177–80.

Ivanoff, Nicola. "Nicolas Régnier," *Arte antica e moderna*, 1965, no. 29, pp. 12–24.

Ivanoff, Nicola. *Valentin de Boulogne (I maestri del colore*, no. 171), Milan, 1966.

Jacksonville, Florida. *The Age of Louis XIII* (exh. cat.), The Cummer Gallery of Art, 1970. (Also The Museum of Fine Arts, St. Petersburg, Florida, 1970.)

Jacob, Sabine. "Ein Selbstbildnis von Luis Tristan?" *Kunstgeschichtliche Studien für Kurt Bauch*, Munich and Berlin, 1967[a], pp. 181–88.

Jacob, Sabine. "Florentinische Elemente in der spanischen Malerei des frühen 17. Jahrhunderts," *Mitteilungen des Kunsthistorischen Institutes in Florenz*, XIII, 1967[b], 115–64.

[Jacobus da Voragine]. *The Golden Legend or Lives of the Saints as Englished by William Caxton*, London, 1900.

Jamot, Paul. *Georges de La Tour*, Paris, 1948.

Judson, J. Richard. *Gerrit van Honthorst*, The Hague, 1959.

Judson, J. Richard. Review of *Hendrick Terbrugghen* by Benedict Nicolson, *The Art Bulletin*, XLIII, 1961, 341–48.

Judson, J. Richard. "Pictorial Sources for Rembrandt's *Denial of St. Peter*," *Oud Holland*, LXXIX, 1964, 141–51.

Judson, J. Richard. "Allegory on Drinking," *News Bulletin and Calendar, Worcester Art Museum*, February, 1969.

Jullian, René. *Caravage*. Lyon and Paris, 1961.

Keown, Priscilla. "Caravaggio: Three Centuries of Critical Reaction" (unpublished master's thesis), Oberlin College, 1965.

Kirwin, W. Chandler. "Addendum to Cardinal Francesco Maria del Monte's Inventory: The Date of the Sale of Various Noteable Paintings," *Storia dell'arte*, in press.

Kitson, Michael. "Caravaggio's Aftermath," *Apollo*, LXXXVI, 1967, 514–15.

Kitson, Michael. *The Complete Paintings of Caravaggio*, London, 1969 (based on the Italian edition of 1967 by Renato Guttuso and Angela Ottino della Chiesa).

Kruft, Hanno-Walter. "Der malteser Ritterorden in Malta— Mattia Preti," *Kunstchronik*, XXIII, 1970, 201–7. (Also published in *Neue Zürcher Zeitung*, June 21, 1970, pp. 49–50.)

Kultzen, Rolf. Review of *The Italian Followers of Caravaggio* by Alfred Moir, *Kunstchronik*, XXII, 1969, 289–305.

Lanzi, Luigi. *The History of Painting in Italy*, transl. T. Roscoe, London, 1852–54.

Lavin, Marilyn Aronberg. "Caravaggio Documents from the Barberini Archive," *The Burlington Magazine*, CIX, 1967, 470–73.

Lépicié, François Bernard. *Catalogue raisonné des tableaux du Roy*, Paris, 1752–54.

Levey, Michael. "Notes on the Royal Collection II: Artemisia Gentileschi's *Self-Portrait* at Hampton Court," *The Burlington Magazine*, CIV, 1962, 79–80.

Levey, Michael. *The Later Italian Pictures in the Collection of Her Majesty the Queen*, London, 1964.

London. *Exhibition of Works by Holbein and Other Masters of the 16th and 17th Centuries* (exh. cat.), Royal Academy of Arts, 1950–51.

London. *Flemish Art, 1300–1700* (exh. cat.), Royal Academy of Arts, 1953–54.

London. *Artists in 17th Century Rome* (exh. cat.), Wildenstein and Co., Ltd., 1955.

London. *The Age of Louis XIV* (exh. cat.), Royal Academy of Arts, 1958.

London. *Italian Art and Britain* (exh. cat.), Royal Academy of Arts, 1960.

London. *Exhibition of Old Master Paintings from the David M. Koetser Gallery, Zurich,…at the Brian Koetser…and David M. Koetser Gallery*, 1969[a].

London. *Exhibition of 16th, 17th and 18th Century Old Masters*, Gallery Lasson, 1969[b].

London. *Fourteen Important Neapolitan Paintings* (exh. cat.), Heim Gallery, 1971.

Longhi, Roberto. "Orazio Borgianni," *L'arte*, XVII, 1914, 7–23.

Longhi, Roberto. "Battistello," *L'arte*, XVIII, 1915, 120–37.

Longhi, Roberto. "Gentileschi padre e figlia," *L'arte*, XIX, 1916, 245–314.

Longhi, Roberto. "Bollettino bibliografico, no. 73," *L'arte*, XX, 1917, 178.

Longhi, Roberto. "Bollettino bibliografico, no. 76," *L'arte*, XXI, 1918, 239.

Longhi, Roberto. "Un San Tomasso di Velázquez e le congiunture italo-spagnole tra il '5 e il '600," *Vita artistica*, II, 1927, 4–11.

Longhi, Roberto. "Quesiti Caravaggeschi," *Pinacotheca*, I, 1928–29, 17–33, 258–320.

Longhi, Roberto. "Giovanni Baglione," in *Enciclopedia italiana*, V, 1930, 851–53.

Longhi, Roberto. "I pittori della realtà in Francia, ovvero i Caravaggeschi francesi del Seicento," *L'Italia letteraria*, XI, January 19, 1935, no. 3, 1, 4–6.

Longhi, Roberto. "Ultimi studi sul Caravaggio e la sua cerchia," *Proporzioni*, I, 1943, 5–63.

Longhi, Roberto. "Giovanni Serodine," *Paragone*, I, 1950[a], no. 7, 3–23.

Longhi, Roberto. "Un momento importante nella storia della 'natura morta'," *Paragone*, I, 1950[b], no. 1, 34–39.

Longhi, Roberto. "Velazquez, 1630, 'La Rissa all'Ambasciata di Spagna'," *Paragone*, I, 1950[c], no. 1, 28–34.

Longhi, Roberto. "Alcuni pezzi rari nell'antologia della critica caravaggesca," *Paragone*, II, 1951[a], no. 17, 44–62; no. 19, 61–63; no. 21, 43–56; no. 23, 28–53.

Longhi, Roberto. "Sui margini caravaggeschi," *Paragone*, II, 1951[b], no. 21, 20–34.

Longhi, Roberto. "Volti della Roma Caravaggesca," *Paragone*, II, 1951[c], no. 21, 35–39.

Longhi, Roberto. *Il Caravaggio*, Milan, 1952.

Longhi, Roberto. "Caravage et les Peintres Français du XVIIIe [sic] siècle—Paris, Galerie Heim, 1955," *Paragone*, VI, 1955[a], no. 63, 62–63.

Longhi, Roberto. *Giovanni Serodine*, Florence, [1955–b].

Longhi, Roberto. "Michele Manzoni, caravaggesco di periferia," *Paragone*, VIII, 1957, no. 89, 42–45.

Longhi, Roberto. "A Propos de Valentin," *La Revue des Arts*, VIII, 1958, 58–66.

Longhi, Roberto. "Presenze alla Sala Regia," *Paragone*, IX, 1959[a], no. 117, 29–38.

Longhi, Roberto. "Un'opera estrema del Caravaggio," *Paragone*, IX, 1959[b], no. 111, 21–32.

Longhi, Roberto. "Un San Giovanni Battista del Caracciolo," *Paragone*, IX, 1959[c], no. 109, 58–60.

Longhi, Roberto. "Un originale del Caravaggio a Rouen e il problema delle copie caravaggesche," *Paragone*, XI, 1960, no. 121, 23–36.

Longhi, Roberto. *Scritti giovanili, 1912–22* (Vol. I of *Opere complete di Roberto Longhi*), Florence, 1961.

Longhi, Roberto. "Giovanni Baglione e il quadro del processo," *Paragone*, XIV, 1963, no. 163, 23–31.

Longhi, Roberto. "Le prime incidenze caravaggesche in Abraham Janssens," *Paragone*, XVI, 1965, no. 83, 51–52.

Longhi, Roberto. "I 'Cinque Sensi' del Ribera," *Paragone*, XVII, 1966[a], no. 193, 74–78.

Longhi, Roberto. "Una cosa giovanile del Ter Brugghen," *Paragone*, XVII, 1966[b], no. 201, 70–72.

Longhi, Roberto. *Caravaggio*, Leipzig, 1968[a].

Longhi, Roberto. *'Me Pinxit' e Quesiti Caravaggeschi* (Vol. IV of *Opere complete di Roberto Longhi*), Florence, 1968[b].

Longhi, Roberto. "'Giovanni della Voltolina' a Palazzo Mattei," *Paragone*, XX, 1969, no. 233, 59–62.

López-Rey, José. *Velázquez*, London, 1963.

Lurie, Ann Tzeutschler. "Gerard van Honthorst: *Samson and Delilah*," *The Bulletin of The Cleveland Museum of Art*, LVI, 1969, 332–44.

Madrid. *Pintura italiana del siglo XVII*, Museo del Prado, 1970.

Mahon, Denis. *Studies in Seicento Art and Theory*, London, 1947.

Mahon, Denis. "Egregius in Urbe Pictor: Caravaggio Revised," *The Burlington Magazine*, XCIII, 1951, 223–34.

Mahon, Denis. "Addenda to Caravaggio," *The Burlington Magazine*, XCIV, 1952, 3–23.

Mahon, Denis. "On Some Aspects of Caravaggio and His Times," *The Metropolitan Museum of Art Bulletin*, XII, 1953, 33–45.

Mahon, Denis. "A Late Caravaggio Rediscovered," *The Burlington Magazine*, XCVIII, 1956, 225–28.

Mahon, Denis (ed.). *Il Guercino* (exh. cat.), Palazzo dell'Archiginnasio, Bologna, 1968.

Mancini, Giulio. *Considerazioni sulla pittura*, eds. Marucchi and Salerno, Rome, 1956–57.

Manning, Robert. "Some Important Paintings by Simon Vouet in America," *Studies in the History of Art Dedicated to William E. Suida*, London, 1959, pp. 294–303.

Marabottini Marabotti, Alessandro. "Il 'Naturalismo' di Pietro Paolini," *Scritti di storia dell'arte in onore di Mario Salmi*, III, 1963, 307–24.

Marangoni, Matteo. *Il Caravaggio*, Florence, 1922.

Marangoni, Matteo. "Note sul Caravaggio alla mostra del Sei e Settecento," *Bollettino d'arte*, II, 1922–23, 217–29.

Marangoni, Matteo. "An Unpublished Caravaggio in Trieste," *International Studio*, XCIV, 1929, 34–35, 106.

Marini, Maurizio. "Due ipotesi Caravaggesche," *Arte illustrata*, III, 1970, nos. 34–36, pp. 74–79.

Marino, Angela. "Un caravaggesco fra Controriforma e Barocco: Antiveduto Gramatica," *L'arte*, N.S., I, 1968, nos. 3–4, pp. 47–82.

Mariotti, Filippo. *La legislazione delle belle arti*, Rome, 1892.

Martinelli, Valentino. "L'amor divino 'tutto ignudo' di Giovanni Baglione e la cronologia dell'intermezzo caravaggesco," *Arte antica e moderna*, 1959[a], no. 5, pp. 82–96.

Martinelli, Valentino. "Le date della nascita e dell'arrivo a Roma di Carlo Saraceni, pittore veneziano," *Studi romani*, VII, 1959[b], 679–84.

Mesuret, Robert. "L'acte de baptême de Nicolas Tournier," *Bulletin de la Société de l'Histoire de l'Art Français*, 1951, 13–18.

Mesuret, Robert. "L'oeuvre peint de Nicolas Tournier," *Gazette des Beaux-Arts*, L, 1957, 327–50.

Michałkowa, Janina. "Une musique caravagesque," *Bulletin du Musée National de Varsovie*, II, 1961, 11–22.

Michiels, Alfred. *L'art flamand dans l'est et le midi*, Paris, 1877.

Milan. *Mostra del Caravaggio e dei Caravaggeschi* (exh. cat.), Palazzo Reale, 1951.

Milan. *Dipinti di due secoli* (exh. cat.), Relarte, 1963.

Milan. *Seicento, arte 'moderna,' arte di domani* (exh. cat.), exh. Algranti, Circolo della Stampa, Palazzo Serbelloni, 1969.

[Miller, Lady Anne]. *Letters from Italy by an English Woman*, London, 1776.

Mirimonde, A. P. de. "*The Musicians* by Theodor Rombouts," *Register of the Museum of Art, The University of Kansas*, III, 1965, 2–9.

Moir, Alfred. "*Boy with a Flute* by Bartolomeo Manfredi," *Los Angeles County Museum, Bulletin of the Art Division*, XIII, 1961, no. 1, 3–15.

Moir, Alfred. "Alonzo Rodriguez," *The Art Bulletin*, XLIV, 1962, 205–18.

Moir, Alfred. *The Italian Followers of Caravaggio*, Cambridge, Massachusetts, 1967.

Moir, Alfred. "Did Caravaggio Draw?" *The Art Quarterly*, XXXII, 1969, 354–72.

Montalto, Lina. "Il passaggio di Mattia Preti a Napoli," *L'arte*, XXIII, 1920, 97–113, 207–25.

Montalto, Lina. "Gli affreschi del Palazzo Pamphilj in Valmontone," *Commentari*, VI, 1955, 267–302.

Montreal. *Héritage de France* (exh. cat.), The Montreal Museum of Fine Arts, 1961. (Also Québec, 1961; Ottawa, 1962; Toronto, 1962.)

Müller Hofstede, Justus. "Abraham Janssens und das Problem des Flämischen Caravaggismus," *Acts of the XXII International Congress of the History of Art, Budapest, 1969* (in press).

Munich. "Caravaggio: Das Selbstporträt der Galleria Borghese," *Hefte des Kunsthistorischen Seminars der Universität München*, nos. 7–8, 1962, pp. 23–25.

Naples. *Caravaggio e Caravaggeschi* (exh. cat.), Palazzo Reale, 1963.

Naples. *La natura morta italiana* (exh. cat.), Palazzo Reale, 1964. (Also Zurich and Rotterdam, 1965.)

Naples. *Arte francese a Napoli* (exh. cat.), Palazzo Reale, 1967.

New Orleans. *Fêtes de la Palette* (exh. cat.), Isaac Delgado Museum of Art, 1962–63.

New York. *French Painting of the Time of Louis XIII and Louis XIV* (exh. cat.), Wildenstein and Co., 1946.

New York. *The Collection of Mr. and Mrs. Henry H. Weldon* (exh. cat.), Finch College Museum of Art, 1966.

Nibby, A. *Itinéraire de Rome*, Rome, 1842.

Nicolson, Benedict. "Current and Forthcoming Exhibitions," *The Burlington Magazine*, XCVII, 1955, 124–27.

Nicolson, Benedict. *Hendrick Terbrugghen*, London, 1958[a].

Nicolson, Benedict. "In the Margin of the Catalogue," *The Burlington Magazine*, C, 1958[b], 97–101.

Nicolson, Benedict. "Figures at a Table at Sarasota," *The Burlington Magazine*, CII, 1960[a], 226.

Nicolson, Benedict. "Second Thoughts about Terbrugghen," *The Burlington Magazine*, CII, 1960[b], 465–73.

Nicolson, Benedict. "The 'Candlelight Master': A Follower of Honthorst in Rome," *Nederlands Kunsthistorisch Jaarboek*, XI, 1960[c], 121–64.

Nicolson, Benedict. "Notes on Adam de Coster," *The Burlington Magazine*, CIII, 1961, 185–89.

Nicolson, Benedict. "Postscript to Baburen," *The Burlington Magazine*, CIV, 1962, 539–43.

Nicolson, Benedict. "Caravaggesques in Naples," *The Burlington Magazine*, CV, 1963, 209–10.

Nicolson, Benedict. "Un Caravaggiste Aixois: Le Maître à la Chandelle," *Art de France*, IV, 1964, 116–39. (Reprinted as "The Rehabilitation of Trophime Bigot," *Art and Literature*, no. 4, 1965, 66–105.)

Nicolson, Benedict. "Bartolommeo Manfredi," *Studies in Renaissance and Baroque Art presented to Anthony Blunt*, London, 1967, pp. 108–12.

Nicolson, Benedict. "The Caravaggesque Movement," *The Burlington Magazine*, CX, 1968, 635–36.

Nicolson, Benedict. "Current and Forthcoming Exhibitions," *The Burlington Magazine*, CXI, 1969, 298–401.

Nicolson, Benedict. "Caravaggesques in Florence," *The Burlington Magazine*, CXII, 1970[a], 636–41.

Nicolson, Benedict. "The Art of Carlo Saraceni" [review of Anna Ottani Cavina's *Carlo Saraceni*], *The Burlington Magazine*, CXII, 1970[b], 312–15.

Northampton, Massachusetts. *Handbook of the Art Collections of Smith College*, 1925.

Ottani, Anna. "Per un caravaggesco toscano: Pietro Paolini (1603–81)," *Arte antica e moderna*, 1963, no. 21, pp. 19–35.

Ottani, Anna. "Integrazioni al catalogo del Paolini," *Arte antica e moderna*, 1965[a], no. 30, pp. 181–87.

Ottani, Anna. "Su Angelo Caroselli, pittore romano," *Arte antica e moderna*, 1965[b], nos. 31–32, pp. 289–97.

Ottani Cavina, Anna. "Per il primo tempo del Saraceni," *Arte veneta*, XXI, 1967, 218–23.

Ottani Cavina, Anna. *Carlo Saraceni*, Milan, 1968.

Ottawa. *Catalogue of Paintings and Sculpture, I: Older Schools*, National Gallery of Canada, 1957.

Pallucchini, Rodolfo. "L'ultima opera del Saraceni," *Arte veneta*, XVII, 1963, 178–82.

Panofsky-Soergel, Gerda. "Zur Geschichte des Palazzo Mattei di Giove," *Romisches Jahrbuch für Kunstgeschichte*, XI, 1967–68, 109–88.

Paolucci, Antonio. "'I seguaci italiani del Caravaggio' di A. Moir," *Paragone*, XVIII, 1967, no. 213, 67–78.

Paris. *Les peintres de la réalité* (exh. cat.), Musée de l'Orangerie, 1934.

Paris. *Caravage et les peintres français du XVIIe siècle* (exh. cat.), Galerie Heim, 1955.

Paris. *Tableaux de maîtres anciens* (exh. cat.), Galerie Heim, 1956.

Paris. *Le Caravage et la peinture italienne du XVIIe siècle* (exh. cat.), Musée du Louvre, 1965.

Paris. *Le seizième siècle européen. Peintures et dessins dans les collections publiques françaises*, Petit Palais, 1965–66.

Pariset, François-Georges. "Georges de la Tour et Saint Sébastien," *Bulletin de la Société de l'Histoire de l'Art Français*, 1935, pp. 13–17.

Pariset, François-Georges. *Georges de La Tour*, Paris, 1948.

Pariset, François-Georges. "Le Saint-Pierre Repentant de Georges de La Tour," *Arts, Beaux-arts, Littérature, Spectacles*, March 30, 1951, pp. 1, 4.

Pariset, François-Georges. "Jean Le Clerc et Venise," *Venezia e l'Europa* (Atti del XVIII congresso internazionale di storia dell'arte), Venice, 1955 [1956], pp. 322–23.

Pariset, François-Georges. "Note sur Jean Le Clerc," *La Revue des Arts*, VIII, 1958, 67–71.

Pauwels, H. "De Schilder Matthias Stomer," *Gentsche Bijdragen tot de Kunstgeschiedenis*, XIV, 1953[a], 139–92.

Pauwels, H. "Enkele Nota's Betreffende Caravaggio," *Gentsche Bijdragen tot de Kunstgeschiedenis*, XIV, 1953[b], 193–200.

Pearce, Stella Mary. "Costume in Caravaggio's Painting," *Magazine of Art*, XLVI, 1953, 147–54.

Peers, E. Allison. *Studies of the Spanish Mystics*, London, ed. 1951–60.

Pérez-Sánchez, Alfonso. *Borgianni, Cavarozzi y Nardi en España*, Madrid, 1964.

Pevsner, Nikolaus. "Die Lehrjahre des Caravaggio," *Zeitschrift für Bildende Kunst*, LXII, 1928–29, 278–88.

Pevsner, Nikolaus. "Some Notes on Abraham Janssens," *The Burlington Magazine*, LXIX, 1936, 120–29.

Philippe, Joseph. *La peinture liégeoise au XVII^e siècle*, Brussels, 1945.

Philippe, Joseph. "Les artistes liégeois à Rome (XVI^e-XIX^e siècle)," *Bulletin de l'Institut archéologique liégeois*, LXXVII, 1964, 71–155.

Pigler, A. *Katalog der Galerie, Alter Meister* [Szépmüvészeti Múzeum], Budapest, 1968.

Pistolesi, Erasmo. *Descrizione di Roma e suoi contorni*, Rome, 1846.

Pointel, Ph. de. *Recherches sur la vie et les ouvrages de quelques peintres provinciaux*, Paris, 1847.

Pollak, Oskar. *Die Kunsttätigkeit unter Urban VIII*, Vienna, 1928–31.

Ponnelle, Louis, and Louis Bordet. *St. Philip Neri and the Roman Society of His Times (1515–1595)*, London, 1932.

Porcella, Amadore. "Carlo Saraceni," *Revista mensile della Città di Venezia*, VII, 1928, 369–412.

Providence. *Northern Baroque Paintings and Drawings from the Collection of Mr. and Mrs. Henry H. Weldon* (exh. cat.), Museum of Art, Rhode Island School of Design, 1964.

Redig de Campos, Deoclecio. "Una 'Giuditta' opera sconosciuta del Gentileschi nella Pinacoteca Vaticana," *Rivista d'arte*, XXI, 1939, 311–23.

Refice Taschetta, Claudia. *Mattia Preti*, Brindisi, [1959].

Rich, Daniel Cotton. *Catalogue of the Charles H. and Mary F. S. Worcester Collection of Paintings, Sculpture and Drawings*, Chicago, 1938.

Richardson, E. P. "*The Fruit Vendor* by Caravaggio," *Bulletin of the Detroit Institute of Arts*, XVI, 1937, 86–91.

Richardson, E.P. "*The Repentant Magdalen* by Niccolo Renieri," *Bulletin of the Detroit Institute of Arts*, XVIII, 1939, no. 6, 2–3.

Richardson, E. P. "Renieri, Saraceni and the Meaning of Caravaggio's Influence," *The Art Quarterly*, V, 1942, 233–41.

Richardson, E. P. "A Masterpiece of Baroque Drama," *Bulletin of the Detroit Institute of Arts*, XXXII, 1952–53, 81–83. (Reprinted in *The Art Quarterly*, XVI, 1953, 91–92.)

Richter, Jean Paul. *Catalogue of Pictures at Locko Park*, London, 1901.

Robert-Dumesnil, A. *Le peintre-graveur français*, Paris, 1835–71.

Roblot-Delondre. "Gérard Seghers," *Gazette des Beaux-Arts*, IV, 1930, 184–99.

Röttgen, Herwarth. "Giuseppe Cesari, Die Contarelli-Kapelle und Caravaggio," *Zeitschrift für Kunstgeschichte*, XXVII, 1964, 201–27.

Röttgen, Herwarth. "Die Stellung der Contarelli-Kapelle in Caravaggios Werk," *Zeitschrift für Kunstgeschichte*, XXVIII, 1965, 47–68.

Röttgen, Herwarth. "Caravaggio-Probleme," *Münchner Jahrbuch der bildenden Kunst*, XX, 1969, 143–70.

Roggen, D. "De Chronologie der Werken van Theodoor Rombouts," *Gentsche Bijdragen tot de Kunstgeschiedenis*, II, 1935, 175–90.

Roggen, D. "Werk van M. Stomer en Th. Rombouts," *Gentsche Bijdragen tot de Kunstgeschiedenis*, XIII, 1951, 269–73.

Roggen, D., and H. Pauwels. "Nog bij 'Het Caravaggisme te Gent'," *Gentsche Bijdragen tot de Kunstgeschiedenis*, XIV, 1953, 201–5.

Roggen, D., and H. Pauwels. "Het Caravaggistisch Oeuvre van Gerard Zeghers," *Gentsche Bijdragen tot de Kunstgeschiedenis*, XVI, 1955–56, 255–301.

Roggen, D., H. Pauwels, and A. De Schrijver. "Het Caravaggisme te Gent," *Gentsche Bijdragen tot de Kunstgeschiedenis*, XII, 1949–50, 255–321.

Rome. *Catalogue de tableaux ayant appartenus à la Galerie Sciarra et d'une collection d'objets d'art d'autres provenances*, Galerie Sangiorgi, cat. no. 83, March 22–28, 1899.

Rome. *Il Seicento Europeo* (exh. cat.), Palazzo delle Esposizioni, 1956–57.

Rome. *Mostra di antichi dipinti restaurati delle raccolte accademiche* (exh. cat.), Accademia Nazionale di San Luca, Palazzo Carpegna, 1968.

Rome. *Acquisti, doni, lasciti, restauri e recuperi, 1962–1970* (exh. cat.), Galleria nazionale d'arte antica, Palazzo Barberini, 1970.

Rosci, Marco. *Orazio Gentileschi* (I maestri del colore, no. 83), Milan, 1965.

Rosenberg, Jakob, Seymour Slive, and E. H. Ter Kuile. *Dutch Art and Architecture, 1600 to 1800*, Harmondsworth and Baltimore, 1966.

Rosenberg, Pierre. *Rouen, Musée des Beaux-Arts: Tableaux français du XVII siècle et italiens des XVII et XVIII siècles* (Inventaire des collections publiques françaises, 14), Paris, 1966.

Rotterdam. *Michael Sweerts en Tijdgenoten* (exh. cat.), Museum Boymans-van Beuningen, 1958.

Rotterdam. *Collectie Thyssen-Bornemisza* (exh. cat.), Museum Boymans-van Beuningen, 1959–60.

Salerno, Luigi. "Di Tommaso Salini, un ignorato caravaggesco," *Commentari*, III, 1952, 28–31.

Salerno, Luigi. "Precisazioni su Giovanni Lanfranco e su Tommaso Salini," *Commentari*, V, 1954, 253–55.

Salerno, Luigi. "Caravaggio e il Priore della Consolazione," *Commentari*, VI, 1955, 258–60.

Salerno, Luigi. "Cavaliere d'Arpino, Tassi, Gentileschi and their Assistants," *Connoisseur*, CXLVI, 1960[a], 157–62.

Salerno, Luigi. "The Picture Gallery of Vincenzo Giustiniani," *The Burlington Magazine*, CII, 1960[b], 21–27, 93–104, 135–48.

Salerno, Luigi, Duncan Kinkead, and William Wilson. "Poesia e simboli nel Caravaggio," *Palatino*, X, 1966, 106–17.

Samek Ludovici, Sergio. *Vita del Caravaggio*, Milan, 1956.

Sandrart, Joachim von. *Academie der Bau-, Bild- und Mahlerey-Künste von 1675*, ed. Peltzer, Munich, 1925.

San Francisco. *Exhibition of Italian Baroque Paintings* (exh. cat.), California Palace of the Legion of Honor, 1941.

San Francisco. *Man: Glory, Jest, and Riddle* (exh. cat.), M. H. de Young Memorial Museum, 1964–65. (Also California Palace of the Legion of Honor and the San Francisco Museum of Art.)

Saxl, Fritz. "The Battle Scene without a Hero: Aniello Falcone and His Patrons," *Journal of the Warburg and Courtauld Institutes*, III, 1939–40, 70–87.

Scannelli, Francesco. *Il microcosmo della pittura*, Cesena, 1657.

Schleier, Erich. "Una postilla per i 'Cinque Sensi' del giovane Ribera," *Paragone*, XIX, 1968, no. 223, 79–80.

Schleier, Erich. "Pintura italiana del siglo XVII," *Kunstchronik*, XXIII, 1970, 341–49.

Schleier, Erich. "Caravaggio e Caravaggeschi nelle gallerie di Firenze," *Kunstchronik*, XXIV, 1971, 85–102.

Schneider, Arthur von. *Caravaggio und die Niederländer* (2nd ed.), Amsterdam, 1967.

Schönenberger, Walter. *Giovanni Serodine, pittore di Ascona*, Basel, 1957. (Also published as *Basler Studien zur Kunstgeschichte*, XIV, 1957.)

Schudt, Ludwig. *Caravaggio*, Vienna, 1942.

Seattle. *Masterpieces of Art* (exh. cat.), Seattle World's Fair, 1962.

Serra, Luigi. *Domenico Zampieri detto il Domenichino*, Rome, 1909.

Sestieri, Ettore. "Un Caravaggio di più," *L'arte*, XL, 1937, 264–83.

Shearman, John. *Mannerism*, Harmondsworth and Baltimore, 1967.

Shell, Curtis, and John McAndrew. *Catalogue of European and American Sculpture and Paintings at Wellesley College*, Wellesley, Massachusetts, ed. 1964.

Slatkes, Leonard. *Dirck van Baburen*, Utrecht, 1965.

Slatkes, Leonard. "David de Haen and Dirck van Baburen in Rome," *Oud Holland*, LXXXI, 1966, 173–86.

Slatkes, Leonard. "Caravaggio's Painting of the Sanguine Temperament," *Acts of the XXII International Congress of the History of Art, Budapest, 1969* (in press).

Soehner, Halldor. "Velázquez und Italien," *Zeitschrift für Kunstgeschichte*, XVIII, 1955, 1–39.

Soehner, Halldor. "Forschungs- und Literaturbericht zum Problem des spanischen Caravaggismus," *Kunstchronik*, X, 1957, 31–37.

Soprani, Raffaello, and Carlo Giuseppe Ratti. *Vite de'pittori, scultori, ed architetti genovesi*, Genoa, ed. 1768.

Soria, Martin. "Some Paintings by Aniello Falcone," *The Art Quarterly*, XVII, 1954, 3–15.

Spear, Richard. "Caravaggisti at the Palazzo Pitti," *The Art Quarterly*, XXXIV, 1971, 108–10.

Spear, Richard. "A Note on Caravaggio's *Boy with a Vase of Roses*," *The Burlington Magazine*, CXIII, 1971 (in press).

Stechow, Wolfgang. "Terbrugghen's *Saint Sebastian*," *The Burlington Magazine*, XCVI, 1954, 70–73.

Stechow, Wolfgang (ed.). *Catalogue of European and American Paintings and Sculpture in the Allen Memorial Art Museum, Oberlin College*, Oberlin, Ohio, 1967.

Sterling, Charles. "Les peintres de la réalité en France au XVIIe siècle. I. Le mouvement Caravaggesque et Georges de la Tour; II. Le portrait, la scène de genre, la nature morte," *La revue de l'art ancien et moderne*, LXVII, 1935, 25–40, 49–68.

Sterling, Charles. "Observations sur Georges de La Tour à propos d'un livre récent," *La Revue des Arts*, 1951, pp. 147–58.

Sterling, Charles. "Gentileschi in France," *The Burlington Magazine*, C, 1958, 112–20.

Sterling, Charles. *Still Life Painting from Antiquity to the Present Time* (rev. ed.), Paris, 1959.

Stockholm. *Äldre Utländska Målningar och Skulpturer*, Nationalmuseum, 1958.

Suida, William. *A Catalogue of Paintings in the John and Mable Ringling Museum of Art*, Sarasota, Florida, 1949.

Testori, Giovanni. "Nature morte di Tommaso Salini," *Paragone*, V, 1954, no. 51, 20–26.

Thuillier, Jacques. "Un peintre passionné," *L'Oeil*, 1958, no. 47, 26–33.

Toesca, Ilaria. "Due tele del 1609 in S. Silvestro in Capite a Roma," *Bollettino d'arte*, XLV, 1960[a], 283–86.

Toesca, Ilaria. "Un'opera giovanile del Cavarozzi e i suoi rapporti col Pomarancio," *Paragone*, XI, 1960[b], no. 123, 57–59.

Toesca, Ilaria. "Observations on Caravaggio's *Repentant Magdalen*," *Journal of the Warburg and Courtauld Institutes*, XXIV, 1961, 114–15.

Torre, Silvio. "Abbiamo trovato un quadro: è un Caravaggio?" *Il giornale d'Italia*, LXII, May 9–10, 1962, 9.

Torriti, Piero. *La galleria del Palazzo Durazzo Pallavicini a Genova*, Genoa, 1967.

Trapier, Elizabeth du Gué. *Ribera*, New York, 1952.

Utrecht. *Caravaggio en de Nederlanden* (exh. cat.), Centraal Museum, 1952. (Also Koninklijk Museum voor Schone Kunsten, Antwerp, 1952.)

Valentiner, W. R. *Catalogue of Paintings Including Three Sets of Tapestries* (North Carolina Museum of Art), Raleigh, 1956.

Valletta. *The Order of St. John in Malta* (exh. cat.), The Palace and the Museum of St. John's Co-Cathedral, 1970.

Venice. *La pittura del seicento a Venezia* (exh. cat.), Ca' Pesaro, 1959.

Venturi, Adolfo. *Studi dal vero attraverso le raccolte artistiche d'Europa*, Milan, 1927.

Venturi, Adolfo. "Un quadro ignorato di Michelangelo da Caravaggio," *L'arte*, XXXI, 1928, 58–59.

Venturi, Lionello. *Il Caravaggio*, Novara, 1951 (rev. ed., Novara, 1963).

Venturi, Lionello. *Studi radiografici sul Caravaggio* (Atti della Accademia Nazionale dei Lincei, Memorie, V, no. 2), Rome, 1952.

Villot, Frédéric. *Notice des tableaux exposés dans les galeries du musée national du Louvre*, Paris, 1876 [1st ed. 1849].

Vivian, Frances. "Poussin and Claude seen from the Archivio Barberini," *The Burlington Magazine*, CXI, 1969, 719–26.

Voss, Hermann. "Charakterköpfe des Siecento," *Monatshefte für Kunstwissenschaft*, I, 1908, 987–99.

Voss, Hermann. Review of *Domenico Zampieri detto il Domenichino* by Luigi Serra, *Repertorium für Kunstwissenschaft*, XXXII, 1909, 360–62.

Voss, Hermann. "Italienische Gemälde des 16. und 17. Jahrhunderts in der Galerie des Kunsthistorischen Hofmuseums zu Wien," *Zeitschrift für Bildende Kunst*, XXIII, 1912, 41–55, 62–74.

Voss, Hermann. "Caravaggios Frühzeit," *Jahrbuch der Preuszischen Kunstsammlungen*, XLIV, 1923, 73–98.

Voss, Hermann. *Die Malerei des Barock in Rom*, Berlin, 1924.

Voss, Hermann. "Die caravaggeske Frühzeit von Simon Vouet und Nicolas Regnier," *Zeitschrift für Bildende Kunst*, LVIII, 1924–25, 56–67, 122–28.

Voss, Hermann. "Neues zum Schaffen des Giovanni Battista Caracciolo," *Jahrbuch der Preuszischen Kunstsammlungen*, XLVIII, 1927, 131–38.

Voss, Hermann. "*The Chastisement of Love* by Caravaggio," *Apollo*, XXVII, 1938, 30–32.

Voss, Hermann. "Ein unbekanntes Frühwerk Caravaggios," *Die Kunst und das schöne Heim*, IL, 1951, 410–12.

Voss, Hermann. "Inediti di Orazio Borgianni," *Antichità viva*, I, 1962, 9–12.

Voss, Hermann. "Die Darstellungen des hl. Franziskus im Werk von Georges de La Tour," *Pantheon*, XXIII, 1965, 402–4.

Waagen, Gustav. *Galleries and Cabinets of Art in Great Britain* (supplemental volume to *Treasures of Art in Great Britain*), London, 1857.

Waal, H. van de. "Rembrandt's Faust Etching, a Socinian document, and the iconography of the inspired Scholar," *Oud Holland*, LXXIX, 1964, 7–48.

Waddingham, Malcolm. "Another look at Gysbert van der Kuyl," *Paragone*, XI, 1960, no. 125, 45–51.

Waddingham, Malcolm. "Notes on a Caravaggesque Theme," *Arte antica e moderna*, 1961, nos. 13–16, 313–18.

Wagner, Hugo. *Michelangelo da Caravaggio*, Bern, 1958.

Waterhouse, Ellis. "Artists in Seventeenth-Century Rome," *The Burlington Magazine*, XCVII, 1955, 221–23.

Weldon, June de H. "The Male Portraits of Simon Vouet" (unpublished master's thesis), Columbia University, 1966.

Wethey, Harold. "Orazio Borgianni in Italy and in Spain," *The Burlington Magazine*, CVI, 1964, 147–59.

Wethey, Harold. "Orazio Borgianni," in *Dizionario biografico degli Italiani*, XII, 1970, 744–47.

Wittkower, Rudolf. *Art and Architecture in Italy, 1600 to 1750* (2nd ed.), Harmondsworth and Baltimore, 1965.

Wright, Christopher. "A Suggestion for Etienne de La Tour," *The Burlington Magazine*, CXI, 1969, 295–97.

Wright, Christopher. "Georges de La Tour: A Note on His Early Career," *The Burlington Magazine*, CXII, 1970, 387.

Wurzbach, Alfred von. *Niederländisches Künstler-Lexikon*, Vienna and Leipzig, 1906–11.

Zandri, Giuliana. "Un probabile dipinto murale del Caravaggio per il Cardinale Del Monte," *Storia dell'arte*, 1969, no. 3, pp. 338–43.

Zeri, Federico. *La Galleria e la collezione Barberini*, Catalogo del Gabinetto Fotografico Nazionale, Rome, 1954.

Zeri, Federico. "Tommaso Salini: la pala di Sant'Agnese a Piazza Navona," *Paragone*, VI, 1955, no. 61, 50–53.

Zeri, Federico. "Orazio Borgianni: Un'osservazione e un dipinto inedito," *Paragone*, VII, 1956, no. 83, 49–54.

ADDENDA TO BIBLIOGRAPHY

Askew, Pamela. "The Angelic Consolation of St. Francis of Assisi in Post-Tridentine Italian Painting," *Journal of the Warburg and Courtauld Institutes,* XXXII, 1969, pp. 280–306.

Berlin. *Neuerwerbungen* (exh. cat.), Gemäldegalerie, 1971.

Bissell, R. Ward. "Orazio Gentileschi: Baroque Without Rhetoric," *The Art Quarterly,* XXXIV, 1971, pp. 275–96.

Blunt, Anthony. "Georges de La Tour at the Orangerie," *The Burlington Magazine,* CXIV, 1972, pp. 516–26.

Bodart, Didier. *Louis Finson,* Brussels, 1970.

Bodart, Didier. *Les peintres des Pays-Bas méridionaux et de la Principauté de Liège à Rome au XVIIe siècle,* Brussels and Rome, 1970.

Bodart, Didier. "Le voyage en Italie de Gérard Seghers," *Studi offerti a Giovanni Incisa della Rocchetta (Miscellanea della Società Romana di Storia Patria,* XXIII), 1973, pp. 79–88.

Borea, Evelina. "Considerazioni sulla mostra 'Caravaggio e i suoi seguaci' a Cleveland," *Bollettino d'arte,* LVII, 1972, pp. 154–64.

Brejon de Lavergnée, Arnauld, "Pour Nicolas Tournier sur son sejour romain," *Paragone,* XXV, no. 287, 1974, pp. 44–55.

Brejon de Lavergnée, Arnauld, and Jean-Pierre Cuzin. *I Caravaggeshi francesi* (exh. cat.), Villa Medici, Rome, 1973–74, and Grand Palais, Paris, 1974.

Brejon, Arnauld, and Jean-Pierre Cuzin. "A propos de caravaggesques français," *La Revue du Louvre,* XXIV, 1974, pp. 25–38.

Cummings, Frederick, James L. Greaves, Meryl Johnson, Luigi Spezzaferro, and Luigi Salerno. "Detroit's 'Conversion of the Magdalen' (The Alzaga Caravaggio)," *The Burlington Magazine,* CXVI, 1974, 563–93.

Dania, Luigi. "A 'St. John the Baptist' by Valentin," *The Burlington Magazine,* CXVI, 1975, pp. 616–19.

Enggass, Robert. "Review of *Caravaggio and His Followers* by Richard E. Spear," *The Art Bulletin,* LV, 1973, pp. 460–62.

Felton, Craig. "The Earliest Paintings of Jusepe de Ribera," *Wadsworth Atheneum Bulletin,* V, 1969 (1972), no. 3, pp. 2–11.

Ferrari, Oreste, "Caravaggio e i caravaggeschi," *Il Veltro,* XV, 1971, pp. 587–94.

Fredericksen, Burton, B., and Federico Zeri. *Census of Pre-Nineteenth-Century Italian Paintings in North American Public Collections,* Cambridge, Mass., 1972.

Frommel, Christoph Luitpold. "Caravaggios Frühwerk und der Kardinal Francesco Maria Del Monte," *Storia dell'arte,* nos. 9–10, 1971, pp. 5–52.

Goldstein, Carl. "Forms and Formulas: Attitudes Towards Caravaggio in Seventeenth-Century France," *The Art Quarterly,* XXXIV, 1971, pp. 345–55.

Gregori, Mina. "Caravaggio dopo la mostra di Cleveland," *Paragone,* XXIII, no. 263, 1972, pp. 23–49.

Gregori, Mina. "A New Painting and Some Observations on Caravaggio's Journey to Malta," *The Burlington Magazine,* CXVI, 1974, pp. 594–603.

Held, Julius. "Caravaggio and His Followers," *Art in America,* LX, 1972, no. 3, pp. 40–47.

Kirwin, W. Chandler. "Addendum to Cardinal Francesco Maria del Monte's inventory: the Date of the Sale of Various Notable Paintings," *Storia dell'arte,* nos. 9–10, 1971, pp. 53–56.

Lavin, Irving. "Divine Inspiration in Caravaggio's Two St. Matthews," *The Art Bulletin,* LVI, 1974, pp. 59–81.

Leningrad. *Caravaggio and the Caravaggesques* (exh. cat., in Russian), The Hermitage, 1973.

London, *Religious and Biblical Themes in French Baroque Painting* (exh. cat.), Heim Gallery, 1974.

Marini, Maurizio. " Tre proposte per il Caravaggio meridionale," *Arte illustrata,* IV, 1971, pp. 56–65.

Matthiesen, Patrick, and D. Stephen Pepper. "Guido Reni: An Early Masterpiece Discovered in Liguria," *Apollo,* XCI, 1970, pp. 452–62.

Milan. *Il seicento Lombardo: catalogo dei dipinti e delle sculture* (exh. cat.), Palazzo Reale, 1973.

Milan. *Immagine del Caravaggio* (exh. cat.), 1973.

Milhau, Denis. "Note sur Nicolas Tournier . . . ," *Gazette des Beaux-Arts,* LXXXIII, 1974, pp. 367–70.

Nicolson, Benedict. "Gerard Seghers and the 'Denial of St. Peter'," *The Burlington Magazine,* CXIII, 1971, pp. 304–09.

Nicolson, Benedict. "Caravaggesques at Cleveland," *The Burlington Magazine,* CXIV, 1972, pp. 113–17.

Nicolson, Benedict. "A New Borgianni," *The Burlington Magazine,* CXV, 1973, p. 42.

Nicolson, Benedict. "Caravaggio and his Circle in the British Isles," *The Burlington Magazine,* CXVI, 1974, pp. 559–60.

Nicolson, Benedict. "Caravaggio and the Caravaggesques: Some Recent Research," *The Burlington Magazine,* CXVI, 1974, pp. 603–16.

Nicolson, Benedict, "Recent Caravaggio Studies," *The Burlington Magazine,* CXVI, 1974, pp. 624–25.

Nicolson, Benedict, and Christopher Wright. *Georges de La Tour,* London, 1974.

Ottani Cavina, Anna. "La Tour all'Orangerie e il suo primo tempo caravaggesco," *Paragone,* XXIII, no. 273, 1972, pp. 3–24.

Paris. *Georges de La Tour* (exh. cat.), Orangerie, 1972.

Pepper, D. Stephen. "Caravaggio and Guido Reni: Contrasts in Attitudes," *The Art Quarterly,* XXXIV, 1971, pp. 325–44.

Pepper, D. Stephen. "Caravaggio riveduto e corretto: la mostra di Cleveland," *Arte illustrata,* V, 1972, pp. 170–78.

Pérez, Marie-Félicie. *Guy François* (exh. cat.), Musée Crozatier du Puy-en-Velay, and Musée d'Art et d'Industrie de Saint-Etienne, 1974.

Posner, Donald. "Caravaggio's Homo-Erotic Early Works," *The Art Quarterly,* XXXIV, 1971, pp. 301–24.

Prohaska, Wolfgang. "Carlo Sellitto," *The Burlington Magazine,* CXVII, 1975, pp. 3–11.

Rosenberg, Pierre, and François Macé de l'Epinay. *Georges de La Tour,* Fribourg, 1973.

Röttgen, Herwarth. Review of *Caravaggio and His Followers* at Cleveland, *The Art Quarterly,* in press.

Salerno, Luigi. "Caravaggio e i caravaggeschi," *Storia dell'arte,* nos. 7–8, 1970, pp. 234–48.

Salerno, Luigi. "A Painting by Manfredi from the Giustiniani Collection," *The Burlington Magazine,* CXVI, 1974, p. 616.

Schleier, Erich. "Un chef-d'oeuvre de la période italienne de Simon Vouet," *Revue de l'art,* no. 11, 1971, pp. 65–73.

Seville. *Caravaggio y el naturalismo español* (exh. cat.), Sala de Armas de Los Reales Alcazares, 1973.

Spear, Richard E. "Unknown Pictures by the Caravaggisti (with Notes on *Caravaggio and His Followers*)," *Storia dell'arte,* no. 14, 1972, pp. 149–61.

Thiel, P. J. J. van. "De aanbidding der koningen en ander vroeg werk van Hendrick ter Brugghen," *Bulletin van het Rijksmuseum* (Amsterdam), XIX, 1971, pp. 91–116.

Thuillier, Jacques. *L'opera completa di Georges de La Tour,* Milan, 1973.

Volpe, Carlo. "Annotazioni sulla mostra caravaggesca di Cleveland," *Paragone,* XXIII, no. 263, 1972, pp. 50–76.

Volpe, Carlo. "I Caravaggeschi francesi alla mostra di Roma," *Paragone,* XXV, no. 287, 1974, pp. 29–44.

LENDERS TO THE EXHIBITION

Caravaggio and His Followers
October 30, 1971-January 2, 1972

The William Hayes Ackland Memorial Art Center, University
 of North Carolina, Chapel Hill
The Akron Art Institute, Akron, Ohio
Allen Memorial Art Museum, Oberlin College, Oberlin, Ohio
Ing. Dr. Edoardo Almagià, Rome
Joële P. Almagià, Rome
The Art Institute of Chicago
N. U. l'Architetto Andrea Busiri Vici, Rome
Centraal Museum der gemeente Utrecht
City Art Museum of Saint Louis
The Cleveland Museum of Art
The Dayton Art Institute, Dayton, Ohio
Isaac Delgado Museum of Art, New Orleans
The Detroit Institute of Arts
Roscoe and Margaret Oakes Foundation, M. H. de Young
 Memorial Museum, San Francisco
Fogg Art Museum, Harvard University, Cambridge, Mas-
 sachusetts
Galleria Borghese, Rome
Galleria degli Uffizi, Florence
Galleria nazionale d'arte antica (Palazzo Corsini), Rome
Galleria Sabauda, Turin
Galleria Spada, Rome
Mr. and Mrs. Morton B. Harris, New York City
Heim Galleries, Paris and London
The Hoblitzelle Foundation, Dallas
Indianapolis Museum of Art
Los Angeles County Museum of Art
The Metropolitan Museum of Art, New York
The Minneapolis Institute of Arts
Musée des Beaux-Arts, Rouen
Musée du Louvre, Paris
Museo Balaguer, Villanueva y Geltru (Barcelona)
Museo del Prado, Madrid
Museo de San Carlos, Instituto de Belles Artes, Mexico City
Museum of Art, Rhode Island School of Design, Providence
Museum of Art, University of Kansas, Lawrence
Museum of Fine Arts, Boston
The Museum of Fine Arts, Houston
The National Gallery of Canada, Ottawa
The National Gallery of Scotland, Edinburgh
Nationalmuseum, Stockholm
Nelson Gallery-Atkins Museum, Kansas City, Missouri
North Carolina Museum of Art, Raleigh
Palazzo Reale, Naples

Park Ridge Public Library, Park Ridge, Illinois
Her Majesty the Queen, Hampton Court
Isabelle Renaud-Klinkosch, Switzerland
John and Mable Ringling Museum of Art, Sarasota, Florida
The Norton Simon Foundation, Fullerton, California
The Estate of Hamilton Smith, III
Collection Thyssen-Bornemisza, Lugano-Castagnola, Swit-
zerland
Earl C. Townsend, Jr., Indianapolis
University Art Museum, University of California, Berkeley
The Wadsworth Atheneum, Hartford, Connecticut
Mr. and Mrs. Henry H. Weldon, New York City
Wellesley College Museum, Wellesley, Massachusetts
The Wellington Museum, Apsley House, London
Worcester Art Museum, Worcester, Massachusetts

Private collection, Chicago
Private collections, Rome

PHOTOGRAPHIC CREDITS

A. C. I., Brussels *45**

Fratelli Alinari 45, 79; *1, 5*

Annan, Glasgow 62

S.r.l. Arte Fotografica, Rome *11, 17*

E. Irving Blomstrann, New Britain, Conn. 14, 55

L. Borel, Marseilles *20*

Photo Braun, Mulhouse-Dornach, Alsace-Lorraine *3*

Foto Brunel, Lugano 16

Bullaty-Lomeo Photographers, New York 31

Barney Burstein, Boston 51

Ron Chamberlain for University Art Museum, University of California 10

Chomon-Perino, Turin 33

Depto. de Artes Plasticas I.N.B.A. *27*

R. B. Fleming, Ltd., London *19*

Thomas Flist, New York 74

Gabinetto Fotografico Nazionale, Rome 47, 53, 59; *6, 7, 13, 40, 44*

G. F. S. G., Florence 11, 46; *31*

Fotowerkstätten Kleinhempel, Hamburg *42*

Stuart Lynn, New Orleans 24

MAS, Barcelona 42; *30*

O. E. Nelson, New York 26

Photo Studios Ltd., London 29

John D. Schiff, New York 6

Service de documentation photographiques, Réunion des Musées Nationaux 18, 63; *43*

Walter Steinkopf, Berlin-Dahlem *9*

Taylor and Dull Photography, New York 56

C. H. Traub 71

Foto Vasari, Rome 4, 27, 72, 77, 78

* Italicized numbers indicate comparative illustrations

Icon Editions

Albarn, K./ Language of Pattern $5.95 IN-50

Andrews, W./ Architecture in New York $4.95 IN-42

Andrews, W./ Architecture in Chicago & Mid-America $4.95 IN-43

Antal, F./ Florentine Painting and Its Social Background $8.95 IN-67

Ashton, D./ A Reading of Modern Art $4.95 IN-5

Avery, C./ Florentine Renaissance Sculpture $5.95 IN(t)-38

Banham, R./ Age of the Masters $5.95 IN-64

Blunt, A./ Art of William Blake $5.95 IN-45

Breton, A./ Surrealism and Painting $7.95 IN-24

Clark, K./ The Gothic Revival $4.95 IN-48

Duvignaud, J./ The Sociology of Art $3.95 IN-35

Freedberg, S. J./ Painting of the High Renaissance in Rome & Florence
 Vol. I $6.95 IN-13; Vol. II $7.95 IN-14

Gilbert. C./ Renaissance Art $4.95 IN-33

Golding, J./ Cubism $5.95 IN-8

Gowing, L./ Vermeer $5.95 IN-66

Hall, J./ Dictionary of Subjects & Symbols in Art $5.95 IN-54

Haskell, F./ Patrons and Painters $5.95 IN-9

Holloway, R. Ross/ A View of Greek Art $4.95 IN-46

Honour, H./ Chinoiserie $6.95 IN-39

Kouwenhoven, J. A./ The Columbia Historical Portrait of New York $7.95 IN-30

Lee, S. E./ Chinese Landscape Painting $4.95 IN-10

Lee, S. E./ Japanese Decorative Style $3.95 IN-17

Lockspeiser, E./ Music and Painting $4.95 IN-40

Mâle, E./ The Gothic Image $4.95 IN-32

Manvell, R./ Masterworks of the German Cinema $4.95 IN-47

Mathew, G./ Byzantine Aesthetics $2.95 IN-6

Medley, M./ Handbook of Chinese Art $3.95 IN-44

Panofsky; E./ Early Netherlandish Painting
 Vol. I $5.95 IN-2; Vol. II $6.95 IN-3

Panofsky, E./ Studies in Iconology $5.50 IN-25

Panofsky, E./ Renaissance & Renascences in Western Art **$5.50** IN-26

Panofsky, E./ Idea $4.95 IN-49

Renrose, R./ Picasso: His Life and Work $6.95 IN-16

Poggioli, R./ The Theory of the Avant-Garde $4.95 IN-1

Richardson, T. and Stangos, N./ Concepts of Modern Art $5.50 IN-41

Rosenau, H./ The Ideal City $6.95 IN-15

Rosenberg, J./ Great Draughtsmen from Pisanello to Picasso $7.95 IN-29

Salvadori, A./ 101 Buildings to See in Venice $2.50 IN-21

Salvadori, R./ 101 Buildings to See in London $2.50 IN-20

Salvadori, R./ 101 Buildings to See in Paris $2.95 IN-31

Spear, R. E./ Caravaggio and His Followers $5.95 IN-34

Stoddard, W. A./ Art and Architecture in Medieval France $7.95 IN-22

Stokes, A./ The Image in Form $4.95 IN-28

Sulik, B./ Polanski: Three Films $4.95 IN-62

Weightman, J./ Masterworks of the French Cinema $4.95 IN-51

White, J./ The Birth and Rebirth of Pictorial Space $4.95 IN(t)-27

Whyte, A./ Godard: Three Films $4.95 IN-65